Hank Willis Thomas, *All Power to All People,* Thomas Paine Plaza,
Monument Lab, 2017. (Steve Weinik/Mural Arts Philadelphia.)

MONUMENT LAB

Creative Speculations
for Philadelphia

Edited by
Paul M. Farber
and Ken Lum

Temple University Press

Philadelphia Rome Tokyo

Support for *Monument Lab: Creative Speculations for Philadelphia* was provided by the Elizabeth Firestone Graham Foundation.

TEMPLE UNIVERSITY PRESS
Philadelphia, Pennsylvania 19122
tupress.temple.edu

Design: Office of Luke Bulman, New York

Library of Congress Cataloging-in-Publication Data

Names: Farber, Paul M., 1982– editor. | Lum, Kenneth Robert, 1956– editor.
Title: Monument Lab : creative speculations for Philadelphia / edited by
 Paul M. Farber and Ken Lum.
Description: Philadelphia : Temple University Press, [2019] | Includes
 bibliographical references.
Identifiers: LCCN 2019005761 | ISBN 9781439916063 (pbk. : alk. paper)
Subjects: LCSH: Monuments—Pennsylvania—Philadelphia. |
 Memorials—Pennsylvania—Philadelphia. | Monument Lab (Art studio) |
 Art and society—Pennsylvania—Philadelphia—History—21st century.
Classification: LCC NA9350.P49 M66 2019 | DDC 725/.940974811—dc23
LC record available at https://lccn.loc.gov/2019005761

Printed in the United States of America

9 8 7 6 5 4 3 2 1

For
Paloma, Linus, and Linnea
Aaron and Ziggy

Mel Chin, *Two Me,* City Hall, Monument Lab, 2017. (Steve Weinik/Mural Arts Philadelphia.)

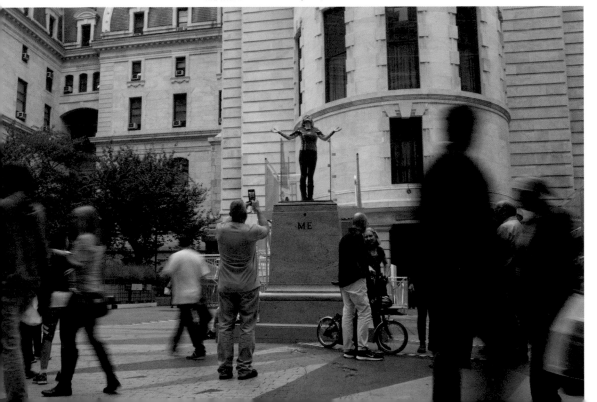

Michelle Angela Ortiz, *Flores de Libertad (Flowers of Freedom/ Liberty),* in conjunction with *Seguimos Caminando (We Keep Walking),* City Hall, Monument Lab, 2017. (Steve Weinik/Mural Arts Philadelphia.)

Like a bell named Liberty, let freedom ring.
Even though cracked, she still manages to sing.
Her sound resonates, both far and wide.
Demonstrates how to be broken, but still have pride.
—Ursula Rucker

Contents

Preface

Paul M. Farber and Ken Lum

Monument Lab is a public art and history studio based in Philadelphia that comprises a team of curators, artists, scholars, and students. We ask open research questions about the ways that publicly sited art, memorials, and monuments operate; we build speculative monuments ("prototypes," as we call them) in public spaces; and we gather creative forms of open data related to cultural memory. Our goals are to unearth the next generation of monuments and change the ways we collectively write the history of our cities.

In 2017, we teamed with Mural Arts Philadelphia, a renowned public arts organization, to produce a citywide exhibition organized around a central question: What is an appropriate monument for the current city of Philadelphia? This line of inquiry was aimed at building civic dialogue about place and history as forces for a deeper questioning of what it means to be Philadelphian in a time of renewal and continuing struggle.

Monument Lab's citywide exhibition resembled, in part, an art biennial, with temporary, site-specific works by numerous artists organized around a theme. But by proposing the exhibition thematic

around a question, rather than a thesis or prompt, and opening that question up to passersby at research labs installed next to the artworks, Monument Lab insisted on direct participation and lived most fully as an engaged, arts-focused research project with hundreds of thousands of co-contributors invited to question and conjure the monumental landscape around them. Monument Lab, as an art exhibition, valued public response as highly integral to its project and by doing so put art in the service of its research and dialogical aims.

The exhibition took place across the five foundational central squares of the city, five neighborhood parks, and a handful of satellite locations in museums (the Pennsylvania Academy of the Fine Arts and the Barnes Foundation), civic institutions (the

Monument Lab exhibition hub, Pennsylvania Academy of the Fine Arts, Monument Lab, 2017. (Steve Weinik/Mural Arts Philadelphia.)

Free Library of Philadelphia and the Art Alliance), and the borderlands of public and private spaces (Franklin Square near Old City, an Impact Services building in Kensington, and a vacant lot in West Philadelphia). Each place where we operated may be perceived as public space, under the jurisdiction of the city, a municipal entity, a neighborhood organization, the federal government, a private company operating on public ground, or a combination thereof. Many of these sites already featured existing monuments or embodied historical identifications. All of the sites contained additional layered histories deserving of critical and creative excavation.

For this citywide project, our aim was to convey public art and history across a complex and contradictory city landscape, rendered through its spaces of connection, lines of division, and conflicting rituals of remembrance. The footprint of the exhibition reflected the realities that we live in a city that was mapped before it was built, that was inhabited for thousands of years before its colonization by Europeans, and that continues to evolve with differing visions of justice and belonging inscribed into the form of the city itself.

We invited twenty contemporary artists to answer the exhibition's central question. They responded with prototype monuments for these iconic public squares and neighborhood parks. The cohort of artists was intended to be intersectional and diverse along lines of age, race, class, gender, sexuality, national belonging, and other matters of identity. We drew the artists from varying fields of public art and social engagement. A large contingent was from Philadelphia or had meaningful affiliations with the city. The monuments these

artists proposed were eventually made of stone and bronze, as well as from images, sounds, performances, recycled materials, and the artifacts of community process.

Accompanying the prototypes, as another pillar of the exhibition, were research labs operated out of modified shipping containers and staffed by teams of art educators and youth research fellows.

Exhibition Map

⊛ **EXHIBITION HUB**
Pennsylvania Academy of the Fine Arts (PAFA) + Special Project
Tania Bruguera

01 City Hall/Thomas Paine Plaza
Mel Chin, Michelle Angela Ortiz, and Hank Willis Thomas

02 Franklin Square
Kara Crombie

03 Logan Square
Emeka Ogboh featuring Ursula Rucker

04 Rittenhouse Square
Sharon Hayes and Alexander Rosenberg

05 Washington Square
Kaitlin Pomerantz and Marisa Williamson

06 Penn Treaty Park
Duane Linklater and RAIR

07 Vernon Park
Karyn Olivier and Jamel Shabazz

08 Norris Square
David Hartt

09 Malcolm X Park
King Britt/Joshua Mays

10 Marconi Plaza
Klip Collective and Shira Walinsky/ Southeast by Southeast

11 Special Project: A Street and East Indiana Avenue
Tyree Guyton

12 Special Project: 42nd Street and Lancaster Avenue
Hans Haacke

The labs were places for passersby to engage with the prototype artworks and contribute their own proposals for appropriate monuments. Rather than asking for only the feasible or practical, Monument Lab sought ideas that spoke to the evolving core values and visions of the city.

After several years of collaborative preparation, the exhibition opened for two months of public activation. Opening September 16, 2017, the exhibition proceeded to register more than 250,000 in-person engagements. Close to 4,500 Philadelphians and visitors contributed monument proposals, which were transcribed, analyzed, and uploaded as a dataset to OpenDataPhilly and presented to city officials and residents in Monument Lab's *Report to the City.* The monuments, the proposals, and the report together offered their own elaborate theories and deep knowledge about Philadelphia's public sphere.

We recognize and embrace a paradox of our approach: we contend that prototype artworks as temporary installations open pathways for changes to the enduring monumental landscape. Accordingly, we do not insist on impermanence for all future monuments. We believe that the temporary feature of these prototypes, whether as built structures or datasets of research proposals, can generate new ways of thinking about the monument, without regarding future monuments as simply permanent or impermanent. We are invested in exploring how public symbols are attached to social systems and vice versa. The idea that monuments are timeless, that they contain universal meaning, and that they are stand-alone figures of history— these are the truisms that we believe must be challenged, not necessarily to defeat the idea of civic

monuments but to invigorate them with new public engagement possibilities so that they function as constantly activated sites for critical dialogue, response, and experimentation.

This book is a compendium of the exhibition and a critical reflection of the proceedings that includes contributions from interlocutors and collaborators. It is also a living handbook for fellow practitioners in cities and regions outside Philadelphia who desire to remediate monumental landscapes in their own profound ways.

As a nation, we are in the midst of a long reckoning over our inherited monuments. This project is, in part, an outcome of our present cultural and political climate. For example, across the country, the removal of selected Confederate monuments and other statues that symbolize the enduring legacies of racial injustice and social inequality is a sign of welcome change in how memory politics operate in these distinct locales. In each instance, the shift was underwritten by years of activism and critical art making that troubled the status quo. That struggle continues, inside municipal bureaucratic structures and artist- and activist-led circles, to change the content and the processes of making monuments. Through this exhibition and book, we are reminded that we must find new, critical ways to reflect on the monuments we have inherited and to imagine those we have yet to build.

I. ESSAYS

How to Build a Monument

Paul M. Farber

Imagine that every monument installed across
the city of Philadelphia, just briefly, comes to life.
Each statue, whether a mythological or historical
figure, rendered in marble or bronze, positioned
in a heroic stance or seated in repose, scattered
across neighborhoods and municipal perches,
loosens from its foundations. In turn, the busts of
prominent Philadelphians blink and cast oblique
glances as if to exhale. At City Hall, three distinct
Benjamin Franklin sculptures on the north side
of Broad Street look quizzically at one another,
as a singular statue of the African American
freedom fighter Octavius Catto, on the other side
of the building, completes a long step toward the
site of his old South Philadelphia home. Beyond
the statuary, voices ring out for recognition, as
the spirits of those namesakes at parks, schools,
boulevards, and recreation centers clamor. A
similar chorus emanates from historic markers
placed outside famous Philadelphians' homes
or sites of protest. The city is filled with noise and
dust, generations of entangled mother tongues
and musical notes. The living are compelled to
pause, a grand reversal.

In this scenario, the dream revelation beckons
further speculation. Would the underrecognized

civic leaders and ancestral ghosts who have never achieved monumental recognition raise their voices as well? Would their improvised shrines, mossy headstones, and memorial murals cast skewed shadows? From such a vantage, would we, as witnesses, fully register the outcome of the processes that continue to shape the city's monumental landscape: that we elevate a disproportionately wealthier, whiter, more militaristic, and overwhelmingly male version of the past above others, in our monuments and our social systems? Are we reminded once again that history is not restricted to our past but is a force in the present?

We live in a city defined by the premise that history was, and is, produced here. Our grand narratives of this place—as Lenape tribal lands,

Terry Adkins, *Prototype Monument for Center Square,* City Hall, Monument Lab, 2015—Discovery Phase. (Lisa Boughter/ Monument Lab.)

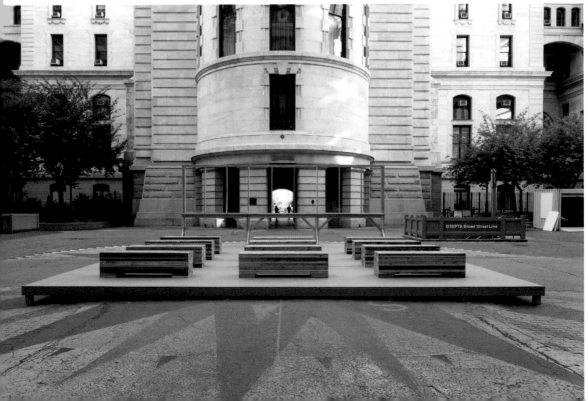

green country town, birthplace of democracy, workshop of the world—are braided together and offered as enduring points of pride. By now, the stories are as much topos as ethos, because it would be hard to imagine this city without the encounter of William Penn and the Lenape chief Tamanend, the outline of the Liberty Bell, the outstretched arms of the Rocky statue, and other iconic symbols as shorthand for civic identity. The city presents itself as a cradle of liberty, and these stories are often leveraged to nourish greater forms of belonging and justice, locally and else-where. While these identifications may sustain, in part, such declarations are nonetheless also haunted by what remains largely unregistered in official modes of public history. Displacement, economic inequity, racial and ethnic violence, and gender and queer exclusion are among several deeply underrepresented pillars of city order. As

Karyn Olivier, *The Battle Is Joined,* Vernon Park, Monument Lab, 2017. (Mike Reali/Mural Arts Philadelphia.)

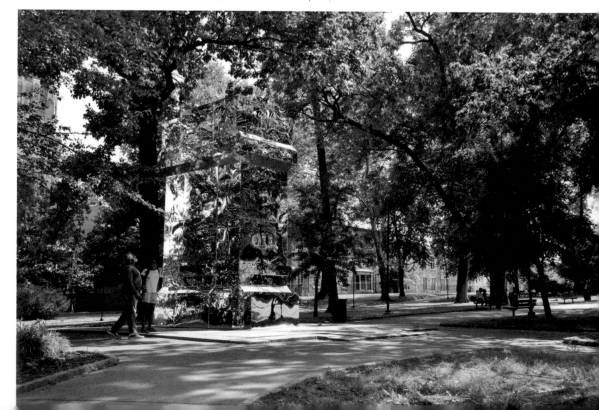

sites of spectacle and triumph, civic monuments participate in this simultaneous presentation and occlusion of what we have remembered, and, at a municipal level, what we have willfully forgotten. Perhaps this is why Essex Hemphill, who lived his final years in Philadelphia, wrote these words about the crisis of compassion and intervention during the AIDS epidemic:

It's too soon
to make monuments
for all we are losing,
for the lack of truth
as to why we are dying,
who wants us dead,
what purpose does it serve?[1]

Here and elsewhere, ambivalence permeates the cultures of monumentality. Who should be honored? Who decides what to remember, and what form should that remembrance take? Who should build the monument? When, if ever, is the right time to commemorate? No matter how grand the scale, history cannot fit into a statue, a plaque, or a marker. Our practice of celebrating elite individuals or transcendent agents of social change often obscures stories of struggle, solidarity, and collective action. Gary Nash highlights "a certain silencing" enacted through much of our city's history by the powerful stewards of artifacts, museums, and institutions who have shaped our understanding of the past while uplifting their own self-interests.[2] For generations, artists, activists, and students have led new directions in the field, adding platforms for exchange, catharsis, interaction, and accountability through the monumental form. They remind us of sprawling narratives and missing monuments that present a different map

of our civic landscape. We, too, as engaged residents and practitioners, are invited to attempt to disentangle myths and reassess our monumental inheritances.

Monuments operate as statements of power and presence in public space. No longer bound by static representations, we have lived through a sea change around monuments, in which creative communities respond to triumph and loss. Scholars such as David Blight, Svetlana Boym, Erika Doss, Toni Morrison, Lisa Saltzman, Kirk Savage, Marita Sturken, Michel-Rolph Trouillot, Dell Upton, and James Young have long argued that monuments no longer signify the universal, idealized, and permanent.[3] Traditionalists may balk at the idea of a monument as anything other than the elevated icon, a single figure of history embodied as a spectacle. But when we consider the most epiphanic, gripping sites of memory—Maya Lin's *Vietnam Veterans Memorial* and Bryan Stevenson's *National Memorial for Peace and Justice,* among them—the physical form of the monument indexes the bygone individual life amid the broader, turbulent currents of history, as memory confronts us in the present. Despite these advances, we have not fully revised the thinking about what a monument is or whom it addresses and for whom it carries value.

And so, the challenge remains: for every new site of reinterpretation and reinvention, there are hundreds that reflect an obdurate status quo. We face a long task of remediation, a process of critical engagement, inspired by environmental practitioners, to diagnose and take steps to address sites with toxic narratives and practices of exclusion as a way to respond to recent and

long-standing nationwide conversations about what to do with the incomplete monumental landscape we have inherited.[4]

We should know by now that history is not written simply by the victors; it is inscribed by those who have the time, money, and power to build monuments. But we also have learned, time and again, that those who lack time, money, or power can stand, gather, or resist next to a monument to amplify their presence, make their voices heard, and confront the systems that wrought the monuments.

Monument Lab—the name of the ongoing public art and history studio as well as of the exhibition documented in this catalogue—was born out of Philadelphia's complex legacies and layers. As a curatorial team, we conceived of the project at

Emeka Ogboh featuring Ursula Rucker, *Logan Squared: Ode to Philly,* Logan Square, Monument Lab, 2017. (Steve Weinik/ Mural Arts Philadelphia.)

a moment in which cities across the United States are pondering their cultures of commemoration, and one in which our own city is experiencing a wave of urban renewal paced by historical dilemmas. Philadelphia's recent recognition as the first U.S. World Heritage City was contemporaneous with a building boom in which developers routinely bulldoze historic row homes, churches, and factories for new commercial projects. The business of higher education spurs millennial civic engagement, while the legacy of neighborhood school closures and budget cuts looms over a generation of underresourced youth. And, in this moment of national reckoning with monuments, especially

Documentation of Monument Lab proposal, LLA27, Franklin Square, Monument Lab, 2017. (Steve Weinik/Mural Arts Philadelphia.)

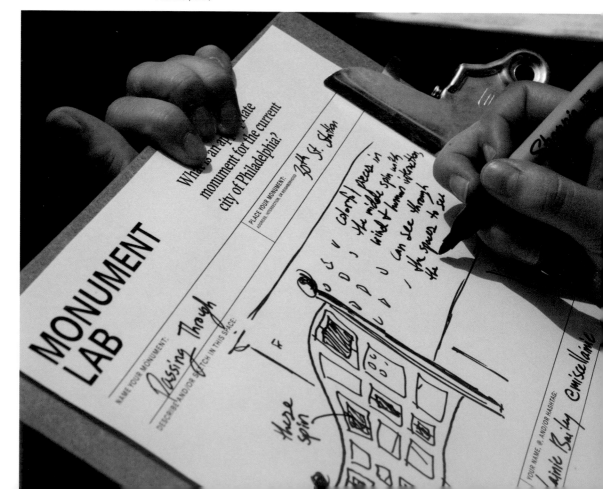

those that reflect racist and unjust legacies, this city's collection of more than fifteen hundred monuments includes only one figure of color on city land and two historical women on public land. Even if we count the handful of statues at the corporate-run stadiums and on private property or the unnamed figures in groups, it is evident we are ready for more conversations about the history and trajectory of the city.

The discovery phase of Monument Lab took place in 2015, in the central courtyard of City Hall. We asked a single question: "What is an appropriate monument for to the current city of Philadelphia?" Of course, no single answer would suffice; rather, the multitude of responses offered varying approaches to memory as the fabric of civic engagement. At its center, the discovery phase featured an "appropriate" prototype monument by the late artist Terry Adkins—an empty class-room signifying recent public school closures and budget cuts to education—and an adjacent learning lab to collect monument proposals. Hundreds of visitors each day spent time walking through the sculpture, occupying it for demonstra-tions or performance, or sketching out monument proposals on Monument Lab clipboards. The relationship between the prototype monument and the lab's modes of invited inquiry sparked tension, urgent memory, and thoughts of possi-bility, participation, and reinvention.

For the 2017 citywide Monument Lab exhibition, we set out with a refined mission to reinterpret the monuments we have inherited, revisit the civic and municipal processes of power that yielded them, and conjure the missing or future monuments, including those bringing forth a public history of

social justice and equity. We partnered with
Mural Arts Philadelphia, which had bridged the
gap around monumental representation in the city
for three decades with murals of underrepre-
sented subjects and visions of collective social
change. We were also drawn to work with them
because of their evolving model of activating
underutilized neighborhood storefronts and saw it
as an inspiration for the labs. Our curatorial team
spent several years in development with Mural
Arts, as well as other municipal agencies, commu-
nity organizations, and high school and college
student fellows. In the end, we recognized that to
produce work about and from Philadelphia is to

Monument Lab exhibition hub, Pennsylvania Academy of the
Fine Arts, Monument Lab, 2017. (Steve Weinik/Mural Arts
Philadelphia.)

inherit long-standing questions of civic belonging and to try to make sense of shifting demographic and ecological conditions and balance aims for striving and coexistence.

The provocative ideas contributed by the artists invited to participate were the driving force behind the citywide exhibition. Each artist brought a unique viewpoint, body of work, and public voice that was essential in building an intersectional cohort along lines of age, race, gender, sexuality, national belonging, and artistic practice. We assembled a strong contingent of local Philadelphia artists, enhanced by others who would bring fresh perspectives as visitors to a city in transition. They spent time in archives, libraries, classrooms, community meetings, and public spaces. They summoned or were situated within circles of collaborators. They considered the range of commemorative sites and forms reflected in the word *monument,* indicative of the deep histories of the region itself, as well as the human activity within it. Together, they attempted to measure this city's storied public art collection against what is missing and what is possible.

Several weeks before the exhibition opened, in August 2017, white supremacists marched through Charlottesville, Virginia, with fire and fury to protest the potential removal of a statue to Confederate general Robert E. Lee. They instigated a week of violence, culminating in the terroristic murder of the antiracist protestor Heather Heyer. The surreal scene of interfaith clergy linked together in a peaceful phalanx, staring down armed militiamen and agitators on the edge of Emancipation Park, was a reminder that the work of monumental revision is deeply

connected to larger struggles for equity and justice. Soon after, in Philadelphia, City Councilwoman Helen Gym picked up on long-standing trauma and discontent over a comparable statue of former mayor Frank Rizzo on the steps of the Municipal Services Building, dedicated to a figure whose policies and rhetoric harmed communities of color, women, and queer people. Gym tweeted, "All around the country, we're fighting to remove the monuments to slavery & racism. Philly, we have work to do. Take the Rizzo statue down." Community organizers rallied around this statement and continued to push for the statue's removal. As exhibition organizers, we understood the heightened sense of urgency and timeliness of such confrontations. We were galvanized to further honor the interventions of our artists and stand in solidarity with those on the frontlines of monumental remediation and revision.

As the exhibition launched, one of our goals—to invite passersby to "unfreeze" the monuments—unfolded in real time. Across the city, at project sites and at the labs, conversations transpired and extended around the prototype artworks, fueled by the memories of the viewers. Prototype monuments and creative proposals, again, evinced dynamism as a facet of monumentality: from the first cracks of Tania Bruguera's elevated outdoor clay sculpture *Monument to New Immigrants* to the mirrored reflections of the surrounding visitors and environs cascading from Karyn Olivier's *The Battle Is Joined* to the flickering neon of *In Perpetuity,* Duane Linklater's monument to Chief Tamanend, to the nearly forty-five hundred public proposals submitted by participants from dozens of Philadelphia neighborhoods.

Through the exhibition, we saw the mantle of this work picked up by others, some of whom we directly engaged, and others we met along the way. Monument Lab high school fellows hired to work in the labs and college students enrolled in a Civic Studio course at the University of Pennsylvania worked side by side in labs led by an intrepid and creative cohort of artist educators who served as managers. Local elementary school, high school, and college classes reinterpreted Monument Lab for their own exercises on public art and history. Partners and colleagues in other cities—Charlottesville, Chicago, Los Angeles, Memphis, Newark (New Jersey), New Orleans, New York, Providence, Richmond, San Francisco, St. Louis, and Washington, D.C., among others—opened conversations about what comes next, bridging local frameworks to a national movement reaching out beyond the exhibition. Potential volumes of reflections, possibilities, and criticisms could be written from the gathered materials. The work of Monument Lab will continue, with Philadelphians and others elsewhere critically reflecting on the monuments we have inherited and unearthing the next generation of monuments together.

On one of the first evenings of the citywide exhibition, at an opening on the roof of the Parkway branch of the Free Library of Philadelphia, the Nigerian sound artist Emeka Ogboh and his Philadelphia collaborator Ursula Rucker premiered *Logan Squared: Ode to Philly,* one of the exhibition's twenty prototype monument projects. They had collaborated on this sonic monument, an epic poem that reflected on the public proposals of Monument Lab. Their work could be experienced throughout the day and night by plugging

headphones into solar-powered sound posts on Logan Circle, or on the rooftop of the library, as a weekly Sunday mediation played through a multichannel sculptural installation. Either way, whether as complement or competition, the sounds of the city blended into the work of art.

The night of the opening, the sky exploded in a peachy sunset. Attendees included the artists, the collaborators and production team, city officials, student collaborators, and a crowd of attendees from their own corners of the city. When the symphony of sounds projected through the speakers, people sat still or leaned against the surrounding railings, and toward the end of the night, as the sky darkened, several burst into improvised dance, while others lingered until the sunset was complete.

The night was monumental—not because the project testified with bronze or marble but because it created a place to weigh the evidence of who we are and where we are going. We gathered on the roof of the Free Library overlooking Logan Circle. We experienced the sonic monument above a public space named after James Logan, the first colonial secretary of Pennsylvania. Logan remains enshrined in our city's history despite having enslaved African Americans and perpetuated a duplicitous land grab from the Lenape known as the Walking Purchase. Several miles away in a North Philadelphia neighborhood, the stewards of Logan's former estate, Stenton, are attempting to reckon with its legacy of enslavement. Our city lives as a conundrum and our uneven memory fuels the puzzlement of our current condition. In this setting, Rucker left another enduring imprint:

We walk on ground of mamma pacha, founding fathers, First Nations, abolitionists and Underground Railroads. Amidst old oaks, freedom, ancient energy, enslavement and escape routes. We are so very interesting. . . . We are our own monuments.

Notes

1. Essex Hemphill and Joseph Beam, *Brother to Brother: New Writings by Black Gay Men* (Boston: Alyson, 1991), 137.

2. Gary Nash, *First City: Philadelphia and the Forging of Historical Memory* (Philadelphia: University of Pennsylvania Press, 2002), 8.

3. See David Blight, *Race and Reunion* (Cambridge, MA: Harvard University Press, 2000) and *American Oracle: The Civil War in the Civil Rights Era* (Cambridge, MA: Harvard University Press, 2013); Svetlana Boym, *The Future of Nostalgia* (New York: Basic Books, 2001); Erika Doss, *Memorial Mania: Public Feeling in America* (Chicago: University of Chicago Press, 2010); Toni Morrison, *Playing in the Dark: Whiteness and the Literary Imagination* (Cambridge, MA: Harvard University Press, 1992) and "Site of Memory" in *Out There: Marginalization and Contemporary Cultures,* ed. Russell Ferguson (New York: New Museum of Contemporary Art, 1990); Lisa Saltzman, *Making Memory Matter: Strategies of Remembrance in Contemporary Art* (Chicago: University of Chicago Press, 2006); Kirk Savage, *Standing Soldiers, Kneeling Slaves: Race, War, and Monument in Nineteenth-Century America* (Princeton, NJ: Princeton University Press, 1999) and *Monument Wars: Washington, DC, the National Mall, and the Transformation of the Memorial Landscape* (Berkeley: University of California Press, 2009); Michel-Rolph Trouillot, *Silencing the Past: Power and the Production of History* (Boston: Beacon Press, 1995); Dell Upton, *What Can and Can't Be Said: Race, Uplift, and Monument Building in the Contemporary South* (New Haven, CT: Yale University Press: 2015); and James E. Young, *The Texture of Memory: Holocaust Memorials and Meaning* (New Haven, CT: Yale University Press, 1994) and *The Stages of Memory: Reflections on Memorial Art, Loss, and the Spaces Between* (Amherst: University of Massachusetts Press, 2016).

4. A signature moment in this era of reckoning: the removal of Confederate monuments in a handful of U.S. cities, including Baltimore, Memphis, and New Orleans. While 2017 was a landmark year for confronting these strange specters of racial apartheid in the United States, the debate over whether to keep them or tear them down obscures several important contextual points. According to the 2018 Southern Poverty Law Center (SPLC) report *Whose Heritage?* "State and local governments have removed at least 110 publicly supported monuments and other tributes to the Confederacy since the 2015 white supremacist massacre In Charleston, South Carolina, but more than 1,700 remain, many of them protected by state laws in the former Confederate states." Further, SPLC's research pointed out that the memorials were dedicated long after the Civil War because they were also intended to hiss at civil rights activism. Beyond these clear symbols of white racial rule are countless other commemorative sites, within and beyond the former Confederacy and throughout the North and West, that monumentalize and reinforce intersectional forms of oppression.

Memorializing Philadelphia as a Place of Crisis and Boundless Hope

Ken Lum

Monument Lab began with a conversation between Paul Farber and me five years ago. Paul had just returned home to Philadelphia after earning his doctorate at the University of Michigan, and I was newly arrived from Vancouver. We both had accepted positions at the University of Pennsylvania, where we would teach classes on public space—he in urban studies and I in fine arts. During our first encounter, we discovered that we had been asking parallel questions about the complex narratives of Philadelphia's memorial landscape. We mused about organizing an exhibition to try to understand the mechanisms of memorialization, particularly questioning the status of the monument and how we might challenge a monument's canonical character. We were also interested in issues of embodiment and the ambivalence that is part of any construction of symbolic unity as well as the negated or unacknowledged histories that have been evacuated from the monument and yet remain palpable as an absence.

The extant memorial landscape of Philadelphia is identified with the dominant citizen class, as evidenced by the near total absence of officially sanctioned statuary of people of color and women.

The city unveiled its first public memorial to an African American in September 2017, a statue of the great nineteenth-century civil rights advocate and educator Octavius Catto. We noted that African Americans make up more than 40 percent of Philadelphia's population, and the struggles and contributions of black residents are central to any appreciation of the city's greatness.

We noted also that only two historical women are represented as full figures: Joan of Arc and the colonial-era First Amendment rights advocate Mary Dyer, both important figures but neither with any affiliation with Philadelphia. This absence of public monuments to historical women was the

Artist Marisa Williamson speaking at public event for *Sweet Chariot: The Long Journey to Freedom through Time,* Washington Square, Monument Lab, 2017. (Steve Weinik/Mural Arts Philadelphia.)

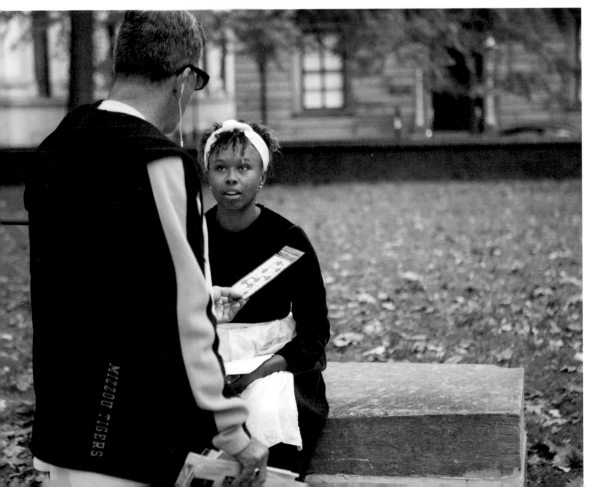

subject of Sharon Hayes's *If They Should Ask* prototype monument in the exhibition, in which an array of reduced-scale pedestals modeled after existing monuments to men were gathered in Rittenhouse Square. Inscribed at the base of the empty pedestals were the names of important local, national, and international women from the Philadelphia area. *If They Should Ask* was predicated on the forgotten histories and exclusionary pronunciations of historiography. The absence of commemoration of women is a willful structuring that produces and reproduces the conditions of patriarchal society.

The many monuments to white men in Philadelphia would have us believe that this is the natural order of history, achievement, and remembrance and that there is no need to acknowledge the enduring violence that has been perpetrated against women and against African Americans and other people of color. In response to this vacuum, Paul and I aimed to create an exhibition that would embody democracy through the participation of a wide and varied audience engaged in public dialogue. We wanted to listen to *all* Philadelphians about their city and give voice to those who too often go unheard.

We also saw Monument Lab as an exercise in which the city's public spaces are opened to question. Monuments tend to render their sites incontestable, where different readings are not permitted and where it is assumed that one system of values is unequivocally shared by all. We wanted to challenge these assumptions. Philadelphia is a vast metropolis, with more than a quarter of its 1.5 million inhabitants living in poverty. Given that poor areas of the city also

suffer more acutely from poorly funded public schools, high crime rates, and familial fracturing, we erected Monument Lab containers in sites located both within and far beyond Center City, including Norris Square, Malcolm X Park, Marconi Plaza, Fairhill, Penn Treaty Park, and elsewhere. Each container offered a busy schedule of activities. Karyn Olivier, whose prototype sculpture *The Battle Is Joined* was sited in Germantown's Vernon Park, noted the local residents' surprise and delight that an important art project would be installed in their neighborhood, which receives a disproportionate amount of civic attention compared with central, more affluent areas of the city.

Monument Lab also took on the reanimating of art in the service of the public or art in the service of activating public space. With the adulteration of public space by private interests, public art has

Lab research team, Karyn Olivier, *The Battle Is Joined,* Vernon Park, Monument Lab, 2017. (Steve Weinik/Mural Arts Philadelphia.)

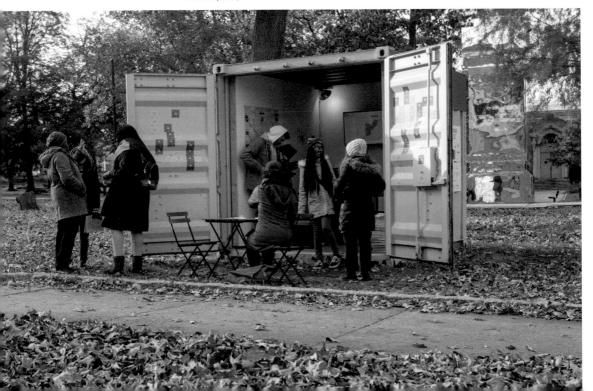

become increasingly instrumentalized in two directions. On one hand, it is called on to compensate for shrinking public space by its sheer symbolic presence. On the other hand, public art becomes an instrument of real estate development logic, as the gifting portion of private interests. All too often, the value of public art is unquestioned as long as it is "artful," without a consideration of the "public" aspect. In other words, public art is often considered, by its very nature, a public good. But it is not always clear whom public art is meant to serve. History demonstrates that when it is poorly planned or divorced from the social or economic reality of its site, public art can cause more harm than good.

In Fairhill, at the intersection of A Street and Indiana Avenue, Tyree Guyton, a Detroit artist and progenitor of the Heidelberg Project, produced *THE TIMES,* which featured community-painted images of giant clocks affixed to the brick facade of an empty warehouse. Each of the clocks denoted a different time but together they existed synchronically. Guyton imbued the piece with a political protest against poverty and the abandonment of the civic body. Fairhill is one of the poorest neighborhoods in Philadelphia, a city that is also the poorest among large U.S. cities. Other than the Market-Frankford Line, the people of Fairhill have no nearby options for rapid transit. Transportation is a significant problem, as is the cost to get to work. I spoke with a woman in the neighborhood who worked three part-time jobs, as a cleaning woman and as a worker in two different fast-food outlets that were far from each other. *THE TIMES* meditates on the ways in which time and money are intertwined cruelly for the poor. People are poor not just because they lack

money; they are poor also because they lack time. The lack of time to think or to properly attend to things, including the most mundane daily tasks, demands that the poor devote their thinking to the next most urgent deadline, so that there is never time enough. The time that capitalism imposes on the poor is unceasing and compulsory. *THE TIMES* demands the end of the system of forced obedience to hegemonic concepts of time and space by which Othered bodies are made to suffer.

Tyree Guyton, *THE TIMES,* A Street and East Indiana Avenue, Monument Lab, 2017. (Steve Weinik/Mural Arts Philadelphia.)

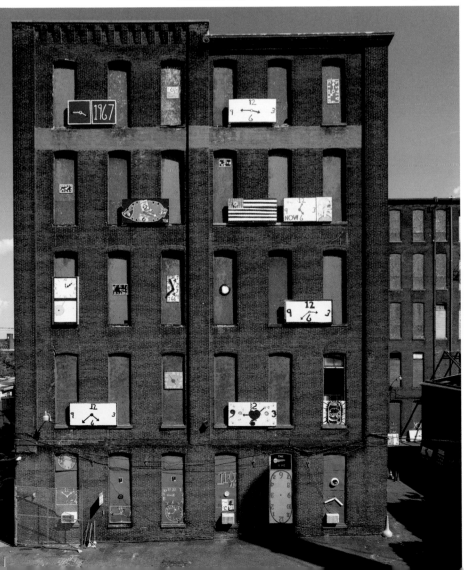

In West Philadelphia, Hans Haacke's proposal for *Digging (Archaeology of the Vacant Lot)* consisted of an archeological dig of a razed triangular block. The idea was to reveal the original foundations of the buildings that once stood along Lancaster Avenue in the Belmont neighborhood. That portion of Lancaster was once a lively commercial street, since left to abandonment. Haacke's work is best remembered as an image of a chain-link-fenced-in area of backhoes and workers digging up the ground. For the person driving by, the image was ambiguous. Was what was happening a sign of redevelopment and all the associations that brings? Was the recent positive turn in the city's financial resources resulting in infrastructural improvement to an area sorely in need of it? For neighborhood residents, too often unrecognized for their insights into histor-ical consciousness, their walking by may spur a different set of associations having to do with the narratives of local memory.

To take in Monument Lab was to travel every precinct of Philadelphia. We wanted to prompt the public to identify with the man about town, who wishes to "rush into the crowd in search of a man unknown to him" and to throw "away the value and the privileges afforded by circumstance," as Charles Baudelaire writes in *The Painter of Modern Life* (1863). We wanted Philadelphians to visit places within their city that they had never visited, to experience their city through the lives and spaces of others.

We were interested in the idea of public memory serving as future speculation. At the labs, members of the public were asked to respond to the exhibition's central question: "What is an

appropriate monument for the current city of Philadelphia?" By asking what would be appropriate rather than what would be ideal, we opened conceptual space for respondents to interpret the question according to their own criteria. Indeed, the most common and immediate response from the public to the question "What is an appropriate monument?" was "What do you mean by 'appropriate'?" The ambiguity of the question was meant to evoke something more than the recollections of memory: the more fundamentally democratic ideals of the origins of new historical knowledge.

The depth of public memory surprised us. Many proposals dealt with the profoundly challenged state of Philadelphia's public school system. Others dealt with the city's distinctive neighborhoods, some at the most immediate street level. A significant number of proposals called for a

City Councilwoman Helen Gym speaking at public event for Sharon Hayes, *If They Should Ask,* Rittenhouse Square, Monument Lab, 2017. (Steve Weinik/Mural Arts Philadelphia.)

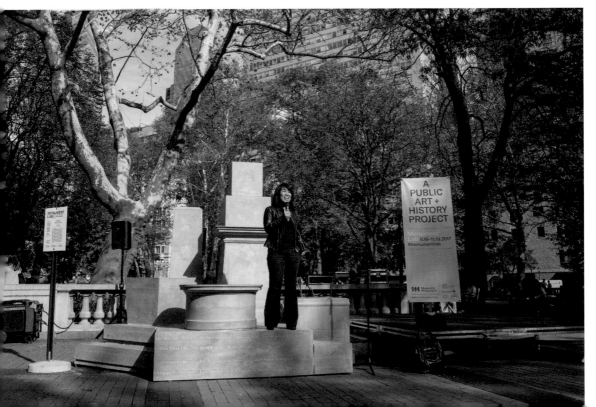

memorial to the 1985 bombing of the compound of MOVE, an African American liberation group. The proposals revealed that Philadelphians are animated about the application of public art and public history to this city. And if they feel their ideas and experiences are valued, they are willing to participate directly and contribute ideas in a process of creative speculation. Through this project, we were reminded how rarely the public is asked to think about what histories, places, and people are worth remembering and commemorating in official contexts.

As we learned, Philadelphians are aware of the impact of politics on debates about memory and advocacy, the importance and significance of a broad range of monuments, and the city's

Selection of Monument Lab proposals related to MOVE, Monument Lab, 2015–2017.

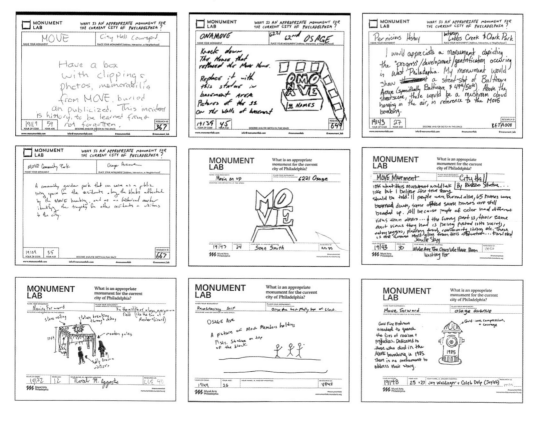

historical sites and perspectives. It became clear to us that the people of Philadelphia were already thinking about our central question—or at least some form of the idea of what the city is, what it was, and what it can be through a process of participation and monumental production.

Philadelphia is the home of the Liberty Bell. We saw the crack in the bell as a discernable fissure that haunts us, a collective wound that refuses to heal. For all the glorious language that makes up the Constitution and the Declaration of Independence, the United States of America is a place founded on the wounded bodies of Others— the indigenous, black, indentured, queer, impoverished, and many more.

Monument Lab operates between civic engagement and public humanities, offering key ideas and methods for Philadelphia and other cities. Seeing a shift in the public understanding of monumentality, we created a welcoming, site-specific research method and the conditions for a more nuanced discussion about public art, public history, and social practice. The message of Monument Lab is that the city is a place of limitless possibility, and that in reflecting on this city, we can begin to understand the power of being a human among other humans. The city is itself a living monument to humanity, with all of its potential and all of its challenges. Monument Lab aims to unearth potential solutions to a better collective future for Philadelphia. But such solutions can come about only if we recognize that our departure point must be from the view that the city is a place of many voices that deserve to be heard.

Public Practice

Jane Golden

In 1985, a year into the start of the Philadelphia Anti-Graffiti Network—a city-sponsored program designed to reduce graffiti and provide art education programs for former graffiti writers—my then colleagues and I first ventured out into communities to work closely with residents in order to brighten and beautify the physical landscape and to alter their experience of city living. As we sat in Rachel Bagby's living room in the Strawberry Mansion section of Philadelphia, we talked about what she and her neighbors might want to see painted on the walls of their neighborhood.

Having worked on murals in Los Angeles, after years spent studying the powerful images of Mexican muralists and the WPA, I had amassed a collection of photographs of some of my favorite public artworks from around the country. I showed them to her, expecting that these iconic images would prove captivating and inspiring. "No, thank you," Bagby and her neighbors said, to my surprise. "Things are mostly done to us, or not done. If we are going to have a mural, we need to see ourselves and our past." The offer of a mural was unfamiliar, as a concept and as a subject matter. The notion that the mural came without strings and that they could make a collective

decision about its subject matter and appearance prompted both skepticism and curiosity.

It was an important opening, and as much an opportunity for us as it was for them. That night, Bagby and her neighbors shared stories that had not been documented and perhaps not even discussed previously with outsiders. Their memories of family farms in the South, the scent of the earth and what grew in it, home life, foodways, and migration north—all of it poured out. While the memories evoked nostalgia and pain, it was clear to these women that these personal histories were worth documenting, for themselves and for their grandchildren, in order to nurture a growing community. This process of developing ideas became a powerful exercise in shared agency.

Shira Walinsky and Southeast by Southeast, *Free Speech*, Marconi Plaza, Monument Lab, 2017. (Steve Weinik/Mural Arts Philadelphia.)

A similar scenario evolved when, a year or so later, looking to expand the city's mural collection, we approached the residents of a burgeoning Puerto Rican community in North Philadelphia, near Norris Square. Local activists had forged powerful bonds around their shared cultural identity and language and their recent experiences of immigration and discrimination. Yet when they were asked to make choices about what they wanted on their walls, the Puerto Rican neighbors looked to the past—to the music, food, and vitality of their Caribbean homeland. They wanted murals "like the ones in Strawberry Mansion" but with Boricua style, energy, and color.

Our efforts to engage communities proved so fruitful that eventually our strategy shifted from soliciting interest in murals to managing rapidly rising expectations. We received an overwhelming number of requests for images of athletes, musicians, politicians, and other historical figures: Julius "Dr. J" Erving, Jackie Robinson, John Coltrane, Mario Lanza, Martin Luther King Jr. These requests embodied the vast potential that Philadelphians sensed was possible, if not always realized. Many mural projects also drew on Philadelphia's more long-standing history of public monuments, which invoke different ways to use public space: to gather, to inspire, to challenge, to uplift, and to transform. While bronze was the most common material used in major civic spaces, mural paint became the vernacular of residential blocks and commercial corridors.

In the intervening decades between the Anti-Graffiti Network and today's Mural Arts Philadelphia—a public/private partnership that works with city agencies and engages social

service providers, cultural organizations, public and charter schools, and countless neighborhoods—we have informally but consistently posed questions about what can be described or interpreted as a current-day monument in Philadelphia. Monument Lab, a project envisioned by a curatorial team led by Paul M. Farber and Ken Lum that had its own history of dialogue in communities about the power of art, brought a golden opportunity to consider those questions with greater depth and intention.

————

At Mural Arts, we move quickly to fulfill our social contracts—to meet stakeholder expectations, to realize obligations to funders and partners, to train and employ artists, and to create works of art that are worthy of the ambitions of the artist, the community, the sponsors, and the organization

Monumental Exchange featuring Hank Willis Thomas and Tariq Trotter, moderated by Salamishah Tillet, City Hall, September 16, 2017, Monument Lab, 2017. (Steve Weinik/ Mural Arts Philadelphia.)

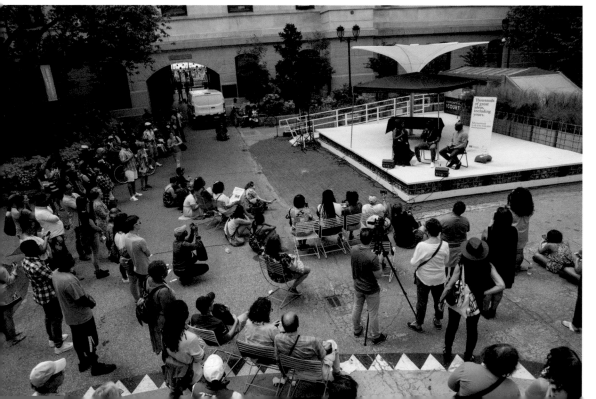

itself. We are deeply invested in ensuring authen-
tic voices, and we have developed listening skills
and patience to that end. But, because of the pace
and volume of our work, it is often hard to recon-
cile the sometimes competing needs to allow
for the artist's voice to rise, to make room for
contemplation, to take on the complications of part-
nerships, and to balance fundamental issues
around representation and social change. With
Monument Lab, however, we embraced this
complexity. We found room for the curatorial
vision, we tried to offer the artists space and
time to experiment, and we built an element
of reflection into the production of these proto-
type artworks, all without giving up the scale,
learning curve, and ambition of any of our recent
citywide efforts.

Kai Davis, Monument to the Philly Poet event, Free Library/
Shakespeare Park, September 27, 2017, Monument Lab, 2017.
(Steve Weinik/Mural Arts Philadelphia.)

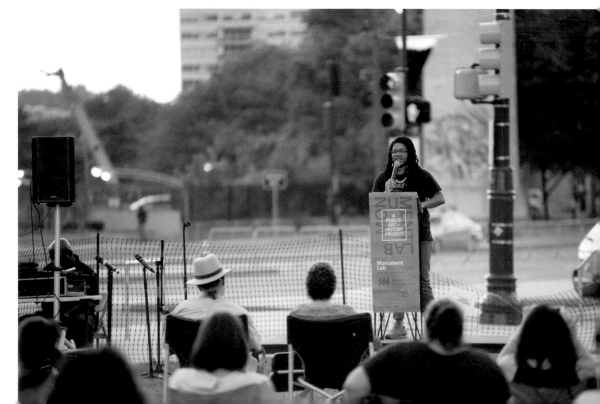

Monument Lab worked in ten distinct communities and used the five public "squares" designated by William Penn in his original plan for Center City Philadelphia, along with five other parks and recreation sites and three special projects. The Monument Lab curatorial model differed from that of Mural Arts in that it began with a list of artists, aligning their interests and their work to specific sites around the city. Mural Arts was called on to build bridges (multiple, in some instances) between artists, communities, and the city itself. We realized the resulting work might feel unfamiliar to many in our well-traversed circles, in that it was temporary, often conceptual or cerebral, and largely nonrepresentational.

In the end, the work spoke for itself. Most of the prototypes created through Monument Lab were moving and powerful, and the curators made good on their goal of preparing Philadelphia for the next generation of monuments by bringing us Hank Willis Thomas's Afro pick, installed on the Municipal Services Building Plaza, adjacent to a statue of the late mayor Frank Rizzo; Sharon Hayes's tribute in Rittenhouse Square drawing attention to the dearth of monuments for women; Kaitlin Pomerantz's displaced stoops in Washington Square; Karyn Olivier's monument that reflected its sylvan setting on new, mirrored faces in Vernon Park; and Tania Bruguera's unfired clay figures of children slowly disintegrating on their pedestals, located outside the Pennsylvania Academy of the Fine Arts. Monument Lab underscored how artistic process can shape conceptual thinking about place—how, in the words of the curator Elizabeth Thomas, a public art organization "can both reflect and generate community."

We are so grateful to Paul Farber and Ken Lum, the Monument Lab team, and all of the participants, for stretching our understandings of history and of the role of art in discovering truth and value. As we continue to incorporate Monument Lab's research and impact into future projects and programs, we at Mural Arts are reinforced in our belief in the value of public practice and fortified with a more robust armature on which to build our new monuments, thanks to new structures for research, participation, and documentation.

We are also left with this useful definition for contemporary monuments by Karyn Olivier: "I think a monument is a living, breathing entity." In that sense, art in public can commemorate, acknowledge, reconsider, reimagine, and investigate the past, with implications for the future and the now. We may continue seeking out the question we have been asking for over thirty-five years—not just what a contemporary monument is, but what it can do.

Public event for Kaitlin Pomerantz, *On the Threshold (Salvaged Stoops, Philadelphia),* Washington Square, Monument Lab, 2017. (Steve Weinik/Mural Arts Philadelphia.)

II. ARTISTS AND REFLECTIONS

Tania Bruguera

Born 1968 · Cuban · Based in Havana, Cuba/New York City, New York/Cambridge, Massachusetts

Monument to New Immigrants

Pennsylvania Academy of the Fine Arts · Wood, paint, clay, steel

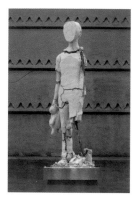

Tania Bruguera's *Monument to New Immigrants* was a meditation on the history and significance of immigration in Philadelphia and beyond. She proposed an elevated statue of an immigrant child. The figure was bifurcated vertically, with the face and torso of the child left blank and unmarked by race, ethnicity, or gender. The statue was molded from clay but unfired to remain vulnerable to outdoor conditions. As Bruguera noted in the preparation of the project:

> The statue represents a kid as a metaphor for what is experienced once you immigrate: no matter how old a person is, they need to start over. The idea behind the statue is not to represent a particular community, but all the immigrants; for this reason, they don't have any specific gender or appearance, and they do not have a "face." The lack of facial details is a way to emphasize the sense of precarity that immigrants experience: they are not always in one place; part of them is somewhere else, in their home country, and their identity is formed by their experiences in their new place.

Bruguera collaborated with students and staff from the Sculpture Department of the Pennsylvania Academy of the Fine Arts (PAFA) to create a series of identical clay immigrant figures. During the exhibition, one was mounted on an outdoor plinth in PAFA's Lenfest Plaza, between Claes Oldenburg's monumental *Paint Torch* and Jordan Griska's naval-plane-turned-terrarium *Grumman Greenhouse.* The pedestal's plaque was inscribed with the following text: "In memory of all the new immigrants, who have the strength to start over and give so much to others." After weeks of weathering, the unfired sculpture deteriorated and was replaced by an identical one. As the summer ceded to fall, the change in humidity caused the clay to crumble, exposing the steel frame that held the figure together. This cycle of installation and decay repeated throughout the exhibition. Bruguera's poetic series monumentalized arrival, adaptation, loss, and renewal as an allegory of immigrant experiences in the United States.

Statues Also Live: On Tania Bruguera's *Monument to New Immigrants*

Homay King

Professor of history of art, Bryn Mawr College

Immigration is a movement. It is a potential that never reaches the state of fait accompli. It is a process, a gerund always under way that never stops migrating. It is, in Tania Bruguera's words, a "perpetual and endless condition." It is social and cultural change, transformation. Without it, communities become static, frozen in time, and they atrophy.

Immigration policy in the United States—the Chinese Exclusion Act of 1882, the Johnson-Reed Act of 1924, and more recently, the repeal of the Deferred Action for Childhood Arrivals program—has historically been predicated on a very different idea: that immigration is not a movement or process but a system for the classification and sorting of persons. Ill treatment of the immigrant is prompted by xenophobia and justified through a more actuarial logic that claims to assess a potential entrant's value as contributor to or drain on a national economy.

Bruguera's *Monument to New Immigrants* disaggregated both of these myths about immigration. It was an anti-monument, in a way. A young, faceless child made of brittle white clay, the statue was designed deliberately to wear away under the elements. The child dragged a teddy bear, Christopher Robin–style, perhaps a transitional object to quell separation anxiety. But the bear did not provide protection: wind, rain, and sunlight gradually eroded the plaster flesh from the statue's limbs. A few weeks into the project's life, a metal support in the statue's leg was exposed as chunks of clay fell away. This bone-like support soon rusted, making the child appear like a cyborg— or perhaps a pirate with a wooden leg or the whalebone-limbed Captain Ahab. The clay husk began to sag on its frame, as if the child were growing weary. Bits of chalky mineral sloughed off like molt, staining the blue pedestal with streaks and traces. Later still, the ponytail fell off, further rendering the statue's gender ambiguous.

This new immigrant was in a state of permanent transformation. Each new stage of decay transformed the child with the empty, upturned face into someone else. Bruguera's sculpture thus became, paradoxically, a monument to impermanence.

Henri Bergson provides a way to think about identity as impermanent and durational. In *Time and Free Will,* he writes that the ego or self is subject to the vicissitudes of temporal change. Rather than a set of antagonistic binary oppositions between selves and others or a taxonomy of types and classes, identity is change itself. We are not the same people throughout our lives. Bergson writes that "pure duration might well be nothing but a succession of qualitative changes, which melt into and permeate one another, without

precise outlines."[1] In Bergson's view, though we are not identical with ourselves over time, we are not merely a jumble of shattered fragments. The self is not a solid inner core or a pastiche of surfaces but rather the sum of all its movements and changes.

One might venture that Bergson's description of subjecthood defines us as "all immigrants." To make such a claim would fail to do justice to those displaced by warfare, colonialism, enslavement, and political upheaval. Still, the Bergsonian understanding of personhood helpfully suggests that we are nothing more than an aggregate of journeys and metamorphoses. It also exposes the idea of natural citizenship as a fiction. *Monument to New Immigrants* accomplished something similar: as the sculpture decomposed, those who saw it may have come to understand that national belonging is as unstable as an eroding shore, crumbling away with each storm and wildfire. In turn, each time the statue was replaced, we saw the opportunity for further metamorphosis, for a community to renew or reinvent itself.

In 1953, Alain Resnais and Chris Marker made an essay film called *Statues Also Die*. Censored in France for many years, the film shows works of African art acquired through colonialism that were looted and placed on display in French museums. Behind glass, the statues are protected from the elements but stripped of their context and ritual significance. Preserving them strangely consigns them to a kind of living death. Bruguera's *Monument to New Immigrants* did not make this mistake: it showed that the work of art is not separate from the world or from the activities of everyday life. We are not behind a glass wall: we are all connected to the earth. We make things out of clay and we, too, are made of clay.

Note
1. Henri Bergson, *Time and Free Will: An Essay on the Immediate Data of Consciousness,* trans. F. L. Pogson (London: George Allen and Unwin, 1921), 104.

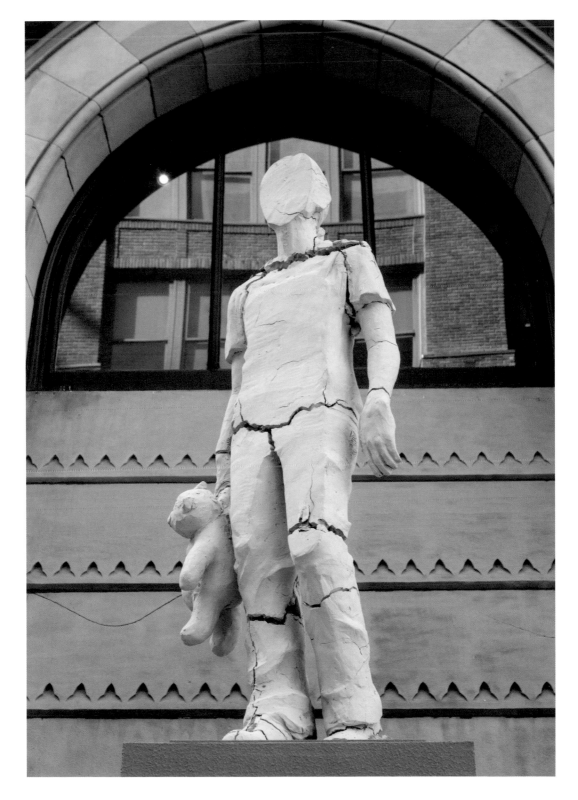

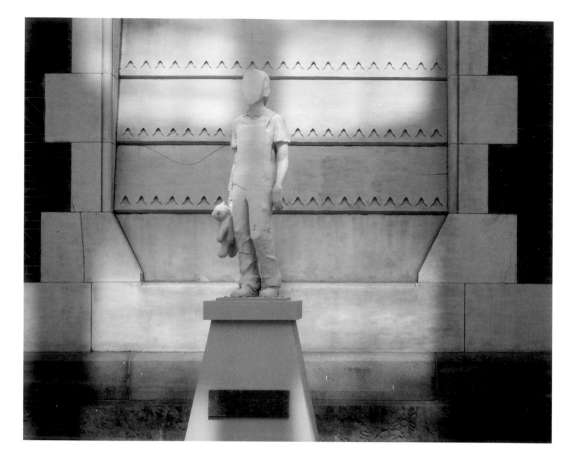

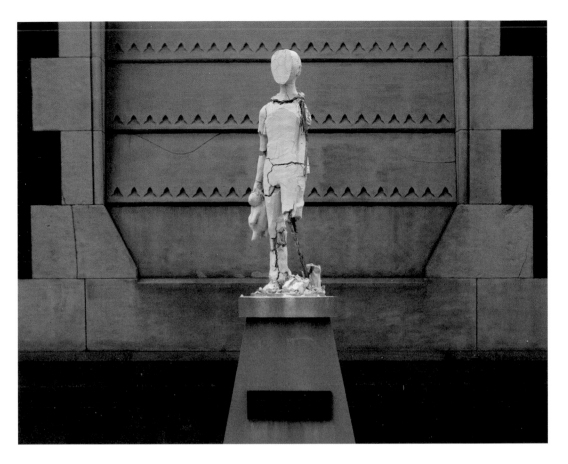

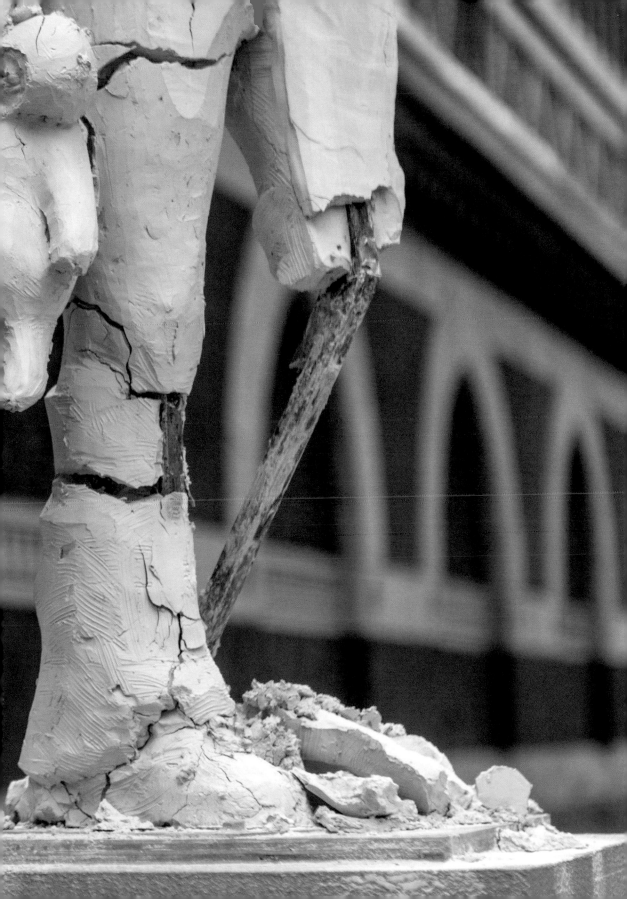

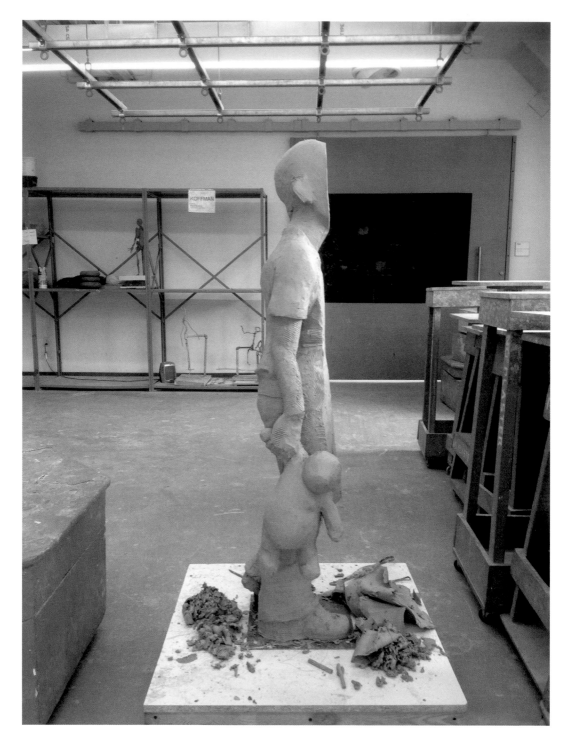

MONUMENT LAB

What is an appropriate monument for the current city of Philadelphia?

NAME YOUR MONUMENT:

PLACE YOUR MONUMENT:
ADDRESS, INTERSECTION, OR NEIGHBORHOOD

Penn Med/CHOP

DESCRIBE AND/OR SKETCH IN THIS SPACE:

We've got so many great portraits & statues of medical professionals in the city. How about a monument to all the patients and people w/ with disabilities who live in Philly or come to Philly for their medical care?

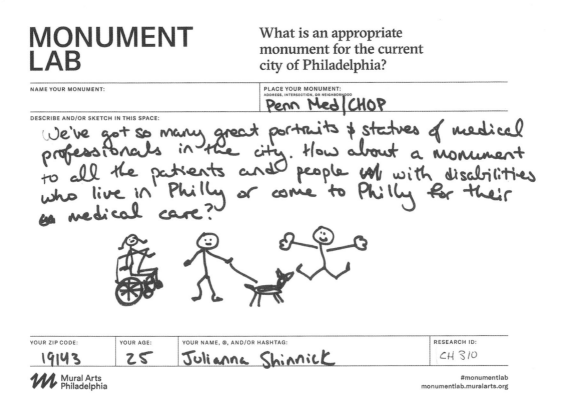

YOUR ZIP CODE:	YOUR AGE:	YOUR NAME, @, AND/OR HASHTAG:	RESEARCH ID:
19143	25	Julianna Shinnick	CH 310

Mural Arts Philadelphia

#monumentlab
monumentlab.muralarts.org

MONUMENT LAB

What is an appropriate monument for the current city of Philadelphia?

NAME YOUR MONUMENT:

Dizzy Gillespie
John Coltrane (& Jazz)

PLACE YOUR MONUMENT:
ADDRESS, INTERSECTION, OR NEIGHBORHOOD

52nd St?
Strawberry Mansion?

DESCRIBE AND/OR SKETCH IN THIS SPACE:

Coltrane is the God of the saxophone. Yet his S.M. house is in shambles (along w/ the rest of the 'hood...). Dizzy transformed the trumpet & 'ran' for pres.

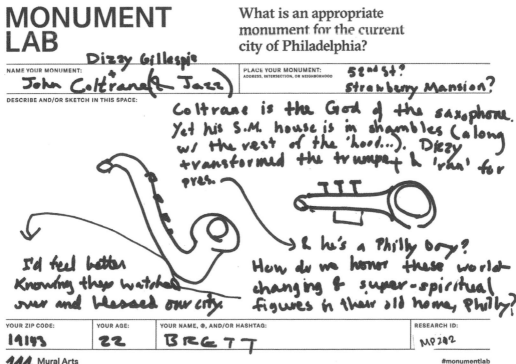

I'd feel better knowing they watched over and blessed our city.

& he's a Philly boy? How do we honor these world-changing & super-spiritual figures in their old home, Philly?

YOUR ZIP CODE:	YOUR AGE:	YOUR NAME, @, AND/OR HASHTAG:	RESEARCH ID:
19143	22	BRETT	MP202

Mural Arts Philadelphia

#monumentlab
monumentlab.muralarts.org

MONUMENT LAB

What is an appropriate monument for the current city of Philadelphia?

NAME YOUR MONUMENT:
Underground Railroad

PLACE YOUR MONUMENT:
ADDRESS, INTERSECTION, OR NEIGHBORHOOD
READING VIADUCT — RAIL PARK

DESCRIBE AND/OR SKETCH IN THIS SPACE:

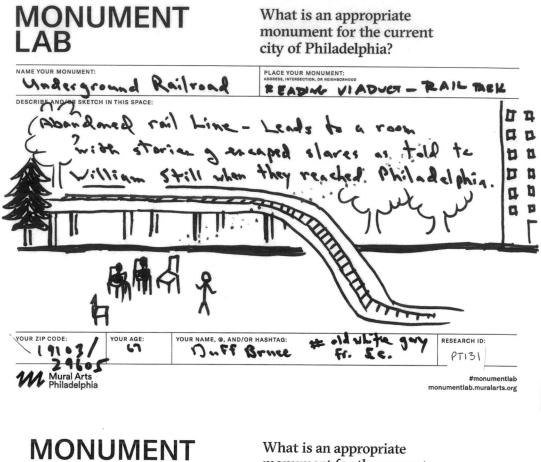

Abandoned rail line — Leads to a room with stories of escaped slaves as told to William Still when they reached Philadelphia.

YOUR ZIP CODE:
19103/ 29605

YOUR AGE:
67

YOUR NAME, @, AND/OR HASHTAG:
Duff Bruce # old white guy fr. S.C.

RESEARCH ID:
PT131

Mural Arts Philadelphia

#monumentlab
monumentlab.muralarts.org

MONUMENT LAB

What is an appropriate monument for the current city of Philadelphia?

NAME YOUR MONUMENT:
Killadelphia

PLACE YOUR MONUMENT:
ADDRESS, INTERSECTION, OR NEIGHBORHOOD
Kensh st + Alleghony Ave

DESCRIBE AND/OR SKETCH IN THIS SPACE:

Giant hypodermic needle

YOUR ZIP CODE:
19137

YOUR AGE:
34

YOUR NAME, @, AND/OR HASHTAG:
@x4k3p

RESEARCH ID:
PT31

Mural Arts Philadelphia

#monumentlab
monumentlab.muralarts.org

Mel Chin

Born 1951 · American · Based in Egypt, North Carolina

Two Me

City Hall · Granite, steel, bronze, glass, commercial-grade aluminum ramp system, marine plywood, pigment, nonslip coatings, and people

Mel Chin's *Two Me* invited members of the public to pose as living monuments in City Hall courtyard. Whether by foot, wheelchair, stroller, or other means, participants could use one of two fully accessible ramps—built to the standards of the Americans with Disabilities Act (ADA)—to ascend to one of two seven-foot-tall granite pedestals inscribed with the word "Me." Visitors attained monumental status on reaching the summit, where they also could greet participants on the opposite pedestal and onlookers below. More than fifty thousand people took their place atop the pedestals during the open hours of the exhibition, striking poses, offering monologues, performing poetry or song, challenging onlookers in debate, or embracing loved ones.

Chin's artwork balanced the longing for individualism with the foundational spirit of coexistence embedded within American culture, as authored in Philadelphia. According to Chin:

> Concepts framed in early Philadelphia loom monumentally in the public mind and express our American identity. The individual with "inalienable rights" (reinforced by the promotion of rugged individualism) . . . combined with the "We" of "We the People." These ideas, from two historic documents [the Declaration of Independence and the Constitution, respectively] define our values as Americans, are brought together as components of a two-part installation, revealing contradictions and activating a curious dialectic.

Chin sparked the living tension around monumental histories that balance individual and collective struggles. His work was sited within the hallowed public space at the heart of City Hall, a building with more than two hundred works of art dedicated on its apron, carved into its facade, and, for the sculpture of the city founder William Penn, crowning its clock tower. Chin modeled his pedestals on the *Citizen* statue on the east side of City Hall, dedicated in 1927 to the local businessman John Wanamaker with the inscription "Citizen." Chin used granite patterned like that of the *Citizen* statue, sourced from a South Philadelphia vendor to present an uncanny site of memory.

Me and Mel Chin

Ken Lum

Chief curatorial adviser, Monument Lab, and professor and chair of Fine Arts, University of Pennsylvania

In Romantic literature, representations of the self are often haunted by the specter of the doppelgänger, the concept of the look-alike double being at once a harbinger of misfortune and a symbol of divided existence. The doppelgänger counteracts aspirations of a subject founded on principles of autonomy and represents a rupture to the politics of self-interest. Whether as an evil twin embodying a conflicted personality or as a sensed presence, the doppelgänger disturbs the action of self-identification in social space. It deconstructs the either/or dualism that is, according to Jacques Derrida, the foundation of all metaphysical history and logic and one that needs to be rejected in the process of recognizing the self as contingent to others. By the doppelgänger's being, hallucination inverts into desire, absence into presence, and Self into Otherness.

In *Modernity and Ambivalence*, Zygmunt Bauman writes:

> In dichotomies crucial for the practice and the vision of social order the differentiating power hides as a rule behind one of the members of the opposition. The second member is but the other of the first, the opposite (degraded, suppressed, exiled) side of the first and its creation. Thus, abnormality is the other of the norm, deviation the other of the law-abiding, illness the other of health, barbarity the other of civilisation, animal the other of the human, woman the other of man, stranger the other of the native, enemy the other of friend, "them" the other of "us," insanity the other of reason, foreigner the other of the state subject, but the dependence is not symmetrical. The second side depends on the first for its contrived and enforced isolation. The first depends on the second for its self-assertion.[1]

Mel Chin's *Two Me* was produced on the occasion of Monument Lab for the central courtyard of Philadelphia City Hall. It consisted of two identical but oppositely winding ramps placed parallel to one another that led up to respective plinths, each of which was adorned with the word "Me" on its facade. People were encouraged to make their way up the ADA-accessible ramps to stand atop a plinth where their bodies would become the embodiment of statuary with the attendant authority that comes with memorialized representational figures in public space.

During the opening of *Two Me,* people waited in line to walk up one of the ramps and pose, however they wished, while people from the ground looked, took pictures, or communicated in some other fashion. People would often come down from one plinth and then ascend to the top of the other, standing in the place of someone else whom they may have looked at from one plinth to the next. The mood was celebratory and yet also

subversive as people on the plinths often posed in amusing ways that mocked the solemnity of statues. *Two Me* functioned like an interactive theater set in which the *I* in identity was assembled around a person's embodied experience of identifying, imbricated with the canonizing language of monumental forms. The ascent up a ramp made of aluminum was a noisy affair, calling attention to the participant. The two mirroring paths terminating in two identical granite-faced plinths called forth each person standing atop as whole and individual, though to varying degrees of success.

Yet, *Two Me* was also destabilizing of this sense of individual wholeness because it was insistently accommodative of the most radical pairings of persons, a *me one* and a *me two* that could be marked by the widest set of differences from one person to another, whether by age, race, ethnicity, gender identification, or any combination thereof. The work also readily exposed the dangers of the lack of interracial circulation in society, magnifying the cross-race effect, a finding of cognitive psychology that a person within a range of physiognomic features more readily identifies with others within the same range of physiognomic features. A case in point is that I was twice misrecognized as Mel Chin by people looking at a promotional picture for Monument Lab. Twice, acquaintances told me that they saw my picture among the roster of artists for Monument Lab. Of course, I was not an artist for Monument Lab, and while my name is acknowledged as a co-curator, my mien is not shown on the Monument Lab website. Two people with whom I have had many interactions had mistaken *me* for a different *me*.

I was long curious about Mel Chin. My curiosity had to do with our shared hyphenated Chinese identity and our respective paths in an art world that once had very few Chinese American–identified or, in my case, Chinese Canadian–identified artists. Although he is not me and his background is far different from mine, I saw in Mel Chin the possibility of a form of kinship that had more to do with routes than roots. *Two Me* centered on the idea of the self as split ontologically and manifestly in space, requital possible only through the recognition of another. There was a parallelism between his idea for Monument Lab and my sense of Chin as someone close but long lost. We share family roots from a particular part of Guangdong province in southern China. We would soon do dim sum lunch together along with Paul Farber in Philadelphia's Chinatown. It turned out that we were curious about one another for similar reasons and at some point during our meal Chin called me his Cantonese brother, which moved me.

Two Me was a work about diaspora writ large—not the diaspora of a cultural group or groups but human diaspora. All humans, no matter the separation of geographical distances, are entangled with one another through exchange, hybridity, and *métissage*. *Two Me* was structured as an interpellation machine, posed as a monument, that called forth interaction from the

Note
1. Zygmunt Bauman,
*Modernity and
Ambivalence* (Ithaca,
NY: Cornell University
Press, 1991), 14.

public conditioned by the logic of social media and the presentation of the individual to the world through the form of the selfie. The interpellation was subversive, however, because it was not a reification of the constitutive process of individuals internalizing ideological values in the creation of subjecthood. *Two Me* operated like a Trojan horse in which an artistic apparatus purposed for the affirmation of the *Me* was revealed as constituted by something else, the *We*.

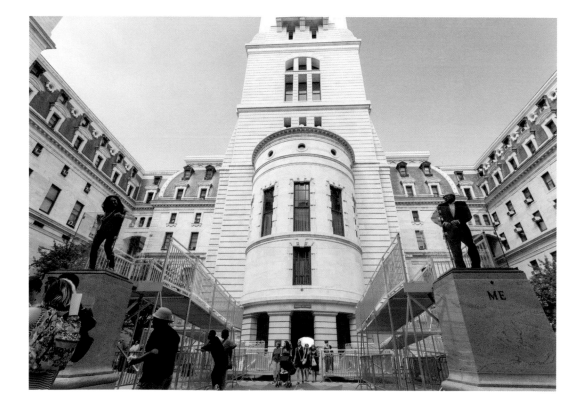

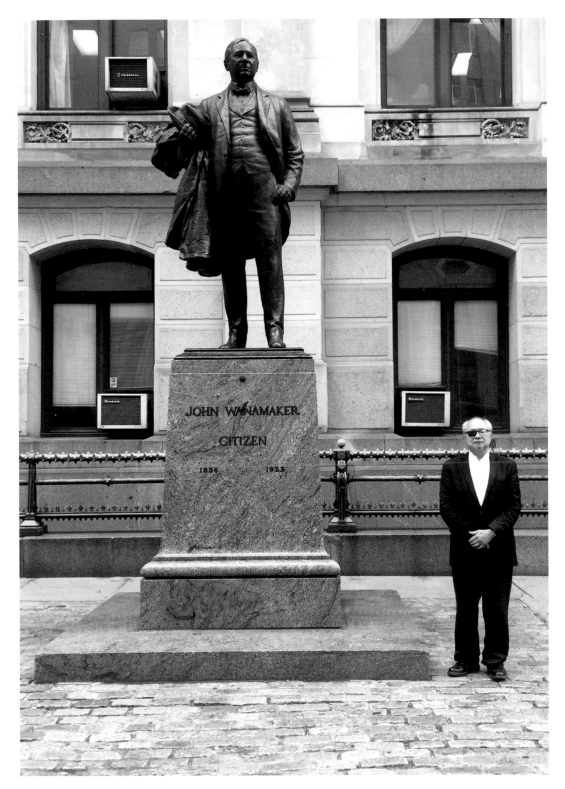

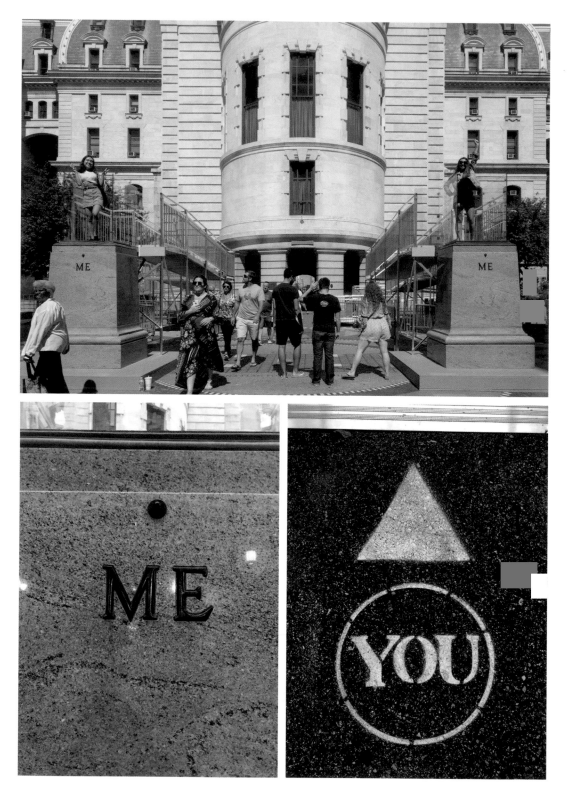

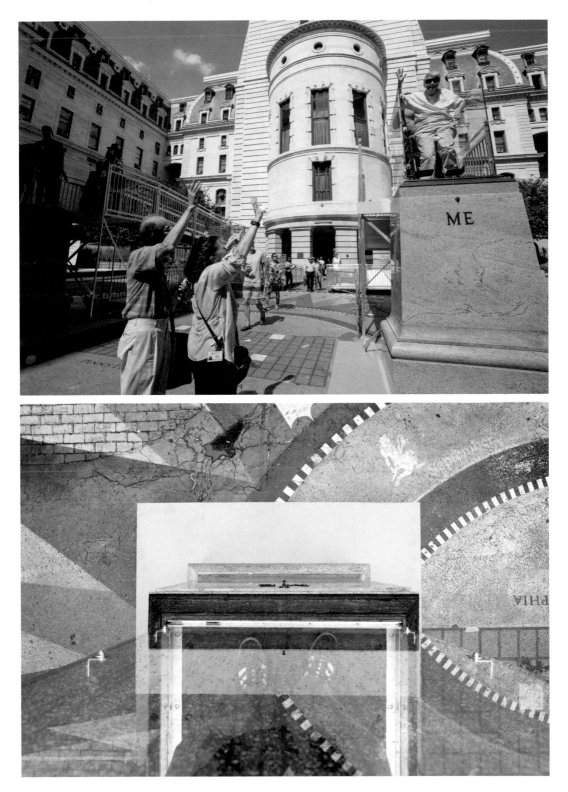

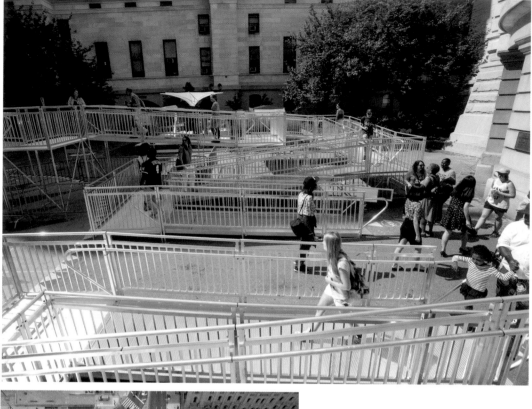

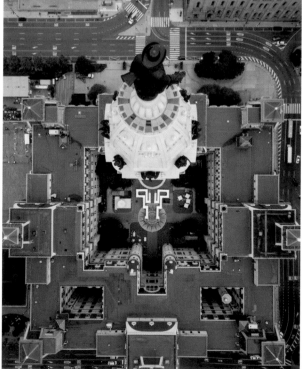

MONUMENT LAB

What is an appropriate monument for the current city of Philadelphia?

NAME YOUR MONUMENT:
the organizers

PLACE YOUR MONUMENT:
ADDRESS, INTERSECTION, OR NEIGHBORHOOD
Philly...

DESCRIBE AND/OR SKETCH IN THIS SPACE:

Monument to activists who organized the civil rights movement from behind the scenes but who aren't well known despite their efforts. Esp. those from Philly.

YOUR ZIP CODE: 08544
YOUR AGE: 26
YOUR NAME, @, AND/OR HASHTAG: Maura
RESEARCH ID: CH 471

Mural Arts Philadelphia

#monumentlab
monumentlab.muralarts.org

MONUMENT LAB

What is an appropriate monument for the current city of Philadelphia?

NAME YOUR MONUMENT:
Women Together

PLACE YOUR MONUMENT:
ADDRESS, INTERSECTION, OR NEIGHBORHOOD
Everywhere there are people + MEN!

DESCRIBE AND/OR SKETCH IN THIS SPACE:

- group of women, all colors, all ethnicities
- Women's rights are human rights!
- We are half the World

globe →

YOUR ZIP CODE: 16109 + Shanghai China
YOUR AGE: 23+36
YOUR NAME, @, AND/OR HASHTAG: Ang + Michelle
RESEARCH ID: CH 751

Mural Arts Philadelphia

#monumentlab
monumentlab.muralarts.org

MONUMENT LAB
Cecil B. Moore

What is an appropriate monument for the current city of Philadelphia?

NAME YOUR MONUMENT:

PLACE YOUR MONUMENT:
ADDRESS, INTERSECTION, OR NEIGHBORHOOD
Cecil B Moore AVE + Broad St

DESCRIBE AND/OR SKETCH IN THIS SPACE:

Cecil looking cool b/c he was for all he did for N. Philly community

— probably smoking a cig.

YOUR ZIP CODE: 19121

YOUR AGE: 22

YOUR NAME, @, AND/OR HASHTAG: Kait Moore @oceanstatic

RESEARCH ID: CHR00

Mural Arts Philadelphia

#monumentlab
monumentlab.muralarts.org

MONUMENT LAB

What is an appropriate monument for the current city of Philadelphia?

NAME YOUR MONUMENT:
We the people

PLACE YOUR MONUMENT:
ADDRESS, INTERSECTION, OR NEIGHBORHOOD
At oval on Ben Frank Parkway

DESCRIBE AND/OR SKETCH IN THIS SPACE:

Statues of individuals, male, female, young, children, elderly, muti-Ethnic, handicaped, walking together. All statues are happy, with their expressions and poses appearing as if they are walking together towards a better future.

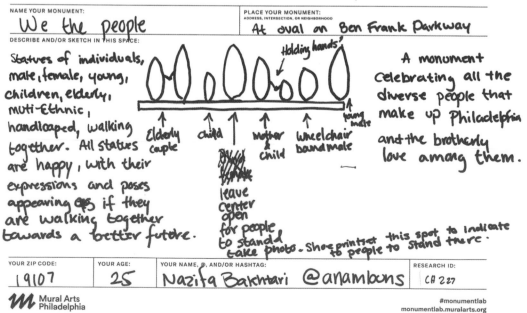

Holding hands?

Elderly couple child mother child wheelchair bound male young male

leave center open for people to stand take photo - Shoe printed this spot to indicate to people to stand there.

A monument celebrating all the diverse people that make up Philadelphia and the brotherly love among them.

YOUR ZIP CODE: 19107

YOUR AGE: 25

YOUR NAME, @, AND/OR HASHTAG: Nazifa Bakhtari @anambons

RESEARCH ID: CA 227

Mural Arts Philadelphia

#monumentlab
monumentlab.muralarts.org

Kara Crombie

Born 1975 · American · Based in Philadelphia, Pennsylvania

Sample Philly

Franklin Square · Digital audio archive, interactive electronic console, speakers, wood, and metal housing structure

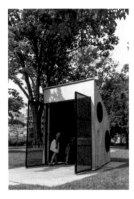

Kara Crombie's *Sample Philly* was an interactive sculpture honoring Philadelphia's rich musical history that doubled as an outdoor boom box and music production studio. Participants could produce their own fantasy musical compositions from a vast archive of songs recorded in and about the city. Crombie's goal, she says, was to allow "participants with all degrees of musical ability and knowledge . . . to create layered songs with sampled audio from Philadelphia's collective musical culture." She adds:

> I have conceptualized this project with the city's children, the next genera-tion of artists, specifically in mind. *Sample Philly* serves as a gateway for youth of Philadelphia to become acquainted with the city's musical history, and its ultimate goal is to provide an outlet for musical creativity at a time when art education has been cut back and the tools of musical expression have become inaccessible to many.

Crombie's sample bank included snippets from hundreds of notable Philadelphia songs, loops, speeches, and other sonic elements crowd-sourced from local musicians, blending the sounds of the past and present. The audio archive referenced a diverse array of artists and public figures, including Frankie Avalon, David Bowie, the Dead Milkmen, DJ Jazzy Jeff and the Fresh Prince, Gamble and Huff, Hall and Oates, Allen Iverson, King Britt, Patti LaBelle, Meek Mill, the Philadelphia Gay Men's Chorus, the Roots, Ursula Rucker, Santigold, Schoolly D, Kurt Vile, and more. During Monument Lab's discovery phase in 2015, supported by the Pew Center for Arts and Heritage, Crombie proposed *Sample Philly* as a speculative monument.

Remixing History

Justin Geller

Music director, Monument Lab, and musician/producer

When David Bowie died in 2016, the hurt from the loss of this prolific artist cut deep through the psyche of music and culture worldwide but languished in a particular way in Philly. Bowie fell in love with "Philly Soul" in the 1970s and recorded much of his 1975 LP, *The Young Americans*, at Sigma Sound Studios and, since then, the city has honored this British alien as an adopted son. Philadelphia's reputation as a rough-and-tumble working-class town has stood seemingly in contrast to its etymological origins as "the City of Brotherly Love," but its residents always remain passionate in their affection

for the artists who understand and celebrate that constant conflict and the ambivalence it evokes.

In the spring of 2015, Kara Crombie was one of the artists approached in the initial, discovery phase of Monument Lab. As a longtime resident of Philadelphia, she was surrounded by inspiration to draw from. If you walk more than two blocks in this historic American city, you will likely see statues of founding fathers, an obelisk built in honor of great war heroes or colonial figures, grand paintings of politicians signing declarations against tyranny; Crombie, however, contends that many of these monuments represent a single idea, from a single narrative, for a seemingly fixed audience—in perpetuity. As times change and society moves on, their relevance can be lost. How many times have you stood wondering in front of a statue of a great nobleman or a famous general whose deeds have been trivialized or, even worse, judged harshly by more informed social norms? How can that speak to you? She envisioned a monument that would grow and evolve, that would speak differently to every person who interacted with it. Rather than marble or concrete, sound itself could act as a more pliant, malleable medium through which to monumentalize Philadelphia culture, one that might change alongside Philadelphians' cultural tastes.

Crombie's project *Sample Philly* answered Monument Lab's provocation, offering an audio tribute to the sounds of Philadelphia. Taking the form of an interactive kiosk stocked with short recordings (samples) of music and sounds from the city's history (including Bowie's *Young Americans*), the work enabled visitors to create their own composite pieces by layering instruments from multiple songs. Users could start with the bass guitar from "For the Love of Money" by the O'Jays, add the drums from "I Can't Go for That" by Hall and Oats, and then layer the voice of Patti LaBelle from "If You Only Knew" to create an entirely new musical tribute to the city. But it's not just music that defines the sound of Philadelphia: with a nod to early hip-hop as much as to Pierre Schaffer's *Musique Concrete,* Crombie also filled *Sample Philly* with the "music" of its people's words and noises. If you repeat it enough, you can find a rhythm in Allen Iverson's infamous "Practice" speech, or in a tirade of insults from the controversial former mayor Frank Rizzo. These vocal samples, then, jostled alongside the beats, horns, guitars, and other instrumental loops in the kiosk's program, resulting in impossible "supergroups." Imagine the jazz futurist Sun Ra and West Philly punks, the Dead Milkmen acting as the backing band for Bessie Smith and Meek Mill, The War on Drugs jamming with Grover Washington Jr, and Frankie Avalon caught in the mosh pit with McRad. And these were perhaps the tamest combinations.

Sample Philly makes total sense as the latest project in Crombie's sampladelic practice, building most notably on her animated series *Aloof Hills.* These films, set in a Civil War–era plantation, smashed together seemingly conflicting media elements, with any given episode incorporating a video of the

South Carolina landscape or a painting or a YouTube clip of a young boy at the dentist's office, intoxicated on nitrous oxide, to tell a story about the past by way of the present. Situating *Sample Philly* in Franklin Square, named for the city's most celebrated polymath, Crombie again engaged in a historical space through the layering of contemporary media, escalating to include contributions from local musicians and also by opening the machine up to public submissions, keeping *Sample Philly* an evolving monument. Some artists even gave her isolated instrumental recordings (percussion noises, guitar licks, and so on), so that their songs could be even more pliably incorporated into visitors' new creations.

Just as important as the actual samples within was the design of the machine's interface, which would go beyond a mere jukebox but maintain a simple, user-oriented elegance. Inspired by the design and programmable sequencer of the Roland TR-808 drum machine (a historically famous and still essential instrument in hip-hop and electronic music), Crombie set about making *Sample Philly* a serious creation device that democratized the writing process and gave listeners control of what they wanted to hear. In its time at Franklin Square, *Sample Philly* was available outdoors, rain or shine, for anyone to use with basic instructions to encourage free-form exploration. Curious visitors to the park cycled through the banks of sounds, sometimes playing just a sample to hear the best part of their favorite song, while others carefully selected each loop and sequenced each drum sound to make their own mark on the machine. A small step stool was even added to accommodate the preschool children who visited the park every day. After repeat visits and button smashes, the children eventually learned how to create their own dance parties. Older users would hear a tune they had danced to as kids, which would in turn spark ideas for new songs to add to the sample bank, like a listener calling up requests to a DJ.

Like Bowie, our homegrown musicians also embody and represent the inherent complexities of Philadelphia's identity. In Beanie Sigel's "Remember Them Days," for example, the listener hears the story of man who celebrates the escape from his former life of struggle while reminiscing about the challenges he went through to attain a relative level of success. It's the conflict that created him and in the same neighborhood in which he coped, he can now wear it as a badge of honor. Across many projects, Monument Lab contended with the longevity we ask of physical art objects in public spaces and how we imagine the symbolic relationships between those objects and the communities that they serve. *Sample Philly* revealed the sonic to be just as dynamic and important a part of that conversation and one that perhaps literalizes the way in which cultural memory can change, shift, and reorient itself around a public object. Just as each parkgoer brings his or her own lifetime of associations to a statue seemingly built decades ago, so too does a listener cart around his or her music history, the memories a song triggers, the associated places, emotions, and reverberations.

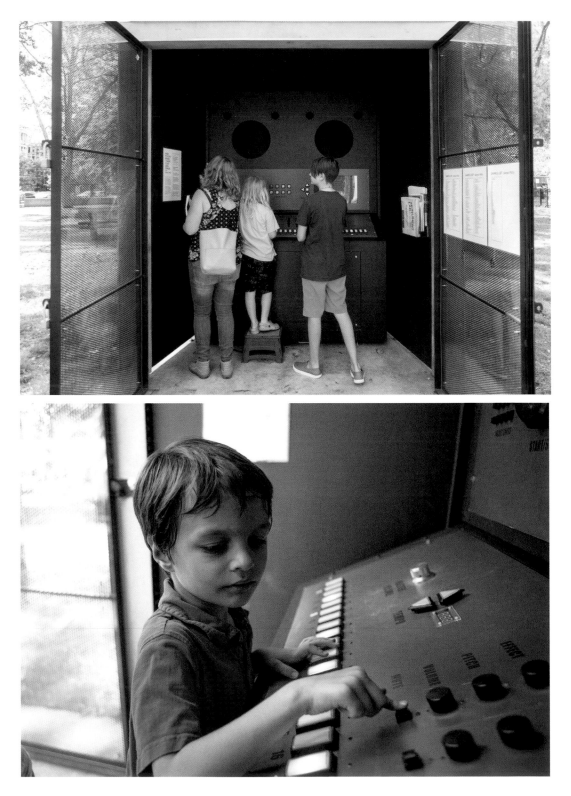

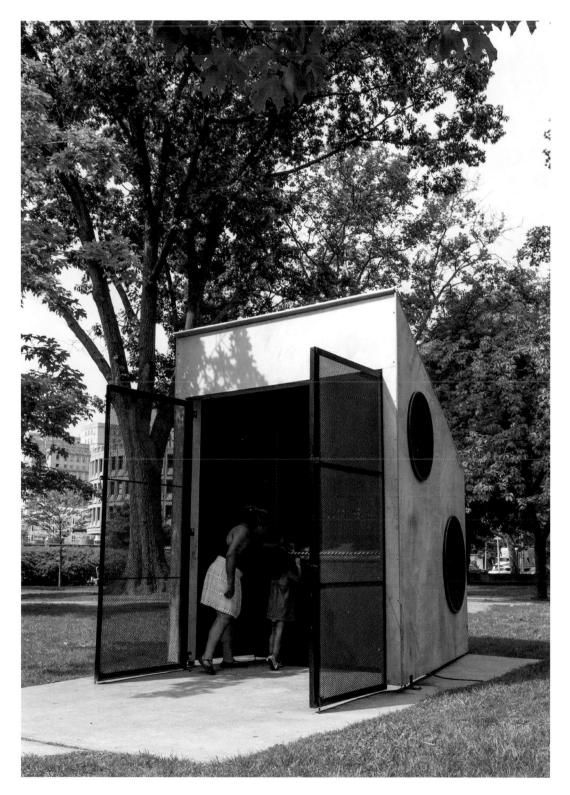

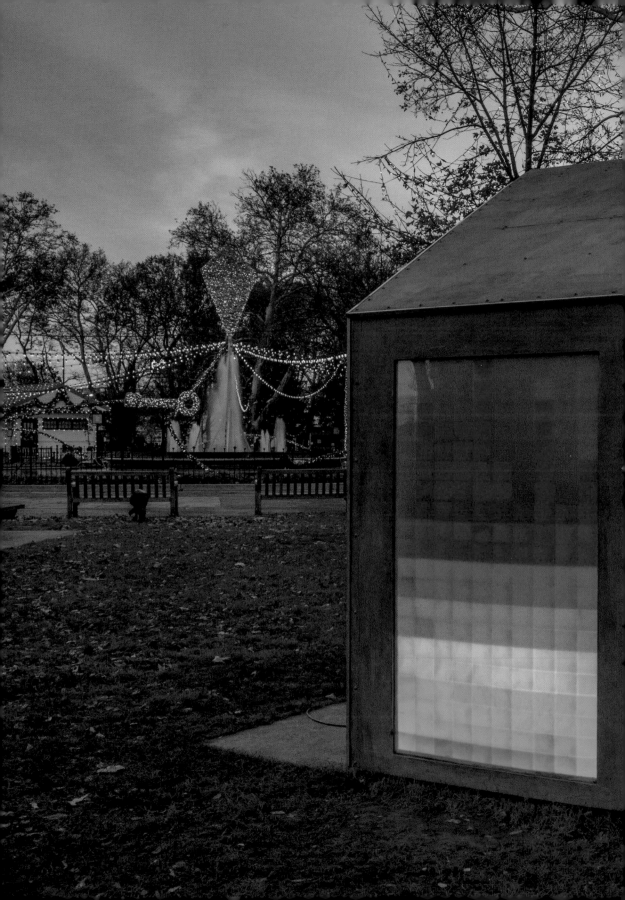

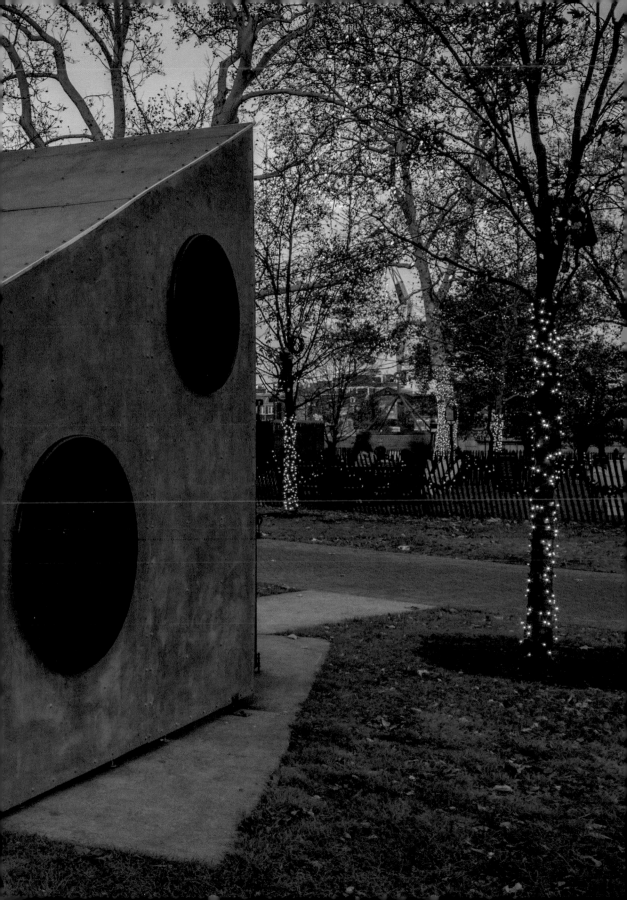

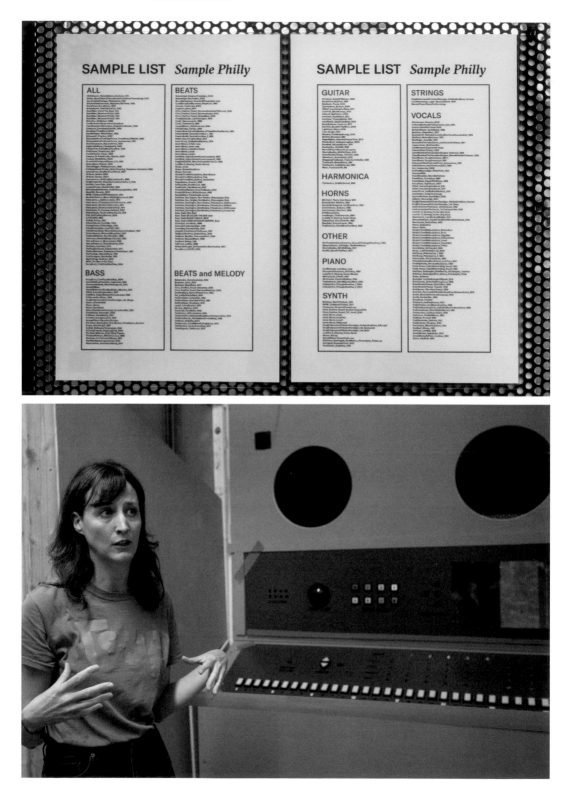

MONUMENT LAB

What is an appropriate monument for the current city of Philadelphia?

NAME YOUR MONUMENT: Yo! THAT'S MY PARKING SPOT

PLACE YOUR MONUMENT:
ADDRESS, INTERSECTION, OR NEIGHBORHOOD
10th ~ SHUNK

DESCRIBE AND/OR SKETCH IN THIS SPACE:

STEEL CHAIR (secured in the 'snow' so as not to be steal stolen).

STONE PILE REPRESENTING SNOW

YOUR ZIP CODE:	YOUR AGE:	YOUR NAME, ®, AND/OR HASHTAG:	RESEARCH ID:
19134	45	C.P. WIRTH	PT 40

Mural Arts Philadelphia

#monumentlab
monumentlab.muralarts.org

MONUMENT LAB

What is an appropriate monument for the current city of Philadelphia?

NAME YOUR MONUMENT: Do you want to be known as Trashadelphia?!

PLACE YOUR MONUMENT:
ADDRESS, INTERSECTION, OR NEIGHBORHOOD
11th + Spring Garden
11th + Chestnut

DESCRIBE AND/OR SKETCH IN THIS SPACE:

Have multiple trash cans on each block, to help eliminate litter bugs (nasty people). There Should also be a trash can at every bus stop.

YOUR ZIP CODE:	YOUR AGE:	YOUR NAME, ®, AND/OR HASHTAG:	RESEARCH ID:
19130	37	S. Cohen #Unstoppablemika	CH 929

Mural Arts Philadelphia

#monumentlab
monumentlab.muralarts.org

MONUMENT LAB

What is an appropriate monument for the current city of Philadelphia?

NAME YOUR MONUMENT:
'Listen'

PLACE YOUR MONUMENT:
ADDRESS, INTERSECTION, OR NEIGHBORHOOD
any gov./bureaucratic office

DESCRIBE AND/OR SKETCH IN THIS SPACE:

YOUR ZIP CODE: 19139

YOUR AGE:

YOUR NAME, @, AND/OR HASHTAG: Ichabod Crane

RESEARCH ID: MX131

Mural Arts Philadelphia

#monumentlab
monumentlab.muralarts.org

MONUMENT LAB

¿Cual es un monumento apropiado para la ciudad actual de Philadelphia?

NOMBRE DEL MONUMENTO:
Whom we owe

LUGAR DE UBICACIÓN DEL MONUMENTO:
DIRECCIÓN, INTERSECCIÓN, O VECINDARIO
By the Franklin Institute

DESCRIPCIÓN Y/O DIBUJO EN ESTE ESPACIO:

Philadelphia is a city of scientific medical innovation — its hospitals and museums exhibit that. But what about a memorial to the victims of scientific progress? Like Henrietta Lacks + Tuskegee patients certainly have Philly analogues

AREA POSTAL: 20001

EDAD: 24

NOMBRE, @, Y/O HASHTAG: Sarah @smargarita z

NÚMERO DE IDENTIFI CH1047

Mural Arts Philadelphia

#monumentlab
monumentlab.muralarts.org

Tyree Guyton

Born 1955 · American · Based in Detroit, Michigan

THE TIMES

A Street and East Indiana Avenue · Wood, paint, and mixed media

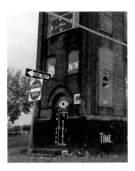

THE TIMES was a collaborative installation envisioned by Tyree Guyton of Detroit's celebrated Heidelberg Project. In partnership with Mural Arts Philadelphia's Porch Light program, Impact Services, and other local partners, Guyton updated the traditional city clock tower with a massive array of painted timepieces covering the facade of a former rug factory in the Kensington neighborhood. In many of his installations, Guyton explores the clock as a symbol and time as a concept. "My challenge," he says of his Kensington installation, was to "help people to appreciate the present time as a time to act, think, be, and do, here and now."

Over the course of a year, Guyton and Jenenne Whitfield, president and CEO of the Heidelberg Project and his spouse, visited with neighborhood partners in Kensington. These meetings culminated in a series of summer paint days in which local collaborators, residents from Impact Services' transitional housing facility adjacent to the factory, and visitors from Detroit painted the clocks on the building's exterior. By calling attention to the urgency and opportunity of our times as a testament to recovery in the face of adversity, *THE TIMES* was a monument to reframing our awareness of this moment in history.

Time and Again

Paul M. Farber

Artistic director, Monument Lab, and senior research scholar, University of Pennsylvania

In Zora, a place conjured by the author Italo Calvino in his *Invisible Cities,* an imagined Marco Polo recounts to Emperor Kublai Khan a tale of "a city that no one, having seen . . . can forget." Zora, one of dozens of locales that Polo renders aloud from memory, stands out for its synchronicity. A "copper clock" orchestrates the synched infrastructure of the city, an anchor left indelible in the minds of society's most learned. As Polo's vignette closes, we learn that Zora has perished and disappeared. The city was stuck in time and could not adapt or evolve beyond its own sense of singular order. As such, "the earth had forgotten her."

Calvino's allegorical atlas reflects the life cycles of cities as places to access memory and strive toward a collective sense of time. The forgotten clock in Zora symbolizes a productive tension of urban spaces. Cities, after all, are where we simultaneously seek to innovate and come to

terms with the past. We build monuments, in part, to mark the passage of time; on a municipal level, we elevate clock towers in center squares as monumental sites for the dual purpose of "time keeping" and "time telling," according to Wu Hung, as we balance our own identities with timed order.[1] Outside of official time, outside of progress, one might find oneself lost in time and out of place.

Enter Tyree Guyton, an artist who has worked for more than thirty years in his native Detroit and elsewhere to recalibrate time as a multitude. A painter, sculptor, and philosopher, Guyton is renowned for his landmark Heidelberg Project, a creative campus populated with an ever-changing landscape of house-sized artworks and sculptural assemblages, fashioned with found materials and forged on the street where he grew up. Guyton's "Heidelbergology" extends out from the street as a form of time travel, visiting postindustrial ruins and resurgent blocks as ripe for creative speculation, proposing a defiant order as a prerequisite for a city.

Clocks are a central motif of Guyton's body of work, with each that appears as an imagined abstraction of time, rather than an orderly distillation. The artist's clocks are realized through paint on squared plywood, through discarded timepieces redeployed as crowning artifacts, or through words as a mantra (a central signpost that reads, "One step at a time.") Perhaps Guyton's other major motif, polka dots, which emphatically appear all over Heidelberg Street and nearby buildings, could be read as a sea of faceless clocks, emptied of structured time, and opened as an extension of the here and now, a mark of existence. That the Heidelberg Project has endured challenges posed by multiple municipal administrations and arsonists seeking its destruction to become a celebrated destination with three hundred thousand visitors a year speaks to the ways Guyton can bend time, or least dance with it.

When invited to participate in Monument Lab, Guyton responded to the curatorial question "What is an appropriate monument for the current city of Philadelphia?" with his own: "What time is it?" Guyton's approach led to his vision for *THE TIMES*, a monument conceived as a collection of clocks, painted to cover the facade of an entire building. At the invitation of Mural Arts director Jane Golden, Guyton and Whitfield spent much of their time in Kensington looking for a site. Two days after the election of Donald Trump, while on a research trip, they began inquiring about a shuttered factory at A Street and East Indiana Avenue.

The building is visible for blocks around it, its grandeur recalling the industrial era when Philadelphia gained a reputation as "the Workshop of the World." Opened in 1892 as Hoyle, Harrison and Kaye's New Mill, a rug manufacturer, the building had been occasionally vacant before Impact Services, an agency that works "to empower people with the skills and resources needed to reach their highest potential," adapted parts of it

as a safe shelter for those seeking their next steps toward recovery. Standing five stories high and shaped as a massive triangle, the building is one of hundreds of factories, churches, and other civic institutions in a prolonged transition (if not disrepair or neglect), but this one hums with the possibility of neighborhood-focused adaptive reuse. Within several years, Impact Services intends to redevelop the site with fair housing options and community health services.

There is no denying this space marks a threshold: the courtyard offers refuge for those just hours or days off the street; catty-corner is Hope Park, which has operated as an open-air drug market; and the building itself is perched above abandoned train tracks that had been an encampment for those in the grips of opioid addiction and cycles of poverty and trauma before it was closed by the city, coincidentally in the months leading up to Guyton's project. A June 30, 2017, newspaper headline reflects the vantage of this building: "From This Rooftop, Philly Heroin Crisis Comes into Focus." But as stewards of the neighborhood reminded Guyton and all the other project partners, this area is more than a nexus of pain. Community organizers, advocates, health officials, and city government have worked to offer holistic planning and healing rather than punishment and stigma.

Guyton spent weeks at the building, in close conversation and collaboration with its denizens. He worked outside in the courtyard, along A Street, at the "tower" on Tusculum Street overlooking the tracks, and at a nearby storefront operated by the Mural Arts Porch Light Program. While Guyton guided the artistic vision of the project, he was joined by key collaborators, including Whitfield, partners at Impact Services and Prevention Point, Mural Arts project manager Gaby Racza, artist and carpenter Anthony Molden, and self-identified artists who lived on-site, including Mr. Clack and Mr. Purdy. Guyton and this group's time spent harnessing people and energy, working against the clock of the opening of the exhibition, was as much a part of the artwork as its final iteration.

When the exhibition opened, *THE TIMES* was rendered through hundreds of timepieces directly painted on the building, attached to its window bays, or outlined on the surrounding sidewalk, with plenty of variations on the theme: clocks with digital time, clocks with no hands, a Mayan calendar, an American flag with a broken clock embedded within the stars with the inscription "GAME TIME." Guyton stapled a cover of *Time* magazine with former president Barack Obama on its cover in the courtyard. On a panel with an upside-down clock, a veteran residing in an Impact Services facility placed his military uniform on a hanger, below an inscription that read, "The [key] is me."

If you have ever loved someone or been someone who is stuck in a moment—especially pulled by trauma, addiction, or marginalization—you

Note
1. Wu Hung, "Monumentality of Time: Giant Clocks, the Drum Tower, the Clock Tower," in *Monuments and Memory, Made and Unmade*, ed. Robert S. Nelson and Margaret Olin (Chicago: University of Chicago Press, 2003), 108.

understand that time is neither stable nor reliable. It does not wait for you but instead disappears, right through your fingers, and then piles up, whether for days or years. When we are lucky, we are met with epiphany or embrace from those seeking to be in sync with us again. For those who have ever dwelled in that space between "lost time" (rife with pain, dread, falter, depression) and "getting lost in time" (ripe for daydreams, wandering, connections), Guyton bridges the sensibilities through a painted inscription on the building: "Love the time u have."

Between society and the self, we are compelled to find our times: to cope and plan, remember and renew, hold and let go, and make a mark.

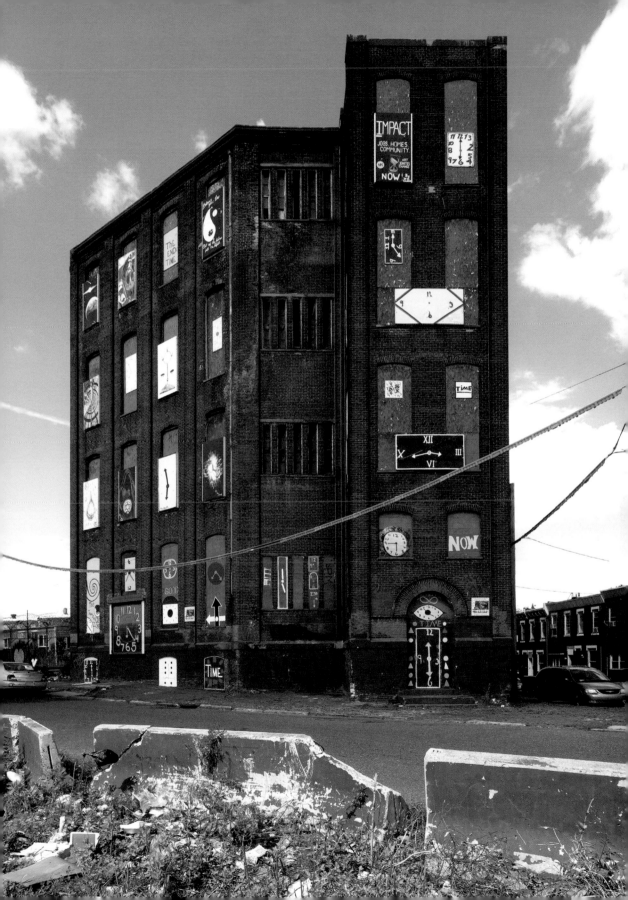

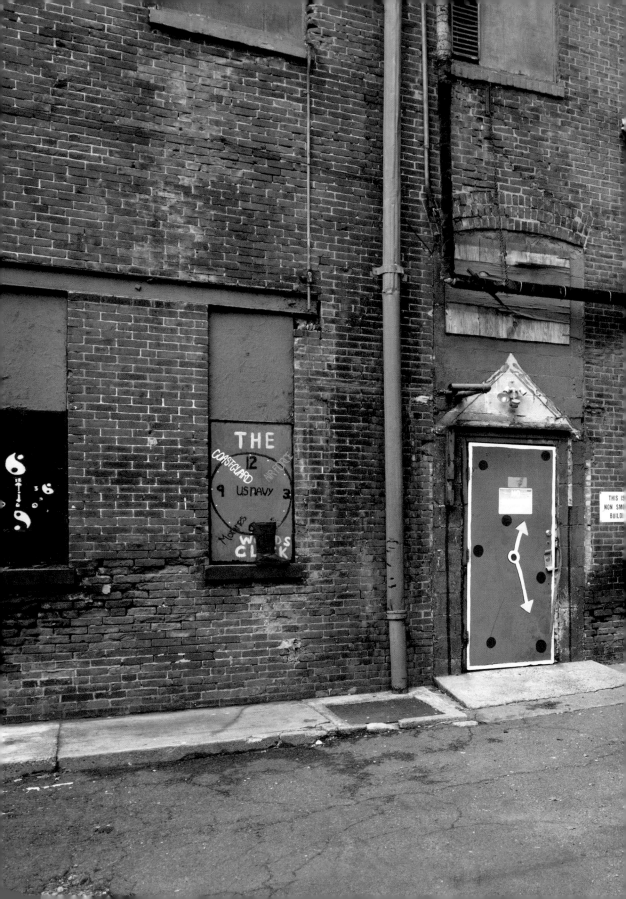

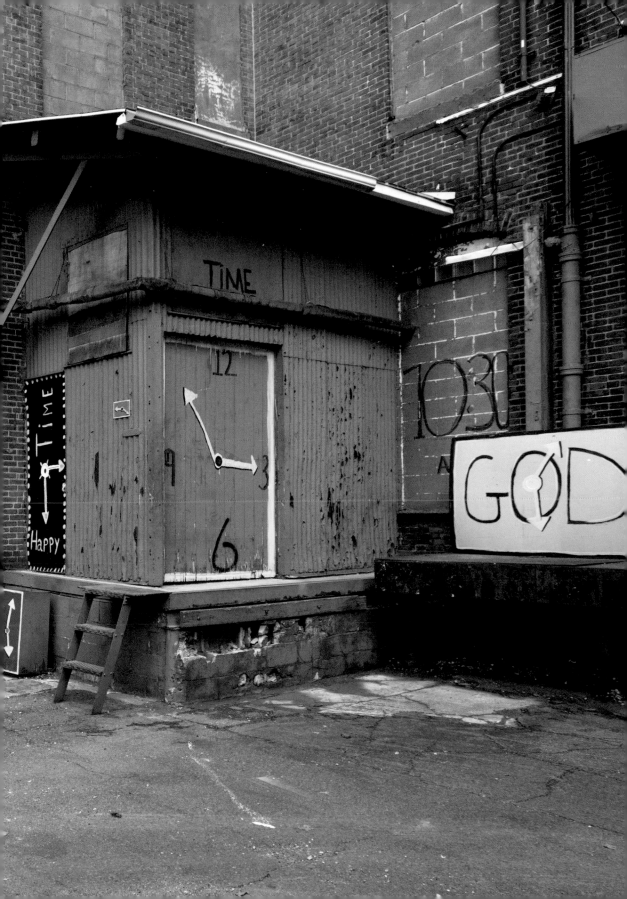

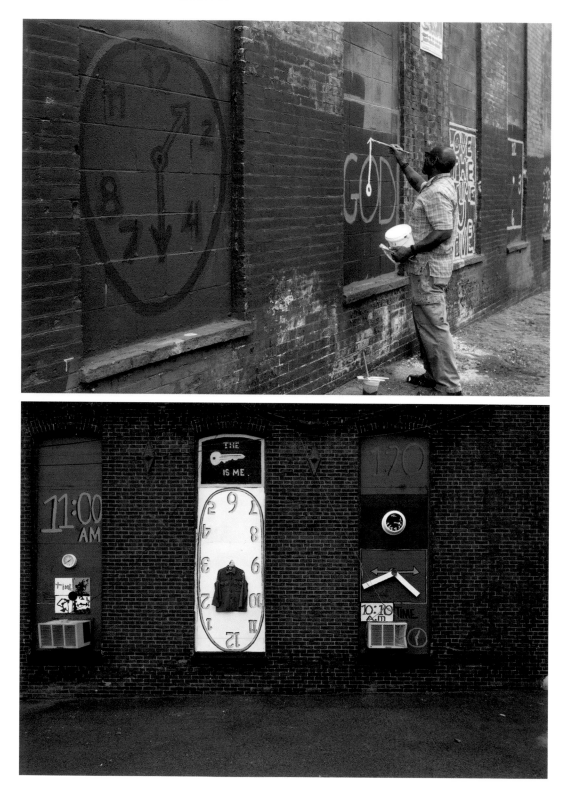

MONUMENT LAB

What is an appropriate monument for the current city of Philadelphia?

NAME YOUR MONUMENT:
The Never-ending Apology

PLACE YOUR MONUMENT:
ADDRESS, INTERSECTION, OR NEIGHBORHOOD
Location of MOVE Bombing, CBH
Race Riots

DESCRIBE AND/OR SKETCH IN THIS SPACE:
Apology to the oppressed of Philadelphia, Victimized by the city ~~arcates~~ multiple locations for multiple apologies

YOUR ZIP CODE: 19143

YOUR AGE: 22

YOUR NAME, @, AND/OR HASHTAG:
Jase Elam @BootBleach

RESEARCH ID: PT39

Mural Arts Philadelphia

#monumentlab
monumentlab.muralarts.org

MONUMENT LAB

What is an appropriate monument for the current city of Philadelphia?

NAME YOUR MONUMENT:
Put your trash in the can

PLACE YOUR MONUMENT:
ADDRESS, INTERSECTION, OR NEIGHBORHOOD
IN FRONT OF MY HOUSE

DESCRIBE AND/OR SKETCH IN THIS SPACE:

YOUR ZIP CODE: 19123

YOUR AGE: 60

YOUR NAME, @, AND/OR HASHTAG:
GG

RESEARCH ID: FS173

Mural Arts Philadelphia

#monumentlab
monumentlab.muralarts.org

MONUMENT LAB

What is an appropriate monument for the current city of Philadelphia?

NAME YOUR MONUMENT: Rainbow of possibilities

PLACE YOUR MONUMENT: ADDRESS, INTERSECTION, OR NEIGHBORHOOD Germantown near Pa. Sch. for the Deaf

DESCRIBE AND/OR SKETCH IN THIS SPACE:

"You could use a hand to express your emotions"

American Sign Language

- Jointed large hand
- public (and move fingers to fingerspell the American Sign Lang. alphabet.
- Created from irradecent rainbow plastics

* if a index, ring + pinky go down middle finger must be engineered to go down as well.

YOUR ZIP CODE: 06033

YOUR AGE: 44

YOUR NAME, ®, AND/OR HASHTAG: Cynthia.Rumery@950-1817.org juliagrayphoto@gmail.com 64Connorgray64@gmail.com

Cynthia, Connor + Julia

RESEARCH ID: FS382

MONUMENT LAB

What is an appropriate monument for the current city of Philadelphia?

NAME YOUR MONUMENT: THE WRONG SIDE OF HISTORY

PLACE YOUR MONUMENT: ADDRESS, INTERSECTION, OR NEIGHBORHOOD 40th and Baltimore (TROLLEY PORTAL)

DESCRIBE AND/OR SKETCH IN THIS SPACE:

A MONUMENT COMMEMORATING THE 1944 TRANSIT STRIKE (WHICH PROTESTED BLACK TRANSIT WORKERS BEING PROMOTED TO TROLLEY DRIVERS); FEATURES A VINTAGE TROLLEY FRONT END, AND SCULPTURES OF A WHITE DRIVER, BLACK PROTESTER, AND A SOLDIER (THE STRIKE ENDED WHEN FDR SENT IN FEDERAL TROOPS BECAUSE OF THE IMPACT ON WAR PRODUCTION.)

FRONT END OF A 1944-era trolley

DRIVER HANGING OUT DOOR (STRIKING)

PROTESTER SOLDIER

DESCRIPTIVE PLAQUE

YOUR ZIP CODE: 19122

YOUR AGE: 47

YOUR NAME, ®, AND/OR HASHTAG: MARK EGGERTS

RESEARCH ID: FS202

Hans Haacke

Born 1936 · German · Based in New York City, New York

Digging (Archaeology of the Vacant Lot)

42nd Street and Lancaster Avenue · Brainpower

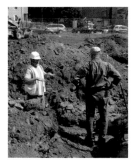

The German-born artist Hans Haacke proposed an archaeological dig to reveal the hidden foundations of homes and buildings buried under a single vacant lot. Haacke studied at Temple University's Tyler School of Art in 1961–1962 on a Fulbright fellowship; when he later returned to Philadelphia, he became intrigued by the empty spaces in the city where buildings once stood. Haacke's deconstructions of monumentalized sculptures and spaces have been exhibited at the Reichstag in Berlin and Trafalgar Square in London. Here in Philadelphia he requested a site for an archaeological dig in which subsumed architectural foundations, intact underground, could be brought to public view. In cooperation with the People's Emergency Center and the property owners, Alvin and Sheila Bunch, the triangular lot at 42nd Street and Lancaster Avenue was imagined as a site for excavation and interpretation. This single location once held seven properties, until an automobile crashed into one of the buildings in the late 1990s, causing the owner to demolish the remaining structures.

Haacke's monument imagined the former buildings not as buried and gone but as a living blueprint to link the city's past and present. The artist described his intent as follows: "The history of each house is to be researched, dating from the original ownership of the land to the present. To be collected are the names, occupations, and sociologically relevant information about the owners of the properties, the circumstances under which they changed ownership (date, price, mortgages, mortgagees, foreclosures), when they became vacant, as well as personal stories and reminiscences by and about the people who lived there. This information, together with an image of each house, is to be posted on or near the site."

After delays for permitting and public safety, the dig began during the opening week of Monument Lab. Excavators revealed brick foundations of the buildings that once stood on the site. Deed information and renderings of the properties were installed on the surrounding fencing. Shortly thereafter, because of further challenges with maintaining the site as an open dig, the area was again covered with earth and returned to its status as a lot.

Hans Haacke in Conversation

Alexander Alberro

Professor of art history, Barnard College/Columbia University

Alexander Alberro: *Digging (Archaeology of the Vacant Lot)*, the art project that you exhibited in the Monument Lab exhibition in Philadelphia in 2017, strips away multiple layers of earth from an urban plot of land to reveal various traces of the past, including objects, foundations, and the like. What was the primary goal of the piece? What did you hope it would accomplish? Who did you imagine would be the artwork's public?

Hans Haacke: The word *digging* has a number of literal and metaphoric meanings: We dig with a shovel, a spade, or a bulldozer in order to turn over or remove earth, sand, or other materials. We dig trenches, holes, and tunnels. We dig for coal, for gold—and other treasures. And, by digging, we unearth, excavate, probe, discover, and reveal. We dig up the past, we go to the foundations, to the bottom of things, and we explore and investigate the history of things.

I dreamt of revealing the remains of a Philadelphia of the past, like excavating the ruins of Pompeii, with all the implications of the meaning of the word *digging* cited earlier. That required the removal of the grass that had grown on (over) an empty lot (the past) to reveal what remains of buildings that once stood there. Neighborhood people and visitors get a visceral sense of what had occupied the site.

But they were also to be offered information dug up in Philadelphia archives (both public and private) about who had lived there; when they came and where they came from; their living circumstances; their ethnic and religious affiliations; the acquisition, ownership, and transfer—or loss—of their real estate properties; and what caused the seven lots on Lancaster Avenue to become covered with weeds.

When one is exposed to such information, one tends to compare it with one's own life experiences, and perhaps also with the experiences of people of a different background. In the process, one learns a bit more about the world we are now living in.

AA: Prior to settling on the site on Lancaster Avenue for the *Digging* project, you had contemplated using several other Philadelphia locations. There was one on Warren Street near the Greater Bible Way Temple at North 52nd Street; another on Market Street at 46th Street; another at Market Street at South 54th Street; and one even at Logan Triangle in North Philadelphia. What prompted the selection of each of these sites? What led to the decision not to use the earlier ones? Were there legal or safety issues involved?

HH: When, after many decades, I returned to Philadelphia to give
a talk in 2012, I was stunned by how it had changed. At my request,
I was taken to areas that I knew from a stint in 1961–1962 as a
Fulbright fellow at the Tyler School of Art, which, at the time, was
in Elkins Park. That year I lived in a dorm on Temple University's
campus on North Broad Street. Five years later, in 1966–1967, I taught
at the Philadelphia College of Art. During my 2012 tour, I was struck
by the many empty lots covered with rubble or overgrown with weeds
in neighborhoods I vaguely remembered from the past. This experi-
ence led my thinking on a proposal for my participation in the
Monument Lab exhibition. Ken Lum took me around to look at pos-
sible sites in North and West Philadelphia. The Warren Street site
intrigued me a lot. At the intersection with North 52nd Street is the
Baptist Greater Bible Way Temple, followed on Warren Street by a
vast empty lot, paved over, as if to serve as a parking lot. It was gated.
An old neon sign announces that here is the "Global Leadership
Academy" and the "Founders Center." Next door, to the east, stands
the skeleton of a roofless building. Through the holes of its windows,
one can see bushes and trees growing on the inside. Its next-door
neighbor is an abandoned, two-story house, entirely covered by ivy.
But the abandoned house has a TV satellite dish at an upstairs window
that still has glass intact and a curtain behind it. And finally, there is
another overgrown empty lot just before one reaches a short cross
street at the end of the block. This was a fascinating collage of dispa-
rate properties. But delving into it would have required much more
time and resources than appeared to be available.

Logan Triangle is a vast area farther east that had been literally
sinking. It had also been devastated by gas explosions in the mid-
1980s. It's a bit out of the way for public transportation, and was
about to be slated for redevelopment, so it was not open to my kind
of digging.

Both Market Street sites are close to subway stations in West
Philadelphia. I believe it was not long after my interest in the North
46th Street site that I first focused on a large, weed-covered triangle
on Lancaster Avenue at North 42nd Street and the intersection with
Brown Street. I got to see it on a cold day in January 2017, and I toured
the neighborhood. Across the street, in the 1950s and 1960s, was
the Nation of Islam's place of worship, where Malcom X and Elijah
Muhammad had preached. One block up on North 42nd Street I dis-
covered the Lutherische St. Petri Kirche. A few blocks down on
Lancaster Avenue, at North 40th Street, Martin Luther King Jr. had
held a rally in 1965. It is a neighborhood with a very rich history.

Mr. Bunch, the current owner of the triangular site, is a heating oil
merchant who has his office in a small corner building across the street

from it at Brown and North 42nd Street. Unfortunately, I couldn't meet him in January, because he was very busy delivering heating oil with his tanker truck that day. It was a very cold day. But Monument Lab had already gotten in touch with him, and he had offered to drop the excavated earth from the triangle onto an empty lot next to his office building.

In June, we learned that Mr. Bunch was ready to sell the triangle, and we therefore had to look for another site. Monument Lab then found a city-owned large empty lot at South 54th and Market Streets that we began to explore. Like the other sites it was in a neighborhood with predominantly African American residents. On the other side of the nearby subway line was a mural that had been sponsored by Mural Arts. This site and other sites, however, were considered to be potentially full of contaminated soil that had to be removed under stringent rules and deposited at a distant location that the city deemed appropriate. Less than a month before the opening of the Monument Lab project, I learned that a house adjacent to the 54th Street site had collapsed, and that it was thus no longer safe to proceed with a Pompeii-like excavation there.

But it turned out that the Lancaster Triangle had not been sold and Mr. Bunch was ready to have it dug up. When a bulldozer arrived to start the digging early in September, I finally met him and his wife in his office. On two walls of the small room they had mounted photos commemorating Martin Luther King Jr. and celebrating Michelle and Barack Obama. There was also an image of Rosie the Riveter with a new caption: "Women in the Fuel Oil Industry." I had never seen an office like that. It was very touching. Before my meeting Mr. Bunch and his wife, he had already supplied photos to Monument Lab from the time in 1998 when a car plowed into one of the structures on the triangle, just before they were all torn down. They, too, had not been occupied for a while. Maya Thomas of Monument Lab complemented this information with deeds from city archives going back as far as the early 1860s. She also collected census records on the people who had lived there.

In retrospect, I believe my proposal may have been far too ambitious in view of the limited resources and time leading up to the exhibition's opening. Added to that, the project was plagued by the need to make several changes in venue. Without the indefatigable managerial efforts of Monument Lab—contacting relevant people and organizations, dealing with city agencies, and signing up professionals to do what needed to be done—absolutely nothing would have come of my proposal.

AA: There's clearly an earth art dimension to *Digging,* but also elements that are related to earlier works of yours for which you dug in archives, or in the storage facilities of museums, for instance. What do you think are some of the ways that *Digging* relates to your previous work, or to your artistic practice at large?

HH: Yes, there are certain precedents. I've worked with soil and its social implications. I've also worked with "digging up" archives and records of various kinds. In 1970, I built *Monument to Beach Pollution* with garbage I collected on the beach of Carboneras, Spain. That same year I dumped soil on the roof of the building in New York City where I had a studio at the time, on the corner of Houston Street and the Bowery. Airborne seeds and spores embedded in the soil soon sprouted, and the pile of earth on the roof became covered with plant growth. But the neighborhood has now been gentrified, and the second floor of a Whole Foods is located at the site where this wild vegetation once grew.

Since 2000, members of the German Bundestag have emptied bags of soil collected from their election districts into a trough around my dedication *"DER BEVÖLKERUNG"* (To the population) in an open-air courtyard of the Reichstag building in Berlin. There too, embedded and airborne seeds produced a spontaneous growth of plants, and even trees. It continues to be a work in progress.

Maybe also my digging up the marble floor of the German Pavilion of the Venice Biennale in 1993, the architecture of which had been re-styled in 1938 to properly represent the Nazi regime, could be mentioned in this context.

As you indicate, I've done a lot of digging over the years to collect information: on real estate in New York City slum areas, on the provenances of artworks and the corporate sponsorship of museum exhibitions, on the collusion by North American and European corporations with the former South African apartheid regime, and on many other research targets. I presume you are also alluding to the exhibition I mounted at the Boijmans Van Beuningen Museum in Rotterdam, where I dug up works from the museum's storage in 1996. Similarly, a few years later, I presented my finds in the collection of the Victoria and Albert Museum at the Serpentine Gallery in London.

AA: Now that the show has ended, the empty lot on Lancaster Avenue has been reverted back to its previous condition. *Digging* was therefore a temporary intervention. Yet, the piece continues to circulate in photo-graphic and textual documentation, as well as in conversations people in the Lancaster Avenue neighborhood share about it. Moreover, there's a sense that the complicated process of conception, planning, and

negotiations (for the site) and construction were also fundamental parts of this piece. To what extent do you consider *Digging* to encompass the activities prior to and after the actual dig?

HH: As I indicated earlier, by the end of the Monument Lab exhibition, my project was not completed to the extent that I had conceived it. However, the process of digging through the surface of the weed-covered triangle on Lancaster Avenue, and that of the gathering and spreading of information, even though limited, about the residents who had once lived there, may have enriched the awareness people have of the richness of that neighborhood. It also may have led to fruitful conversations and insights elsewhere. In that sense, it could perhaps be considered as a work that is still in progress.

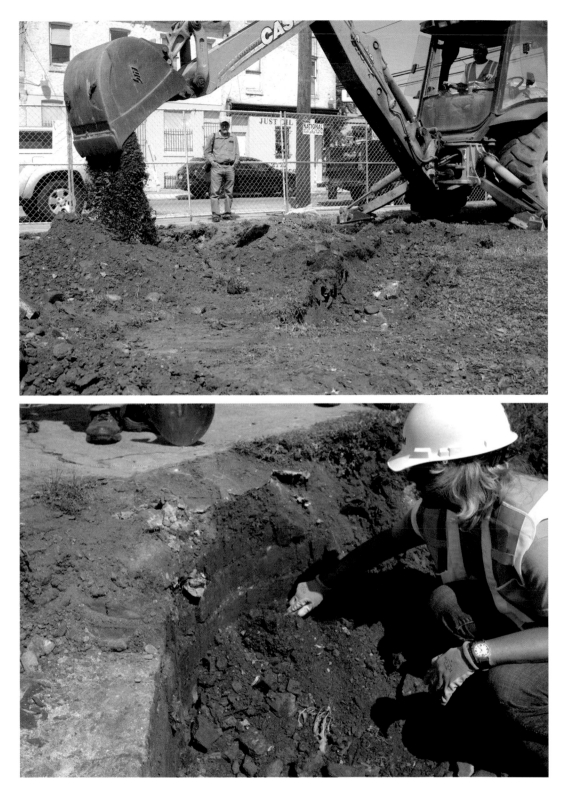

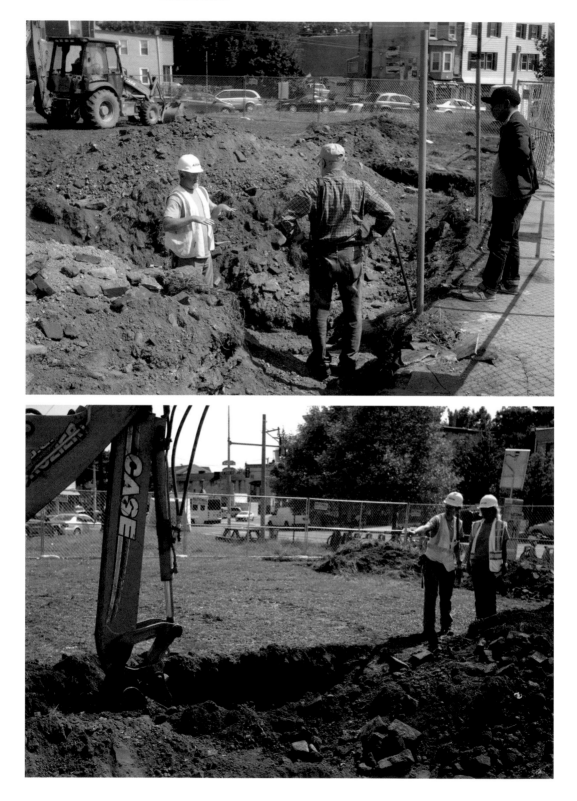

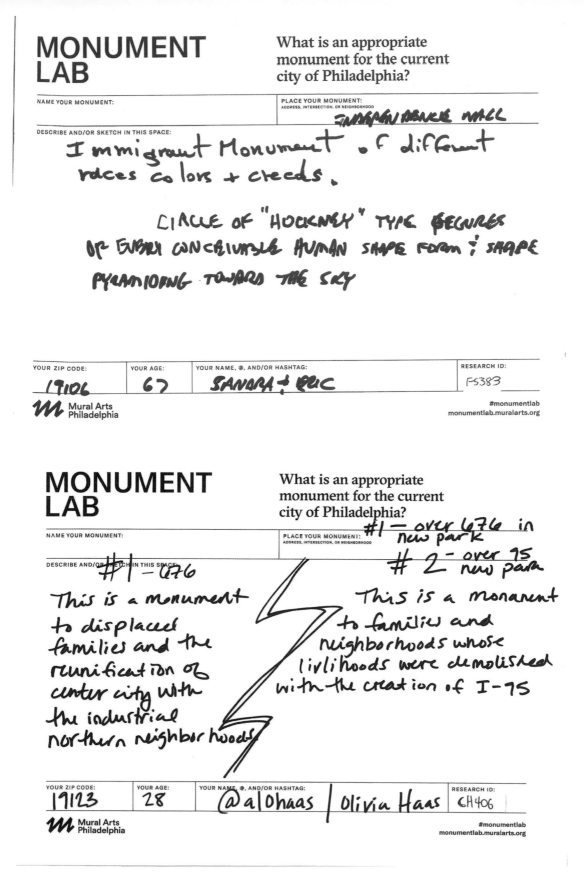

MONUMENT LAB

What is an appropriate monument for the current city of Philadelphia?

NAME YOUR MONUMENT:

PLACE YOUR MONUMENT:
ADDRESS, INTERSECTION, OR NEIGHBORHOOD
~~INDEPENDENCE~~ INDEPENDENCE MALL

DESCRIBE AND/OR SKETCH IN THIS SPACE:

Immigrant Monument of different races colors + creeds.

CIRCLE OF "HOCKNEY" TYPE FIGURES OF EVERY CONCEIVABLE HUMAN SHAPE FORM; SHAPE PYRAMIDING TOWARD THE SKY

YOUR ZIP CODE: 19106

YOUR AGE: 67

YOUR NAME, @, AND/OR HASHTAG: SANDRA + ERIC

RESEARCH ID: FS383

111 Mural Arts Philadelphia

#monumentlab
monumentlab.muralarts.org

MONUMENT LAB

What is an appropriate monument for the current city of Philadelphia?

NAME YOUR MONUMENT:

PLACE YOUR MONUMENT:
ADDRESS, INTERSECTION, OR NEIGHBORHOOD
#1 — over 676 in new park
#2 — over 95 new park

DESCRIBE AND/OR SKETCH IN THIS SPACE:

#1 — 676

This is a monument to displaced families and the reunification of center city with the industrial northern neighborhoods

#2

This is a monument to families and neighborhoods whose livlihoods were demolished with the creation of I-95

YOUR ZIP CODE: 19123

YOUR AGE: 28

YOUR NAME, @, AND/OR HASHTAG: @al0haas / Olivia Haas

RESEARCH ID: CH406

111 Mural Arts Philadelphia

#monumentlab
monumentlab.muralarts.org

MONUMENT LAB

What is an appropriate monument for the current city of Philadelphia?

NAME YOUR MONUMENT: MR. RAB

PLACE YOUR MONUMENT:
ADDRESS, INTERSECTION, OR NEIGHBORHOOD
CITY HALL COURTYARD

DESCRIBE AND/OR SKETCH IN THIS SPACE:

ITS UP TO THE young PEOPLE to DECIDE WHAT MONUMENTS THEY WANT TO BUILD TO: EDUCATION, HISTORY, SCIENCE, JOB SITE & WORK HISTORY, ATHLETICS, COMPUTERS & ROBOTICS, TIME TRAVELING (SPACE + TIME)

P.S. UNCOVER STATE SEAL IN CITY HALL COURTYARD

YOUR ZIP CODE: 19143-5715

YOUR AGE: 67

YOUR NAME, @, AND/OR HASHTAG: MR RAB

RESEARCH ID: MP117

Mural Arts Philadelphia

#monumentlab
monumentlab.muralarts.org

MONUMENT LAB

What is an appropriate monument for the current city of Philadelphia?

NAME YOUR MONUMENT: Reflect love

PLACE YOUR MONUMENT:
ADDRESS, INTERSECTION, OR NEIGHBORHOOD
gayborhood

DESCRIBE AND/OR SKETCH IN THIS SPACE:

glasses with love and inclusive relationships in the reflection (diverse and same sex)

YOUR ZIP CODE: 19104

YOUR AGE: 20

YOUR NAME, @, AND/OR HASHTAG: Grace Boroughs

RESEARCH ID: MP123

Mural Arts Philadelphia

#monumentlab
monumentlab.muralarts.org

David Hartt

In collaboration with Caseem, Vicky, Sam, Gabby, Ashanti, Nadir, Davida, Carlos, and Anthony

Born 1967 · Canadian · Based in Philadelphia

for everyone a garden VIII

Norris Square · Exterior: 3M Scotchprint; interior: monitor, digital media player, and digital video

David Hartt worked in collaboration with the Norris Square Neighborhood Project (NSNP), an organization that provides green space and youth education for residents of North Philadelphia. In particular, Hartt partnered with youth from NSNP's Semillas del Futuro summer program to create a film that explores the connections between city planning, community gardens, and civic engagement. Hartt was initially inspired by NSNP's gardens as a connection to Philadelphia's founding vision as a "Green Country Town" and to the neighborhood's long-standing investments in greening. Hartt set up a studio in the NSNP building on North Howard Street, adjacent to Norris Square. During the production process, Hartt and his collaborators constructed a room-sized model of the neighborhood, and asked, "Who participates in the process of making a city and a neighborhood and how can we imagine a more inclusive future?" To approach these prompts, the film imagined Norris Square in fifty or one hundred years. According to Hartt, the film is an inadequate monument to the time he spent working with the youth and their shared vision of a possible future. The film was shown in the Norris Square Lab, with a large image of the youth cohort with their model of the park installed on the lab's north-facing outer wall.

From the Seeds: Cultivating Monuments

Aviva Kapust

Executive director, Village of Arts and Humanities

David Hartt's collaborative project for Monument Lab produced, in the artist's words, an "inadequate monument." In my view, the outcome is only one facet of a larger process of inquiry. Hartt's project demonstrated a critical, complex, and ambiguous process that should precede the imagining and making of monuments, temporary or permanent, in public spaces across the country.

Hartt's work as a contemporary artist seeks out the social, cultural, and economic complexities of his various subjects. As an established artist and educator, he operates with clear boundaries and parameters around the designation of authorship. In my many years of experience working with artists, designers, and residents in a tremendously disinvested neighborhood of Philadelphia, I have witnessed the complex relationships required of civic practice art and the incompatibility between high art and authentic

co-creation with community. But the relative success of *for everyone a garden VIII* does not rest on Hartt's contemporary artistic practice alone. Rather, the project tested his discipline and humanity as a whole person. Above all, the work required trust; trust is built through consistency over time, something that the exhibition's framework could only partially accommodate. So, Hartt and his young community collaborators designed a new framework that brought them together for more than three hundred hours over two months, in a modified studio space on the second floor of the Norris Square Neighborhood Project, in the surrounding garden plots operated by the organization, including Las Parcelas, and in the square itself. They claimed space to question, to dream, and to create. The resulting relationships are living monuments to that meaningful period of their lives.

To impose an enduring, or closed, monument on Norris Square would have required an impossible amount of certainty in stark contrast to the volatility, uncertainty, and ambiguity present in the neighborhood today. This North Philadelphia neighborhood, while rich with cultural tradition, deep familial roots, and a cadre of renowned artist/activists, is also wrought with traumatic symptoms of systemic disinvestment—crime, poverty, and loss permeate deep and wide. Hartt's project took place in Norris Square as developers, politicians, and institutions took advantage of these conditions and accelerated the pressures of gentrification for their own profit.

The making of a monument is an act of knowing and asserting. But *for everyone a garden VIII* was an act of questioning and discovering in this time of public contestation. Hartt writes, "The title itself is a manifesto, a clear and reasonable demand, a basic right like education, housing, and free speech." The artist did not enter the community with a steadfast or unwavering understanding of its history and current landscape. He entered as a co-learner, co-educator, and co-creator alongside several youth from Norris Square Neighborhood Project's Semillas del Futuro summer program. They are named as collaborators, and their faces appear in a documentary film that attempts to capture the team's experience working together. (Four of the young filmmakers were hired as research fellows at the lab during the exhibition.) Hartt narrates: "These are the sons and daughters of Norris Square and its adjacent communities; they became my crew, partners, and collaborators. We looked together at this community at a moment where its form is contested."

The project *for everyone a garden VIII* recognized the creative powers present in every community that can help reset the civic table. The collaborators explored the central question, "Who participates in the process of making a city and a neighborhood and how can we imagine a more inclusive future?" Put another way: Who decides? Who pays? Who benefits? The groups' questions were not meant to unearth a historical figure, moment, or movement worth memorializing. They were meant to begin generating the next figures, moments, and movements that can envision and build a better future for

themselves and for all of us. For the youth collaborator Anthony, this future holds a place where "almost touching the sky, the gardens and the woods are on top of the highest buildings of the city." A seed is planted, a garden grows.

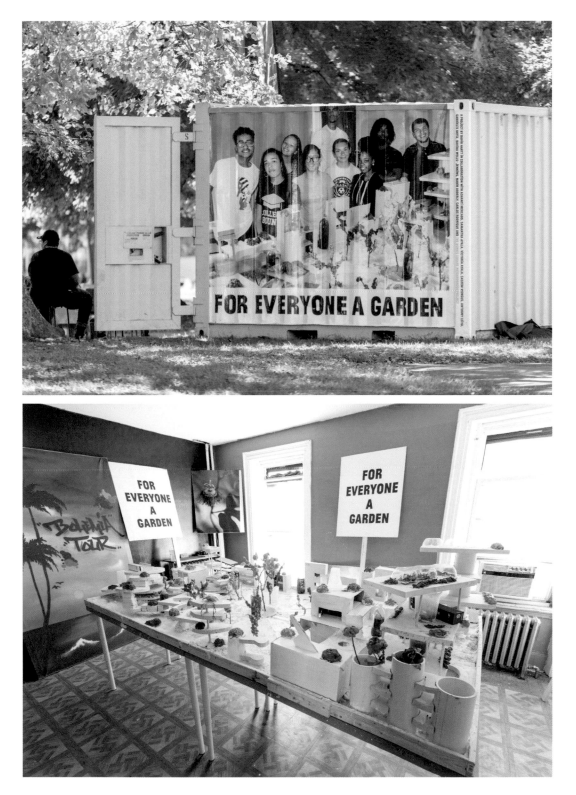

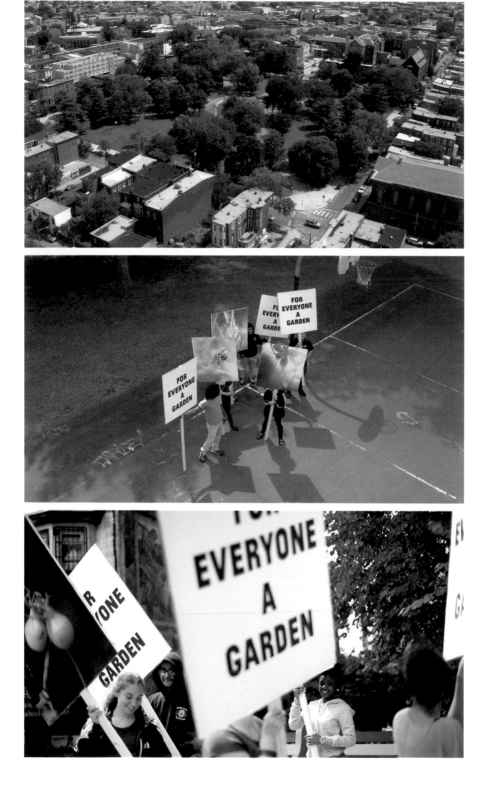

MONUMENT LAB

What is an appropriate monument for the current city of Philadelphia?

Hoop Trail

NAME YOUR MONUMENT: Hoop History

PLACE YOUR MONUMENT:
ADDRESS, INTERSECTION, OR NEIGHBORHOOD: listed below ↓

DESCRIBE AND/OR SKETCH IN THIS SPACE:

maybe 4 or 5 or 11 in a series of famed basketball gyms

Sonny Hill (McGonigle Hall) Dawn Staley (Dobbins Tech)

Wilt Chamberlain (Overbrook HS) Renee Dunn St Joe's
 (Shields)

Gustine Lake (Philadelphia Belles
John began there) → started by Mike Flynn
Cheney (Temple)

YOUR ZIP CODE: 19026

YOUR AGE: 51

YOUR NAME, @, AND/OR HASHTAG: Barbaraann Keffer

RESEARCH ID: LLB 28

Mural Arts Philadelphia

#monumentlab
monumentlab.muralarts.org

MONUMENT LAB

What is an appropriate monument for the current city of Philadelphia?

NAME YOUR MONUMENT:

PLACE YOUR MONUMENT:
ADDRESS, INTERSECTION, OR NEIGHBORHOOD:
11th & Fairmount - 9th Brown

Mural, Plaque or Street Sign Richard Allen Area

DESCRIBE AND/OR SKETCH IN THIS SPACE:

She was important because of her Involvement with Richard Allen, helping to transform the poverty + violence to better living. Standing up + showing out for her Community.

YOUR ZIP CODE: 19146

YOUR AGE: 53

YOUR NAME, @, AND/OR HASHTAG: Fredericka Jones

RESEARCH ID: CH 763

Mural Arts Philadelphia

#monumentlab
monumentlab.muralarts.org

MONUMENT LAB

What is an appropriate monument for the current city of Philadelphia?

NAME YOUR MONUMENT:

PLACE YOUR MONUMENT:
ADDRESS, INTERSECTION, OR NEIGHBORHOOD

DESCRIBE AND/OR SKETCH IN THIS SPACE:

Let Do a complet
over haul of The
Hrstical commsion
1 ST TO 90 is our
Local Developer
Sarle Sam serwood
spring Gardon SJ

YOUR ZIP CODE: 19121

YOUR AGE: —

YOUR NAME, @, AND/OR HASHTAG:

RESEARCH ID: MP197

Mural Arts Philadelphia

#monumentlab
monumentlab.muralarts.org

MONUMENT LAB

What is an appropriate monument for the current city of Philadelphia?

NAME YOUR MONUMENT: Women in TV

PLACE YOUR MONUMENT:
ADDRESS, INTERSECTION, OR NEIGHBORHOOD
Some where in center city

DESCRIBE AND/OR SKETCH IN THIS SPACE:

• a monument to woman
they're unrecognized a lot to day in the World
and in media so, something to memorialize the
women working in Media

Tv with
famous women
in them

YOUR ZIP CODE: 19146

YOUR AGE: 16

YOUR NAME, @, AND/OR HASHTAG: @mayaheins

RESEARCH ID: MP125

Mural Arts Philadelphia

#monumentlab
monumentlab.muralarts.org

Sharon Hayes

Born 1970 · American · Based in Philadelphia, Pennsylvania

If They Should Ask

Rittenhouse Square · Cast concrete, steel, and acrylic lettering

In a city that boasts hundreds of monuments to founding Philadelphians and esteemed visitors, only two publicly sanctioned, full-figured statues are dedicated to historic women: the French heroine Joan of Arc and the Bostonian Quaker Mary Dyer. In her project, Sharon Hayes sought to address this absence of women as well as the intersectional dynamics of race, class, sexuality, and gender identity. Her sculpture, *If They Should Ask*, recognized a long line of Philadelphia women, from the mid-1600s to the present day, who could have been or could be recognized with monuments. Hayes created nine pedestals—based on those on which statues of historic men currently stand across the city—and scaled them to half-size, casting them in concrete and clustering them together in a singular assemblage in the middle of Rittenhouse Square.

To create the inscription that encircled the sculpture, Hayes convened a group of intergenerational, intersectional, and civically engaged women to discuss, as Hayes notes, "the persistent and aggressive exclusion of women from this form of public recognition." Hayes and these interlocutors initiated an ongoing collection of names of Philadelphia-area women who have contributed to the social, cultural, political, and economic life of the city. A selection of these names was incorporated into the work.

"In pointing to the vast contributions that women (inclusive of trans women) make and have made to the city of Philadelphia," Hayes explains, "*If They Should Ask* proposes both that these contributions be remembered more actively and prominently in the commemorative objects that populate U.S. cities, and that to do so requires a collective effort of reimagining what a monument can and should be."

An accompanying installation of Hayes's work related to this project was shown at the nearby Art Alliance.

For a full list of names and to contribute your own, visit iftheyshouldask.com.

The Meaning of Absence: Sharon Hayes's *If They Should Ask*

Jodi Throckmorton

Curator of contemporary art, Pennsylvania Academy of the Fine Arts

Monument pedestals that once held historic figures from the defeated Confederacy now sit empty across the country. The absence of the statues that once occupied these platforms—generals ready for battle and determined men on horses—has become form, an opening that begins to acknowledge the hidden systems of oppression that these statues represent. This emptiness feels palpable and perceivable—a nothingness that occupies space and feels distinctly physical. In *If They Should Ask*, Sharon Hayes used empty sculptural platforms to invoke the memory of important, yet forgotten, women and to create a place for social activism, engagement, and reflection on the discriminatory structure that monumentalizes a white, male version of history. In considering Hayes's piece as part of the current discussion on monuments and memorials, one understands the meaningfulness of absence—that emptiness is a powerful representation of memory, removal, and omission.

Like the altered Civil War monuments, Hayes's monument was an effort to rectify a disturbingly unfair historical record. These monuments leave space (one through creation, the other through destruction and removal) for revision, recognition, and inclusion. Hayes appropriated the forms of pedestals from Philadelphia's multitude of historical sculptures and statues into a multitiered monument. (A multitude, however, that lamentably includes only two fully rendered women on public lands.) Her subjects were absent and present at the same time; their names were cut into the concrete pedestals, yet one woman was not singled out for depiction or representation. This was a collective memorial, not about the individual but about a movement. The unoccupied pedestals pointed to the invisibility of these women—though without form, the subjects of the monument were nonetheless invoked.

Sited in the middle of Rittenhouse Square, one of Center City Philadelphia's wealthiest and most heavily trafficked areas, Hayes's monument claimed active public space for political discourse. These empty pedestals were platforms for free speech. Akin to the discretely potent *Column of Earth and Air (Free Speech Monument)* (1991) by Mark Brest van Kempen on the University of California–Berkeley campus, *If They Should Ask* was both memorial and soapbox. Brest van Kempen's ode to the Free Speech Movement of the 1960s is a piece of granite five feet in diameter. Inscribed along its perimeter is the assertion: "This soil and the air space extending above it shall not be a part of any nation and shall not be subject to any entity's jurisdiction."[1] Hayes's monument similarly carved out space for action—children climbed on it, musicians played perched on the platforms, and Philadelphians used the space to freely exchange ideas and concerns. Shortly before Halloween

2017, the Philadelphia-based activist Mike Hisey occupied the monument for an afternoon dressed in a Donald Trump mask and orange prison jumpsuit. Hisey stood still as a statue while holding a brown paper bag labeled "Trick or Treason" and giving peace fingers. These monuments become sites for activism, protest, and play, thus enacting the intentions of the movements they memorialize.

The list of names of noteworthy women—noteworthy through their actions, whether public or private, large or small—on the monument began with the words, "On this site there could be a statue to . . ." Much like the language that she used for the title of this work, Hayes's choice of words was courteous, suggesting approachability. She was asking for discussion—perhaps a wise tactic to prevent the evasion of an unsympathetic listener and to build bridges across political divides. Hayes's choice to use receptive language echoed the way in which she worked with a group of Philadelphia women to decide on the names to be featured—a collaborative process that the public was invited to join by offering their suggestions for names on the project's website. A spirit of collective activism defined Hayes's monument. While her list covered many noteworthy Philadelphia women—such as Lear Green, who, at age eighteen, escaped slavery by traveling to Philadelphia hidden in a chest; the group of trans women who protested discrimination by occupying a Center City café in 1965; and Ethel Waters, who overcame her poverty-stricken upbringing in Philadelphia to become a well-known actress and singer—it still represented only a small fraction of those that shaped the city's history.

Hayes's piece invalidated the assumption that presence equals truth and merit that only worthy people are memorialized as public sculpture in bronze and stone. By simply existing, monuments give credibility. *If They Should Ask* was as much a monument to refuting this false assumption as it was a monument to the many women who have been excluded from public memorialization. This omission is detrimental to our understanding of history and thus disastrous in the way these exclusionary narratives permeate contemporary civil discourse, which, as reflected in our monuments, glorifies war (even Joan of Arc, in one of the very few sculptures of women in Philadelphia, is depicted riding into battle on a horse) and reinforces unjust power structures. Hayes redefined the meaning of monuments in the twenty-first century—as boundless, rather than finite, records of history; as products of open and collective decision making; and as active sites for public discourse.

Note
1. Peter Selz, *Art of Engagement: Visual Politics in California and Beyond* (Berkeley: University of California Press, 2006), 102.

On this site there could be a statue to Jaren

• Alice Paul • Crystal Bird Fauset • Billie Hol

• the transwomen at the 1965 sit-in at Dewey's

• Happy Fernandez • Jaci Adams • I. P. • Char

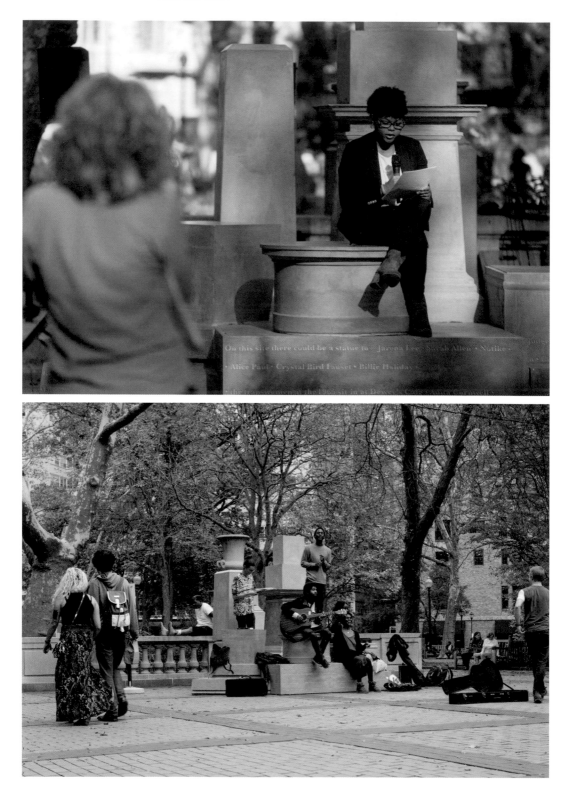

MONUMENT LAB

What is an appropriate monument for the current city of Philadelphia?

NAME YOUR MONUMENT:
Joe Frazier

PLACE YOUR MONUMENT:
ADDRESS, INTERSECTION, OR NEIGHBORHOOD
Broad & Glenwood / North Phila

DESCRIBE AND/OR SKETCH IN THIS SPACE:

Philly Real Champ.

YOUR ZIP CODE: 19144
YOUR AGE: 41
YOUR NAME, @, AND/OR HASHTAG: Amone Bradley
RESEARCH ID: MP198

M Mural Arts Philadelphia

#monumentlab
monumentlab.muralarts.org

MONUMENT LAB

What is an appropriate monument for the current city of Philadelphia?

NAME YOUR MONUMENT:
Touch

PLACE YOUR MONUMENT:
ADDRESS, INTERSECTION, OR NEIGHBORHOOD
15th Market

DESCRIBE AND/OR SKETCH IN THIS SPACE:

Tree of paper hands starting of small at the top getting bigger at the bottom with different sizes and colors hands showing support and what is needed in the city unity.

YOUR ZIP CODE: 19150
YOUR AGE: 59
YOUR NAME, @, AND/OR HASHTAG: Jocobra Glenn
RESEARCH ID: MP67

M Mural Arts Philadelphia

#monumentlab
monumentlab.muralarts.org

MONUMENT LAB

What is an appropriate monument for the current city of Philadelphia?

NAME YOUR MONUMENT:
DR-1 (PRONOUNCED "DRONE")

PLACE YOUR MONUMENT:
ADDRESS, INTERSECTION, OR NEIGHBORHOOD
A RIVER IN PHILA. (DELAWARE, SCHUYLKILL)

DESCRIBE AND/OR SKETCH IN THIS SPACE:

ABSTRACT: SOLAR/WIND/HYDRO - POWERED DRONE
IN A RIVER (DELAWARE, SE-SCHUYLKILL, WISSA.)
SAMPLES WATER FOR HEALTH/PUBIC SAFETY
EQUIPPED W/ · CAMERA → VIDEO STREAM VIDEO DURING DAY
· NEON DISPLAY → LIGHT UP AT NIGHT
 — LOCAL FISH, SWIMMER, POETRY, etc.
· OR LED DISPLAY W/ SCROLLING POETRY

YOUR ZIP CODE: 19123
YOUR AGE: 34
YOUR NAME, @, AND/OR HASHTAG: DAVID BEATUS
RESEARCH ID: PT350

M Mural Arts Philadelphia

#monumentlab
monumentlab.muralarts.org

MONUMENT LAB

What is an appropriate monument for the current city of Philadelphia?

NAME YOUR MONUMENT:

PLACE YOUR MONUMENT:
ADDRESS, INTERSECTION, OR NEIGHBORHOOD
W PHL

DESCRIBE AND/OR SKETCH IN THIS SPACE:

Popup reading Room

YOUR ZIP CODE: 19130
YOUR AGE: 28
YOUR NAME, @, AND/OR HASHTAG: X
RESEARCH ID: CH 259

M Mural Arts Philadelphia

#monumentlab
monumentlab.muralarts.org

King Britt and Joshua Mays

Born 1968 and 1973, respectively · American · Based in Philadelphia, Pennsylvania, and Oakland, California, respectively

Dreams, Diaspora, and Destiny
Malcolm X Park · Sound, light, vinyl panels, and student collaborations

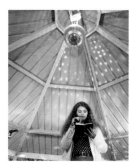

King Britt and Joshua Mays collaborated with high school students from Mural Arts Philadelphia's Art Education program on a performance-based project for Malcolm X Park. Britt, a celebrated producer and sound artist originally from West Philadelphia, and Mays, a painter and muralist from Oakland, were already working with Mural Arts on a longer-term project when they were invited to join Monument Lab. They envisioned a one-night-only performance in the park under a central gazebo as a "monumental time portal." They drew inspiration from their art education summer course focused on art, music, and history. In particular, they explored with the students how artists of color conceptualize stories that are set in the future, including those channeling the legacy of Malcolm X. Britt and Mays explain their conceptual framework:

> All of us are here learning who we are through our ancestral makeup and the dreams of what our ancestors wanted for us. They laid the groundwork for our lineage and are now carrying on the dream. Many of our ancestors were displaced by various circumstances. As we delve into diaspora studies, we learn more about ourselves and how we wound up in this present time and space. So what will we do with this, what is the future, and what will we leave?

For the performance, held October 14, 2017, Britt led a musical ensemble featuring Chuck Treece (guitartronics), John Morrison (electronics), Heru Shabaka-Ra (trumpet), Rich Hill (upright bass), Lyrispect (poet), Anthony Simpson (vocals), and Gionna Clift (vocals). Mays illustrated thirty-foot-long rectangular panels with Afrodiasporic-inspired images of transcendence, struggle, and futurity. Britt and Mays worked with Mural Arts to complete a mural at 53rd Street and Lansdowne Avenue that features an augmented reality app to provide access to archival images and sounds from this collaboration.

A Monument to Constant Change
Mariam I. Williams
Writer, arts educator, public historian, and Malcolm X Park Monument Lab manager

Established in 1903 to be "an open public place and park for the health and enjoyment of the people," Black Oak Park preceded Malcolm X Park in name by ninety years.[1] As West Philadelphia has transitioned from a white to a mixed-race neighborhood, beginning in the early 1950s and continuing

today, the park has remained a contested public space for surrounding residents with different goals, agendas, and expectations.

Greg Cojulun (or Mr. Greg), president of Friends of Malcolm X Park, explained that in the 1960s when he was growing up, black children were relegated to a small section of Black Oak Park to play. If he and his friends left their designated area, white people in the park "would call the Red Car on you," he said, referring to police, whose cars were red then. Throughout the 1980s and 1990s, Black Oak Park became a symbol of neighborhood deterioration as vandals and drug dealers and users dominated the space and the presence of cheap liquor stores increased in the surrounding neighborhood. Black residents supporting community uplift imagined different possibilities for West and Southwest Philadelphia. The park, which sits amid homes between 51st Street and the 52nd Street corridor and is adjacent to key transit routes linking West Philadelphia to the broader metropolitan region, functioned as one site for grassroots renewal. In 1992, neighbors organized "to help revive the park and the adjoining community."[2] They pushed City Council to rename the park after "someone the youths could identify with."[3] In 1993, City Council passed an ordinance changing the name to Malcolm X Memorial Park.

Today, the park and its adjoining community continue to regenerate. Friends of Malcolm X Park raised money to build a covered gazebo at the center of the park in 2001. Spreading approximately two thousand square feet, the structure hosts everything from drug deals and beer sips to tricycle races and the sponsored summer Jazz Heritage series. Meanwhile, the surrounding neighborhood is changing, as gentrification threatens its longtime African American residents. In 2018, Plan Philly reported that whites in Philadelphia are far more likely than blacks to benefit from financial lenders' required investment in low-income neighborhoods such as West and Southwest Philly. "In some Philadelphia census tracts, whites account for just six percent of the population, but are applying for twice as many loans as blacks"—and "white Philadelphians receive ten times as many conventional mortgage loans as black Philadelphians."[4]

How can public art operate as a monument to this ongoing change, particularly when that art is set in a place that functions as its own commemorative space?

In their artist statement about their one-night-only concert, *Dreams, Diaspora, and Destiny*, King Britt and Joshua Mays acknowledge that "many of our ancestors were displaced by various circumstances." The monument nodded to that history through staging intended to emphasize circles and cycles. The staging was set up so that the audience could move through the space; poets performed on an elevated stage in the center, musicians lined the walls created by Mays's panels, and audience members entered and

exited from the two gaps the six panels left on the east and west sides of the octagonal structure.

With the assembled live band and electronic musical tools, Britt's sound collages responded to neighborhood change and aimed to transform the existing space through improvisation, a response to his sense of what was occurring at this historic moment. Through his work with the Mural Arts Education summer students, he transformed the sounds they had collected into other sounds and sonic movements. His artistic license allowed him, in a venue of contested space, to demonstrate the ability, and perhaps by extension, responsibility, to disrupt the existing narrative and transform it into something else.

Mays describes his work "as windows communicating the variety of possibility and the power we hold [as] individuals and collectives to shape those possibilities." On his vinyl panels draped from the roof of the gazebo, audiences saw light bouncing off the disco ball in the center, specks of pink, orange, green, and purple dancing onto hand-drawn figures. Mays rendered human-like, yet disembodied, images—eyes blending into masks blending into cathedrals, hands blending into gardens hovering above skyscrapers. His maroon-and-white panels featured genderless, bodiless forms, marking a departure from many of Mays's previous works, which have tended to center goddess-like images of black women and invite viewers to rethink the possibilities of black art and culture. Nonetheless, as we find ourselves in a time in this country in which people who inhabit bodies of color, fat bodies, bodies with varying abilities, and nonbinary gender bodies constantly negotiate the terms and limitations of their very existence, I speculate that Mays and the youth he collaborated with were inviting viewers to imagine a time when there are no limitations put on those bodies, when there is a consensus about humanity, and when spaces as contested as concrete and nature emerge unified. Together, the sound, poetry, and visuals were reminiscent of Robin D. G. Kelley's description of surrealism as a tool for social revolution: "a movement that invites dreaming, urges us to improvise and invent, and recognizes the imagination as our most powerful weapon."[5]

With the setup serving as a canopy, the artist-described "monumental time portal" could not fully escape the current moment. Inside the gazebo, I didn't observe most of the usual denizens of the park, many of whom we engaged in conversation at the lab. Outside, on the south side of the park, most of our park regulars congregated: black children from the neighboring charter school, their parents, teens and adults, long-time residents who walk their dogs in the park daily, all orbiting outside their space. In the process of honoring the past and building a utopian future, perhaps together we had conjured an ironic but appropriate monument to current West Philly.

Notes
1. Common Council of the City of Philadelphia. *Journal of the Common Council of the City of Philadelphia, Year 1903*, vol. 1. (Philadelphia: J. Van Court, 1903), 70.
2. Winslow Mason Jr., "Malcolm X Memorial Park Proposed in S.W. Phila.," *Philadelphia Tribune*, May 11, 1993, A1.
3. Ibid.
4. Jen Kenney, "Unequal Lending Keeps Redlining Alive in Philadelphia's Gentrifying Neighborhoods, *Plan Philly*, February 15, 2018, https://whyy.org/articles/unequal-lending-keeps-redlining-alive-philadelphias-gentrifying-neighborhoods/.
5. Robin D. G. Kelley, *Freedom Dreams: The Black Radical Imagination* (Boston: Beacon Press, 2002), 159.

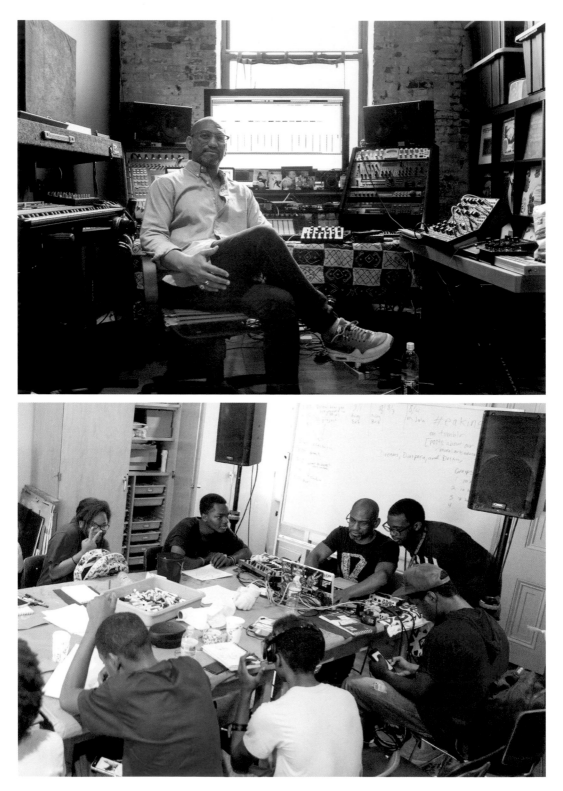

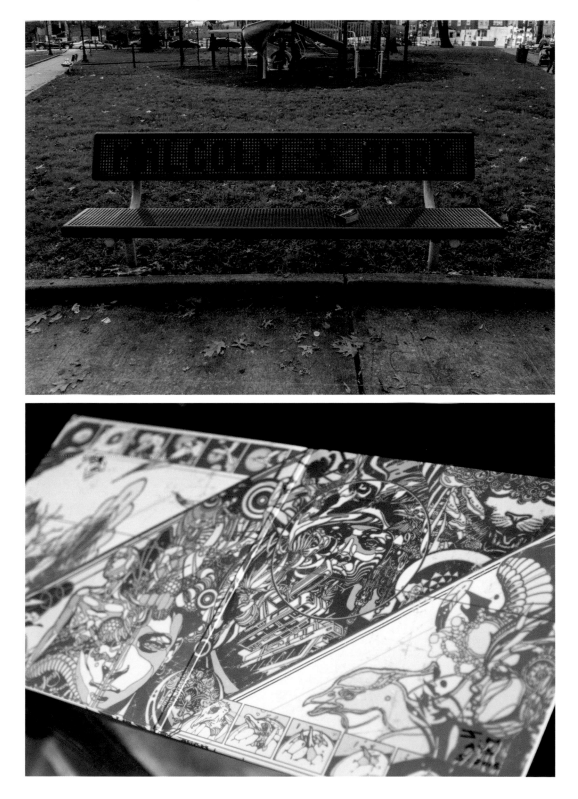

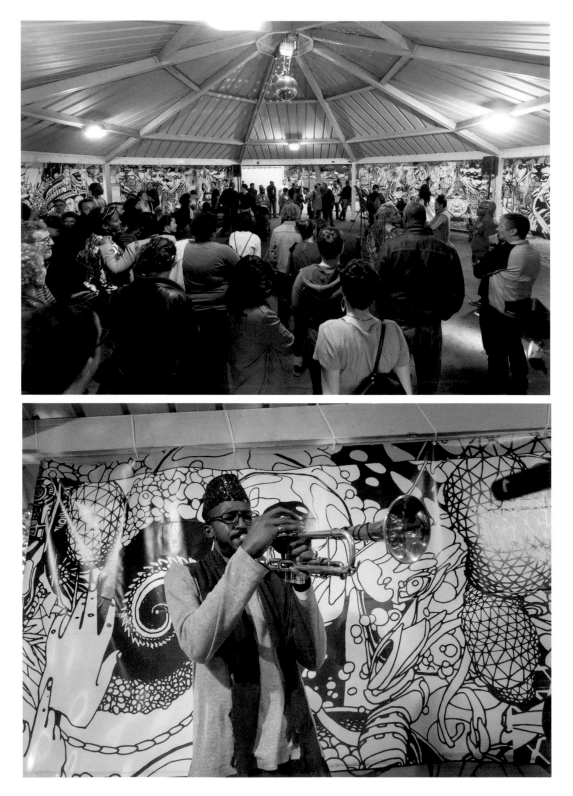

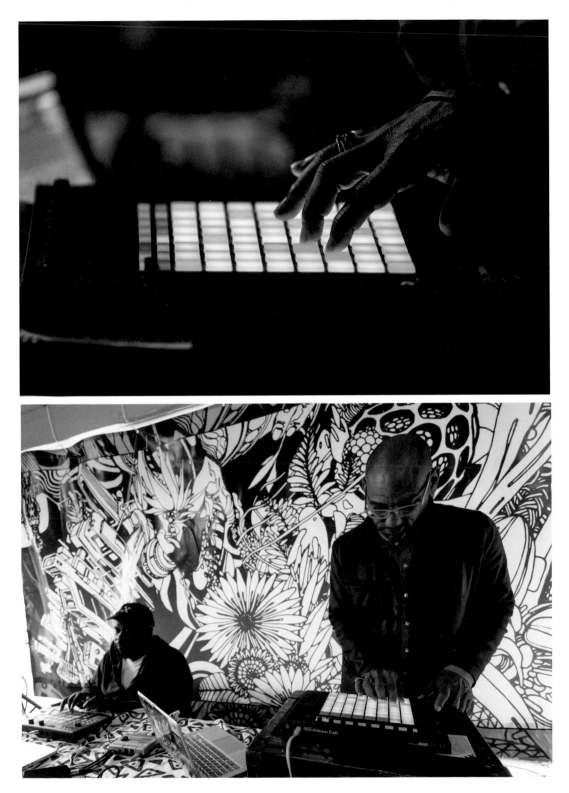

MONUMENT LAB

What is an appropriate monument for the current city of Philadelphia?

NAME YOUR MONUMENT:

PLACE YOUR MONUMENT:
ADDRESS, INTERSECTION, OR NEIGHBORHOOD

near schools

DESCRIBE AND/OR SKETCH IN THIS SPACE:

NOT Confederate
NOT Rizzo
monument to Japanese interment Camps
monument criticizing 3 military occupations in Cuba

monument pro Guam, PR independance

YOUR ZIP CODE: 19061
YOUR AGE: 23
YOUR NAME, @, AND/OR HASHTAG: @rachelgarveyy IG
RESEARCH ID: MP209

Mural Arts Philadelphia

#monumentlab
monumentlab.muralarts.org

MONUMENT LAB

What is an appropriate monument for the current city of Philadelphia?

NAME YOUR MONUMENT:

"WHAT A GEM (Monument to Jewelers Row)

PLACE YOUR MONUMENT:
ADDRESS, INTERSECTION, OR NEIGHBORHOOD

JEWELERS ROW!

DESCRIBE AND/OR SKETCH IN THIS SPACE:

#SAVEJEWELERSROW

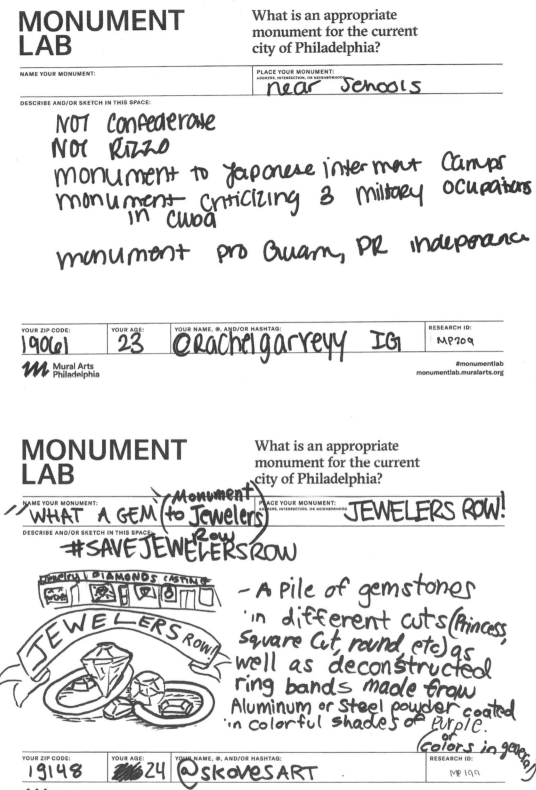

- A pile of gemstones in different cuts (Princess, square Cut, round etc) as well as deconstructed ring bands made from Aluminum or Steel powder coated in colorful shades of purple. or (colors in general)

YOUR ZIP CODE: 19148
YOUR AGE: 24
YOUR NAME, @, AND/OR HASHTAG: @skovesART
RESEARCH ID: MP199

Mural Arts Philadelphia

#monumentlab
monumentlab.muralarts.org

MONUMENT LAB

What is an appropriate monument for the current city of Philadelphia?

NAME YOUR MONUMENT: **PhillWe**

PLACE YOUR MONUMENT:
ADDRESS, INTERSECTION, OR NEIGHBORHOOD **NE Philly**

DESCRIBE AND/OR SKETCH IN THIS SPACE:

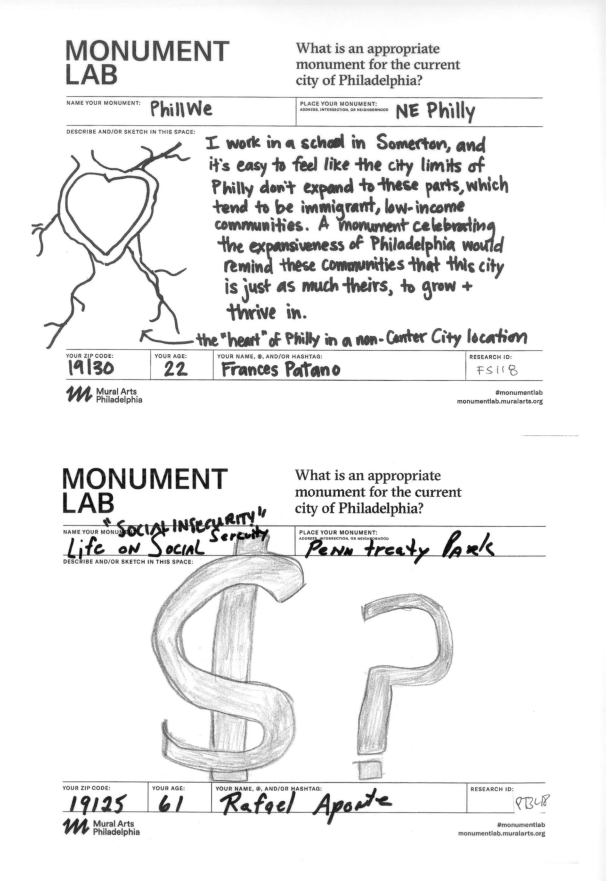

I work in a school in Somerton, and it's easy to feel like the city limits of Philly don't expand to these parts, which tend to be immigrant, low-income communities. A monument celebrating the expansiveness of Philadelphia would remind these communities that this city is just as much theirs, to grow + thrive in.

← the "heart" of Philly in a non-Center City location

YOUR ZIP CODE: **19130**

YOUR AGE: **22**

YOUR NAME, @, AND/OR HASHTAG: **Frances Patano**

RESEARCH ID: **FS118**

Mural Arts Philadelphia

#monumentlab
monumentlab.muralarts.org

MONUMENT LAB

What is an appropriate monument for the current city of Philadelphia?

NAME YOUR MONUMENT: "SOCIAL INSECURITY" Serwity
Life on Social

PLACE YOUR MONUMENT:
ADDRESS, INTERSECTION, OR NEIGHBORHOOD **Penn treaty Park**

DESCRIBE AND/OR SKETCH IN THIS SPACE:

YOUR ZIP CODE: **19125**

YOUR AGE: **61**

YOUR NAME, @, AND/OR HASHTAG: **Rafael Aponte**

RESEARCH ID: **PB48**

Mural Arts Philadelphia

#monumentlab
monumentlab.muralarts.org

Klip Collective

Founded 2003 · Based in Philadelphia, Pennsylvania

Passage :: Migration

Marconi Plaza · Video projection, sound, fabric, and smoke

Klip Collective, led by the video and light artist Ricardo Rivera, integrated projection with critical and celebratory storytelling in South Philadelphia's Marconi Plaza. Rivera lives in the community and envisioned a monument to the multiple generations of immigrants, migrants, and refugees who have made it their home. For *Passage :: Migration*, he collected the surnames of numerous South Philadelphia families into one immersive text and installation. As Rivera explains: "The names pass over and around the viewer in waves, projected on translucent planes of fabric and smoke, creating a floating sensation. By entering, the viewer would become an active part of the installation, as the projections wash over their body. Like this country, once you enter, you are a part of it." The artist gathered the names from passenger ship manifests at the Coast Guard Station on Washington Avenue, from books obtained by Monument Lab researchers from the University of Pennsylvania Libraries, and from publications produced by the Mural Arts Southeast by Southeast initiative. *Passage :: Migration* was installed for a one-night-only viewing on October 28, 2017.

South Philly, My Namesake

Kristen Giannantonio

Associate curator, Monument Lab, and assistant director of the Undergraduate Fine Arts Program, University of Pennsylvania

On a mild October evening, just after dusk, a triangular-shaped tunnel of oscillating lights could be seen from hundreds of feet away, enveloping one of the many pedestrian walkways that cut through Marconi Plaza. A low cloud of smoke emanated from the abstract illuminated form located in the northeast corner of the park, steps away from the bocce courts and SEPTA's Oregon Station. An ambient score, layered with sounds of water and melodic piano chords, played softly and could be heard as one approached.

On entering the tunnel, the visitor was engulfed in fluorescent streams of white, purple, and blue letters. The letters moved upward from the ground, alternating between handwritten and typed text. The pace of the score synchronized with each element. The components merged and the subject of the abstraction was revealed: the letters formed names, hundreds of them, stacked closely in rows, as if delivered in waves.

When exiting the tunnel, visitors felt their sense of time and space waver. The vibration of the subway under the pavement, a rumbling bus, the sound

of a car horn, and golden flashes of taxicab lights hurtling down Broad Street reminded visitors exactly where they were—the spirited neighborhood of South Philadelphia.

Passage :: Migration, an alluring site-specific installation of projected light and sound designed by Klip Collective, invited visitors to immerse themselves in a sea of names representing the generations of families who have immigrated to South Philadelphia. Ricardo Rivera, the collective's founder and creative director, has lived in South Philadelphia for fifteen years. "I'm very proud of this city," he says, "and I'm not leaving. It's a great place to be an artist."

Pride is a word that resonates with many South Philadelphians. The neighborhood's grit is so authentic that clichés are obsolete. The gridded streets are comfortably claustrophobic. Neighboring row homes are dressed with brick facades and peppered with rusty pinstriped tin awnings. Strings of holiday lights cover certain side streets year round. Bay window fronts have been turned into personalized altars, adorned with delicate religious figurines, Eagles flags, political stickers, and high school graduation photos. The city's best barbacoa, cannoli, and pho are to be found there. South Philly is more than a place; it's an attitude.

The generations of families who have arrived in the city through South Philadelphia's ports and highways include those of Irish, German, Polish, Italian, Jewish, and African descent. For at least a generation, immigrants from Southeast Asia, particularly Vietnam and Cambodia, and from Central America have settled in the neighborhood. Families from Burma, Bhutan, and Nepal, and others, are among the newest residents, the first of them arriving in 2008.

"I wanted to make a statement about current events," Rivera, a son of parents from Puerto Rico and Thailand, said. The site of the installation, the nineteen-acre Marconi Plaza, designed by the renowned French American architect Paul Cret and adapted by the Olmsted Brothers, opened in 1914. Among its first stewards was an enclave of the Italian American community, who sought to counter the anti-Italianism of the early twentieth century and proudly celebrate the neighborhood's cultural identity. The park served as an official gateway for the nation's sesquicentennial celebration in 1926, with a massive Liberty Bell–shaped light sculpture that spanned Broad Street. *Passage :: Migration* extended these historical sentiments to monumentalize an inclusive portrait of an increasingly diverse neighborhood.

Rivera obtained the names from various sources, including the manifests of ships that entered the United States through the Port of Philadelphia, in operation from the late 1800s through 1945. The handwritten script personified the names and quickly overwhelmed the viewer with an archive of individual narratives. The presentation of names and their country of origin reflected

the neighborhood's ethnic breadth and connected personal vignettes to our present national discourse.

Dougherty . . . Millet . . . Lovatt . . . Mercado . . . Segovia . . . Araujo . . .
Willis . . . Li . . . Oliver . . . Ramirez . . . Jones . . . Truong . . . MacPhail . . .
Eng . . . Bello . . . Schulz . . . Lee . . . Khan . . . Perez . . . Sugiyanto . . . Alleva . . .
Ngo . . . Mastero . . . Zadik . . . Watkins . . . Nhem . . . Goldschmid . . .

When I saw my maiden name drift by, I was reminded of my ancestors' stories of migration. My great-great-grandparents emigrated from Germany, Ireland, and Poland. They opened storefront restaurants in Queen Village, gambled on South Street, built paper factories in the Northeast, rode the electric streetcars, and called South Philadelphia home for almost seventy years. I wondered whether I would see my married name. Cherished Giannantonio recipes, colloquialisms, and family traditions originated on Colorado Street and in Packer Park. I have lived in South Philadelphia for ten years, returning after generations of relatives moved to the nearby suburbs. Having family origins in the neighborhood and living as a part of its current culturally vibrant community are fundamental parts of my own identity.

The site specificity of *Passage :: Migration* was fundamental to the accessibility of its message. South Philadelphia is a case study for telling a diverse, inclusive American story, while retaining cultural identities in the neighborhood and beyond. According to Rivera, this installation immersed visitors in a dreamlike environment as a way to map the surrounding neighborhood across time and offer evidence of prolonged coexistence. "It's experiential art," he says, "about creating a feeling, a vibe." Those who engage with the installation and make their own interpretations of it are the final component of the artwork.

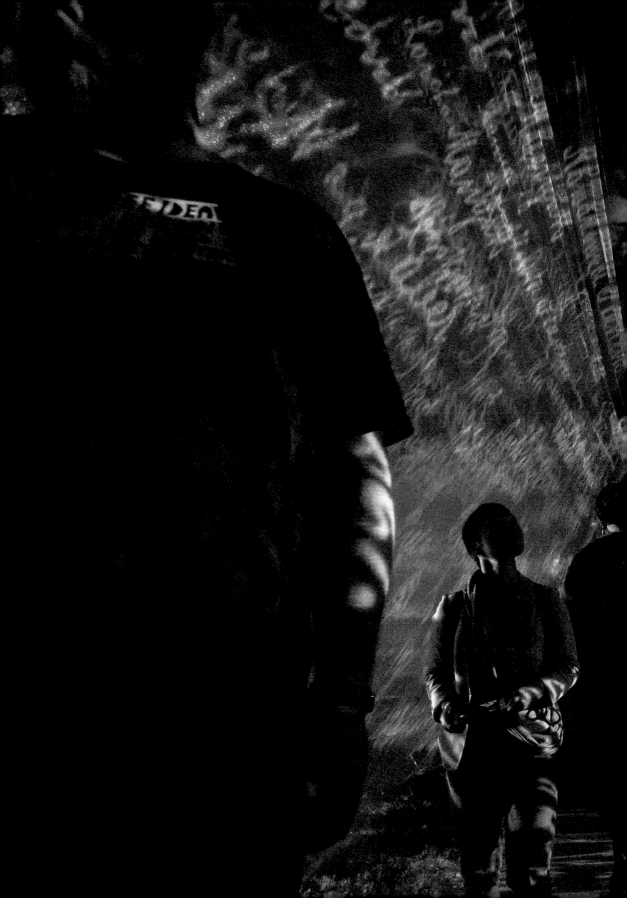

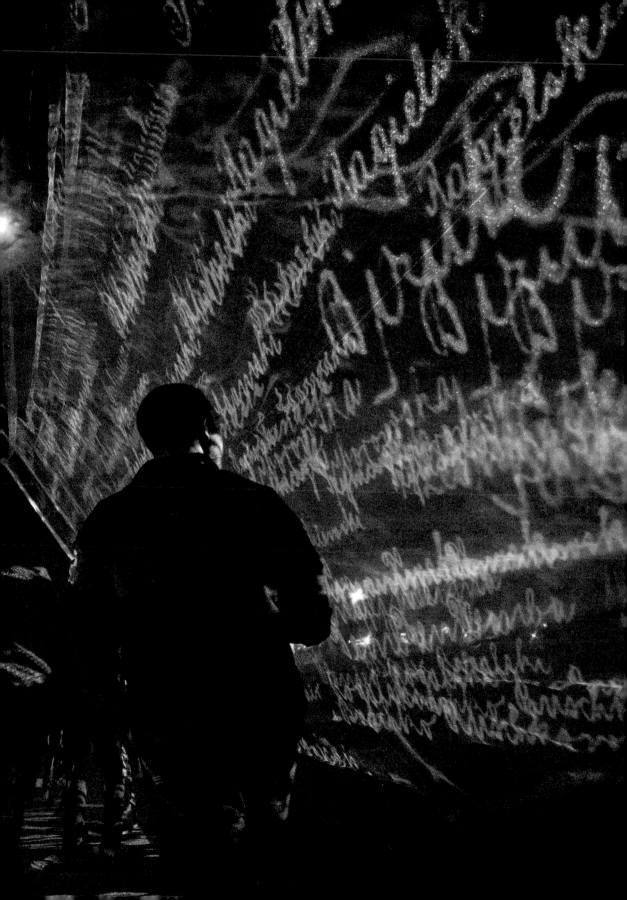

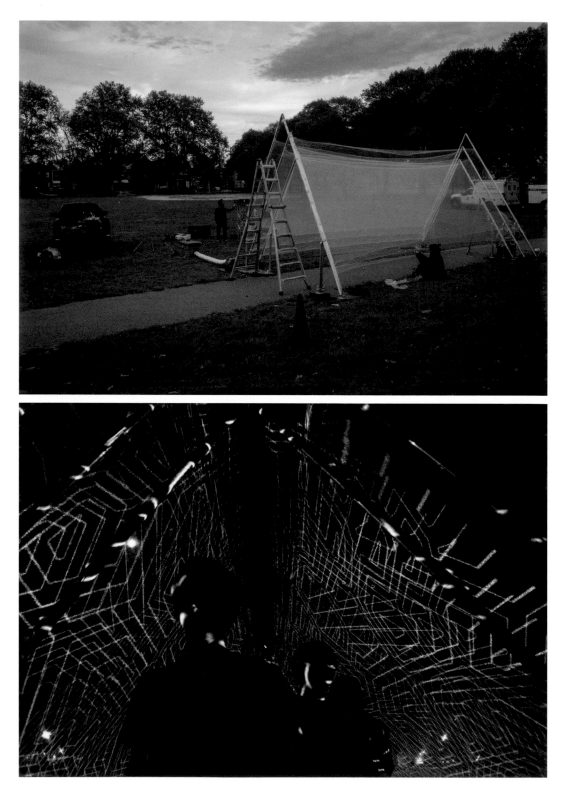

MONUMENT LAB

What is an appropriate monument for the current city of Philadelphia?

NAME YOUR MONUMENT:
Monument To The Black AMERICAN Soldiers (buried at Congo Square)

PLACE YOUR MONUMENT:
ADDRESS, INTERSECTION, OR NEIGHBORHOOD
(CONGO Square)
WASHINGTON Square

DESCRIBE AND/OR SKETCH IN THIS SPACE:

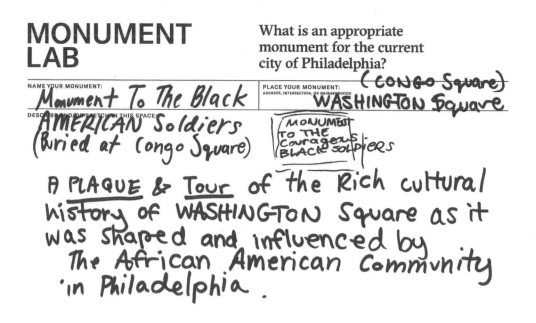

MONUMENT TO THE Courageous BLACK SOLDIERS

A PLAQUE & Tour of the Rich cultural history of WASHINGTON Square as it was shaped and influenced by The African American Community in Philadelphia.

YOUR ZIP CODE:	YOUR AGE:	YOUR NAME, ®, AND/OR HASHTAG:	RESEARCH ID:
19148	24		MP200

M Mural Arts Philadelphia

#monumentlab
monumentlab.muralarts.org

MONUMENT LAB

What is an appropriate monument for the current city of Philadelphia?

NAME YOUR MONUMENT:
US

PLACE YOUR MONUMENT:
ADDRESS, INTERSECTION, OR NEIGHBORHOOD
City Hall

DESCRIBE AND/OR SKETCH IN THIS SPACE:

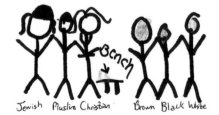

Jewish Muslim Christian Brown Black White

YOUR ZIP CODE:	YOUR AGE	YOUR NAME, ®, AND/OR HASHTAG:	RESEARCH ID:
19139	10/29	Tianna Davis	# mx180

M Mural Arts Philadelphia

#monumentlab
monumentlab.muralarts.org

MONUMENT LAB

What is an appropriate monument for the current city of Philadelphia?

NAME YOUR MONUMENT: A Leader

PLACE YOUR MONUMENT:
ADDRESS, INTERSECTION, OR NEIGHBORHOOD
Any park / children's park

DESCRIBE AND/OR SKETCH IN THIS SPACE: Two metal poles holding a metal road that twists. first, an adult leads a child. In the middle the child is on top, adult below, At the end the child is leading the adult.

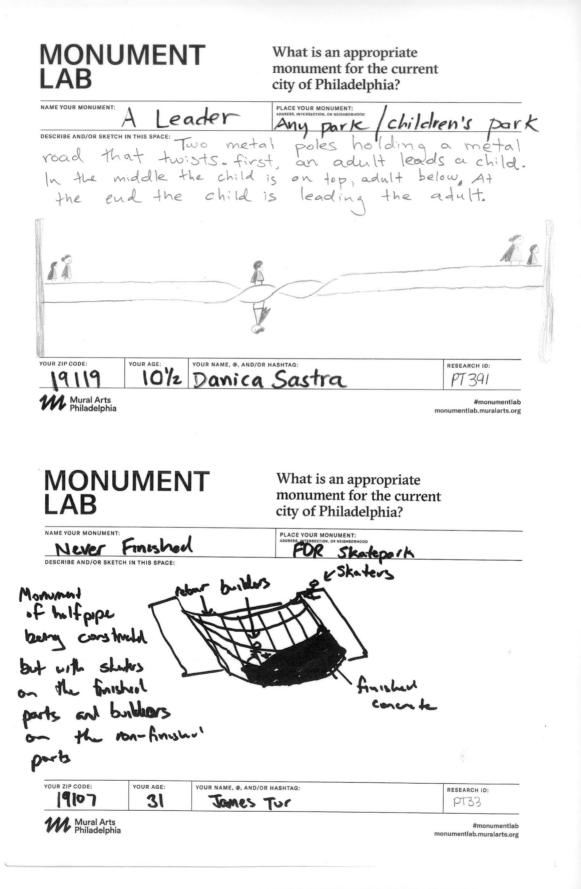

YOUR ZIP CODE: 19119

YOUR AGE: 10½

YOUR NAME, @, AND/OR HASHTAG: Danica Sastra

RESEARCH ID: PT 391

Mural Arts Philadelphia

#monumentlab
monumentlab.muralarts.org

MONUMENT LAB

What is an appropriate monument for the current city of Philadelphia?

NAME YOUR MONUMENT: Never Finished

PLACE YOUR MONUMENT:
ADDRESS, INTERSECTION, OR NEIGHBORHOOD
FDR Skatepark

DESCRIBE AND/OR SKETCH IN THIS SPACE:

Monument of halfpipe being constructed but with skaters on the finished parts and builders on the non-finished parts

rebar builders

skaters

finished concrete

YOUR ZIP CODE: 19107

YOUR AGE: 31

YOUR NAME, @, AND/OR HASHTAG: James Tur

RESEARCH ID: PT33

Mural Arts Philadelphia

#monumentlab
monumentlab.muralarts.org

Duane Linklater

Born 1976 · Omaskêko Ininiwak/Moose Cree First Nation · Based in North Bay, Ontario, Canada

In Perpetuity

Penn Treaty Park · Neon, transformers, aluminum, polycarbonate, and handwritten text by Sassa Linklater

Duane Linklater's *In Perpetuity* was a monument to Lenape chief Tamanend and a historical reference point for the broad erasure of the presence of Indigenous peoples from lands that now include the city of Philadelphia. The artwork was installed on the banks of the Delaware River, in an area known as Shackamaxon, which served as a meeting place for thousands of years before the colonial encounter. In 1682–1683, William Penn and Chief Tamanend met there to secure a "treaty of friendship." The Lenape's agreement, according to historical accounts, was meant to last "as long as the rivers and creeks flow, and the sun, moon, and stars endure." Linklater asked his nine-year-old daughter, Sassa, to handwrite these words. He then worked with a Philadelphia-area neon fabricator to reproduce the phrase as a lit sign installed on the edge of the park to mark the enduring legacy of the Lenape people and the unraveling of a treaty intended to promote long-standing coexistence.

Perpetuity's Promise

Stephanie Mach

Diné/Navajo, academic coordinator, Penn Museum

Duane Linklater is Omaskêko Ininiwak from Moose Cree First Nation in Northern Ontario. His work often focuses on issues of cultural loss and recovery, authenticity and appropriation, and institutional critique.

For Monument Lab, Linklater created a monument to Lenape chief Tamanend, who in the 1680s negotiated a treaty of peace with William Penn, proprietor of the newly formed colony of Pennsylvania. Linklater's monument took the form of Tamanend's words in response to Penn, passed down through oral history and recounted in Governor Patrick Gordon's address to the Lenape people in 1728: "We will live in love with William Penn and his children as long as the creeks and rivers flow, and the sun, moon, and stars endure."[1]

Enigmatic and seemingly out of context, these poetic words were placed in the very context in which they were spoken. Linklater situated Tamanend's words at a scenic overlook on the banks of the Delaware River in Penn Treaty Park. The area was once a large Lenape village called Shackamaxon in use since time immemorial and the political center of the Delaware Valley. Today, it is best known as the famed location of the Treaty of Friendship.

The title of the work, *In Perpetuity,* refers to the presumed permanency of this agreement. But peace did not last. In less than a century, the Lenape were largely dispossessed of their lands and seeking refuge farther west and east. Just feet from Linklater's work, a flag pole stood tall, waving the American flag and proclaiming to all who visited the park or passed along the shores that this is American land. Monuments are created to help us remember, so perhaps a secondary intent of Linklater's work was to highlight how quickly we forget. It highlights how the sovereignty of Native nations are so easily and purposefully neglected in order to aggrandize the birth of the American nation.

Penn's name, his likeness, and his memory cover Philadelphia's physical and cultural landscape, yet fuller recognition of this region's first people is more difficult to find. Throughout the rest of the park, not one monument mentions the Lenape or Chief Tamanend, and instead thousands of years of history have been ignored for one colonial event—the landmarks generically refer to the Lenape as "the Indians."

For centuries, artists have trapped the Indigenous peoples of this continent in a romanticized past: noble, stoic, and static. Philadelphians are all too familiar with this image of the male Native scattered across the city. The sidewalks of East Passyunk Avenue are lined with medallions depicting a menacing Native male wearing a headdress not at all traditional to the Indigenous people of this region or representative of the Lenape's renowned peace-making abilities. On display at the Pennsylvania Academy of the Fine Arts, Benjamin West's 1772 painting *Penn's Treaty with the Indians* translates this historic event into an allegorical image nearly a century after it took place, further obscuring and distancing the trail of broken treaties from the realities faced by contemporary Native Americans. Representations such as these maintain the misrepresentation of Indigenous people as in the distant past and irrelevant to today's concerns.

Linklater departed from the stereotypical monument of a bare-chested warrior wearing a headdress, moccasins, chest ornaments, and breechcloth. Instead, Linklater represented Tamanend not by his body but by his words, which symbolize the ongoing significance of this place for the Lenape, and thus created a dialogue across time that made visible the displacement of Indigenous people from this land. The words stood as a reminder of a broken promise, their beauty starkly contrasting against the reality of their surroundings: the products of settler colonialism and the historical erasure of the Lenape.

The materiality of the piece—fabricated from neon tubing—made Linklater's monument stand out for its unnatural qualities when placed in a park setting. By translating the message into a modern, eye-catching material, Linklater reaffirmed the contemporary significance of this centuries-old promise. His collaboration with his daughter, Sassa Linklater, to write the

Notes
1. Kenneth W. Milano, *The History of Penn Treaty Park* (Charleston, SC: History Press, 2009), 21. See also William Henry Egle, *Notes and Queries: Historical, Biographical, and Genealogical, Chiefly Relating to Interior Pennsylvania*, vol. 2 (Harrisburg Publishing, 1895).
2. Mary Elvira Weeks, *Discovery of the Elements: Collected Reprints of a Series of Articles Published in the Journal of Chemical Education* (Whitefish, MT: Kessinger, 2003), 287.

text demonstrates the importance that this history be passed on to the next generation. Sassa's handwritten script by day was nearly invisible, but by night it glowed red like a campfire across the park grass, drawing the viewer closer. The supportive structure for the neon text was clear, such that the viewer could see through the words to the river flowing behind it, and experience the evidence of a broken treaty: the water flowing through the acrylic sign and at night the enduring stars and moon shining.

Duane Linklater eschewed the phallic monuments and overstated, canonical statues of white men in favor of a commercial material best known for attracting the attention of Americans. Neon has a history of allure going back to the day it was discovered, when the British chemist Morris Travers stated, "The blaze of crimson light from the tube told its own story and was a sight to dwell upon and never forget."[2] Linklater appropriated the captivating tool of the colonizer to shed light on a history that should not be forgotten.

as long as the creeks and rivers flow
and the sun moon and stars endure

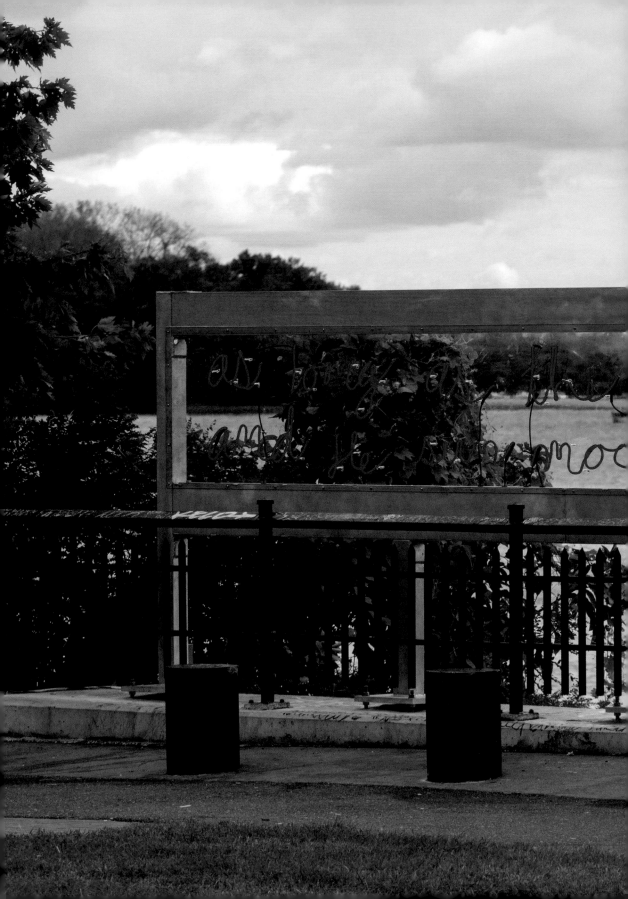

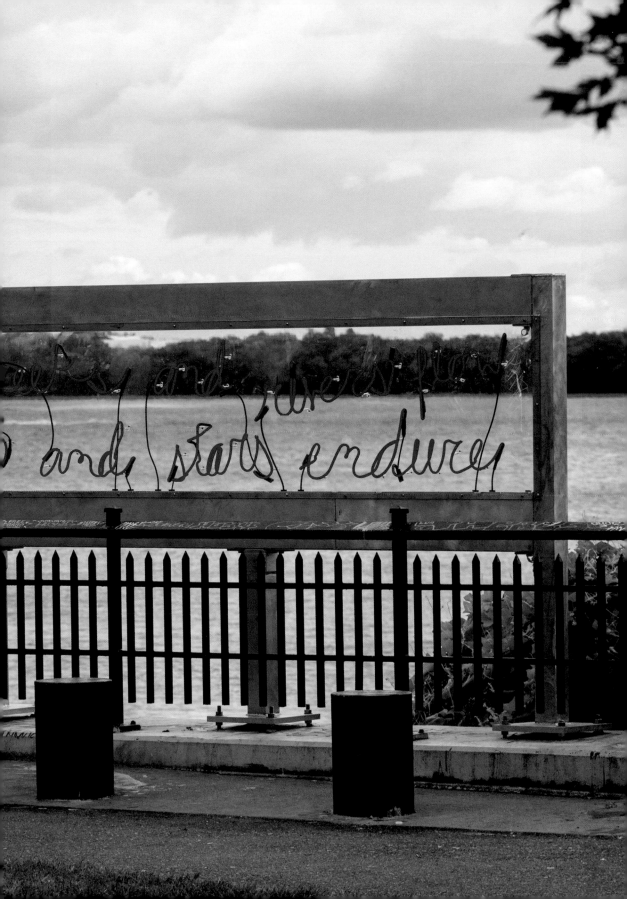

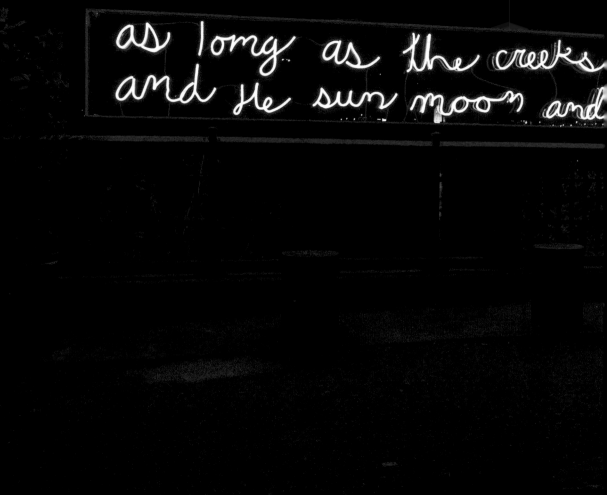

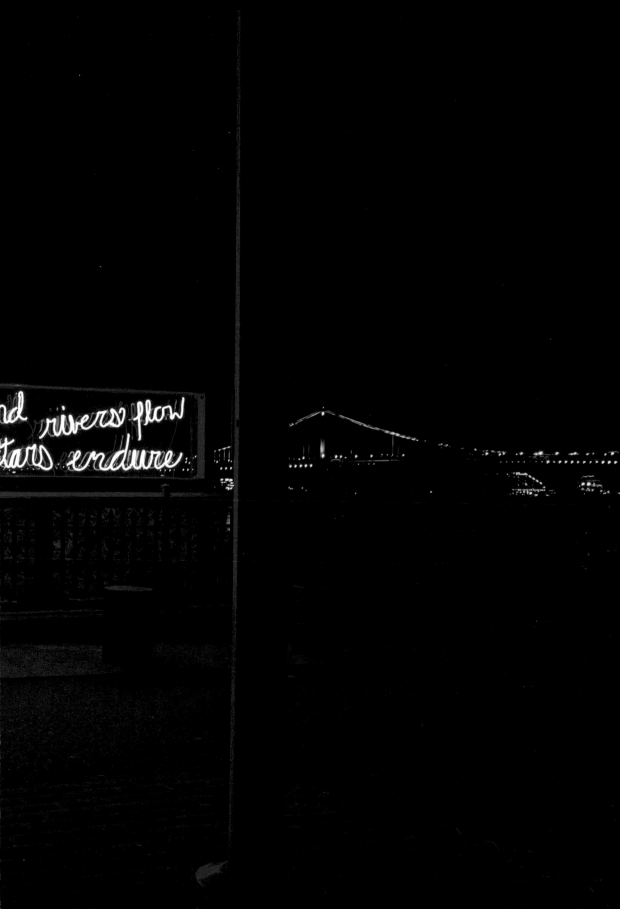

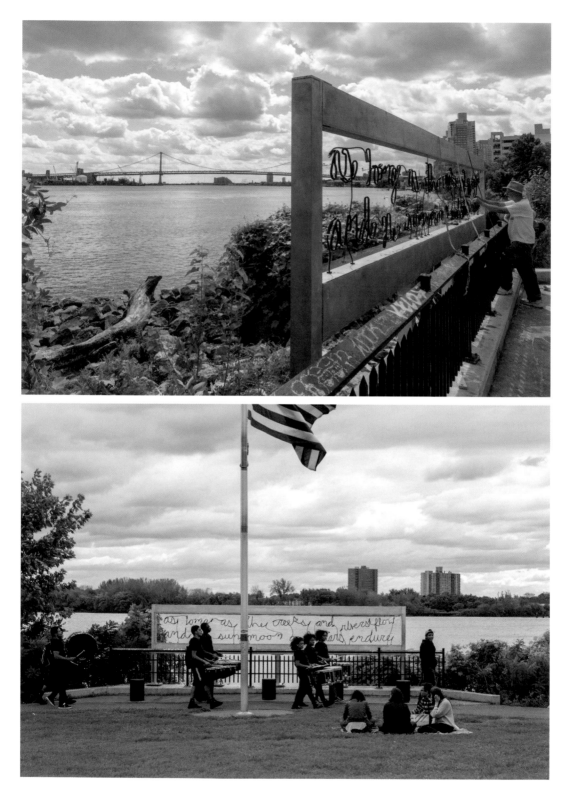

MONUMENT LAB

What is an appropriate monument for the current city of Philadelphia?

NAME YOUR MONUMENT:

PLACE YOUR MONUMENT:
ADDRESS, INTERSECTION, OR NEIGHBORHOOD

All in the AFRICAN COMMUNITY

DESCRIBE AND/OR SKETCH IN THIS SPACE:

MORE postive statue in the Black communities.

YOUR ZIP CODE:	YOUR AGE:	YOUR NAME, @, AND/OR HASHTAG:	RESEARCH ID:
19143	55	DELANDO JONES	mx211

MONUMENT LAB

What is an appropriate monument for the current city of Philadelphia?

NAME YOUR MONUMENT: (the light up sign)
In Perpetuity finds a permanent home in Penn Treaty Park

PLACE YOUR MONUMENT:
ADDRESS, INTERSECTION, OR NEIGHBORHOOD

Penn TREATY PARK

DESCRIBE AND/OR SKETCH IN THIS SPACE:

as long as the creek and the sun & the moon endure

This monument should stay year round / forever but be powered by the sun! You could put them on the fence in front of the piece. it makes this park beautiful ♡

— solar powered energy to light the sign year round!!!

YOUR ZIP CODE:	YOUR AGE:	YOUR NAME, @, AND/OR HASHTAG:	RESEARCH ID:
19145	24	@symonesalib	PT345

MONUMENT LAB

What is an appropriate monument for the current city of Philadelphia?

NAME YOUR MONUMENT:

FACING PREJUDICE

PLACE YOUR MONUMENT:
ADDRESS, INTERSECTION, OR NEIGHBORHOOD

THOMAS PAINE PLAZA

DESCRIBE AND/OR SKETCH IN THIS SPACE:

A MAZE WITH OPAQUE WALLS AND PHOTOGRAPHS OF RANDOM PHILADELPHIANS EACH NEXT TO A MIRROR. YOU LOOK AT THE PHOTOGRAPH, WHICH IS JUST A FACE, AND THEN MAKE A JUDGMENT ABOUT THEM BASED ON WHAT YOU SEE. BENEATH THE MIRROR IS A PANEL WHICH YOU OPEN AFTER CONTEMPLATING THE FACE. THE PANEL CONTAINS A BIOGRAPHICAL NARRATIVE ABOUT THE PERSON. THE EXERCISE, IF PROPERLY EXECUTED, SHOULD PROVIDE FOR SELF-REFLECTION ABOUT JUDGMENTS YOU MAKE ABOUT OTHER PEOPLE BASED SOLELY ON APPEARANCES

YOUR ZIP CODE: 19147

YOUR AGE: 41

YOUR NAME, @, AND/OR HASHTAG: JENNIFER QUINN

RESEARCH ID: PT 402

Mural Arts Philadelphia

#monumentlab
monumentlab.muralarts.org

MONUMENT LAB

What is an appropriate monument for the current city of Philadelphia?

NAME YOUR MONUMENT:

MONUMENT TO MY 1st KISS

PLACE YOUR MONUMENT:
ADDRESS, INTERSECTION, OR NEIGHBORHOOD

PENN TREATY PARK

DESCRIBE AND/OR SKETCH IN THIS SPACE:

FIRST BENCH BY THE WALL OF THE ELECTRIC FACTORY.
ELENOR ♡ JOE

"I WAS 13 YEARS OLD WHEN I HAD MY FIRST KISS."

Elenor lived Germantown and Girard, I LIVED @ 3rd and Master

YOUR ZIP CODE: 18073

YOUR AGE: 74

YOUR NAME, @, AND/OR HASHTAG: JOE SEIFRIED

RESEARCH ID: PT 415

Mural Arts Philadelphia

#monumentlab
monumentlab.muralarts.org

Emeka Ogboh featuring Ursula Rucker

Born 1977 · Nigerian · Based in Paris, France

Logan Squared: Ode to Philly

Logan Square · Mixed-media sound installation

Emeka Ogboh creates soundscapes to honor and understand cities. For *Logan Squared: Ode to Philly*, the artist collaborated with the renowned Philadelphia poet Ursula Rucker and members of the Chestnut Street Singers, drawing on the ideas of hundreds of Philadelphians who submitted proposals during Monument Lab's 2015 discovery phase. Ogboh notes: "The point of departure for this work begins with what the city of Philadelphia remembers and what it chooses not to remember in terms of its history. The question is put across its citizenry in the form of research feedback."

Responding to the open dataset of proposals, Rucker composed an epic poem that formed the backbone of the project. Each Sunday, visitors were invited to experience a special weekly listening to a multichannel sound installation on the Skyline Terrace atop Philadelphia's Parkway Central Library. The composition included the sounds of Rucker's poem and a special choral arrangement of Louis Gesensway's "Logan Square at Dusk" from *Four Squares of Philadelphia*. Visitors were also able to hear the sound monument at solar-powered listening stations around the square below, where they could plug in their headphones.

Listening as Monument

Naomi Waltham-Smith

Associate professor, Centre for Interdisciplinary Methodologies, University of Warwick, United Kingdom

At first blush, it is hard to conceive of sound as a monument. Monuments typically have mass, weight, and bulk. They are hewn from dense materials and held down by stabilizing pedestals (of the kind replicated in Sharon Hayes's sculpture *If They Should Ask*)—all the better to commemorate the burdens of history and the enormity of human achievements. Sound, by contrast, is inherently flighty. It slips and skips from place to place. It disperses through space and then evaporates into thin air. If monuments are designed to preserve the past and endure into the future, sound is an antimonument that flaunts its own ephemerality. Anxious about its finitude, sound has also sought out means to perpetuate and immortalize itself—in the notation of the score, in grooves on vinyl, in the bodies of performers, and in the earworms that go round and round in our heads. Of course, music has frequently served as an instrument in the work of mourning and remembering, but if sound can be a container for our memories, it is

perhaps even more true to say that we are the monuments that preserve sound's memory.

The epic poem by the spoken-word recording artist Ursula Rucker—that itself forms something of a monument at the heart of the sound installation *Logan Squared: Ode to Philly*—grapples with this paradox. Rucker's poem unfolds by interrogating the dialectic between the standing still of the monument and the movement of the city that announces itself in the opening lines:

> Momentum. Monument.
> Monument. Momentum.
> Movement. Staying.
> Can a city move and stand still at the same time? Yes.
> If it's magic.

Sound thus reveals itself as the mediation of momentum and monument. *Logan Squared* offers the voices of city-dwellers as monuments to the city's history. The inhabitants of Philadelphia, Rucker's poem tells us, are their own monuments.

In a particularly fascinating verse drawn from the Monument Lab open dataset, Rucker conjures up a vivid image of the listening statue: "On front stoops on blocks, we look like statues sometimes . . . 'cause that's where we stay, sit, see everything, hear everything." What is especially intriguing about this image is that it presents the idea of a monument that listens, suggesting that what is memorializing in the sonorous is less the voices as such than the act of listening itself. The ear monumentalizes by making the history of urban life stand still. Nineteenth-century German thinkers often described architecture as "frozen music," but here it is sound that freezes the city.[1] The sonorous—that which is always moving and fleeing—stills the rush of urban life once it takes up residence in our ears.

These notions of listening-as-monument resonate with Emeka Ogboh's other work as a sound artist. In his audio installations, Ogboh is interested in "how private, public, collective memories . . . are translated, transformed and encoded into sound."[2] Ogboh is known above all for his engagement with the soundscapes of Lagos and in particular for the use of raw, unmodified field recordings of urban life. To those in the global North accustomed to comparatively quiet urban environments, Ogboh's recordings can be shockingly noisy. Thinking of Rucker's monument-momentum dialectic, what is striking in listening to these works is their embrace of movement: the rush of vehicles, the frantic honking, the sounds of people hurrying around. Even in his more recent forays into visual work, Ogboh prefers to eschew the static quality of snapshot representations, creating experimental videos that he describes as "time-based paintings." They are conceived of as visual counterparts to the ways in which his soundscapes of Lagos capture the intensity of

urban speed and bustle. Most of Ogboh's sound works, though, are designed to be listened to with headphones or in confined gallery spaces. In other words, we are asked to slow down time and stay still to listen to the hubbub.

Logan Squared was broadcast through a series of solar-powered listening stations in Logan Square where passers-by could plug in headphones. A multichannel installation was also sounded in regular "performances" on the Skyline Terrace of the Parkway Central Library above the square. In different ways, both settings asked listeners to stop still to take in the sound and, on the roof, to view the city from a distance or, if one faced the speakers, to turn one's back on it entirely. The sonic materials of *Logan Squared* also contrast sharply with Ogboh's urban field recordings. Rucker's performance—part spoken and part sung—is underpinned by a choral arrangement of Louis Gesensway's "Logan Square at Dusk" from the set *Four Squares of Philadelphia* composed in 1955 for narrator and orchestra. The choice of human voice over instruments or environmental sound gives the installation a very different character from much of Ogboh's other work and easily reads as commemorative. Not only does the Latin text of the choral setting lend the work an archaic character; the use of voices and of an existing composition adds a layer of mediation absent in Ogboh's field recordings.

The representation of urban life in *Logan Squared*, recounted in the anecdotes about Philadelphia, is already a narrative. It is already heard in the past tense, at one remove. Both Rucker's poem and the musical content of this installation are less explicitly political than the artists' other work, which has directly confronted issues of immigration, precarity, and racial and sexual violence. The effect is a tone at once more hopeful and more resigned. The narrative disposition of the work thereby says something about the temporality of monumentality and the character of its sociopolitical engagement, locating its conserving and preserving instincts elsewhere than the eventual now of activism.

In a way, this work reveals something about sonic representations of the city more broadly—that, in listening, urban commotion comes to a standstill. We might say that listening thereby monumentalizes the city. But monumentalizing need not be part of a hagiographic, congratulatory historiography. Monument and momentum—very nearly anagrams for one another—can in their dialectic become critical, can interrupt and even disrupt history. Moments can be, in Rucker's words, "momentous"; the city can "change in an instant . . . in an eye blink." We might say, recalling Walter Benjamin's notion of "dialectics at a standstill," that, in listening, something of the past flashes up and finds a certain echo in the present, shaking history's narrative.[3]

Notes
1. Arthur Schopenhauer (*Die Welt als Wille und Vorstellung*, vol. 2, ed. Arthur Hübscher [Zurich: Diogenes Verlag, 1977], 534), among others, traces this much-cited aphorism to Johann Wolfgang von Goethe (Johann Peter Eckermann, *Gespräche mit Goethe in den letzten Jahren seines Lebens*, ed. Gustav Moldenhauer [Leipzig, Germany: Philipp Reclam, 1884], 88).
2. Emeka Ogboh, artist's website, http://www.14thmay.com/about/ (accessed January 20, 2018).
3. See Walter Benjamin, "On the Concept of History" and "Paralipomena to 'On the Concept of History,'" in *Selected Writings: Volume 4, 1938–1940*, ed. Howard Eiland and Michael W. Jennings, trans. Edmund Jephcott et al. (Cambridge, MA: Belknap/Harvard University Press, 2033), 389–411.

Epic Poem
Ursula Rucker

Born 1967 · American · Based in Philadelphia, Pennsylvania
Composed as part of Emeka Ogboh's *Logan Squared: Ode to Philly*

Momentum. Monument. Monument. Momentum. Movement. Staying. Can a city move and stand still at the same time? Yes.

If it's magic.

Ode to Philly

Like a bell named Liberty, let freedom ring. Even though cracked, she still manages to sing. Her sound resonates, both far and wide. Demonstrates how to be broken, but still have pride.

Wedding pics on Broad, while Billy watches over. Head nods mean hello, misunderstood as cold shoulders.

Don't ever make assumptions before you get to know us. Cause this city sparkles bright, even in the darkest shadows.

Like a bell named Liberty, let freedom ring. Even though cracked, she still manages to sing. Her sound resonates, both far and wide. Demonstrates how to be broken, but still have pride.

The Declaration of Independence was signed here, plus Cornbread was Here . . . so we major First zoo, first capital, first public library, first black church . . . we on that first type behavior. The architecture, the murals, the music, the water ice . . . we got all the best flavors.

Proud to be from Philly, it's like second nature.

For our teams, our specialties, our royalty, our family . . . for our city . . . we go hard. These histories and legacies here . . . run so deep . . . reach so far.

Influence the nation with the songs and stories of our people . . . we unequaled. We stand apart . . . from four corners and creeks and rivers . . . to structures and culture . . . we original, no sequel.

From history to revelry and back up around the way.

We love us. We love us.

We are unique. We love water ice. "what's water ice?" "it's a Philly thing, you wouldn't understand." We also love soft pretzels. Sometimes we get em

toasted wit cheese on em. Oh we love cheesesteaks too. And hoagies. "what's a hoagie?" "well, it's kinda like a . . . never mind . . . it's a Philly thing, you wouldn't understand." We're different. I love us.

We live in the place that's boasted having been both the capital of the United States as well as the city with the highest murder rate. I mean that's interesting right? We're interesting.

We drink and brush our teeth with Schuylkill punch and live to tell about it.

We walk on ground of mamma pacha, founding fathers, First Nations, abolitionists and Underground Railroads. Amidst old oaks, freedom, ancient energy, enslavement and escape routes. We are so very interesting.

And we are tough. We just are. Sometimes too much. We should show our soft spots more. But . . . only when the city lets us. Our armor is to guard those soft spots. It's a Philly thing . . . you know the rest . . .

Bumps, bruises, bright spots . . . and all.

I love us.

Momentum. Monument. Monument. Momentum. Movement. Staying. Can a city move and stand still at the same time? Yes.

If it's magic. Magic cities deserve monuments. Moving. Musical. Mesmerizing.

Momentous. Monuments.

When a city is magic . . . it can hustle and bustle and be all abuzz . . . while simultaneously being stilled and stunned by burnished golds and dusky pinks of sunsets at rush hour. It's a brilliant thing to witness. It's magical.

It's monumental. Big, small cities are something special.

Those that master this dichotomy . . . balance millions . . . with many . . . but make them look singular. The nooks. The neighborhoods. The nature. Special. Magical. Momentous. Monumental. Worth a monument, I think.

Momentum. Monument. Monument. Momentum. Movement. Staying. Can a city move and stand still at the same time? Yes.

If it's magic.

Haiku for PHILLY

Independence and
abandoned buildings make odd,
undying allies.

Our language is our own. It's filled with "yo's" and "jawns" and symphonies and sirens and the songs of winged things and Philadelphia International strings.

On front stoops on blocks, we look like statues sometimes . . . cause that's where we stay, sit, see everything, hear everything, be everything . . . Philly. Hmm . . . we are our own monuments. Yeah. We are our own monuments.

I wish everyone in the city felt important and exceptional enough to be their own monument. After all . . . it's the people of this place that give it its true character, its heartbeat, its history . . . its now and future. The people.

North. West. South. East. And all parts in between. The people. The neighborhoods and "sections" . . . that change in an instant . . . from block to block . . . in an eye blink . . . these neighborhoods would be nothing . . . without the people here. The soul and spirit of the people here. Not perfect. Nothing ever is. But in a way . . . perfectly imperfect. Or imperfectly perfect. Like home.

The house is just a house without the people in it.

We . . . the people. We make this place pop. We make it exciting . . . invigorating . . . ALIVE. I mean real Philly folks.

You might have to work a little harder for a hello . . . but when you get it?! Oh when you get it?! It's real! It holds weight! It feels real. Like you can touch it. Hold it in your hands. Put it in your back pocket. Pull it out whenever you need it. Whenever you need to feel . . . like you're home.

This city makes you. It creates you. It drives you. It teaches you . . . the best, most valuable lessons. And you can take those lessons anywhere . . . and apply them. It gets all up into your bloodstream. You can't deny it. And Even if you want to leave . . . or if you actually leave. You're always proud to say . . . when people ask you . . . "Where you from?" Philly baby. I'm from Philly. And that makes me . . . my own monument.[1]

Note
1. Printed with permission of Ursula Rucker.

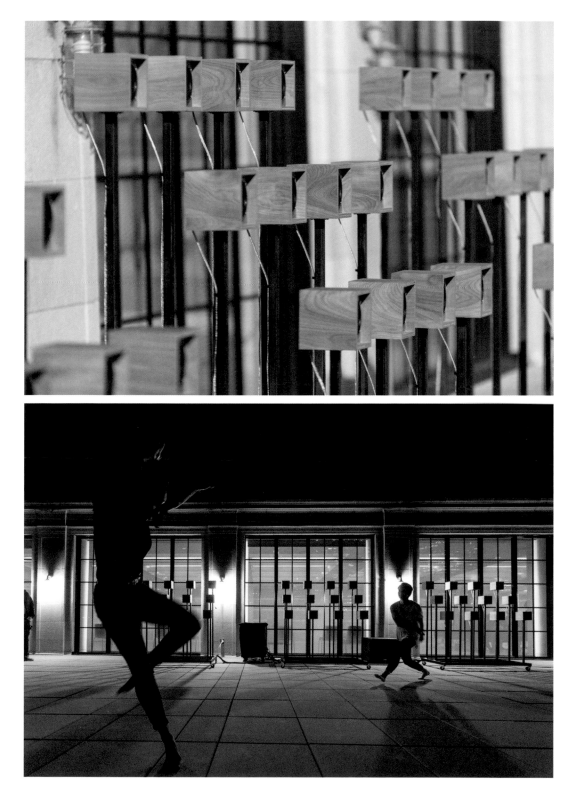

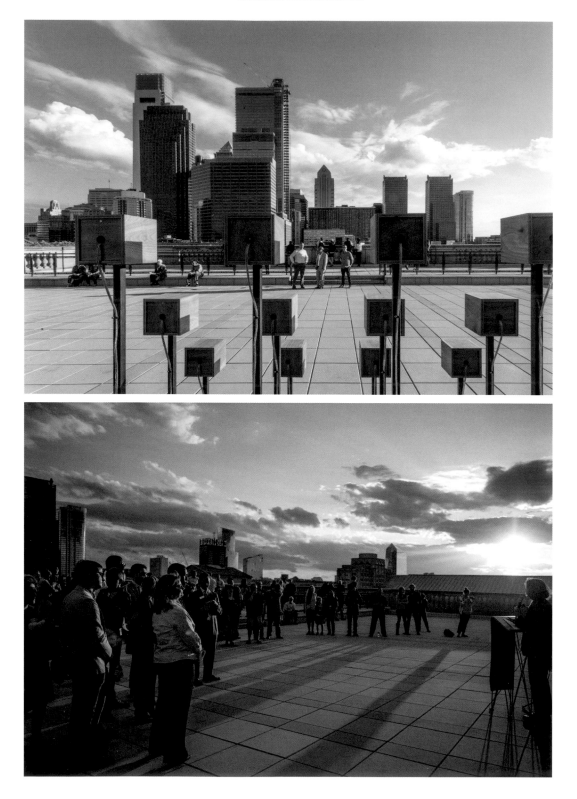

MONUMENT LAB

¿Cual es un monumento apropiado para la ciudad actual de Philadelphia?

NOMBRE DEL MONUMENTO:

LUGAR DE UBICACIÓN DEL MONUMENTO:
DIRECCIÓN, INTERSECCIÓN, O VECINDARIO

William Cram School

DESCRIPCIÓN Y/O DIBUJO EN ESTE ESPACIO:

Una Ciudad limpia No Es
La que se Barre sino La que
No se ensucia.

BXLDM

ÁREA POSTAL:	EDAD:	NOMBRE, ®, Y/O HASHTAG:	NÚMERO DE IDENTIFICACIÓN:
19140	41	LLDM Jose Villalobos	PT179

Mural Arts Philadelphia

#monumentlab
monumentlab.muralarts.org

MONUMENT LAB

What is an appropriate monument for the current city of Philadelphia?

NAME YOUR MONUMENT: MODERN Women Suffragates

PLACE YOUR MONUMENT:
ADDRESS, INTERSECTION, OR NEIGHBORHOOD Love park

DESCRIBE AND/OR SKETCH IN THIS SPACE:

Powerful women of all ages
who represent women here + now —
famous, and every day women.
Our Daughters;
Liz, Kali + Nicole
♡ Keep The fight up!"

YOUR ZIP CODE:	YOUR AGE:	YOUR NAME, ®, AND/OR HASHTAG:	RESEARCH ID:
19123	57	maysisdots@msn.com	PT26

Mural Arts Philadelphia

#monumentlab
monumentlab.muralarts.org

MONUMENT LAB

What is an appropriate monument for the current city of Philadelphia?

NAME YOUR MONUMENT:

FACING PREJUDICE

PLACE YOUR MONUMENT:
ADDRESS, INTERSECTION, OR NEIGHBORHOOD

THOMAS PAINE PLAZA

DESCRIBE AND/OR SKETCH IN THIS SPACE:

A MAZE WITH OPAQUE WALLS AND PHOTOGRAPHS OF RANDOM PHILADELPHIANS EACH NEXT TO A MIRROR. YOU LOOK AT THE PHOTOGRAPH, WHICH IS JUST A FACE, AND THEN MAKE A JUDGMENT ABOUT THEM BASED ON WHAT YOU SEE. BENEATH THE MIRROR IS A PANEL WHICH YOU OPEN AFTER CONTEMPLATING THE FACE. THE PANEL CONTAINS A BIOGRAPHICAL NARRATIVE ABOUT THE PERSON. THE EXERCISE, IF PROPERLY EXECUTED, SHOULD PROVIDE FOR SELF-REFLECTION ABOUT JUDGMENTS YOU MAKE ABOUT OTHER PEOPLE BASED SOLELY ON APPEARANCES

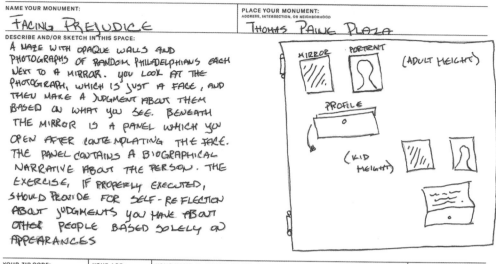

YOUR ZIP CODE: 19147

YOUR AGE: 41

YOUR NAME, @, AND/OR HASHTAG: JENNIFER QUINN

RESEARCH ID: PT 402

Mural Arts Philadelphia

#monumentlab
monumentlab.muralarts.org

MONUMENT LAB

What is an appropriate monument for the current city of Philadelphia?

NAME YOUR MONUMENT:

Built to Last/Reckoning

PLACE YOUR MONUMENT:
ADDRESS, INTERSECTION, OR NEIGHBORHOOD

In the water between Penn Treaty Park + Sugarhouse

DESCRIBE AND/OR SKETCH IN THIS SPACE:

A statue of the word "Liberty" that has been chipped away at to the point where it is barely able to be understood/read. At the bottom of the statue, people of various demographics appear to be planning to repair it.

YOUR ZIP CODE: 19130

YOUR AGE: 34

YOUR NAME, @, AND/OR HASHTAG: Dan

RESEARCH ID: PT403

Mural Arts Philadelphia

#monumentlab
monumentlab.muralarts.org

Karyn Olivier

Born 1968 · Trinidadian and American · Based in Philadelphia, Pennsylvania

The Battle Is Joined

Vernon Park · Acrylic mirror, wood, screws, and adhesive

Karyn Olivier's *The Battle Is Joined* was a response to the *Battle of Germantown Memorial*, a twenty-foot-high monument built in Vernon Park in 1903 and dedicated to a Revolutionary War skirmish between American and British troops in a former colonial settlement. Today, Germantown is a predominantly African American working-class neighborhood in the city. Olivier built out an acrylic mirror encasement that covered the monument as a way to bring people closer to one another, to their surroundings, and to their living histories.

Olivier explains: "My reinterpretation of the *Battle of Germantown Memorial* will ask the monument to serve as a conductor of sorts. It will transport, transmit, express, and literally reflect the landscape, people, and activities that surround it. We will be reminded that this memorial can be an instrument and we, too, are instruments—the keepers and protectors of the monument, and in that role, sometimes we become the very monument itself."

The Battle Is Joined also referenced another monument in Vernon Park, designed by Albert Jaegers and dedicated to Francis Daniel Pastorius, a German settler who led a Quaker protest against slavery in 1688. The construction of Jaegers's monument to Pastorius began in 1908, but during World War I, one of its sponsors, the U.S. War Department, boxed over the structure. During World War II, the statue was again boxed and removed from public view. Olivier's enclosure extended this history, engaging the site of the park as a space to question inherited symbols from the past and envision new modes of interpretation.

The Artist Installed a Mirror over the Monument in Germantown

Trapeta B. Mayson

Poet

When you arrived in Germantown, you were immediately confronted with the past and the present occupying the same space. It was daunting, the awesomeness of this gritty and green urban community. Maybe it was because of this juxtaposition that inhabitants had tended to walk by a major monument in a neighborhood park for years without noticing—until one day the monument wasn't there anymore and instead was covered by a twenty-foot-tall mirror that encased the sculpture. And it wasn't just any mirror but one that reflected the viewer, giving her back her quizzical brows and him his perplexed wonderment. I think that it is precisely these moments Karyn

Olivier aimed to capture, the moments when a community gets to reckon with what something used to be, how it came to be, and what it could be.

> *The artist installed a mirror over the*
> *monument and the people have come to gawk.*
> *Rubberneckers wonder what was there before.*[1]

It is refreshing when an artist understands that history is alive and embedded in the bones and fiber of the community. What is even more impressive is when the artist presents a way to push history forward, to make history relevant by bolstering what we've come to know and allowing us to reimagine and reframe. What was a memorial commemorating the 1777 Battle of Germantown (which was installed in 1903) is now reflecting an image of somebody's grandmother adjusting her hat as she strolls by or schoolchildren cackling and taking selfies in the glass or even a young man on his way to work pausing to be reflected in his community narrative.

> *You have come too, laying in the cut;*
> *statue still for seconds, your reflection edging off*
> *a 20 foot high bronze looking glass.*
> *You are an alluring hunk of stone—beguiling me;*
> *yes you, brown boy*
> *rough cut, monolith.*
> *I see you.*
> *You are a low slung jean wearing,*
> *grandmother greeting pillar,*
> *an obelisk, marking the entrance of your hood.*
> *You need to be somebody's memorial —*

I first encountered Olivier's mirrored remix of the *Battle of Germantown Memorial* when I received a call about it. A somewhat upset community member wanted to know, "What happened to that statue that was there, who covered it up and why?" This person didn't really know what the *Battle Is Joined* prototype monument symbolized or the artist who created it or even why it was in the park. She just knew that the *Battle of Germantown Memorial* had been there "forever" and that it belonged there. And because it wasn't there anymore, she was forced to "see" herself as we were all forced to see ourselves and each other. If we are able to see ourselves as stewards of Germantown's past and creators of its present and future, we are also able to ask hard questions, such as: Where are the memorials to the people and places that are also significant? This includes people often not represented in the monuments to colonial figures or historic episodes—especially those that represent intersectional, diverse backgrounds and those whose impact is more recent than that conjured foundational past. We would then need to assign new names, narratives, and monuments. There is a power that comes with being the narrator of your own story; this is what the installation invited us to do.

*you are now and present, alive and in color
and you need to be somebody's walking shrine,
somebody's testament, somebody's tribute in this city.*

When I describe Germantown to strangers, I mention its remarkable history and architecture, but I also laud its community culture of resilience and reinvention. Germantown is markedly different today than it was in the colonial times that most of our historic sites interpret. We do a really good job of bringing forth the past and a sometimes awkward job of wrestling with the present. The latter was evident when I opened Historic Germantown's door several years ago to four confused tourists who were "looking for a German neighborhood, German people and German food." They had heard someone say "historic Germantown" and ventured out to see a German community. Talk about wrestling with the present! I was tasked with explaining the evolution of the neighborhood, the significance of the past, and the nuances of the present. This is a different Germantown, I told them. While they didn't meet a neighborhood of Germans, they encountered a vibrant place with a broader story and they wanted to learn more.

Much like my experience with the tourists, Olivier's *The Battle Is Joined* in Vernon Park also opened a door. The community member's distressed push back opened a door, too—she has a right to question what happens in her community. This is what art does and what the artist did so expertly; she placed a huge mirror over our assumptions and invited us to look inward, to dialogue and to truly see ourselves in this neighborhood called Germantown.

*Look how you beaming off that seeing glass.
I'm catching your shine.*

Note
1. This essay includes elements from Trapeta B. Mayson's poem inspired by *The Battle Is Joined,* which she read at the Monument Lab event "Monument to the Philly Poet."

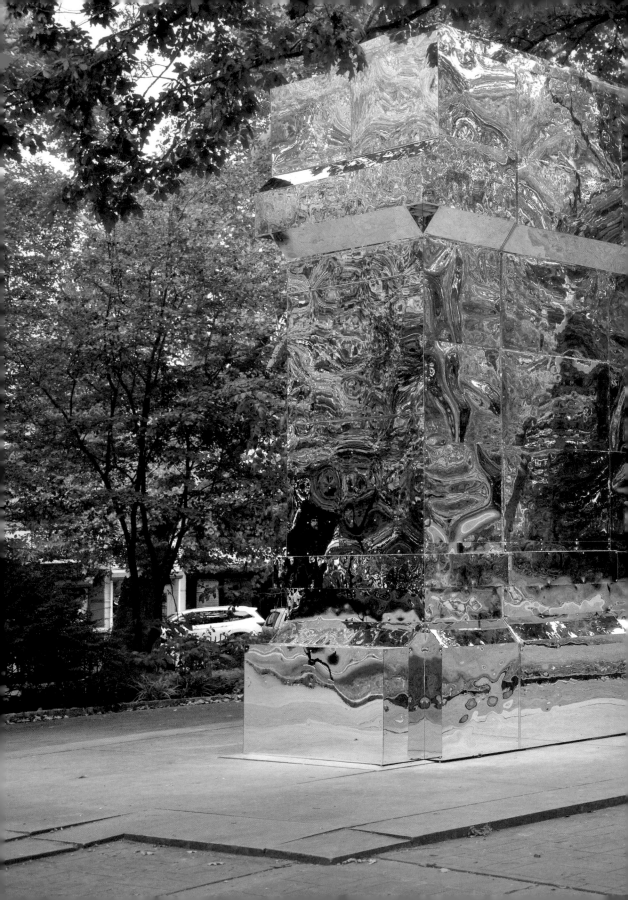

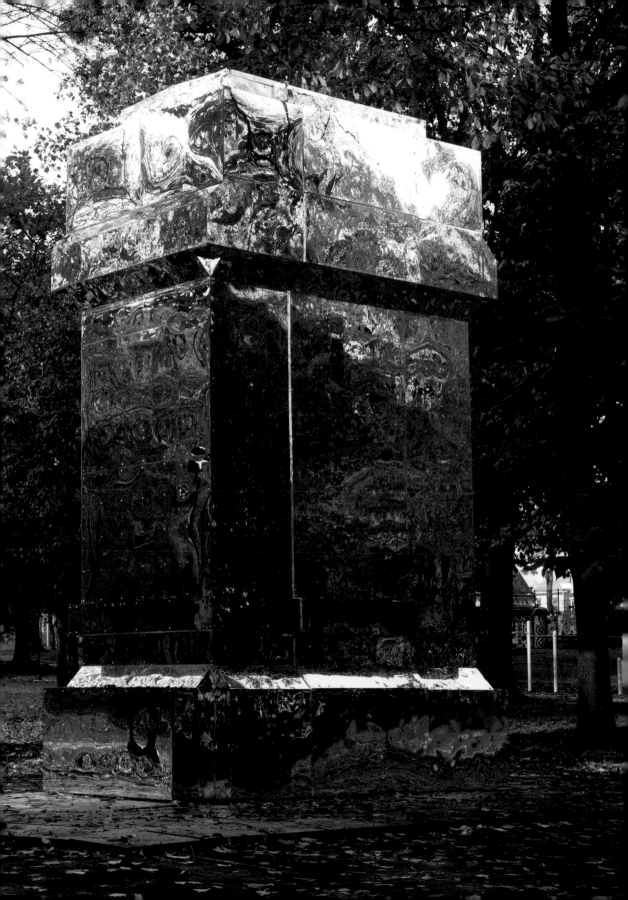

MONUMENT LAB

What is an appropriate monument for the current city of Philadelphia?

NAME YOUR MONUMENT:
MOTHER NATURE

PLACE YOUR MONUMENT:
ADDRESS, INTERSECTION, OR NEIGHBORHOOD
PENN TREATY PARK

DESCRIBE AND/OR SKETCH IN THIS SPACE:

I'm 65 years old. I have lived and still do live along the Delaware River for all of those years. I could have actually walked to the river but drove past it on Delaware/Columbus Avenues and crossed it for pretty much 4 decades over the Walt, Ben, and Betsey predominantly going to work in NJ but also on Sundays going to my 4 favorite farmers for veggies when they were open for the season.

I'm very, very, very newly retired. I have newly discovered both the Delaware in a very different sense and rediscovered the Center City where I went to High School, University City where I went to College and to some Post-Grad and North Philly where I did some Post-Grad.

Among the asphalt, concrete, high rise towers, busses, etc., and the hordes of people, I would nominate something that can reconnect us to nature. The river itself has a nature that's there but that we may not see. The river can be placid and silken, it can look like there are diamonds on the water, it can seem to flow North or South depending on the winds, sometimes there are whitecaps. Sometimes the color changes right before your eyes depending on depth. It all depends on what Mother Nature decides.

But Mother Nature also sends ducks, geese, sparrows, wrens, pigeons, crows, seagulls, an occasional hawk, and squirrels (who may be demanding). But isn't that's what we're here for. To not forget the connection.

YOUR ZIP CODE: **19134**

YOUR AGE: **65**

YOUR NAME, @, AND/OR HASHTAG: **JANICE CIESIELSKI**

RESEARCH ID: **PT 428**

Mural Arts Philadelphia

#monumentlab
monumentlab.muralarts.org

MONUMENT LAB

What is an appropriate monument for the current city of Philadelphia?

NAME YOUR MONUMENT:
BIKE - ~~SKATEPARK~~

PLACE YOUR MONUMENT:
ADDRESS, INTERSECTION, OR NEIGHBORHOOD
GRAFFiTi PiER

DESCRIBE AND/OR SKETCH IN THIS SPACE:

EXTending GRAFFITI Pier

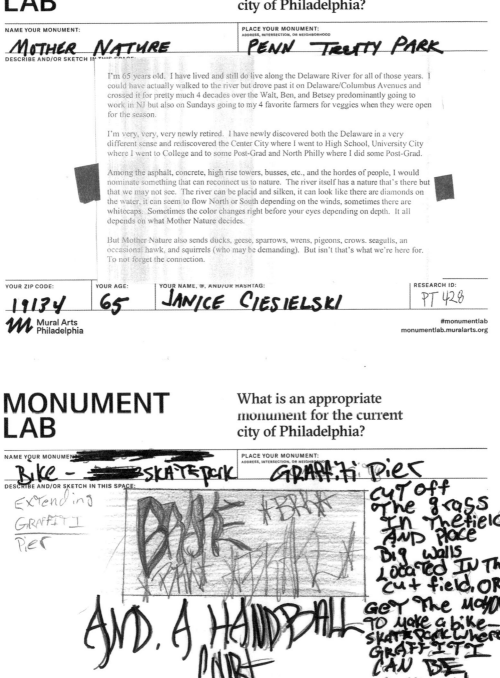

AND, A HANDBALL COURT

CUT off The grass IN The field AND place Big walls Located IN The cut field. OR GET The mayor To make a bike- SkatePark where GRAFFITI CAN BE DONE!!!

YOUR ZIP CODE:

YOUR AGE: **17**

YOUR NAME, @, AND/OR HASHTAG: **MARK LOPEZ**

RESEARCH ID: **PT33(**

Mural Arts Philadelphia

#monumentlab
monumentlab.muralarts.org

MONUMENT LAB

What is an appropriate monument for the current city of Philadelphia?

NAME YOUR MONUMENT:
Original River

DESCRIBE AND/OR SKETCH IN THIS SPACE:

PLACE YOUR MONUMENT:
ADDRESS, INTERSECTION, OR NEIGHBORHOOD
Penn Treaty Park

Explore the relationship between the Lenape, or other native people, to the River. Transportation ⬭ or food 🐟 or recreation °°°° or spirituality ✸ or anything else.

YOUR ZIP CODE: 19125

YOUR AGE:

YOUR NAME, @, AND/OR HASHTAG:

RESEARCH ID: PT 44A

Mural Arts Philadelphia

#monumentlab
monumentlab.muralarts.org

MONUMENT LAB

Name of monument ↑

What is the most appropriate monument ↑ for the city of Philadelphia today?

¿Cual es un monumento apropiado para la ciudad actual de Philadelphia? ↗ Place your monument

NOMBRE DEL MONUMENTO:
MONUMENT TO THE AFRICAN-AMERICANS MURDERED BY A WHITE MOB ON LOMBARD ST. IN AUGUST, 1842

LUGAR DE UBICACIÓN DEL MONUMENTO:
DIRECCIÓN, INTERSECCIÓN, O VECINDARIO
PENN TREATY PARK OR CITY HALL PLAZA

DESCRIPCIÓN Y/O DIBUJO EN ESTE ESPACIO:

STONE CIRCLE (PERHAPS A MINIATURE STONEHENGE)

Zip Code ↑ Age ↑ Name, Username (hashtag) ↑

ÁREA POSTAL: 19147

EDAD:

NOMBRE, @, Y/O HASHTAG:
M. RICHARD NALBANDIAN
nalbandianmr@comcast.net

PT317

Mural Arts Philadelphia

#monumentlab
monumentlab.muralarts.org

Michelle Angela Ortiz

Born 1978 · American/Latina · Based in Philadelphia, Pennsylvania

Seguimos Caminando (We Keep Walking)

City Hall · Animation and projection

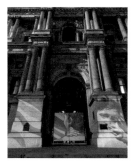

Michelle Angela Ortiz engages the experiences of immigrants in Philadelphia, especially through family stories and intergenerational histories. *Seguimos Caminando (We Keep Walking)* offered what she terms a "moving monument" to mothers unjustly detained at the Berks County Residential Center, a prison outside Philadelphia for undocumented immigrant families. Ortiz reimagined City Hall's north gates and facade as a space to project these women's narratives, rendering them through animated images based on writings by and interviews with two mothers who told their stories while they were detained. The projections were shown on Wednesday and Friday evenings during the run of the exhibition, with accompanying narration broadcast through speakers on the City Hall apron. On a building decorated with hundreds of sculptures marking the city's historic and mythic past, from Indigenous figures to European colonists, Ortiz's monumental projection highlighted the story of mothers who arrived in Philadelphia for a contemporary moment.

Ortiz's work addressed aggressive immigration policy and efforts to affirm Philadelphia's status as a sanctuary city. The artist produced *Seguimos Caminando* with the Shut Down Berks Coalition and the mothers detained at the center. Together, they organized a creative action, titled *Flores de Libertad (Flowers of Freedom),* that involved making hundreds of paper flowers in open workshops, in classrooms, and at the detention center. The flowers, which included messages from and to the mothers, were assembled at City Hall to spell out the word *LIBERTAD* and draw attention to the movement to shut down the center.

Moving Monuments to Undocumented Migration

Jennifer Harford Vargas

Associate professor of English, Bryn Mawr College

A multimedia installation projected onto the facade of City Hall, *Seguimos Caminando* was what Michelle Angela Ortiz evocatively characterizes as a "moving monument." This designation captures how it functioned as an aesthetically and affectively impactful public testament to the resilience of undocumented migrants who are forced to flee their home countries and who are detained in the United States awaiting deportation proceedings. *Seguimos Caminando* was moving in various connotations of the term. It was a moving or animated image that used boldly colored imagery to depict a mother and

her two-year-old son's movement or journey through Central America to the United States and their subsequent detention. It was designed to raise public consciousness about family incarceration in the Berks County Residential Center, one of three family detention centers in the United States, and to move or emotionally inspire them to be in solidarity with the political movement for migrants' rights. Providing a formal contrast to the inert statues that adorn City Hall, as well as the stasis of incarceration, the monument demanded that the passerby stop moving and experience the installation.

Migrants' aspirations of being able to move freely unfolded visually across the four columns and the gates of City Hall. The central focal point was the gates, whose spiral design was superimposed over the images of the mother and son when they were captured by immigration authorities. The effect was eerie because the aesthetically pleasing spiral designs visually converted City Hall into the prison where the family was detained. At the end of the video, the bars on the gate turned into lush vines as the mother imagined escaping the detention cell with her son. Afterward, the vine-like design dissolved into the outline of the spirally adorned gates once again, visually capturing how *Seguimos Caminando* was a monument both to dreams of liberation and to the fact that the doors to liberty are closed to the families incarcerated at Berks while the government acts as a gatekeeper for the so-called American Dream.

The accompanying voice-over, narrated by one of the mothers at Berks and transmitted across the speakers, took the form of a prose poem. Realist events were fused with more lyrical descriptions and richly saturated mythic imagery. The narration recounted one family's experience, but as a *testimonio,* it stood in for a collective experience of poverty, violence, displacement, and incarceration. *Seguimos Caminando* turned the building into a palimpsest of memories, histories, experiences, national geographies, and institutional spaces. It visually and sonically overlaid onto City Hall the trauma of migration and detention as well as the resilience that is necessary to survive and to continue to dream of liberation.

Seguimos Caminando was an aesthetic and imaginative intervention that projected gorgeous images and an arresting story onto a public space, providing a powerful alternative vision of undocumented migration that stood in stark contrast to the threat narrative usually projected into the public sphere by anti-immigrant groups and politicians.[1] As a creative past- and future-oriented speculative act, the monument asserted that undocumented migrants are subjects worthy of publicly remembering and honoring. Deliberately titled in the "we" pronoun, *Seguimos Caminando* referred to the families caught in the crimmigration apparatus, and it also invoked us as viewers to keep journeying toward a more just world that we must forge together.[2]

Ortiz used the same spot at City Hall to stage *Flores de Libertad,* which brought art and political intervention together in a more expansively collabo-

rative and more explicitly activist way through what Ortiz aptly calls a "creative action." The audio narrative of *Seguimos Caminando* ended with the mother imagining that she turned into a star shining in the dark as she walked with her son toward "*la libertad*." Ortiz monumentalized this final word in a ten-by-fourteen-foot sign made of sixteen hundred paper flowers that spelled out *LIBERTAD* in bright shades of pink. The flowers were hand-made by mothers detained at Berks, by Philadelphia-area volunteers, and by Ortiz's own mother. Ortiz and several helpers ran workshops on making paper flowers that also disseminated information about Berks, providing those of us who attended an opportunity to connect with others in the immigrant rights movement and to exchange professional resources and personal stories. This aesthetic education taught an artistic skill, created an aesthetic product, modeled a process of engagement, and constituted a political act.

The individual flowers collectively became both the medium and the message. Around the flowers' edges, we wrote messages of solidarity for the families detained at Berks and for undocumented migrants more generally, as well as messages criticizing the state's policing and incarceration of them. Ortiz later hand dyed all the flowers and placed the dozen flowers that the mothers made at the center. Our flowers and words echoed outward from theirs, supporting their struggle and amplifying their resistance. In collaboration with the Shut Down Berks Coalition, Ortiz placed the floral sign outside the gates of City Hall as part of a rally demanding the closure of Berks on a day when Pennsylvania governor Tom Wolf had meetings at City Hall.

Ortiz chose *libertad* because the mothers she interviewed at Berks used this word to characterize their aspirations. *Libertad*, which translates as "freedom" or "liberty," taps into the discourse that celebrates Philadelphia's central place in U.S. revolutionary history, demands that the city continue to labor to be a sanctuary city for undocumented migrants, and links the movement to shut down Berks alongside other decolonial struggles in the Americas (and more globally). When viewed from an aerial perspective, "*LIBERTAD*" boldly asserted its message in all capital letters, making this Spanish-language declaration hyper visible in the public sphere. The floral sign did a different kind of cultural work and produced a different kind of material presence than the animated film. Yet, *Flores de Libertad* also functioned as a moving monument that affectively, aesthetically, and politically educated people in an art practice and in a cruel incarceration practice and brought a community together to co-create the monument.

Flores de Libertad and *Seguimos Caminando* extended the intervention into the public space of City Hall that Ortiz began in her 2015 *Familias Separadas* project, which also creatively used the built environment to publicly document the lives of undocumented migrants. In *Familias Separadas,* Ortiz placed artwork in four key sites in Philadelphia—in front of the Immigration and Customs Enforcement building, in front of the "Love" sign, at a major intersection in 9th Street Market, and at City Hall—that monumentalized

Notes
1. For more on this anti-immigrant discourse, see Leo R. Chávez, *The Latino Threat: Constructing Immigrants, Citizens, and the Nation* (Stanford, CA: Stanford University Press, 2013), and Otto Santa Ana, *Brown Tide Rising: Metaphors of Latinos in Contemporary American Public Discourse* (Austin: University of Texas Press, 2002).
2. For more on the crimmigration system, see Amada Armenta, *Protect, Serve, and Deport: The Rise of Policing as Immigration Enforcement* (Oakland: University of California Press, 2017), and Tanya Maria Golash-Boza, *Deported: Immigrant Policing, Disposable Labor, and Global Capitalism* (New York: New York University Press, 2015).
3. For more on undocumented migration and cultural production, see Marta Caminero-Santangelo, *Latino/a Narratives and Social Justice in the Era of Operation Gatekeeper* (Gainesville: University of Florida Press, 2016), and Alicia Schmidt Camacho, *Migrant Imaginaries: Latino Cultural Politics in the U.S.-Mexico Borderlands* (New York: New York University Press, 2008).

how local families are affected by deportation. Ortiz later power-washed the artwork off the ground to call attention to the power imbalances inherent in the government's policy of removing migrants from the nation state. Erasing their images from public space, this action materially captured the precarious situation of undocumented migrants and symbolically reenacted how deportation disappears them from our communities and traumatizes families who are torn apart. The installation at City Hall, which was placed inside the compass at the center of the inner courtyard, featured a mother embraced by her daughter; thorny barbed wire, flowering branches, and words drawn from letters the deported father sent them encompassed the pair. By embedding the family's image within the directional instrument, Ortiz's artwork mapped out transnational affective connections. Both *Seguimos Caminando* and *Familias Separadas* incorporated the structure of City Hall into the artwork itself. The gates that were made to resemble prison bars helped bring the incarceration of undocumented migrant families into public view, while the compass helped orient viewers to the necessity for remapping national belonging so that families are not torn apart by detention and removal. Because of the ever-increasing demonization, policing, imprisonment, and deportation of undocumented migrants, we need more public artwork like Ortiz's that provides alternative narratives and imagery to visibly and audibly resist this criminalization.

Ortiz's creative projects were acts of cultural memory and monuments to the undocumented migrant imaginary.[3] Though temporary installations, they left a lasting presence in the memories of those who walk by City Hall and recall the beautiful artwork and paper flowers once so hauntingly visible there. *Seguimos Caminando* and *Flores de Libertad* stand as moving monuments to the liberation dreams of undocumented migrants who too often are stigmatized in or disappeared from the public sphere.

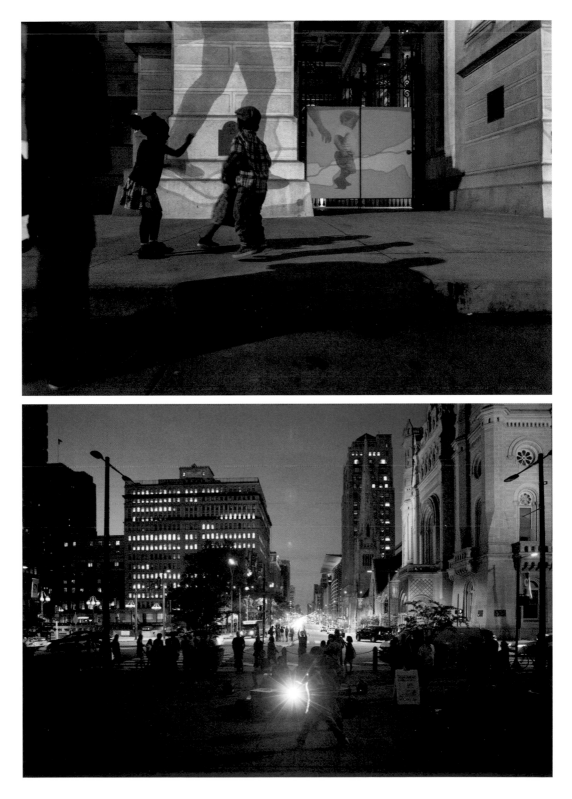

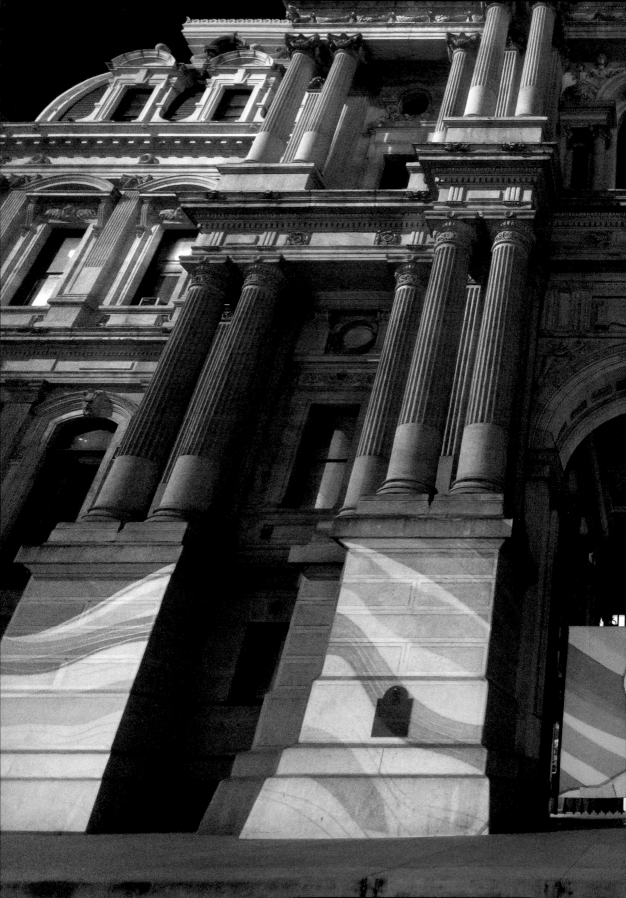

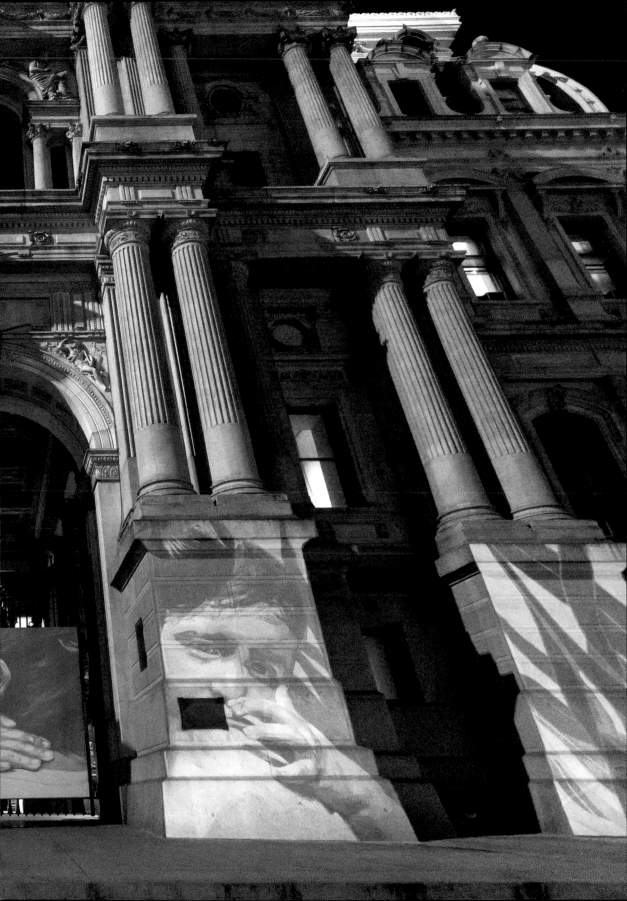

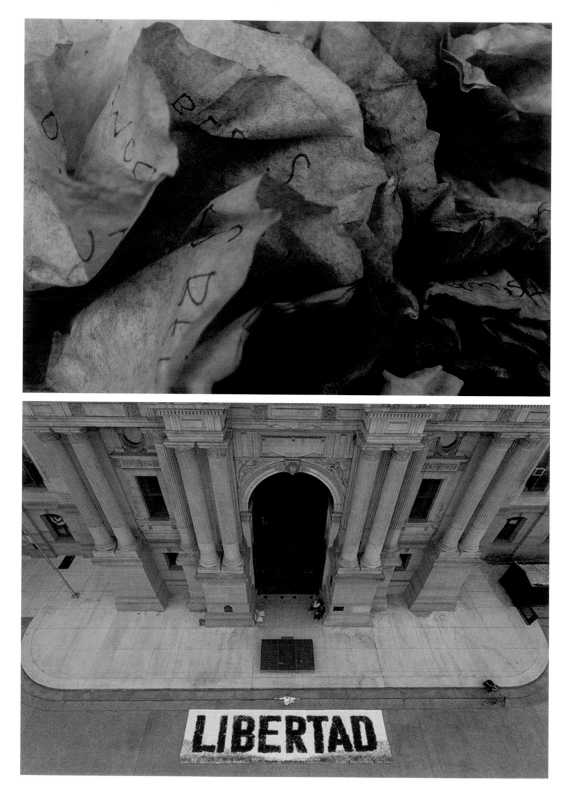

MONUMENT LAB

What is an appropriate monument for the current city of Philadelphia?

NAME YOUR MONUMENT:
House of Windows Pt. 2

PLACE YOUR MONUMENT:
ADDRESS, INTERSECTION, OR NEIGHBORHOOD
Somewhere where it can be seen by lots of people.

DESCRIBE AND/OR SKETCH IN THIS SPACE:

A monument of a giant house filled with windows. Each window being in different colors. Behind each window there will be telling a story.
For example one window demonstrating everyones stereotype on a certain person's race or family. And the other window what its actually like behind the window. Demonstrates stereotypes on ethnicitys and the way society thinks then what actually happens behind closed doors (windows). Everyone would be able to see whats happening behind the windows and realize the way society thinks.

YOUR ZIP CODE: 19149

YOUR AGE: 16

YOUR NAME, @, AND/OR HASHTAG: Nayeli Mejia

RESEARCH ID: PT 412

Mural Arts Philadelphia

#monumentlab
monumentlab.muralarts.org

MONUMENT LAB

¿Cual es un monumento apropiado para la ciudad actual de Philadelphia?

NOMBRE DEL MONUMENTO:
PLEASE MORE UPLIFTING MURALS IN N. PHILLY!

LUGAR DE UBICACIÓN DEL MONUMENTO:
DIRECCIÓN, INTERSECCIÓN, O VECINDARIO
FRANKLIN + DIAMOND

DESCRIPCIÓN Y/O DIBUJO EN ESTE ESPACIO:

Goal — I would like to see african American, Hispanic, Asian + European people depicted optimistically In murals in my. neighborhood. I Live at N. Franklin + Diamond we have murals in North Phila that have people who appear sad, stressed, + unhappy.
I Look forward to happier people In Phila murals. Thank you.

ÁREA POSTAL: 19122

EDAD:

NOMBRE, @, Y/O HASHTAG: KAHREEM

NÚMERO DE IDENTIFICACIÓN: PT 429

Mural Arts Philadelphia

#monumentlab
monumentlab.muralarts.org

MONUMENT LAB

What is an appropriate monument for the current city of Philadelphia?

NAME YOUR MONUMENT: "INSECURE Housing IN Phila"

PLACE YOUR MONUMENT: ADDRESS, INTERSECTION, OR NEIGHBORHOOD: Port Richmond

DESCRIBE AND/OR SKETCH IN THIS SPACE:

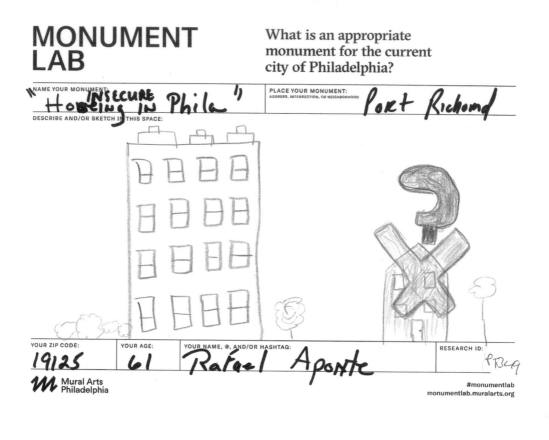

YOUR ZIP CODE: 19125

YOUR AGE: 61

YOUR NAME, ®, AND/OR HASHTAG: Rafael Aponte

RESEARCH ID: RB49

Mural Arts Philadelphia

#monumentlab
monumentlab.muralarts.org

MONUMENT LAB

What is an appropriate monument for the current city of Philadelphia?

NAME YOUR MONUMENT: Latino Monument.

PLACE YOUR MONUMENT: ADDRESS, INTERSECTION, OR NEIGHBORHOOD: 9th and Hunting Park

DESCRIBE AND/OR SKETCH IN THIS SPACE:

Sculpture celebrating latino culture, anything about spanish culture.

Not many monuments around that area about hispanic culture.

Huge spanish community, diversity needs to be celebrating more.

YOUR ZIP CODE:

YOUR AGE: 50

YOUR NAME, ®, AND/OR HASHTAG: Justina

RESEARCH ID: PT 61

Mural Arts Philadelphia

#monumentlab
monumentlab.muralarts.org

Kaitlin Pomerantz

Born 1986 · American · Based in Philadelphia, Pennsylvania

On the Threshold (Salvaged Stoops, Philadelphia)

Washington Square · Brick (from the first Women's Medical College, East Falls), concrete (from the former Rocket Cat Cafe building, Frankford Avenue, Kensington), and marble, blue stone, and brown stone from various demolished buildings throughout the city of Philadelphia (from the neighborhoods of West Philadelphia, Powelton, Tioga/Nicetown, Brewerytown/Sharswood, Kensington, South Philadelphia, and Southwest Philadelphia) supplemented with mortar, cinder block, and rebar

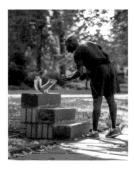

Kaitlin Pomerantz's *On the Threshold (Salvaged Stoops, Philadelphia)* was a monument to a beloved symbol of Philadelphia neighborhood culture: the stoop, or the step or steps, as it is known in South Philadelphia. The stoop, Pomerantz notes, is "a threshold between private and public space. . . . [It] functions as a site of social interaction, of relaxation, and of participation." Responding to extensive renovations and redevelopment that were taking place across the city, Pomerantz intercepted historic building materials from demolition sites that would otherwise have ended up in the waste stream. In the six months leading up to the exhibition, she collected marble, concrete, and brick. She then worked with members of the Bricklayers and Allied Craftworkers Local 1 PA-DE to reconstruct the materials using traditional masonry techniques and lined a pedestrian walkway on the east side of Washington Square. The park's history as a public gathering place and an unmarked cemetery had sparked the idea for the project, which stimulated conversation about architectural and individual memory.

Pomerantz adds, "As relics of bygone buildings, the stoops also invite viewers to contemplate the history of Washington Square as a site of lives lost and histories buried, as the park once functioned as a common burial ground—or potter's field—for many years before becoming a public park. These unmarked pieces of material history recall the unmarked lives and stories buried below the soil."

Sitting on History

Nathaniel Popkin

Cofounder, Hidden City Philadelphia

The low masonry structures lined the edge of the grass in Philadelphia's Washington Square, each slightly different from the other, as if headstones set into place at various times long ago. Smoothed by time, worn by wind and rain, cracked by expanding and contracting ice, the monuments begged inspection. You might run a hand along the cool stone and, just as in an old cemetery, commune with another world.

One of these ancient cemeteries is just a half a block away from Washington Square, pressed along the edge of the Holy Trinity Church; a block or so

farther on, the city's oldest Presbyterian church, Old Pine, is surrounded by disintegrating grave markers and headstones. With each passing year the names and dates that mark the lives of long-ago Philadelphians interred here become harder to interpret and yet their headstones, obelisks, and carvings whisper to us from another age.

Washington Square was redesigned a handful of times beginning in 1825 when city officials decided to rename "Southeast Square" in honor of the first president. In that moment, the park took on new meaning as a site of public memory. (The same instinct to memorialize George Washington and the Revolutionary generation resulted in the preservation of Independence Hall, which was otherwise likely to be torn down.) But memory is selective. The landscape designers who turned the square into a botanical garden paid no attention to its legendary past as "Congo Square," where free and enslaved African Americans gathered to play music and be at ease; nor did they nod to the Revolutionary soldiers taken by the British buried in the ground or the remains of poor white and black residents of the city, some the victims of the various disease epidemics of the early city, buried here starting in 1706 because it was a potter's field. Only in 1954, when civic leaders began to plan for a Washington memorial, did they decide to remember these ordinary people by disinterring a soldier and installing his remains in a crypt as the "unknown soldier." In front of the crypt they lit an eternal flame.

Then, in fall 2017, Kaitlin Pomerantz installed a new kind of stone memorial along the grass edge of the square's east walkway, some facing the Washington monument and the crypt: twelve row house stoops that she had removed while the houses and other buildings were torn down and then reassembled, for a couple of months replacing the usual park benches. The installation, Pomerantz says, calls out "a parallel between the demolished row houses inhabited by different lives that are erased as the park itself has erased its history."

Pomerantz, whose work in sculpture and other media often explores themes of vacancy and loss, conceived the project *On the Threshold (Salvaged Stoops, Philadelphia)* to draw attention to the personal and communal history that is lost when a building is demolished, particularly during this decade of rapid neighborhood redevelopment and gentrification. "The irony," she says, "is that the replacements tend not to have stoops." Not only is the material lost—Pomerantz believes Philadelphia should adopt salvage protocol to track and reuse the remaining architectural elements after demolition—but the loss of stoops devalues neighborhood life. People who sit on their stoops, she notes, recalling Jane Jacobs, serve as "eyes on the street."

The stoops—made of brick, sandstone, marble, and concrete—that Pomerantz reconstructed in Washington Square with the help of members of the Bricklayers and Allied Craftworkers union came from row houses and commercial buildings in Germantown, Kensington, South Philadelphia, East

Falls, and various places in North Philadelphia, including Brewerytown and Fairmount. The range carries its own civic meaning: most people in Philadelphia, rich and poor, live in a row house. *On the Threshold (Salvaged Stoops, Philadelphia)* reifies a Philadelphia way of life that is unifying and also particular. No other U.S. city quite repeats Philadelphia's form, architectural rhythm, or material palette.

Because a stoop is heavy and difficult to move, Pomerantz noticed, it is often the last vestige of a house to remain on a demolition site. In that sense, like a gravesite headstone, the stoop comes to represent the house itself and the people who occupied it, their footsteps, day after day, recorded in the worn stone. Like a headstone, which marks the passage from living to dead, the stoop becomes a threshold, moving the person between realms, from the public world of the street to the private and domestic. Even the steps seem to recall the traditional ladders Native people of the American Southwest keep outside their houses to represent the ascent to the spirit world.

Like the ladders, whose purpose is mostly symbolic and religious, the stoops transported to Washington Square seemed likely to carry mostly symbolic meaning. Pomerantz wasn't sure what purpose the stoops fully detached would serve. She wondered how the stoops would feel to the user of what she calls "the perfect park." Somber? Distasteful? Uncomfortable? Death and loss are unwelcome intruders and domestic materials rarely translate fluidly to public space. "You make a pedestal but don't know what will happen," Pomerantz notes.

But to her surprise, the stoops, which were expertly installed by union bricklayers, seemed immediately to merge with the landscape. Taken out of context, the lushly veined marble (originally mined from a now-extinct local quarry) and the fine sandstone spoke on their own terms, as expressive human materials. As pedestals, they seemed to beg for people, often in social groups, to occupy them. Perhaps in death, then, the stoops came to tell us why they matter, and we in the present, and future, would do well to listen.

MONUMENT LAB

What is an appropriate
monument for the current
city of Philadelphia?

NAME YOUR MONUMENT:
Black Lives Matter

PLACE YOUR MONUMENT:
ADDRESS, INTERSECTION, OR NEIGHBORHOOD
Germantown Avenue

DESCRIBE AND/OR SKETCH IN THIS SPACE:

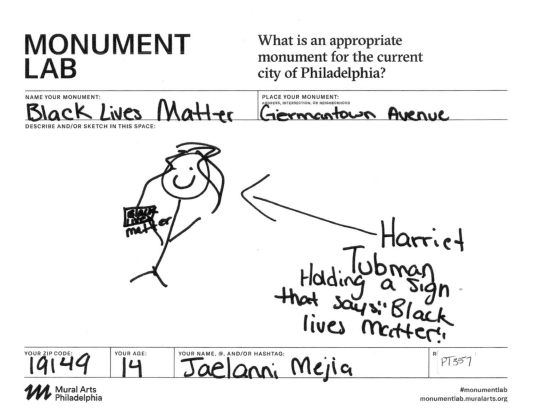

Harriet Tubman Holding a sign that says: "Black lives matter!"

YOUR ZIP CODE: 19149

YOUR AGE: 14

YOUR NAME, @, AND/OR HASHTAG: Jaelanni Mejia

R PT357

Mural Arts Philadelphia

#monumentlab
monumentlab.muralarts.org

MONUMENT LAB

What is an appropriate
monument for the current
city of Philadelphia?

NAME YOUR MONUMENT:
BEN FRANKLIN EATING A CHEESESTEAK + PUNCHING IVAN DRAGO

PLACE YOUR MONUMENT:
ADDRESS, INTERSECTION, OR NEIGHBORHOOD
ON TOP OF THE BEN!

DESCRIBE AND/OR SKETCH IN THIS SPACE:

YOUR ZIP CODE: 19147

YOUR AGE: 60

YOUR NAME, @, AND/OR HASHTAG: CHRISTINE ERIKSEN

RESEARCH ID: LLE 38

Mural Arts Philadelphia

#monumentlab
monumentlab.muralarts.org

MONUMENT LAB

¿Cual es un monumento apropiado para la ciudad actual de Philadelphia?

NOMBRE DEL MONUMENTO: one island one nation one race

LUGAR DE UBICACIÓN DEL MONUMENTO: DIRECCIÓN, INTERSECCIÓN, O VECINDARIO: Penn treaty Park

DESCRIPCIÓN Y/O DIBUJO EN ESTE ESPACIO:

my monument would be something reminding everybody on how Puerto Ricans are also american citizens but are treated so differently. We are also citizens and there so should be treated like ones. United we stand. #PuertoRicoselevanta ♡

ÁREA POSTAL: 19140

EDAD: 22

NOMBRE, @, Y/O HASHTAG: Nyja Valentín

NÚMERO DE IDENTIFICACIÓN: PT501

Mural Arts Philadelphia

#monumentlab
monumentlab.muralarts.org

MONUMENT LAB

What is an appropriate monument for the current city of Philadelphia?

NAME YOUR MONUMENT: FLOW

PLACE YOUR MONUMENT: ADDRESS, INTERSECTION, OR NEIGHBORHOOD: PENN TREATY PARK.

DESCRIBE AND/OR SKETCH IN THIS SPACE:

Restore the power plant and make it run! Light up the city and make it beautiful. Use the power of the river to power the city

YOUR ZIP CODE: 18064

YOUR AGE: 63

YOUR NAME, @, AND/OR HASHTAG: CARLA THOMAS

RESEARCH ID: PT383

Mural Arts Philadelphia

#monumentlab
monumentlab.muralarts.org

RAIR (Recycled Artist in Residency)

Founded 2010 · Based in Philadelphia, Pennsylvania

Plainsight Is 20/20

Penn Treaty Park · Maple tree, excavator, mirrored vinyl, and construction fencing

RAIR (Recycled Artist in Residency) regularly hosts visiting artists to source materials and produce site-specific projects within its construction and demolition recycling facility in the Tacony neighborhood of Northeast Philadelphia. RAIR's hosts, Revolution Recovery, receive more than 450 tons of reusable waste each day. For Monument Lab, RAIR lead artists and co-directors Billy Dufala and Lucia Thomé envisioned a sculpture for Penn Treaty Park that would express the tensions between Philadelphia's identity as a green, sustainable city and its current building boom. The park site is named for the treaty between William Penn and Lenape chief Tamanend. There the city of Philadelphia was founded, in a meeting that took place under a massive elm tree, later referred to as the "Penn Treaty Elm." *Plainsight Is 20/20* featured an enormous excavator holding a large, uprooted tree—two objects regularly found in construction sites in the city. The construction equipment, wrapped in metallic vinyl, was meant to stand out from and reflect the landscape; the tree, diverted from the waste stream, was exhibited roots and all. The tree and the excavator were presented together, behind an eight-foot-tall construction fence in Penn Treaty Park, as a symbol of the messy, prevailing culture of rapid redevelopment.

Urban Renewal in a Peaceable Kingdom

Bethany Wiggin

Associate professor of German and faculty director, Penn Program in Environmental Humanities, University of Pennsylvania

THE SCENE
Penn Treaty Park, Philadelphia. October 2017. The afternoon light blurs in steady rain. I've parked my car on the broad, empty street on the park's west side. The Delaware River, the park's eastern bank, is visible in the near distance through the streaky windows. I get out and see the squat oil tanks on Petty's Island in the middle distance, almost to the Jersey shore. In the middle of the grassy lawn, an excavator wrapped in reflective sheeting is parked parallel with the river. It holds a tree in its teeth. The tree faces the site where the Treaty Tree once stood, the Treaty Elm at Shackamaxon (Sakimauchheen Ing in Lenape; "to make a chief or king place"), now marked by an obelisk and whose scion stands several hundred feet to the left. Under the Treaty Elm—as depicted by Benjamin West in a painting tirelessly copied, engraved, and reprinted on everything from teapots to handkerchiefs to advertisements for cough medicine and as told and retold by both Lenape (Delaware) and Penn family histories and well known in

Pennsylvania lore and Quaker parable—William Penn signed a treaty of land for goods and privileges. It was the only treaty, Voltaire quipped, "never sworn to and never broken."

The excavator-tree ensemble is bordered by a square of the eight-foot chain-link fencing of construction sites everywhere. As I slowly circle this enclosure in the commons, I count four or five backhoes—yellow, blue, and green—dotting the park's south perimeter and parked on the far side of Columbus Boulevard to the east. A Monument Lab marker on the chain-link identifies the fenced-off ensemble as *Plainsight Is 20/20*, the melodramatic monument proposed by RAIR as "appropriate" for contemporary Philadelphia.

THE CRIME
J'accuse! Plainsight levels a charge. It's plain even at a distance. You are guilty. Reflected in the excavator's sides and shovel, you are implicated. You and your thirst for new construction with a river view have dug up this tree. You have dug up nature itself! The elm, its root-ball hanging in the air, its leaves withering and dropping, has been pulled up and with it the branch and root of Philadelphia's origin story of "peaceful Quakers" and "noble savages." You, *Plainsight* asserts, have gotten us all thrown out of the Peaceable Kingdom.

Plainsight might even press its case. Maybe Billy Penn was not all our city fathers cracked him up to be, perched all those years as the highest point in the city. Maybe, as the canny and cranky historian Francis Jennings wrote, it is all cant, thin cover for the brutal realities of European conquest. Pacifist or not, they became settler colonists. Maybe, *Plainsight* insinuates, William Penn was the first real estate developer. The colonial relation endures, *Plainsight* suggests, and you too are part of it. You too are caught in the on-going history of an imperial legacy structured on more or less shady land deals exchanging waterfront real estate for imported consumer goods.

THE MORAL
Plainsight was not a subtle monument (most monuments aren't), and its hard accusations felt even less subtle that October day in the rain. Nearby, it flowed off another Monument Lab prototype on the riverbank at Penn Treaty Park, Duane Linklater's lyrical *In Perpetuity. Plainsight* stood on heavier feet, caterpillar treads actually, and it stolidly insisted on its ability to reveal the truth of the historical past. In hindsight, history is plain, it proclaims. *Plainsight* sees clearly, its very title told you. *Plainsight* shows you where you've come from with 20/20 vision. *Plainsight* has perfect vision, and it perfectly sees your past. *Plainsight* has you in plain sight now: you are the snake in the garden. *Plainsight* itself would be on the side of the angels.

SURROUNDING THE MELODRAMA
Plainsight's melodramatic staging—the play of good and evil between the tree and the excavator—was surrounded by chain link. In my conversation

with one of *Plainsight*'s creators, Billy Dufala, I learned that, weeks before the scheduled installation, project organizers announced that a fence would be required. The artists were angered enough to counter the demand for safety with a proposal to enclose the excavator-tree pair in barbed wire; only later did all parties agree to the chain link.

But the unplanned fence raises a number of subtle questions around the interior melodramatic crime scene. By fencing in this public monument prototype qua art, *Plainsight* directed attention to the land enclosures on which land tenure systems based on private property are grounded (and for which Penn negotiated). The fence lightened the heavy melodrama and opened up room for questions beyond good and evil. It provided a reminder that monuments take up and occupy public space. And that art no less than, no other than, commerce is implicated in the tragedy of the commons—and in this neighborhood's rapid gentrification.

The fence also helped remind us that the machine has long been in the garden. We are entangled in a world where centuries of toxic leakages and slow seepages contaminate "private" property. Can Petty's Island be remediated? It used to be called Shackamaxon Island. Now it's slated to be made into a public park.

William Penn first landed in Philadelphia just downriver from Shackamaxon, coming on land by way of Dock Creek. The creek has been mostly buried since the 1780s and was converted fully into a sewer no later than 1820. Is there any going back? As the rain fell and the rivers flowed and rose, *Plainsight,* enclosed in fence, finally nudged us toward considerations that we no longer live in a world of man versus nature, if we ever did. Subtly questioning with its own enclosure, it finally ceded high ground to suggest our origins were never so pure in the past—and in doing so it asked how we want to and can live in the future.

MONUMENT LAB

What is an appropriate monument for the current city of Philadelphia?

NAME YOUR MONUMENT: helping our community

PLACE YOUR MONUMENT:
ADDRESS, INTERSECTION, OR NEIGHBORHOOD
Fishtown. Mascher and berks

DESCRIBE AND/OR SKETCH IN THIS SPACE:

reparing old playground
community gardens

~~buildings~~

Kids progams for kids like
rec center more organized
toweys play ground needs fixing up.
and hasnt been fixed up for a while

YOUR ZIP CODE:	YOUR AGE:	YOUR NAME, @, AND/OR HASHTAG:	PT355
19122	15	Alaha Manassra	

Mural Arts Philadelphia

#monumentlab
monumentlab.muralarts.org

MONUMENT LAB

¿Cual es un monumento apropiado para la ciudad actual de Philadelphia?

NOMBRE DEL MONUMENTO: " Thank you for your service "

LUGAR DE UBICACIÓN DEL MONUMENTO:
DIRECCIÓN, INTERSECCIÓN, O VECINDARIO

DESCRIPCIÓN Y/O DIBUJO EN ESTE ESPACIO:

Educational Monument w/images of significant
Philadelphia public servants working as advocates
for :
- school system (public)
- homeless
- people w/disabilities
- LGBT community
- people of color
- the arts
- women's reproductive rights
- immigrant rights
- impoverished youth
- people w/ HIV/AIDs

ÁREA POSTAL:	EDAD:	NOMBRE, @, Y/O HASHTAG:	PT324

Mural Arts Philadelphia

#monumentlab
monumentlab.muralarts.org

MONUMENT LAB

What is an appropriate monument for the current city of Philadelphia?

NAME YOUR MONUMENT:
Stewart's Stables

PLACE YOUR MONUMENT:
ADDRESS, INTERSECTION, OR NEIGHBORHOOD
Trenton Avenue

DESCRIBE AND/OR SKETCH IN THIS SPACE:

Stables are located on Trenton Avenue. The Stables were started by Robert "Bronc" Stewart. they were a pillar in the neighborhood. The Stables were an escape for ANYBODY in the community. They were often visited by celebrities like Sally Starr and Chief Halftown. The Stables are an important part of Fishtown/Kensington history.

YOUR ZIP CODE:
1912S

YOUR AGE:
29

YOUR NAME, @, AND/OR HASHTAG:
Robert Stewart III

RESEARCH ID:
PT392

Mural Arts Philadelphia

#monumentlab
monumentlab.muralarts.org

MONUMENT LAB

What is an appropriate monument for the current city of Philadelphia?

NAME YOUR MONUMENT:
Gay Pride

PLACE YOUR MONUMENT:
ADDRESS, INTERSECTION, OR NEIGHBORHOOD
On top of indepence Hall

DESCRIBE AND/OR SKETCH IN THIS SPACE:

Gay is the way

Very Colorful

amos. Jenhugbug@
JordynKrzyz@

YOUR ZIP CODE:
19607

YOUR AGE:
1,000

YOUR NAME, @, AND/OR HASHTAG:
@Jenhubug

RESEARCH ID:
LLP288

Mural Arts Philadelphia

#monumentlab
monumentlab.muralarts.org

Alexander Rosenberg

Born 1981 · American · Based in Philadelphia, Pennsylvania

The Built/Unbuilt Square

Rittenhouse Square · Modified coin-operated binoculars, steel, cement, aluminum, iPads, optical lenses, augmented reality software, high-capacity battery packs, black paint, wood, glass, and Rittenhouse Square

Alexander Rosenberg's *The Built/Unbuilt Square* offered a view into the historical landscape of Rittenhouse Square with the help of augmented reality technology. Passersby were invited to look into a pair of viewfinders—devices often placed on the edge of important vistas—that faced into the park's center. Rosenberg installed tablets with gyroscopic technology in each viewfinder to approximate actual views of the park and interspersed archival photographs and renderings of constructed and proposed buildings. The artist's goal was to create a shared space for the forgotten physical and cultural histories of the park. He explains:

> Looking around the square today, one might wonder how this planned green space ended up containing so many disparate, and in some cases disharmonious, elements. The research attempting to answer this question revealed a great quantity of proposals built and removed, unrealized, temporary and partially completed: an unusual series of structures and events that leave the square with a collection of fragments of mistakes, replacements, and long-forgotten intentions.

Visitors could shift the angle of the viewfinder to reveal multiple perspectives of the real and imagined landscape. Together, the viewfinders of *The Built/Unbuilt Square* collected the stories, images, and numerous evolutions of the park in a shared frame. An accompanying installation of Rosenberg's work related to this project was shown at the nearby Art Alliance.

A Monument as a Sensory Intervention

Andrew Friedman

Associate professor of history, Haverford College

You know those viewfinders you see at big national parks or on the tops of skyscraper observation decks? They're a prosthetic. When your eyes touch the telescopic machine, it amplifies the power implicit in our visual sense. The viewfinders, also called tower viewers or coin-operated binoculars, magnify distant views into intimacy. They disclose details the silence of vision can enter but that any human movement might disturb. All of a sudden, the body, fixed in place and sculpted by the grandeur of space around it, can reclaim its primacy and roam with a spectacular eyesight more like a hawk's, enfolding distance and proximity with a gaze both powerful and private, of

a great magnitude and microscopic. A human revenge against the human body's limits: it's perhaps no surprise the machines seem to date from the new visual matrix of the modernist metropolis and the scoping vistas of New Deal America.

Alexander Rosenberg's prototype monument for Rittenhouse Square, *The Built/Unbuilt Square,* had two of those viewfinders at its center. Rather than a means of experiencing a monument too large for conventional vision to encompass, the viewfinders became the monument—the monument as a sensory intervention. The viewfinders looked from two of the park's entry walkways into the square. When you put your eyes up to them, thanks to a touch screen locked inside, different images of historical habitations in Rittenhouse sprang back into visual existence, appearing in the part of the park you were looking at, changing with the scene as you rotated the viewer. An albino deer roaming in the 1880s. Swells perusing art shows on the cusp of economic crisis in 1928. An astronomical observatory never built in 1840 now built, pointing toward the stars of 1840. A fountain for Greek gods pouring 1872 water. Turn the viewer, a hundred years pass in only a few feet, and then it's 1972, people marching for gay pride in Nixon's America.

Rosenberg reversed the viewfinder's promise. In the close city square, your gaze roamed not spatially but temporally. Intensive rather than extensive, the viewfinders were a prosthetic for simultaneous time—for occupying, if fleetingly, the dense, deep fabric of populated urban time.

Then you took your eyes away. That was weird. It could be hard to look through the viewfinder for as long as it took to see all the images, the metal pressing against your face. It could be hard to turn, stretching the machine's swivel and your own body until it felt as though you might topple off the platform. When you came away, you blinked. You looked up at the tops of the trees, which are quite tall in Rittenhouse, which was surprising, because who looks up? There was a balloon stuck in one, a silver, half-deflated balloon trapped at the top of a tree. You hadn't been looking at the park in the viewfinder at all. It was just a frozen image of the park, looped background footage that had been captured way back in the summertime by a small 360-degree still camera, only an image of the park, just as it existed in reality but at another time, a time that was now gone, just used as a background to the historical images that themselves were all leftovers from another time, other times.

There were no beautiful fuchsias in the flower beds anymore, not in the early days of November 2017 at the end of Monument Lab. Those hadn't been there since 1934. Nothing was as bright and green as it was in the embalmed image in the viewfinder. But when you looked again at the park now, the depth, complexity, and ambiguity of the park's colorless greens and grays practically vibrated. It was cold and overcast. People were in the park doing what people do in the park in our time, but the square itself also seemed

alert, alive, and you were there, on that day, immersed in the park's regular movements and shifting images, which had taken on a sharp, poignant intensity.

As you walked through the park, from one end to another, you came upon the other viewfinder. They looked like faces, really, sentinels, co-inhabitants. "Turn to clear vision," the little red button on the viewfinder's forehead read. You turned. Then you looked away. Rittenhouse Square exceeded the image square. But it was clear that it did only after you understood this particular kind of monument not as an object of reverence in the sober face of history but as a portal, a sensory intervention that you pass through and then stand on the other side of with your eyes open. Prosthetic vision, the intervention reminds us, got all its ideas from one place: vision. Just as all history got its ideas from a present.

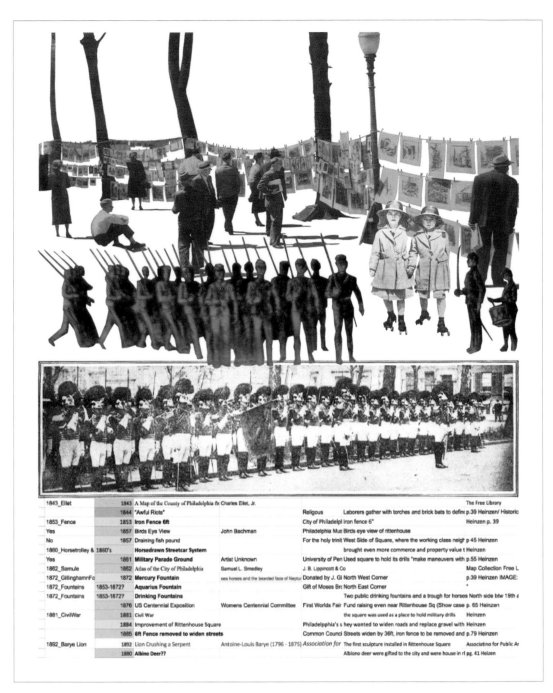

The area became known as "goosetown" due to the many geese drawn to the clay pits (1824 - 1850)

In 1825, the square was named for David Rittenhouse - president of the American Philosophical Society and a skilled clockmaker whose orrery was considered a great scientific achievement and in 1840 the Philosophical Society proposed an astronomical observatory on the square which was accepted but never carried it out.

In 1881 Civil war began and the square was used as a place to hold military drills.

Most notorious was the small goat sculpture, it was hated by the most of the art committee but cleverly circumnavigated the beaurocracy and got placed in the park. It was loved by children and is roumored to come off its perch and roam around at night.

By 1859 the square had finally become a "neighborhood Park" where children could play unattended and young men and women could court without chaperones because of the respectability of the owners of the homes overlooking the square

Phillipe Cret designed later improvements including a children's fountain and memorial for Dr. William White. He replaced the gravel around the pool with cement because children were throwing pebbles in the fountain, clogging it and causing it to overflow.

The fountain's brass knobs were repeatedly stolen by scrappers

RITTENHOUSE SQUARE EVENING TIMELINE

Vol 1 · No. 1 1682 2017

Rittenhouse is the only one of William Penn's proposed squares to stay true to its original purpose, first depicted in a map by Thomas Holme in 1682, an imaginary grid of the then nonexistent city to attract english investors.

All the other squares were at some point cemeteries and the northwest square was also the site of public gallows.

Looking around Rittenhouse Square today one might wonder how this planned greenspace ended up containing so many disparate and in some cases disharmonious elements. The research attempting to answer this question revealed a great quantity of proposals built and removed, unrealized, temporary and partially completed: an unusual series of structures and events that result in a confusing collection of fragments of mistakes, replacements, and long forgotten intentions.

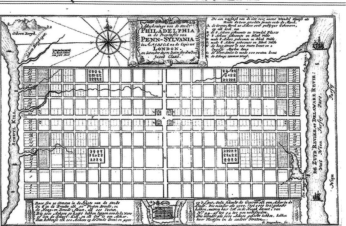

(above) Thomas Holme's 1682 rendering of the future city

There is evidence of the square's history as a densely wooded hunting ground in 1710 only to be completely deforested in 1777

(below) 183(?)
A map showing the many brickyards surrounding Rittenhouse Square

(below) 1934 A studey for new plants in Rittenhouse Square

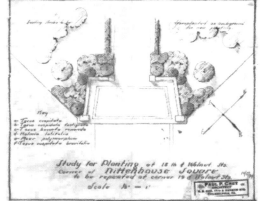

In the 1860's a horsedrawn streetcar system brought even more commerce and property value to the area, but also created a lot of noise and droppings.

1853 brought an iron fence and three large ornamental fountains depicting Mercury and Aquarius, and public drinking fountains were built with troughs for horses. These fountains were criticized and eventually removed by the city council's orders because they would overflow and muddy mens trousers and womens skirts

What is an appropriate monument for the current city of Philadelphia?

NAME YOUR MONUMENT:
THE FRO

PLACE YOUR MONUMENT:
ADDRESS, INTERSECTION, OR NEIGHBORHOOD
CENTER CITY

DESCRIBE AND/OR SKETCH IN THIS SPACE:

YOUR ZIP CODE: 19142

YOUR AGE: 17

YOUR NAME, @, AND/OR HASHTAG: @Syneece Felder

RESEARCH ID: PT336

Mural Arts Philadelphia

#monumentlab
monumentlab.muralarts.org

MONUMENT LAB

What is an appropriate monument for the current city of Philadelphia?

NAME YOUR MONUMENT:
Public Bathroom

PLACE YOUR MONUMENT:
ADDRESS, INTERSECTION, OR NEIGHBORHOOD
Penn treaty Park

DESCRIBE AND/OR SKETCH IN THIS SPACE:

I Think we should have public Bathrooms in the park because no one wants to see some peeing on a tree in public

YOUR ZIP CODE: 19122

YOUR AGE: 31

YOUR NAME, @, AND/OR HASHTAG: Eric

RESEARCH ID: PT35

Mural Arts Philadelphia

#monumentlab
monumentlab.muralarts.org

MONUMENT LAB

What is an appropriate monument for the current city of Philadelphia?

NAME YOUR MONUMENT: REBUILD! → PRIDE

PLACE YOUR MONUMENT: ADDRESS, INTERSECTION, OR NEIGHBORHOOD
ON A BLOCK WITH MANY ABANDONED BUILD'

DESCRIBE AND/OR SKETCH IN THIS SPACE:

AN IMAGE OF PEOPLE LEAVING AN ABANDONED BUILDING/FACTORY/HOME WITH THEIR BACKS TURNED. ALSO THE PEOPLE WHO ARE LEFT BEHIND FACING OUTWARD TO THE FUTURE OR TO EACHOTHER OR UNDERTAKING THE WORK OF REBUILDING, SUPPORTING.

YOUR ZIP CODE: 19125

YOUR AGE:

YOUR NAME, @, AND/OR HASHTAG:

RESEARCH ID: PT379

m Mural Arts Philadelphia

#monumentlab
monumentlab.muralarts.org

MONUMENT LAB

What is an appropriate monument for the current city of Philadelphia?

NAME YOUR MONUMENT: "THE NATIVES"

PLACE YOUR MONUMENT: ADDRESS, INTERSECTION, OR NEIGHBORHOOD
Penn treaty Park

DESCRIBE AND/OR SKETCH IN THIS SPACE:

Native statues

Taino People

Mohawk People

YOUR ZIP CODE: 19142

YOUR AGE: 17

YOUR NAME, @, AND/OR HASHTAG: @Syneese felder

RESEARCH ID: PT337

m Mural Arts Philadelphia

#monumentlab
monumentlab.muralarts.org

Jamel Shabazz

Born 1960 · American · Based in New York City, New York

Love Is the Message

Vernon Park · Photographic mural and installation

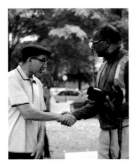

With *Love Is the Message*, the celebrated documentary photographer Jamel Shabazz paid tribute to African American veterans and their families against the backdrop of Germantown's Vernon Park. A U.S. military veteran, the artist served alongside men from Philadelphia when he was stationed in Germany in the 1970s. He had long planned a tribute to their service, resilience, style, and culture.

Shabazz notes, "I created images that recognize and celebrate the cross-generational connection, from servicemen and women who made sacrifices for this country since WWII to the present, to ordinary citizens, both young and old, who call Germantown home." He adds, "So much of who I am is a direct result of the music that came out of Philadelphia during the 1970s, under Philadelphia International Records. It was that constant theme of 'Love is the message' that really resonated with me and inspired my creative process since first embracing the arts. As a documentary photographer, the camera is the tool that I use to create. My main objective in working on this project was to make intimate portraits of the residents of Germantown, centering on the historic Vernon Park as a natural backdrop."

Through Shabazz's collaborations with Friends of Vernon Park, the Aces Museum, the Black Writers Museum, iMPeRFeCT Gallery, and others, his portraits of veterans and neighborhood residents were featured on a photographic mural near Vernon Park on Germantown Avenue. Additionally, the artist conducted several pop-up photo sessions between Memorial Day and Veterans Day, inviting veterans and others to sit for free printed portraits. A selection of Shabazz's photographs from the project were displayed at iMPeRFeCT Gallery from September 9 to October 7, 2017.

Posing Together

Leslie Willis-Lowry

Archivist, Charles L. Blockson Afro-American Collection, Temple University Libraries

In the fleeting time we have on this earth, what matters is not wealth, or status, or power, or fame—but rather, how well we have loved, and what small part we have played in making the lives of other people better.
—President Barack Obama
 January 12, 2011, Tucson, Arizona

Although they employ different methodologies, murals and monuments in public spaces are created to impress, tell a story, and make a statement about an event, a community, or a moment in history. They also can open up a place for artists to pursue free aesthetic expression and provide an opportunity to use the creative process as a means of social intervention. This position liberates the artist to create spaces for sharing between the artist and his or her community. The collaboration that which results from this social connectivity brings awareness to art's potential to be relevant and necessary to the basic foundation of a society.

Philadelphia is known worldwide for its murals and monuments in urban settings, in museums, and in the business communities. Unlike most monuments, murals are placed in communities. They romanticize particular moments in history and at the same time idealize individuals. Jamel Shabazz's mural did both. The title of the mural *Love Is the Message* highlighted the respect and care the artist was asking his viewers to experience in the adjacent Germantown's historic Vernon Park. Within the pictorial frame, the mural was emblematic of a photo quilt and functioned as a visual interlocutor. It offered a space for visitor reflection on not only the individual stories of heroism but also the local histories and the iconic site of reverence that symbolizes survival and resilience. The cadence of such narratives informs the content of our memories and shapes the way we visualize and interpret the role of particular human agency in the construction of visual meaning.

Quilts are beguiling and Shabazz allowed us to be captivated by the stories found in the photographic portraits. The reference to the quilt format refers to memory and the importance of quilt making in communities from the American Revolution to now. The quilting process is piecing, cutting, and reconnecting disparate and similar fragments to create an image—an image that warms the heart and soul. The large-scale photographs in this contemporary quilt were colorful and sent a message of love. *Love Is the Message* was located in a public space that undoubtedly impacted the neighborhood residents and passers-by as they confronted the ongoing conflicting issues of how Americans in the military are viewed—valued, celebrated, remembered, and overlooked. Jamel Shabazz's stunning collection of photographic portraits was a love story that revealed the nation's history through the

photographic lens. It was a reminder for us to honor our veterans and the purpose for those engaged in the emotionally raw narrative of the complexity of war.

Through the underlying theme of *Love Is the Message,* Shabazz was able to create another narrative that uniquely filled the photographic frame with a tapestry of individual stories of pride and patriotism among African Americans. Shabazz focused his lens on artistic and historical testimonial that skillfully interweaved the veteran's collective history within a quilt-design aesthetic. This format allowed local monument watchers to approximate the sensation of a large quilt weaved together as a labor of love expressed by veterans that will and should not be forgotten. Those are the historical narratives captured in the photographic sessions that Shabazz was confronting. By creating a space by which to appreciate, visually, the bravery of these proud and strong veterans, Shabazz allowed the beauty of place to emerge through the lens of his camera. Enlivened by a visual imagination that extended the expressive boundaries of the quilt genre, these amazing group portraits by Shabazz represented and constituted crucial chapters in military history—specifically, the importance of family. With pride and conviction, veterans who were in conflicts from World War II, the Korean War, Vietnam, Desert Shield/Storm, Iraq, Afghanistan, and various other missions and humanitarian operations posed for the photographer. Shabazz invited us to look anew at these portraits of men and women who have served in the military. His photographs were a compelling reminder of his love for photographing communities. In an act of reunion with the larger populace of Germantown, he added images of neighbors who gathered in the park on days when he was in residence. His images celebrated and made visible their collective stories. By forging and sustaining structures that opened the door to a new cultural understanding, the artist transformed his subjects' love for country into a patchwork tradition that organizes, identifies, and seals human relationships.

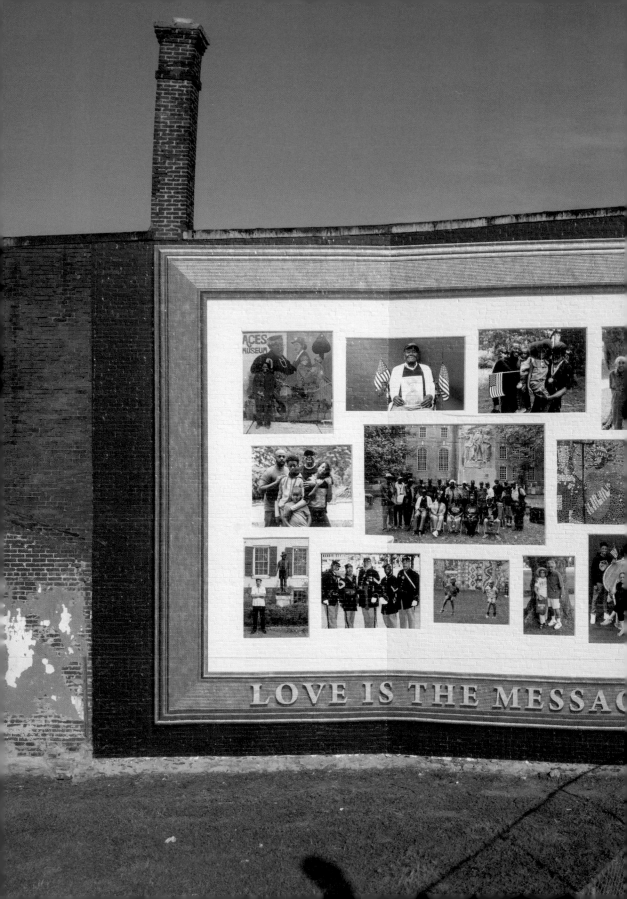

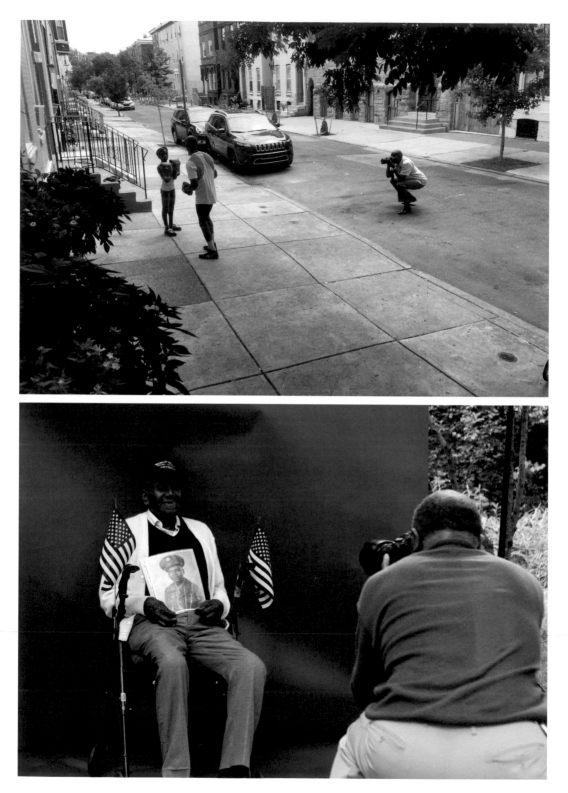

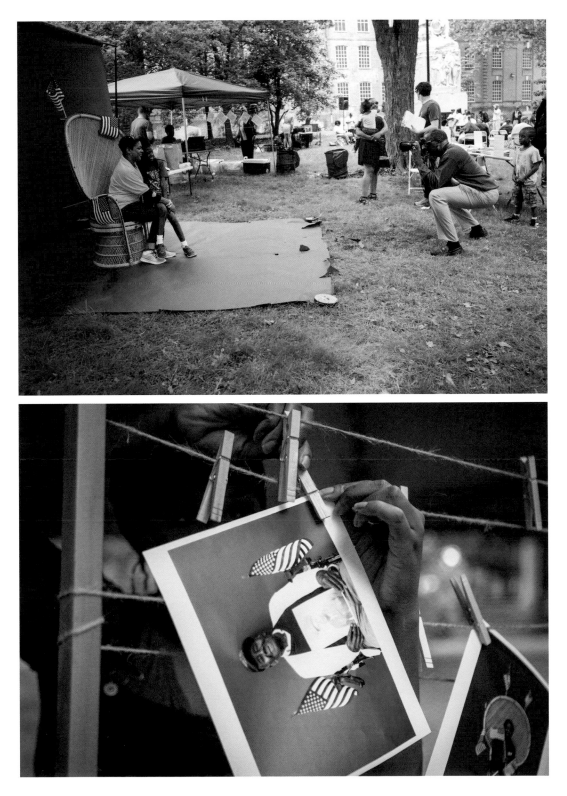

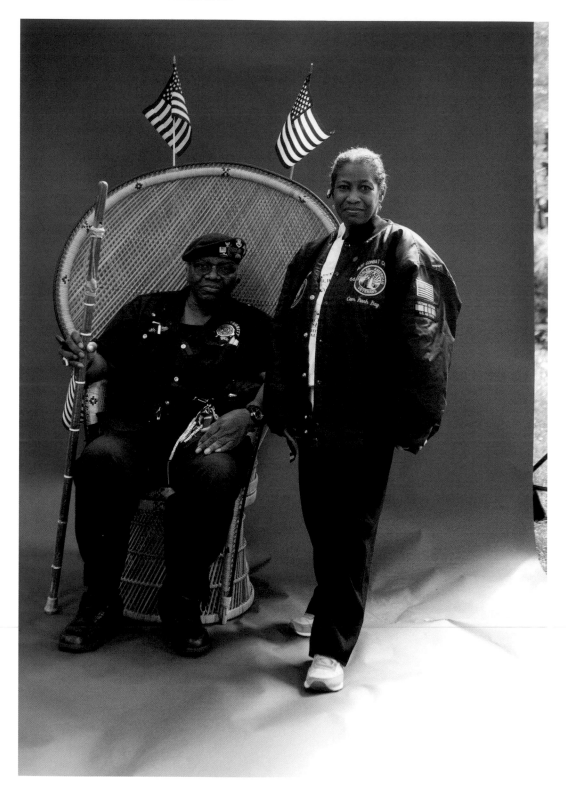

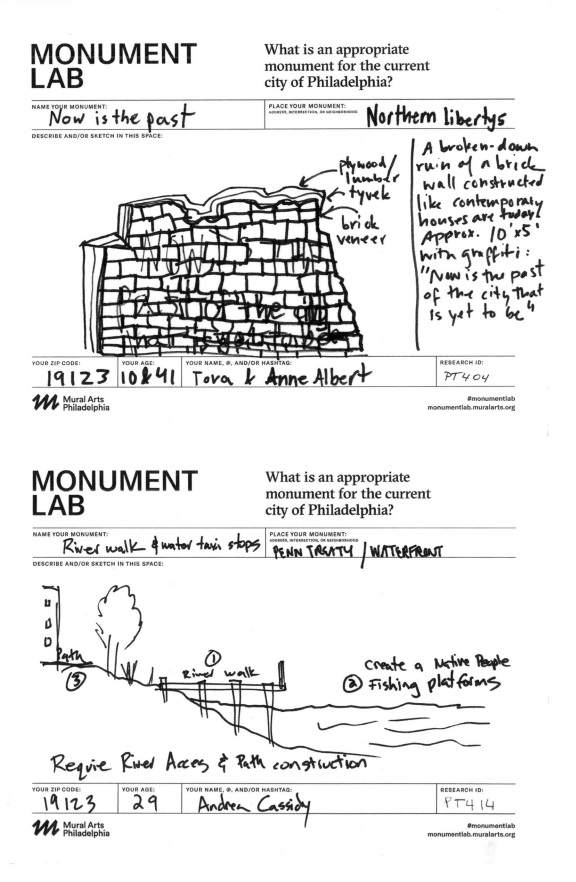

MONUMENT LAB

What is an appropriate monument for the current city of Philadelphia?

NAME YOUR MONUMENT:
Now is the past

PLACE YOUR MONUMENT:
ADDRESS, INTERSECTION, OR NEIGHBORHOOD
Northern libertys

DESCRIBE AND/OR SKETCH IN THIS SPACE:

plywood / lumber / tyvek

brick veneer

A broken-down ruin of a brick wall constructed like contemporary houses are today! Approx. 10'x5' with graffiti: "Now is the past of the city that is yet to be"

YOUR ZIP CODE: 19123
YOUR AGE: 10 & 41
YOUR NAME, @, AND/OR HASHTAG: Tova & Anne Albert
RESEARCH ID: PT404

Mural Arts Philadelphia

#monumentlab
monumentlab.muralarts.org

MONUMENT LAB

What is an appropriate monument for the current city of Philadelphia?

NAME YOUR MONUMENT:
River walk & water taxi stops

PLACE YOUR MONUMENT:
ADDRESS, INTERSECTION, OR NEIGHBORHOOD
PENN TREATY / WATERFRONT

DESCRIBE AND/OR SKETCH IN THIS SPACE:

Path ③

River walk ①

Create a Native People Fishing platforms ②

Require River Access & Path construction

YOUR ZIP CODE: 19123
YOUR AGE: 29
YOUR NAME, @, AND/OR HASHTAG: Andrea Cassidy
RESEARCH ID: PT414

Mural Arts Philadelphia

#monumentlab
monumentlab.muralarts.org

MONUMENT LAB

What is an appropriate monument for the current city of Philadelphia?

NAME YOUR MONUMENT: Untold History

PLACE YOUR MONUMENT: ADDRESS, INTERSECTION, OR NEIGHBORHOOD
North Philadelphia

DESCRIBE AND/OR SKETCH IN THIS SPACE:

- more monuments related to women in history & black history (or a combo #intersectionality)
- diversity = IMPORTANT

YOUR ZIP CODE: 19211

YOUR AGE: 18

YOUR NAME, @, AND/OR HASHTAG: Delaney Chaffin

RESEARCH ID: CH446

Mural Arts Philadelphia

#monumentlab
monumentlab.muralarts.org

MONUMENT LAB

What is an appropriate monument for the current city of Philadelphia?

NAME YOUR MONUMENT: PHILADELPHIA, THE ELECTRIC CITY

PLACE YOUR MONUMENT: ADDRESS, INTERSECTION, OR NEIGHBORHOOD
PENN TREATY

DESCRIBE AND/OR SKETCH IN THIS SPACE:

" PHILADELPHIA, THE ELECTRIC CITY"

This sign was on the roof of the POWER STATION. Ships used it as a marker as they came down the Delaware.

YOUR ZIP CODE: 18073

YOUR AGE:

YOUR NAME, @, AND/OR HASHTAG: JOE SEIFRIED

RESEARCH ID: PT 416

Mural Arts Philadelphia

#monumentlab
monumentlab.muralarts.org

Hank Willis Thomas

Born 1976 · American · Based in New York City, New York

All Power to All People

Thomas Paine Plaza · Aluminum and stainless steel

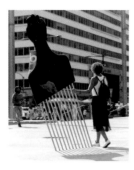

Located in Thomas Paine Plaza, across the street from City Hall, Hank Willis Thomas's *All Power to All People* was a public art intervention that dealt with black identity and representation in Philadelphia. The artist's Afro pick sculpture, standing eight feet tall and weighing close to eight hundred pounds, was installed not far from Claes Oldenburg's monumental *Clothespin* and *Paint Torch*, Jacques Lipchitz's *Government of the People*, and Zenos Frudakis's statue of former mayor Frank Rizzo.

The Afro pick, Thomas explains, dates from "the time of ancient Egyptians," among whom it was "an article of status and cultural belonging." He adds:

> The clenched black fist comb in particular is associated with the 1970s Black Power Movement. As an accessory of a hairstyle, it represented counterculture and civil rights during one of the most important eras of American history. It exists today as many things to different people; it is worn as adornment, a political emblem, and signature of collective identity. The Afro pick continues to develop itself as a testament to innovation. This piece serves to highlight ideas related to community, strength, perseverance, comradeship, and resistance to oppression.

Installed the same month as the city's Octavius Catto statue (the first monument on public land in Philadelphia dedicated to a historic person of color) and amid public debates about the Frank Rizzo statue, Willis's temporary monument inspired conversations about equal justice and civic belonging. Thomas has deep family connections to Philadelphia, including his maternal grandmother, Ruth Willis, who was a beautician in North Philadelphia; his mother, Deborah Willis, a celebrated scholar of African American photography; and his father, Hank Thomas, a jazz musician and former Black Panther. The artwork's name derives from a rallying call popularized in speeches by the Black Panther Party activist Fred Hampton.

Black Lives, Pop Art, and the Public Sphere

Salamishah Tillet

Faculty founder, New Arts Justice at Express Newark; associate director, Clement A. Price Institute; and Henry Rutgers Professor, African American and African Studies and Creative Writing, Rutgers University—Newark

I bought my first Afro pick in 1993 after cutting off all my hair. I had just finished my first year as an undergraduate at the University of Pennsylvania and decided to go natural after reading *The Autobiography of Malcolm X* and

Assata: An Autobiography. Like finding those books, growing out my perm was a rite of passage for my group of hip hop–loving, black-nationalist-leaning, and feminist-reading college friends, and styling our new coifs had become a communal adventure. Between my bi-weekly trips to my West Philly barber, I discovered a new world of hair products, half-ounce fragrance oils, and Afrocentric stores. Every once in a while, I'd lose the Afro pick that I proudly nestled in the back pocket corner of my flared jeans and would have to travel downtown, pass City Hall, and pick up a new one at the bustling Gallery mall.

Along with other cultural symbols of the late 1960s to mid-1970s, like dashikis, black berets, and Afros themselves, the pick became an attestation of black power pride, a marker of belonging and collective longing. Since my mother wore cornrows or long braids, my father was the only one whose picks graced our bathroom counter. My strongest image of him wearing an Afro is not from memory but is based on an image in our family photo album. In that picture, he is turned sideways and blazing a full grin; his full Afro crowns his brown pinstripe suit and mahogany briefcase. I always imagine him spending several hours in front of the mirror trying to pick out his loose curls into a statement of professional aspirations and political solidarity. In such moments, the Afro pick was his most vital tool in his process of transitioning from a newly arrived Trinidadian immigrant to a full-blown African American dissenter.

Like me, Hank Willis Thomas was a baby of the Black Power Movement. The son of Hank Thomas Sr., a jazz musician and former member of the Black Panther Party, and Deborah Willis, a photographer, curator, and historian of African American visual culture, Thomas spent much of his childhood in his parents' hometown of Philadelphia. Inspired by the iconicity of Claes Oldenburg's 1976 *Clothespin,* a weathering steel sculpture across the street from City Hall and above the city's main subway thoroughfare, Thomas's metal monument, an eight-foot Afro pick titled *All Power to All People,* also fused domesticity, urbanity, and history.

In a 2017 interview with the *Philadelphia Inquirer*, Thomas says, "When you're a kid and you are driving around the city, what you see are these wonderful things, you see the huge clothespin which is weird and wonderful." But, ultimately the sculpture appealed to him because of Oldenburg's unique idea of "taking up the mundane or ordinary object and giving them monumental value."

Born in 1976, the same year that *The Clothespin* was mounted, Thomas created a monument that played on our nation's bicentennial legacy by invoking a political movement that was conterminous with the nationwide celebrations: the democratic vision of the Black Panther Party (BPP). The BPP slogan from which Thomas pulled his titled, *All Power to All People,* not only riffed on the democratic potential of "the Declaration of Independence"

but also reclaimed it on behalf of all Americans, especially its marginalized African American citizenry.

The placement of Thomas's sculpture near Zenos Frudakis's bronze statue of the racially controversial Frank Rizzo, who served as the city's police commissioner from 1968 to 1971 and mayor from 1972 to 1980, resulted in the temporary overshadowing of Rizzo himself: a feat that was captured at the time in a *Philadelphia Daily News* editorial cartoon that shows Rizzo trapped or imprisoned by Thomas's Afro pick. That power reversal neatly underscores how Thomas's work conjured up the racial tension of the past, while hinting at the possible triumph of Thomas's vision in the present. The September afternoon that I first visited the monumental Afro pick, I saw two black women, one old and the other young, smiling and holding up black power fists while taking pictures of each other in front of the monument. In the absence of statues commemorating them or the lives of countless other Philadelphia black girls and women in or near City Hall, they posed their own bodies and voices alongside the Afro pick to reclaim Philadelphia's most heavily foot-trafficked space. By the time *All Power to All People* came down, its aluminum body was covered with hundreds of fingerprints, providing a poignant counterpoint to the image of Rizzo's autocratic pointing hand nearby.

A few minutes after I left his sculpture, I asked Thomas about its origins. He proudly pointed to his maternal grandmother, Ruth Willis, who sat across from us, and told me that she had worked as a beautician at an Apex Beauty school in the 1970s. Reminiscing, Thomas added: "I was getting used to getting my hair combed with an Afro pick. It hurt with the metal picks. And I always wondered why there was a fist on top of the handle and it was one of those little questions that you have as a child: But why?"

All Power to All People was his larger-than-life answer that offered a timely tribute to Thomas's own multiple legacies—familial, feminist, and Philly's pop art—and reminded us of the power of icons to remap a city and remake history.

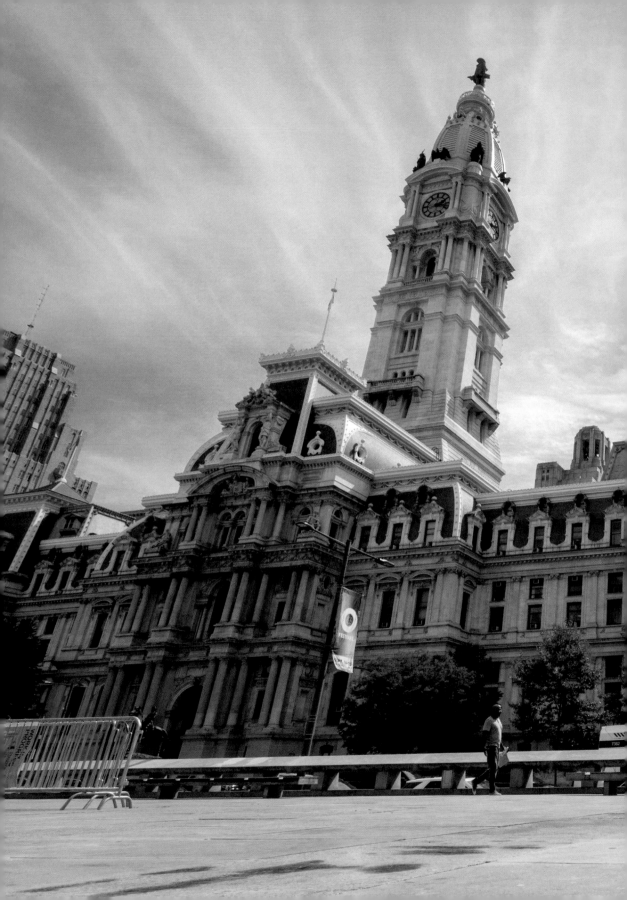

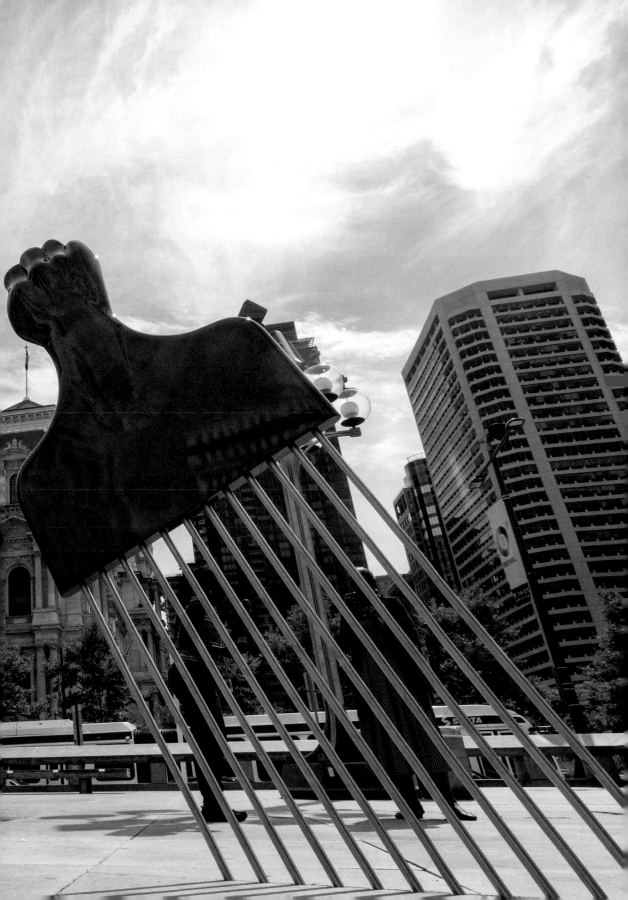

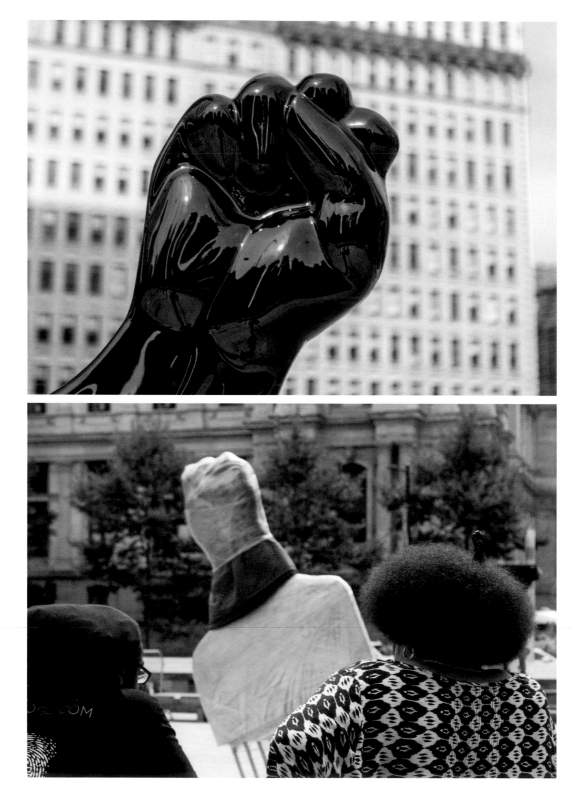

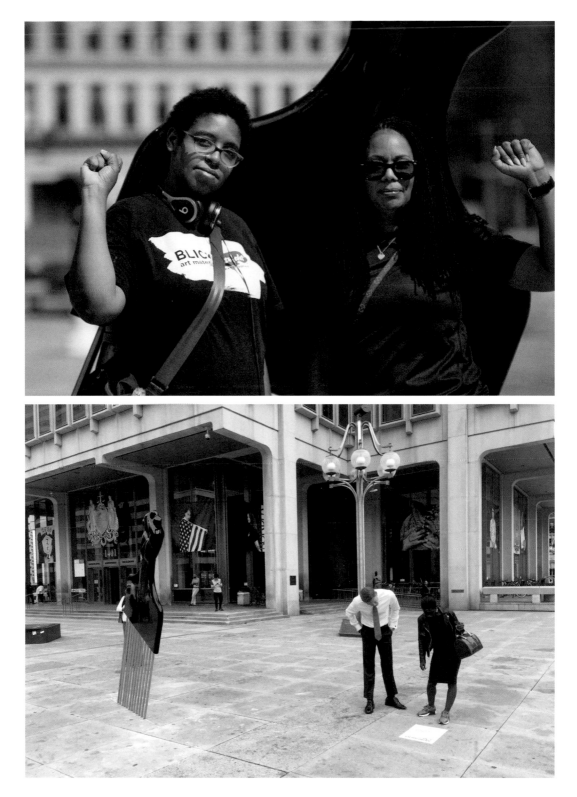

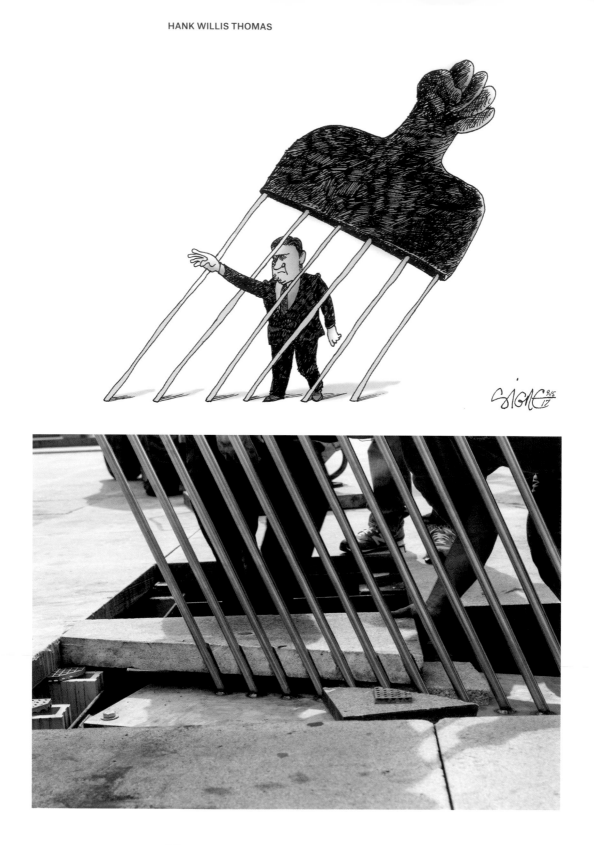

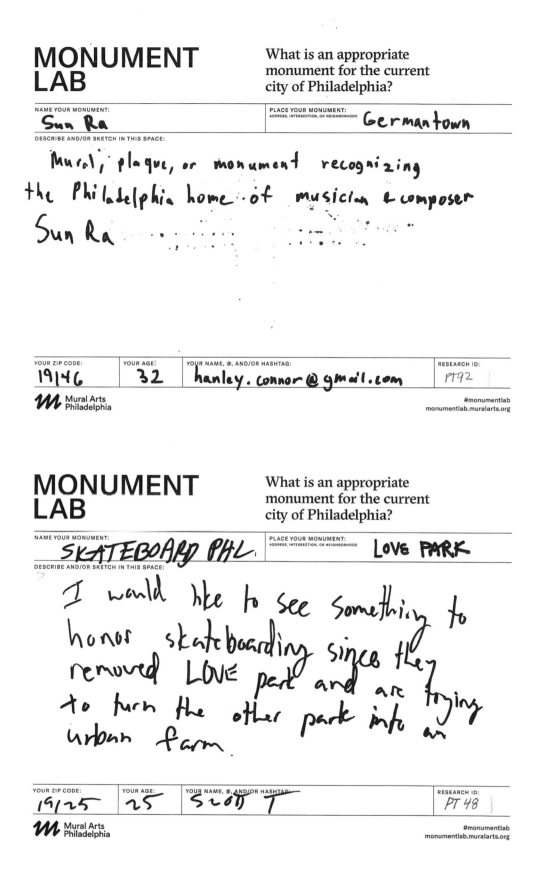

MONUMENT LAB

What is an appropriate monument for the current city of Philadelphia?

NAME YOUR MONUMENT: Sun Ra

PLACE YOUR MONUMENT: ADDRESS, INTERSECTION, OR NEIGHBORHOOD Germantown

DESCRIBE AND/OR SKETCH IN THIS SPACE:

Mural, plaque, or monument recognizing the Philadelphia home of musician & composer Sun Ra

YOUR ZIP CODE: 19146

YOUR AGE: 32

YOUR NAME, @, AND/OR HASHTAG: hanley.connor@gmail.com

RESEARCH ID: PT92

Mural Arts Philadelphia

#monumentlab
monumentlab.muralarts.org

MONUMENT LAB

What is an appropriate monument for the current city of Philadelphia?

NAME YOUR MONUMENT: SKATEBOARD PHL.

PLACE YOUR MONUMENT: ADDRESS, INTERSECTION, OR NEIGHBORHOOD LOVE PARK

DESCRIBE AND/OR SKETCH IN THIS SPACE:

I would like to see something to honor skateboarding since they removed LOVE park and are trying to turn the other park into an urban farm.

YOUR ZIP CODE: 19125

YOUR AGE: 25

YOUR NAME, @, AND/OR HASHTAG: Scott T

RESEARCH ID: PT48

Mural Arts Philadelphia

#monumentlab
monumentlab.muralarts.org

MONUMENT LAB

What is an appropriate monument for the current city of Philadelphia?

NAME YOUR MONUMENT: *The Answer*

PLACE YOUR MONUMENT:
ADDRESS, INTERSECTION, OR NEIGHBORHOOD

DESCRIBE AND/OR SKETCH IN THIS SPACE:

Allen Iverson

PPG : 26.7
AST : 6.2
12 Seasons in phi
2001 mvp

YOUR ZIP CODE: 02135

YOUR AGE: 26

YOUR NAME, @, AND/OR HASHTAG: Nick Robert

RESEARCH ID: RS276

Mural Arts Philadelphia

#monumentlab
monumentlab.muralarts.org

MONUMENT LAB

What is an appropriate monument for the current city of Philadelphia?

NAME YOUR MONUMENT: TIDAL MEASURING WALL

PLACE YOUR MONUMENT:
ADDRESS, INTERSECTION, OR NEIGHBORHOOD
PENN TREATY PARK

DESCRIBE AND/OR SKETCH IN THIS SPACE:

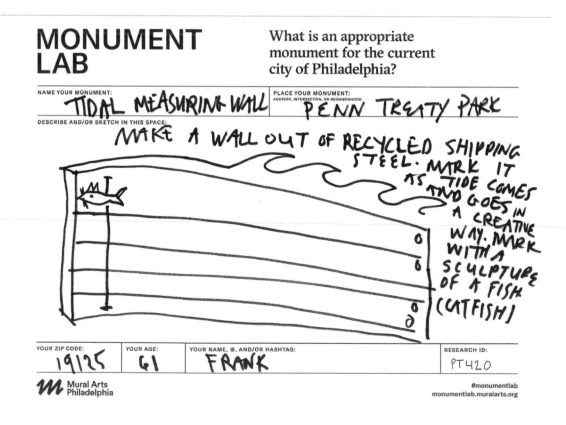

MAKE A WALL OUT OF RECYCLED SHIPPING STEEL. MARK IT AS TIDE COMES AND GOES IN A CREATIVE WAY. MARK WITH A SCULPTURE OF A FISH (CATFISH)

YOUR ZIP CODE: 19125

YOUR AGE: 61

YOUR NAME, @, AND/OR HASHTAG: FRANK

RESEARCH ID: PT420

Mural Arts Philadelphia

#monumentlab
monumentlab.muralarts.org

Shira Walinsky and Southeast by Southeast

Born 1972 and founded 2011, respectively · American · Based in Philadelphia, Pennsylvania

Free Speech

Marconi Plaza · Vinyl-wrapped kiosk, postcards, T-shirts, books, community zines, videos, maps, audio, and other materials

Free Speech was an interactive news kiosk in Marconi Plaza featuring the stories of immigrant and refugee artists in Philadelphia. Envisioned by Shira Walinsky, the kiosk offered free written and artistic materials, including maps, books, postcards, oral histories, and recipe cards to passersby. Installed next to SEPTA's Oregon Avenue subway and bus stations, *Free Speech* was embedded in a South Philadelphia neighborhood that has long been home to migrant, immigrant, and refugee families. Among Walinsky's projects housed within *Free Speech* was a stylized, hand-drawn map of immigrant businesses. Walinsky notes: "A small business is often the first big step many new immigrant and refugee families take in beginning their lives in the U.S. *Free Speech* is a metaphor for that first step, a symbol of why so many risk their lives to come to the United States."

The project was informed by over six years of work by Walinsky as lead artist at the Mural Arts Southeast by Southeast community hub in South Philadelphia, in collaboration with Mural Arts Philadelphia, the Department of Behavioral Health and Intellectual disAbility Services, and members of the Bhutanese, Burmese, Nepalese, and other immigrant and refugee communities. For *Free Speech,* Walinsky collaborated with several Southeast by Southeast artists, including Mayyadah Alhumssi, Noor Azizah, Laura Deutch of PhillyCAM, Sanctuary Poets, Ma Kay Saw, Krishna Tamang, and Catzie Vilayphonh of Laos in the House.

Welcome Signs

Fariha Khan

Associate director, Asian American Studies Program, University of Pennsylvania

See me. Hear my story. Embedded in the neighborhood of South Philadelphia, a small kiosk stood greeting Philadelphians at Marconi Plaza, on the side of a busy intersection and the Oregon Avenue subway station. Covered in bright vinyl, it displayed images of migration, a past homeland, a plane, and a new life. The small rectangular space beckoned people to come inside and learn more about their immigrant neighbors in Philadelphia. Within the kiosk were postcards, photos, and artwork that spoke of past homes and of new lives that visitors could read about and take home.

The kiosk structure of *Free Speech* was chosen to symbolize work, the first steps of a new immigrant life, and the Constitutional right to be seen and heard.

A second look and a closer examination, however, revealed a monument dedicated to perhaps the deepest desires of all immigrants—to be seen, to be heard, and to be understood. On the edge of Marconi Plaza, a public plaza, and situated in a neighborhood with a long immigrant history in Philadelphia, the monument reminded people of cultural difference but also of shared locales. This section of the city traces its roots to multiple ethnic communities, including the Irish, the Italians, the Lebanese, and, more recently, the Vietnamese, other Southeast Asian immigrants, and the Mexican community. The area surrounding Marconi Plaza in South Philadelphia has for many generations been the space where immigrant groups have arrived and settled, building their lives and raising their children.

Kiosks are a familiar sight in Philadelphia, found throughout the city serving and connecting people from all backgrounds. But *Free Speech,* standing defiant against the city's concrete landscape and covered in brightly colored patterns, demanded attention.

The doors opened with personal stories, hand-written memories. Inside the entrance hung a crocheted "Welcome" sign. The space was filled with family photos and postcards of artwork. An audio recording of a community member telling a personal story played as visitors to the kiosk looked at a vast array of faces and lives. The space radiated with vitality. Contributions largely from women and youth offered glimpses of individual journeys to the United States and, more specifically, to Philadelphia. Passersby could come in and learn about key moments in an individual life or the migration narrative of a family from a refugee camp to South Philadelphia. Multiple routes have brought people to Philadelphia to make a home and every inch of the kiosk spoke to the journey. For some, it was a desperate escape from war and poverty, and for others it was the only choice for survival. The stories, often handwritten and accompanied by family photos, gave a face to the migration histories that are largely unknown in the United States. Alongside a map of the world were numerous stories that highlighted the humanity of individuals from various parts of the world, linking them in a new land and revealing that people all over the world want safety and a better life for themselves and their families. The artwork lining the walls created by youth celebrated memories and a new life from multiple perspectives. Postcards that were made for visitors to take home showcased art from people who hailed from Syria, Vietnam, Bhutan, Burma. T-shirts were emblazoned with hand-blocked prints of letters in different scripts, and, outside, a henna artist painted intricate designs. The vibrant and dynamic art forms complemented the diverse migration narratives. Through the histories and the art, the communities found ways to be seen and heard. More important, the brightly covered stall empowered immigrant communities to reframe their lives

through their own stories, in their own voice and language, and their expressions in word and in art. New communities could change the narrative about immigrants and refugees through the *Free Speech* kiosk. The art and the narratives gave community members an opportunity to be more than the labels "immigrant" and "refugee" and to uplift themselves from misconceptions and stereotypes. Sharing intimate parts of these people's lives allowed visitors to gain a deeper knowledge of the struggles and the joys involved in creating a new life in the United States. In this way, misunderstandings and fear of new neighbors from afar could be distilled. By boldly demanding to be seen and to be heard, *Free Speech* honored the lives of refugees and immigrants in South Philadelphia and reclaimed the dignity of all humans as they navigate their lives and share their stories.

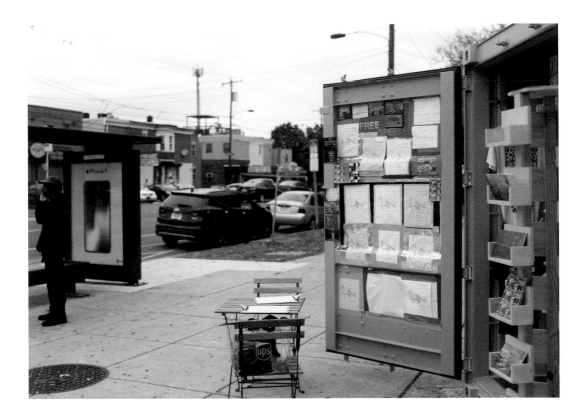

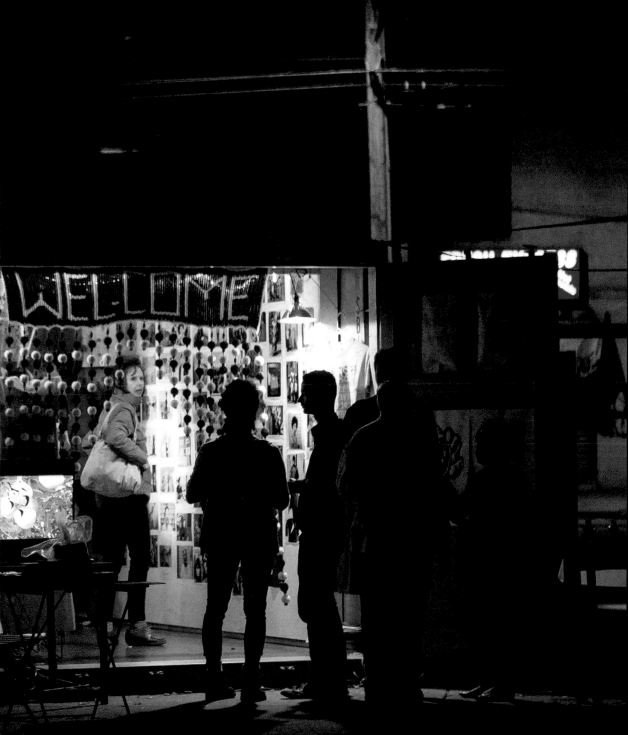

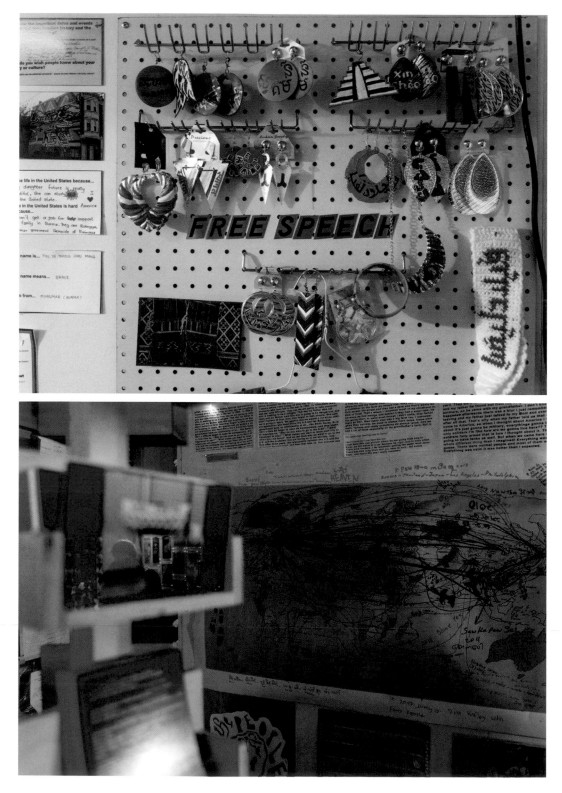

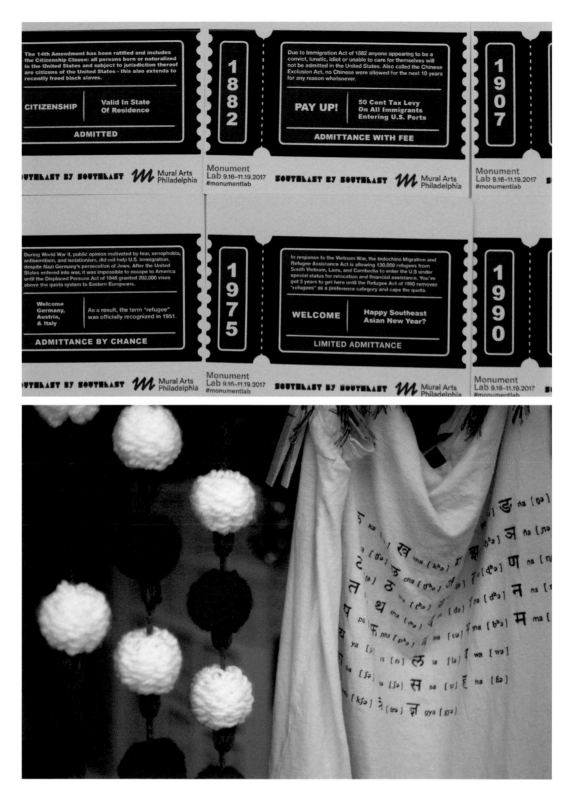

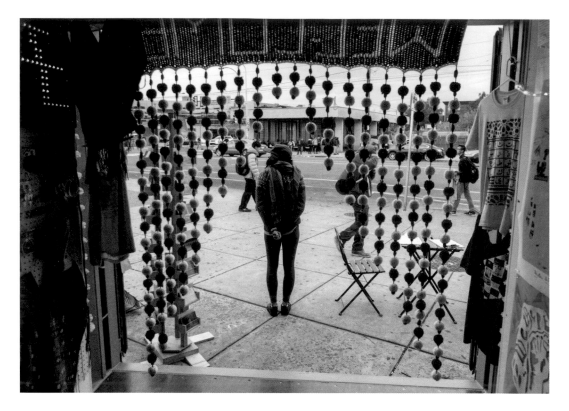

MONUMENT LAB

What is an appropriate monument for the current city of Philadelphia?

NAME YOUR MONUMENT: Underground.

PLACE YOUR MONUMENT:
ADDRESS, INTERSECTION, OR NEIGHBORHOOD
Cobbs Creek PARKWAY

DESCRIBE AND/OR SKETCH IN THIS SPACE:

I want to build a billboard with this message, & install on the parkway across from the MOVE bombing location a 6200 osage AVE.

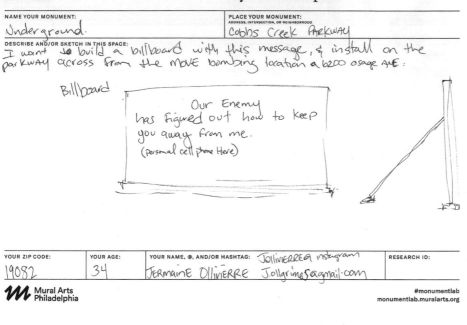

Billboard

Our Enemy
has figured out how to keep
you away from me.
(personal cell phone Here)

YOUR ZIP CODE: 19082

YOUR AGE: 34

YOUR NAME, @, AND/OR HASHTAG:
JollivierrE @ instagram
JERMAINE Ollivierre J.ollgrimes@gmail.com

RESEARCH ID:

M Mural Arts Philadelphia

#monumentlab
monumentlab.muralarts.org

MONUMENT LAB

What is an appropriate monument for the current city of Philadelphia?

NAME YOUR MONUMENT: Black muslim memorial

PLACE YOUR MONUMENT:
ADDRESS, INTERSECTION, OR NEIGHBORHOOD
52nd St / Malcolm X Park

DESCRIBE AND/OR SKETCH IN THIS SPACE:

More representation of local populations which is more diverse than seems to be currently represented — for instance black muslims.

YOUR ZIP CODE: 20002

YOUR AGE: 32

YOUR NAME, @, AND/OR HASHTAG:
William McKelvey, @thedelawarean

RESEARCH ID: WS167

M Mural Arts Philadelphia

#monumentlab
monumentlab.muralarts.org

MONUMENT LAB

What is an appropriate monument for the current city of Philadelphia?

NAME YOUR MONUMENT: Leaders of the Village
Strong Black African American Women

PLACE YOUR MONUMENT: *ADDRESS, INTERSECTION, OR NEIGHBORHOOD* North Phila, Center City

DESCRIBE AND/OR SKETCH IN THIS SPACE:

Dorothy Height

Mary mcloud Bethune

Shirley Chisholm

1°

YOUR ZIP CODE: 19140

YOUR AGE: 59

YOUR NAME, @, AND/OR HASHTAG: Darlene Carter

RESEARCH ID: CH 324

Mural Arts Philadelphia

#monumentlab
monumentlab.muralarts.org

MONUMENT LAB

What is an appropriate monument for the current city of Philadelphia?

NAME YOUR MONUMENT: Rufus Harley

PLACE YOUR MONUMENT: *ADDRESS, INTERSECTION, OR NEIGHBORHOOD* Vernon Park

DESCRIBE AND/OR SKETCH IN THIS SPACE:

Renown Jazz
Bag Pipe Player
Decades of performaces
in vernon Park
Alone and
with extra
Curriculars
Rec. Education

YOUR ZIP CODE: 19104

YOUR AGE: 30

YOUR NAME, @, AND/OR HASHTAG: Toure7K@Gmail.com

RESEARCH ID: VPS8

Mural Arts Philadelphia

#monumentlab
monumentlab.muralarts.org

Marisa Williamson

Born 1985 · American · Based in Newark, New Jersey

Sweet Chariot: The Long Journey to Freedom through Time

Washington Square and Pennsylvania Academy of the Fine Arts · Video, digital application, and scratch-off ticket

Sweet Chariot was an interactive video scavenger hunt, conceptualized and directed by Marisa Williamson. For her work, Williamson developed a *Sweet Chariot* image-recognition smartphone app and scratch-off map, in which participants could unlock a series of site-specific videos that revealed hidden moments in the landscape of historic Philadelphia, opening a window onto the African American struggle for freedom. The journey began in Washington Square and invited viewers to look for clues hiding in plain sight, prompted by images on signs, plaques, and murals. Each unlocked video presented a creative and collaborative interpretation of a story from Philadelphia's African American history, allowing viewers to follow the protagonist Amelia Brown (embodied by Williamson) on her way "home" through interactions with historical figures that included Margaret Forten, Octavius Catto, and W.E.B. Du Bois. Brown's character was based on a real Philadelphian whose gravestone was excavated in a former burial ground for Mother Bethel African Methodist Episcopal Church, under present-day Weccacoe Park in South Philadelphia's Queen Village neighborhood. During the exhibition, *Sweet Chariot*'s scratch-off map was available at the Washington Square Lab and at the exhibition hub at the Pennsylvania Academy of the Fine Arts. The map is currently available at Philadelphia's African American Museum.

Carrying the Stories Home

Alliyah Allen

Assistant curator, Monument Lab

Marisa Williamson's *Sweet Chariot: The Long Journey to Freedom through Time* was a scavenger hunt that left participants with a central message: "Listen, learn, and remember." While providing a virtual rendering of an African American history that lives in and around "Old City" Philadelphia, Williamson's prototype monument also reinvigorated the lost eighteenth- and nineteenth-century African American graveyard as a point of much larger civic importance. Under the name "Amelia Brown," Williamson doubled as the storyteller and guide. The figure referred to her original projected site for Monument Lab, at the Weccacoe playground at 6th and Catherine Streets, which is a rediscovered, and largely forgotten, burial ground for the historic Mother Bethel A.M.E. Church, the resting place for more than three thousand African American worshippers. The resurfaced headstone marking the grave for Brown, who died at age twenty-six, reads: "Whosoever live and believeth in me, though we be dead, yet shall we live."[1] The

chilling tone of Brown's memorial lays bare a deep sense of tragedy. But Williamson's virtual embodiment of Brown resurrected her from the subsumed burial grounds as a figure of collectivity and possibility. Williamson's commitment to performance to help Brown find her way "home," while inviting participants to unlock interpretive vignettes as augmented reality on their smartphones, was an attempt to fulfill Brown's demand to live on beyond her earthly lifespan.

Sweet Chariot progressed across a constellation of nearby sites. Williamson's stories took cultural forms such as dances, songs, plaques, books, speeches, paintings, and more that were all made accessible on the mobile app. Through such blending and innovation, *Sweet Chariot* charged viewers not only to read between the lines in which history is written but also to experience the power and truth that the story brings forward. For example, at the location of the first clue in Washington Square, visitors would find a wide array of plaques and statues that detailed specific moments of the history and creation of Washington Square before settling on the portal for Williamson's prompt. A major structure in the park is a statue of President George Washington, standing frozen in time above an unmarked tomb and an eternal flame, symbolizing the lives of the soldiers who died in service of the Revolutionary War. While a typical viewer might have expected the square and the city to mark only Washington's presence as an emblem of Philadelphia's historical fabric, Williamson used the hunt to direct participants to the smaller but equally important plaque that read, "Sorrow and Joy."

The plaque noted the unofficial but well-known mapping of the space as "Congo Square," where, in the eighteenth and nineteenth centuries, African Americans would gather to celebrate their culture, bringing the spirit of joy and life to a space marked by death and mourning, in an effort to make the park a place of home for both the enslaved and the free. In the app, once visitors had read the plaque, the interpretive panel disappeared, and the "bird woman," performed by Noelle Lorraine Williams, entered, walking, dancing, and making ritual offerings as she made her way to the Washington statue. All the while, Amelia Brown, performed by Williamson, read a poem by Lamont Steptoe from his book *Meditations in Congo Square* to the sound of a steady but provocative percussive beat. Keeping to that beat, the bird woman moved about the square on what seemed to be a normal, unremarkable day in Philadelphia. The presence of visitors walking about the square, listening and observing, did not interfere with the grace with which the bird woman created a path to block the statue of Washington and physically insert her living testimony in front of it. The beat of the music, the sound of the poem, and the movement of the bird woman transformed the way in which freedom is defined and even celebrated. Washington's monument memorializes freedom through its reference to sacrifice and war. *Sweet Chariot* challenged such a singular notion of freedom, allowing viewers to reimagine the many sides and forms in which freedom is manifested.

While the bird woman was locating freedom through her offerings and dance, Brown continued her journey through time to reveal the many challenges to and faces of freedom. As she traveled, she drew visitors to the former site of abolitionists' Pennsylvania Hall, burned down in 1838, where Kyla Ayers performed a beautiful dance to honor the hall and the Shelter for Colored Orphans, which was damaged by the same racist mob that destroyed the hall. And then Brown moved on to the Museum of the Revolutionary War, where Dena Bleu played the nineteenth-century figure Margaret Forten, a single mother who faithfully cleaned up "after the founding fathers" while harboring the hope that she might advocate for a better life for her children. The journey continued with visits to such luminaries of black Philadelphia as W.E.B. DuBois and Octavius Catto and to other contributors who are members of contemporary cultural practice, including Steptoe, Erica Armstrong Dunbar, and Yolanda Wisher. The beauty that emanated through the moments at each site also provoked a sense of pain. Through it all, however, Williamson's voice pushed forward and the viewers learned that that pain was necessary in the journey that leads to the safety and acceptance of home.

Note
1. Simon Van Zuylen-Wood, "There May Be 3,000 Corpses under This Philly Playground," *Philadelphia Magazine*, July 26, 2013.

The journey ended at Weccacoe Playground, where the gentle tones of Paul Robeson singing "Swing Low, Sweet Chariot" and Williamson reciting Yolanda Wisher's "sweet tea blues," a poem that recounts Brown's story, reminded participants that the process of finding home involves unlocking truths and untold stories. Perhaps these acts of listening, learning, and remembering in the effort to find and recreate are an important part of the purpose and role of a monument.

HELP AMELIA
FIND HER WAY HOME.

USE THE SWEET CHARIOT MAP TO FIND
EIGHT DOORWAYS THROUGH TIME.

THE DOORWAYS ARE IMAGES.

Some are about the size of a book:
PLAQUES, SIGNS, AND MARKERS.

WHILE OTHERS, ARE
MONUMENTALLY BIG: MURALS.

Step 1
Download the Sweet Chariot
App from the App Store onto
your SmartPhone.

Step 2
Navigate using the Sweet Chariot
Map. Scratch off each golden
link to reveal a visual clue.

Step 3 🎧
Hold your phone up to the
images to unlock doorways
once you've found them.

Step 4
Unlock the first seven to unlock
the eighth: the doorway to
Amelia's home.

1. 210 W. Washington Square
2. 151 N. 6th Street
3. 101 S. 3rd Street
4. 243 Delancey Street
5. 600-44 Lombard Street
6. 823 South Street
7. 601 South Street
8. 400 Catherine Street

**MONUMENT
LAB**

**Mural Arts
Philadelphia**

monumentlab.muralarts.org #monumentlab

Hints 1:This is an illustrated plaque 2:This is a text plaque beneath the tree
3:This is a wall sculpture 4:This is by the front door 5:This is near the four square court
6:This is across the street from Octavius Catto's marker 7:This is on the Engine 11
Fire Station 8:In weccacoe, this is the map itself

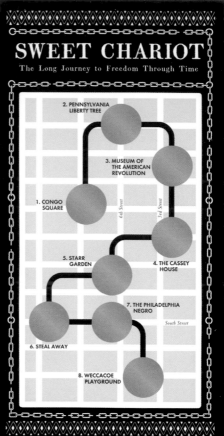

SWEET CHARIOT
The Long Journey to Freedom Through Time

1. CONGO SQUARE
2. PENNSYLVANIA LIBERTY TREE
3. MUSEUM OF THE AMERICAN REVOLUTION
4. THE CASSEY HOUSE
5. STARR GARDEN
6. STEAL AWAY
7. THE PHILADELPHIA NEGRO
8. WECCACOE PLAYGROUND

6th Street 3rd Street South Street

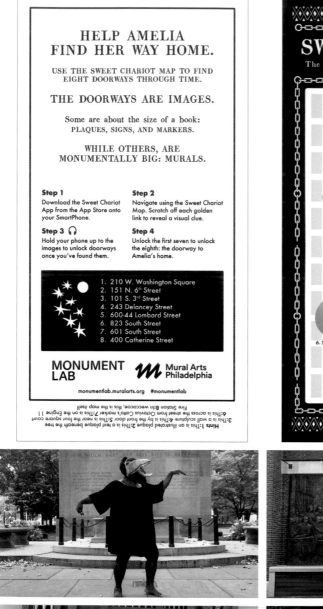

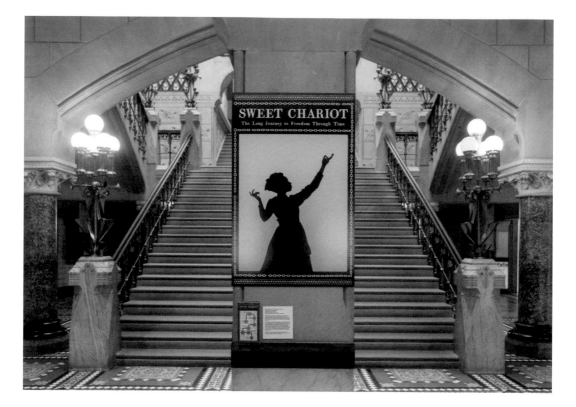

MONUMENT LAB

What is an appropriate monument for the current city of Philadelphia?

NAME YOUR MONUMENT:
Rizzo Statue → move it to

PLACE YOUR MONUMENT:
ADDRESS, INTERSECTION, OR NEIGHBORHOOD
remote place in West Fairmount Park

DESCRIBE AND/OR SKETCH IN THIS SPACE:

where the monument "Colored Soldiers and Sailors of all wars" was hidden for 60 years (1936 - 1996). It would be appropriate for Rizzo to be there for 60 years, then another public discussion could take place. The "Colored Soldiers and Sailors" monument is now prominently located on Ben Franklin Parkway, a permanent installation I hope, but who knows, maybe a time will come when statues glorifying wars will all be moved to places less visible.

YOUR ZIP CODE: 19103

YOUR AGE: 72

YOUR NAME, @, AND/OR HASHTAG: Tom Wilson Weinberg

RESEARCH ID: RS 28

Mural Arts Philadelphia

#monumentlab
monumentlab.muralarts.org

MONUMENT LAB

¿Cual es un monumento apropiado para la ciudad actual de Philadelphia?

what is an appropriate monument for the current city of Philadelphia

NOMBRE DEL MONUMENTO: (NAME OF MONUMENT)
Joel Embiid, Trust The Process (#TTP)

LUGAR DE UBICACIÓN DEL MONUMENTO: (PLACE)
DIRECCIÓN, INTERSECCIÓN, O VECINDARIO
Capitolo Playground

DESCRIPCIÓN Y/O DIBUJO EN ESTE ESPACIO: DESCRIPTION AND /OR DRAWING

Picture of him with his arms spread out wide with a nameplate below it and his official moniker of "Trust The Process" below it.

This is the park he came out to shoot hoops with kids a few months ago. A superstar of his caliber doesn't do stuff like that ever + he's really a man of the people

AREA POSTAL: ZIP ~~19147~~ 19147

EDAD: AGE 28

NOMBRE, @, Y/O HASHTAG: NAME Omar Sardimanie + Jerome Radojevic

NÚMERO DE IDENTIFICACIÓN: NS166

Mural Arts Philadelphia

#monumentlab
monumentlab.muralarts.org

III. RESEARCH

Reading Imagined Monuments
Laurie Allen

Research director, Monument Lab, and senior research specialist at the Library of Congress

Walking through Philadelphia, it's not hard to find a statue of a white man on a horse. We see him there, and while we might not know who he is, we can assume there's a plaque nearby to tell us his name. Of course, we could look him up on Google or Wikipedia to find out why he made his way into the history books and perhaps find out where his personal papers or archives are located or what stories his contemporaries told about him. But for many Philadelphians, if we notice that monumental figure at all, we don't actually wonder much about who he is. Instead, we assume he's another character in the story of American progress that we've been told over and over in so many ways—a story that elevates the victors on horseback but that we know is belied by the full facts of our shared history.

As historical artifacts, our monuments don't stand on their own. They're supported by networks of information, shared stories, shorthands, official records, and data. Most of the city's monuments reinforce a narrow version of our history, where great white men came to a land of opportunity, made friends with the people who lived here (people who somehow disappeared immediately thereafter), and set about taming the wild, building civilization, and establishing Philadelphia as the cradle of liberty and freedom. But the truth of our city's history is richer, trickier, fuller, more beautiful, and more painful than the stories told by most of our monuments.

Through Monument Lab, we invited twenty artists to answer the question: "What is an appropriate monument for the current city of Philadelphia?" Their temporary prototype monuments brought the city to life: they stood out, asked new questions, and called attention to absences, hidden stories, open wounds, and points of communal hope. They were necessary provocations for a new conversation. They led the way to new kinds of engagement with a city whose populace was eager to join and, also, to respond to the question.

To become a place with a deeper, broader, and truer official history, we need new processes for telling the stories of our city together and for gathering, recording, and sharing what we know about our past and present and why these facts matter. As Shannon Mattern writes, "Just as important as the data stored and accessed on city servers, in archival boxes, on library shelves and museum walls are the forms of urban intelligence that cannot be easily contained, framed, and catalogued."[1] The data we offer here is not always easy to categorize, and its collection took place in the midst of complex and sometimes

238

difficult conversations in public parks. It's hard to make claims of statistical significance about the city using this data or to train neural networks or new algorithms. But as cities turn increasingly to data-driven decision making, this project offers a data set that reflects a method for learning from the artistic, creative, intelligent, and complex people who make up Philadelphia.[2]

Monument Lab's research process, living alongside the prototype monuments, was designed to invite necessary conversations and to gather data that might call for new interventions into the networks of intertwined information and power. We need forms of data and networks of information that don't simply reinforce the power of the powerful and we need to imagine systems that optimize care, complexity, and justice over efficiency in the service of capitalism.

The tools and technologies for the Monument Lab research process were simple and were tested in a discovery phase in the courtyard of City Hall in 2015. People in public spaces, at ten labs around the city, were handed a clipboard with a paper form and a Sharpie. The information network for gathering the data was created by a team of local artists, activists, educators, and youth researchers who were employed at each lab. Each team invited Philadelphians and visitors to offer their own answers to the project's guiding question and to fill out a research form about their imagined monument. The form asked people to give a name to their monument, to say where they would like to see the monument, and to include, if they chose, their home zip code, age, and a

Lab research team, David Hartt, *for everyone a garden VIII*, Norris Square, Monument Lab, 2017. (Steve Weinik/Mural Arts Philadelphia.)

name they'd like to use to get credit for their idea. After each respondent handed in a form, the team scanned it into a data system, where each field in each proposal was transcribed and mapped by the data team, following a similar process used for any other piece of civic data or city statistic. The proposals were posted immediately on the Monument Lab website during the exhibition and were shown in the exhibition hub at the Pennsylvania Academy of the Fine Arts. At the close of the project, all proposals and the data set representing them were added to opendataphilly.com, the city's civic data catalogue, and became part of the permanent collection of the University of Pennsylvania Libraries.

In our system, the data were created from the stories, memories, values, worries, and desires that people offered as they passed through parks rather than from information harvested from their browser histories or website clicks. The data include powerful words and phrases and drawings; they include points that can be mapped to a precise address and some that can barely be imagined. The data were injected into a network of municipal data, a museum, and a library collection so that they might feed new networks and social histories. From those official channels, the data can be engaged by civic technologists, municipal leaders, artists, scholars, and students.

MONUMENT LAB

born in Philly

4.7.19

What is an appropriate monument for the current city of Philadelphia?

NAME YOUR MONUMENT: *Billie Holiday*

PLACE YOUR MONUMENT:
ADDRESS, INTERSECTION, OR NEIGHBORHOOD
LOMBARD ST.

DESCRIBE AND/OR SKETCH IN THIS SPACE:

To acknowledge remember the struggle work + of black female artists —

One more: recognition of A sculpture for ACT-UP — an amazing force in the city from the 80s —

YOUR ZIP CODE: *19103*

YOUR AGE: *56*

YOUR NAME, @, AND/OR HASHTAG: *Bronwyn Lepore*

RESEARCH ID: *RS64*

M Mural Arts Philadelphia

#monumentlab

With 4,445 people offering proposals, it's clear that Philadelphians are overflowing with ideas for monuments. As with history itself, the collected proposals defy easy summarization. They can be read as notes jotted down to the city, as strands in a giant tapestry, as a data set, and as thousands of unique artworks.

In many instances, a single piece of paper included multiple ideas, so that the total count of proposals is higher even than the number of forms. For example, a proposal from Bronwyn Lepore from Center City at the Rittenhouse Square lab calls for a monument named "Billie Holiday—Born in Philly 4/7/1915." In the space to describe or sketch the monument, Lepore wrote, "To acknowledge/remember the work+struggle of black female artists." Lepore inserted the words "remember" and "work" as she went, as if to say it is not sufficient to acknowledge Holiday's struggle; we should also remember and celebrate the work of this important Philadelphia-born, black woman jazz artist. Beneath that description, as though the act of reflecting on the legacy of Holiday brought another idea to mind, Lepore added: "One more: recognition or a sculpture for ACT-UP—an amazing force in the city from the '80s." ACT-UP, or AIDS Coalition to Unleash Power, organized direct actions on the city's streets to raise awareness of and care for people with HIV and AIDS. Lepore's thought process is rendered

visible in this proposal; this same process—starting with a person who deserves honor and then moving to a community or movement—occurred in conversation after conversation at the labs. People proposed monuments to famous Philadelphians and ordinary citizens, including one gem, a monument to "regular people doing regular things" proposed at the lab at Marconi Plaza by cee heard @ceescapes.

Many monument proposals touch on themes similar to those that were identified by the artists, including inequality, immigration, state violence, and the particularities of everyday life in Philadelphia. Sixty-three proposals call out for a monument to those displaced by William Penn's colonial enterprise. Within this subset, one proposal offered by @pretzelpup at Malcolm X Park in West Philadelphia calls for monuments to the Munsee, Unami, and Unalachtigo peoples, all groups or languages within the Lenape First Nation. There are 209 proposals celebrating women, ranging from broad calls for "sisterly love" and "women's rights" to proposals identifying specific women deserving of recognition, such as the two for a monument to Sister Rosetta Tharpe, a queer woman of color who helped shape early rock 'n' roll. There are proposals for monuments to unity and calls to end police and state violence.

MONUMENT LAB

What is an appropriate monument for the current city of Philadelphia?

NAME YOUR MONUMENT:
" ORIGINAL PEOPLE "

PLACE YOUR MONUMENT:
ADDRESS, INTERSECTION, OR NEIGHBORHOOD
replace the Columbus monument @ Penn's Landing

DESCRIBE AND/OR SKETCH IN THIS SPACE:

The Munsee "People of Stony Country"

The Unami "People Down River"

The Unalachtigo "People of the Ocean"

YOUR ZIP CODE: 19143
YOUR AGE: 26
YOUR NAME, @, AND/OR HASHTAG: @pretzelpup
RESEARCH ID: mx 6

Mural Arts Philadelphia

#monumentlab
monumentlab.muralarts.org

Various visual motifs also appear among the proposals, including several in the shape of the famous Robert Indiana *LOVE* sculpture ("MOVE," "LIKE," "JAWN"). Benjamin Franklin, who has more than a dozen memorials around the city, is reimagined in many proposals, including one in which he is posing as Rocky and another in which he is eating a cheesesteak while punching Ivan Drago, the fictional villain from *Rocky IV.* More than eighty proposals describe monuments of people holding hands, generally as a call for unity across lines that regularly divide people.

The Monument Lab data highlight themes in Philadelphia's story, but the data can also be used to build an understanding about what a monument is, or might be, and how people choose to express themselves. Of the 4,445 submissions made in 2017, 962 are entirely visual (with no words on the forms, though some of those were beautifully illustrated). People who proposed monuments imagined them taking a broad range of physical forms, including trees, songs, protests, parades, and digital projects. A large number of people imagined their monuments as a sculpture or statue, which, to some extent, is to be expected. But the second most popular form for monuments to take was "interactive," meaning that the proposers imagined people using the statues, not just marveling at them. Many people proposed monuments designed to

Proposals by Type, Data Visualization, *Report to the City*, 2018.
(William Roy Hodgson and Stephanie Garcia/Monument Lab.)

help create a new kind of public space or to provoke people toward new modes of engagement.

Our data team read the research forms proposed by Monument Lab participants to glean conclusions about the medium or genre used for each speculative monument. What is not shown, however, is that while 1,403 proposals take the form of a sculpture, 1,727 have no discernable form at all. This "other/no form" category includes a huge number of proposals that either take a form we could not have accounted for in our categorization (for example, clouds or imaginary

Map of Proposal Locations, Data Visualization, *Report to the City*, 2018. (William Roy Hodgson and Stephanie Garcia/ Monument Lab.)

machines) or describe only what the monuments should symbolize or represent. That is, the respondents centered their responses on how the monuments should make the city feel or what they should help us remember or understand. For example, someone named Alex proposed a monument at the King of Prussia Mall, explaining that it would be nice to have "something that speaks to the natural friendliness of Philly & surrounding areas" and adding: "As someone from the South, Philadelphians are the friendliest, most neighborly people ever. When I visit the city, it's only proven further. I'd love to see a huge symbol of that!" Another person, Anna, from West Philadelphia, who gives no monument name or location, just says, "To think about how the city is changing with the gentrification of West Philadelphia." For Anna, the answer to a request for an appropriate monument was a call for consideration and reflection. An anonymous proposer from Port Richmond writes simply, "Something about being a sanctuary city." Other proposals treat the form more like a comment box about the project or the city itself. In a proposal offered at Penn Treaty Park, Michael from an area nearby speaks directly to the mayor: "Message to the mayor! Could you remove the car auction lot and reclaim it for the people. Expand Pulaski Pier Park! Return the waterfront to the people that want to use it for recreational/community space, making it an exceptional park that extends to the next pier!!! Many of these businesses don't need to be by the water!!!!???!!!"

People used the paper, the question, and the project for their own purposes. They offered some responses that cannot easily or adequately be mapped in our system, rejecting tight definitions of ages, places, and even zip codes and challenging the systems we have for storing and sharing spatial and numeric data. The Monument Lab data are difficult to contain and catalogue for many reasons. But their richness shines a light on the ways that official forms of data collection and distribution hide valuable truths and perspectives. The Monument Lab research is a small intervention that was designed to spark rich conversations and to create new stories and new data to feed networks of information that might eventually support new kinds of monumental expression.

Notes
1. Shannon Mattern, "The City Is Not a Computer," *Places Journal,* February 2017, https://placesjournal. org/article/a-city-is-not-a-computer/.
2. *The Monument Lab: Report to the City* and the full open data set are available at monumentlab.com.

IV. MONUMENTAL EXCHANGES

Public Conversation: Hank Willis Thomas and Tariq Trotter,
moderated by Salamishah Tillet
City Hall Courtyard, September 16, 2017

Salamishah Tillet: Hello, Philadelphia. It's a real honor for me to be here because of you all and, obviously, what Monument Lab and Mural Arts are giving to the city of Philadelphia and to the world. I've been a fan and student of these two artists [Hank Willis Thomas and Tariq "Black Thought" Trotter] for a very long time, for my adulthood. I'm honored to share the stage with you both. I'm going to start off with Hank, because, obviously, your artwork, *All Power to All People,* has inspired lots of different kinds of conversations and debates. I want to talk about the inspiration for the piece, both in terms of when you were asked to create this sculpture and what kind of Philadelphia history you were pulling on, because I know your family is from Philly. The title channels the language of the Black Panther Party, which continues to hold a lot of meaning for people today. But the title you have is so utterly democratic and I think there are ways in which the Black Panther Party and the Black Power Movement get stereotyped or scapegoated as being undemocratic, unpatriotic. But you revive, in many ways, the way in which it was such an inclusive movement. So just talk about what you were thinking when you created the sculpture.

Hank Willis Thomas: Well, thanks. It is great to be here, great to be here with you [Tariq Trotter], living legend. I think that the work could have easily been titled *Black Thought.* It did actually cross my mind but I didn't get your approval [*laughs*]. I think for me, the work is most inspired by my grandmother, Ruth Willis, who's sitting over there, who went to Apex Beauty School and was a beautician in North Philadelphia. And also by Claes Oldenburg, who has a sculpture there, on the other side [of City Hall], of a huge clothespin. When I was a kid in Philadelphia, we'd drive around City Hall and, if you looked out the window, all you could see was that clothespin. And I remember thinking: "Why is there a big clothespin?" And someone said, "That's art." And I was like, well, "Why is that art?" And also probably around that same time is when I was getting used to getting my hair combed with an Afro pick. It hurt with the metal picks. And I always wondered why there was a fist on top of the handle and it was one of those little questions that you have as a child: But why? And when I got an opportunity to collaborate with Monument Lab, I just, for some reason, really wanted to make this kind of memorial to an element of American history and African American history and Philadelphia history that I think isn't often talked about or celebrated. My father was a Black Panther here in Philly. My

grandfather and his brothers were all police officers during the Frank Rizzo era and so I heard multiple stories about that time. And then, lastly, the title, *All Power to All People,* is a quote from Fred Hampton, who was murdered by the Chicago police, where he was giving a speech where he said, you know, we want white power for white people, we want yellow power for yellow people, we want brown power for brown people, we want black power for black people, and all power to all people. And this idea, sometimes, that black power is supposed to be in negation of other people's power, rather than an elevation of all of us to equal levels, is forgotten about in the Black Panther movement.

ST: Black Thought, Tariq, you're from Philly and you must've seen that Frank Rizzo statue a lot growing up. And also, obviously, lived and understand the legacy of the Rizzo era here, so I was wondering what struck you when you first saw Hank's sculpture. And there's been a lot of conversation about the proximity of the two monuments to each other. So I was just wondering what your feelings were, what your thoughts are, and then I'll ask you a follow-up question about, since you're on the board of Mural Arts, the role that you think public art plays in Philadelphia.

Tariq "Black Thought" Trotter: I kind of grew up down here at City Hall, which functions as a crossroads to the city. It's where buses, trolleys, and trains intersect. It's where lives literally intersect and it's what unites north with south and east with west here in the city. I remember, as a young person, I lived within relative walking distance, so I would walk here and this was one of those places that we would kind of kick it long before we had the ability to text one another and say W-Y-A, "where you at," or whatever. We would use landmarks like City Hall or the Annex Building, which is where I first met Jane Golden, or the clothespin across the street, you know. The clothespin always resonated with me as a representation of the working class and just the common man. It was an item that I was familiar with. Almost everyone I knew had a clothespin in their home. When I was young, I couldn't afford action figures and stuff like that, so clothespins were my army men. That was my GI Joe or whatever. That being said, the fact that this monument that Hank has created is on display in such close proximity to the statute of Frank Rizzo speaks volumes to the people like myself who feel like the idea of *Clothespin* and monuments like that resonated with us, but I didn't feel like the clothespin was necessarily for me. I didn't feel like City Hall was necessarily, you know, functional for me. I've seen people get married here and start their lives together. I've witnessed the pageantry of the Mummers Parades and

choirs singing out here during the holidays. But this is also the building where I sat through the murder trial of my mother's killer, the building that I've witnessed many a neighbor and a family member disappear down into the catacombs of, you know, sometimes never to see the light of day again. So this building, this courtyard, that statue have always brought about many different emotions within me. And when I saw the monument that Hank put together, it just resonated with me in a different way. I felt like a voice was being given to a voiceless people and I felt like a part of our community that has been underserved for such a long time was being spoken to.

ST: I want to ask about the process of designing the sculpture, Hank, and I'm going to keep on bringing up this Rizzo thing only because they're just very different monuments physically. One, obviously, is built in such a way that it's supposed to stave off time. I would think the Rizzo one was built with this sense, hyper awareness, that it's supposed to outlast us all. And then I was wondering about your piece, which I know will be moved permanently to another site. But we're in this moment of temporariness, right? You post on Snapchat and it lasts only twenty-four hours. Our photos live in or on Clouds and we don't necessarily print them out anymore. So our understanding of time has changed. What does it mean for you in terms of building a sculpture and how we experience monuments today? This is even different than murals that are put on a building, I think. If we think that time is so fleeting, then what's the role of the monument at a moment in which our relationship to time has changed?

HWT: Well, I think a lot about it. I really appreciated getting to hear Mel Chin speak about this a little bit earlier about the way in which the individuals activate the monuments in his sculpture here. And I think with all the artists in Monument Lab, what we were really, I think, subconsciously dealing with is a time when we're almost in a post-hero nation, a post-hero moment where we now recognize that all of our heroes are flawed or incapable of doing the impossible. I think monuments like the one to Frank Rizzo suggest this larger-than-life figure who was welcoming people from the municipal sector and, obviously, there are many other sides to that story. But what I wanted to do, and what I think a lot of the artists wanted to do, was make monuments that were open-ended. So they don't just make one statement, but they make many statements and they actually don't really make sense unless someone is engaging with them, which is different than other monuments around the city. And so that's what I really love with this piece. I really thought of it more of a question than an answer. I think all art is trying to propose a question and the community that interacts with it is actually the answer. And so I really

loved learning and listening and watching people interact and rethinking my own perception of what I'm capable of and what artwork in public space is capable of doing.

ST: So what's one of the questions you wanted to ask the public?

HWT: First [*laughs*], will somebody pay to put this Afro pick in public? That was the first question [*laughs*], you know. That seemed to work out. We have an answer. But it's never just one question. But there's also, like, how will people respond to it? Will it make sense, you know? And I think the question that I had to deal with is why some people might see it as offensive because there are Afro picks in stores pretty much everywhere in the country and it has a six-thousand-year-old history. And so I don't quite understand how that could be seen as offensive to certain people. But I also have to recognize that it's also an interpretation of the work.

TT: I agree. I feel like something's going to be interpreted by the eyes of the beholder, you know? I definitely think with the short attention span that we have right now, the fact that messages do self-destruct and, you know, the shelf life of art is becoming far shorter than it has been in the past, that it kind of allows us to avoid ownership. It allows us to, you know, to escape being held liable for our words and our actions and for the way that we are as a people, as a society. We text one another "Love you" far more than "I love you." We text "Sorry" far more than "I'm sorry." So there's a disconnect and, again, I just feel like this monument being so close to that Frank Rizzo statute speaks volumes about the relevance of the Afro pick originally. And, you know, it speaks to the sad truth that the statement being made in the seventies with those combs is still very relevant. There are still police officers just like Frank Rizzo out here today. There are politicians, you know, like Frank Rizzo, out here today. Personally, in my opinion, I think it should stay up. I think it should be a permanent monument.

ST: Since we're all from the same generation, I want to talk a little bit about what we can think of as a hip hop aesthetic and the way in which maybe Hank—and, you have to follow my line of thinking here, but I've followed your work for a long time and one of the dominant modes of hip hop is using things from the past and recycling and refurbishing them to give new meaning in the present. And, obviously, you know, you [Trotter] are, you know, a hip hop legend, so I don't have to tell you what hip hop aesthetic is in terms of your work. But I wanted to talk a little bit about, like, what does that mean today? How can we think about the Afro pick? Even though it's a nod to the past, it's inspired by

the past, it's almost like only someone from our generation could have created it, right? Like, maybe your mom [Dr. Deborah Willis], Hank, for example, she may have created this as an image. But the Afro pick may not have been what comes to mind for an earlier generation to make as a statue. And so it seems so generational. But it also seems so hip hop to me. And I just wanted to talk a little bit about what that means in terms of the way in which hip hop has informed so much of American life and also has helped us innovate art in really new ways. If you think that's true, you can say it's not true or whatever.

HWT: This is the first time I have ever said this, so I might take it back, but I think hip hop is the ultimate realization of the American dream.

TT: Can you say that again, please?

HWT: Hip hop is the ultimate realization of the American dream, and this idea that I, just me, can change the world with what little I have, with my ideas, with my words, my powers of persuasion, is something that I think the Founding Fathers who weren't thinking at all, well, they were thinking about the descendants of the ancestors that were founders of hip hop as property but they weren't thinking of them as actually the creators of the future and the creators of this nation. And so, I guess, that's one thing I think about. I've been thinking a lot about Muhammad Ali, and by re-naming himself but also by stating that he is the greatest, and even after his passing, he still is the greatest. The audacity of putting your ideas, putting yourself out there, that, I think, is really what hip hop is founded on. And this work, you know, although it's also inspired by a Swedish American artist, Claes Oldenburg, you could also make a hip hop gesture and be like, I'm going to put a big clothespin down in City Hall. A visual culture DJ is what I refer to myself, where I've taken elements of visual culture and tried to remix them and put them back. And when we call something art, it allows us to think deeper about stuff we already know.

TT: I totally agree. I feel like this work is hip hop. This work is jazz. It's punk rock. It's, you know, rock and roll, rhythm and blues. It's something that is guerilla and gangster and it's daring, you know, to be different. I think art at its best challenges us. And I feel like that's what Hank has done here is. It's definitely hip hop.

ST: Does visual culture impact your lyrical prowess and your musical sensibility? Is it a back and forth?

TT: Absolutely. You know, every form of art impacts the other. I feel like the arts are the arts and they go hand in hand and music inspires spoken word, which inspires song lyrics and visual art and then, you know, it's a never ending circle, the circle of life, so to speak. The medium is ever changing and ever evolving for me. But I wouldn't be where I am today without the arts as a whole, without visual art and creative writing and drama and theater. You know what I'm saying?

ST: Hip hop also was a multimedia art. I want to follow up on another icon in the city, the Liberty Bell, and the fact that it is cracked. I think it gets to your idea that symbolizes the moment we're in, the post-hero moment. It's the crack, as we heard earlier, that symbolizes this moment, but I mean, what's interesting about Monument Lab existing today is, you know, a year ago or two years ago, it would've had a different resonance. But post-Charlottesville, a movement has really grown to have certain statues removed, not as a way of us forgetting the past, but as a way of us really remembering the horrors of the past and inequalities of the present. Then there are some people who are saying, you know, keep these Confederate statues up because they are the past and we don't want to forget. There seems to be a real tension between some people who think the removal of certain statues means we're going to forget and other people agitating for that as a way of remembering. I was just wondering what you think about any of these. I know it's a heavy question.

TT: I'll definitely agree that the crack in the Liberty Bell, you know, could represent something deeper, depending on how you look at it. I look at it as representing a flawed system. With regards to monuments, post-Charlottesville, that people are entertaining the ideas of taking down, I think that's a good thing and I think it's a catalyst for change, you know? I think we'll never forget with or without the monument. So I feel like the symbolic meaning of moving some of these structures just speaks volumes to progress.

HWT: I think we always have to consider how we remake public space. At some point, there needs to be, you know, a reconsideration of who we are, where we're going, and how we want to present ourselves to the world. I go back and forth about taking down. I think some of them, yes, there's definitely far too many and you have to make space for new monuments and I think, unfortunately, for some people from the past, you know, they're going to have to stay there [*laughs*]. Part of what my struggle currently is, is not being reactionary. I think it's far more important to be visionary and it's hard to be visionary sometimes when you really, really just want to react. But if I'm too busy wrestling with

them, I'm not going to be able to reimagine the future. So I also think the public should be part of the discourse about what we do with these sculptures. It's too often that someone decides, in a room, what our history is, because that's the other thing, our history, it's ours. It's ours. It's not a history, it's our story and if it's only history then we're missing most of it.

ST: You, Tariq, were saying when you were passing through City Hall: On one hand, you're from Philadelphia so you obviously belonged, but then you didn't feel like you belonged and this idea of black bodies taking up public space or black symbols taking up public space. And I think it's really fascinating because there've been a lot of ways, like, when you said, Hank, that we have to remove certain statues to create almost the possibility for us to see a different future, a different America, and just literally have the space for new monuments. What does this mean for creating a safe space for black bodies in the public and symbols of an African American history in the public? The challenges to that exist, because they are fused with so many possibilities, but there's also a lot of backlash. What are the challenges of occupying these kinds of spaces with our symbols, with our bodies, with our voices, and how does that impact your art in any way?

HWT: I mean, I'm curious because the thing that I think is the most powerful about The Roots is that it feels like it's ours, you know, with so many of the ways in which you guys create a space where people, like the Picnic, you know, the different studio sessions, et cetera. I think there's a generosity that is what I think has kept The Roots alive and I'm curious about in 1986, was it?

TT: '87.

HWT: Calling yourself Black Thought and what it meant for you guys, I'm asking a question within your question, why you went the route you went rather than trying to go for the stars, actually creating a grassroots network?

ST: As a band originally and then a collective.

TT: I feel like we're all here to serve a particular purpose, whether we're aware of it or we come into consciousness at a later date, you know. So, I mean there're definitely powers at play that are beyond our control. And there have been a lot of different points in my career that were in the trajectory of The Roots where we've had an opportunity to take the easy road or the low road. And, you know, we just couldn't. We just couldn't.

HWT: Probably because you're from Philly?

TT: You know, that's a part of it. We've never wanted to have the city feel as if we've abandoned [it] or let the city down. But I think more so, we didn't want to let ourselves down, you know? So, I mean, it's just a delicate balance of remaining credible without, you know, offending and without, you know, coming off as hostile. And, you know, it's not easy, but that's just something that we've managed to do. And I think the fact that they we were able to continue to reinvent ourselves and that we're still here is a testament to it having been the best decision.

HWT: I'm just learning from that, this idea of being credible without being considered hostile. There is that balance also within the work, when you deal with images or ideas that are charged, where people want to put you in a box, but you actually want to be part of many boxes [*laughs*], is really something I've been trying to balance.

ST: What does that mean, though, credible without being hostile? Because I think all of us in our different fields are trying to achieve that. But then it's interesting to think about your piece, which some people see as hostile but only because it's from a different era or represents a different moment, or represents freedom in a particular way. So what does that mean for you as artists?

TT: For me, it means to represent, to speak to the interests of the community, my community, you know, without making some of the, for lack of a better term, mistakes of those who have come before me. You know, I've seen many an artist from various media fall from grace. It's just that delicate balance. Just like that game of the juggle is what I mean. And it's something that is, even if you're not an artist, something that you kind of always, we always have to be conscious of as black people, especially as young black people, or, in my case, not so young. It's difficult to get your point across in a way that, you know, is not going to be interpreted as offensive.

HWT: Often, when you take a stand, people want you to be stuck there. And I think we can take stands and take steps. And I like to say that the road to progress is always under construction. Every time we reach a milestone, we have to actually anticipate that there's more work to be done. And I think the danger is sometimes when you make a bold statement is that you can define you if you fall into certain traps, so to speak, about who you must be if you say this or you call yourself this. And, that again was the power of Muhammad Ali—you know, [his] becoming a universal figure in spite of all of the ways in which people were talking about black

Muslims and Muslims and his position on empowering people of African descent, the fact that he was embraced seemingly by the entirety of the world through maintaining his integrity and credibility in spite of amazing success or setbacks.

ST: To close, because I'm obsessed with Nina Simone for many years now, you know, that quote that you hear so often now, she thought the responsibility of the artist was to "reflect the times" and there's risk and reward that comes with it. And I just wanted to know, if you have to close out, and say what is it that you think. You spoke about responsibility to community, responsibility to the past, responsibility to the present. But, I guess, if you had to come up with your own artwork, what's the role of the artist, what would it be? Or the responsibility of the artist, if anything?

TT: I agree with Ms. Simone in that the responsibility of the artist is to reflect the times. It's to, you know, be a capsule. It's to document our existence here for years and generations to come afterwards. You know, it's not easy and it takes a lot of bravery and daring, but when you make the choice to become an artist, I feel like that's the responsibility that you have to accept.

HWT: And when I think about Nina Simone, I immediately think of her song "22nd Century."

ST: Which you told me about for the first time, many years ago.

HWT: Only because she wrote it in 1972. And I don't know how many of us are thinking about the twenty-second century, much less the twenty-third century. And that's about being visionary, about thinking about the future. James Baldwin spoke about the artist's role to search for [his or her] own integrity. I think within my work I don't necessarily feel like we all should be doing the same thing or achieving the same role, but finding our own authentic integrity and learning how to express that and hopefully become better people. He said that the artist's search for integrity must be considered the metaphor for the struggle, which is universal and daily for all human beings to get to become human beings. And I think that means that our job is to try to become the closest to what we can as true human beings.

Monumental Exchange 2
Public Conversation: Sharon Hayes and Karyn Olivier,
moderated by Paul M. Farber
University of the Arts, September 20, 2017

Sharon Hayes: Thank you all for coming. It's a pleasure to be here.
I have shown in Philadelphia before, but not since I have lived here.
So, it's a pleasure to have a public event in which I can intersect in the
conversations with students and colleagues and friends and neigh-
bors and fellow artists. It's a real pleasure to be here on this panel
with Karyn, whose work I love, all of her work, but also in particular
her project for Monument Lab and I look forward to the conversation.
I also want to take this beginning moment to say that this kind of
project, everything that I've made, is a collective effort with a lot of
people behind me who contribute intellectual, physical, and temporal
labor to what I do and for sure with this project that was true. So I
thank Ken and Paul for inviting me in and, in particular, just wanted
to acknowledge parts of the team. The full team is available through
various mechanisms, but in particular Corin Wilson, who is the
project manager; Pavel Efremoff, who was the production manager;
Heryk Tomassini, who helped along the way in terms of drafting and
rendering. Some of them are here, and I'm deeply grateful for your
labor and time.

Whenever as an artist I'm invited into a project, particularly a com-
mission, there's something that precedes me and I think it's maybe
not something we always think about but it's also important to what
happened. And that is to say, there's a reason why I was invited into
this project and to this consideration of monuments and my thought
today about the ten minutes I have today is to give you a little bit of a
sense of maybe what that ground was and then to show you because
we didn't want to assume that everybody had seen the work that we
have up in Philadelphia. So I'll show you that project, talk just a little
bit about it, then it will unfold, I think, in conversation. So, in my work
for the past twenty years, I have dealt with specific intersections
between history, politics, and speech in this kind of wide-ranging
investigation that foregrounds in some ways performance and then
mediums that can convey performance after the fact. Video, sound,
still images, slide projection. I've been particularly interested in the
relationship between these spheres that I think we separate that are
not so separate: the public and the private or the personal and the
political. I think much of the reason, in a way, that I was invited into
Monument Lab was that, in some ways, for the past decade or a little
under a decade, a lot of my work has sited itself in public space.
Maybe what's important about how I arrived at this, which I think
lingers in this object a little bit, is I came to the street or to the space

of the public through an interest in public speech, not so much public space. And, so much of the work that I have done over the past twenty years has also been investigating these very specific histories or legacies of remnants of un-schooling the history of a queer history, feminist history, and histories around resistance or protest. In that, I think what is also important to me is that very often my work is engaging a past moment, a historic text, a historic event, and pulling it into the present moment, but not with an understanding that I can unpack what happened, but rather to ask questions of the present moment.

So, in some ways, I think of the present moment as a moment that is stacked with other moments and a moment that is constantly pushing us both backward and forward, not stacked with all moments, but stacked with precise moments that agitate around unresolved conflicts, open wounds, things that I can say live on in various ways in our embodied lives and encounters with each other. So, when I was mulling through or hashing through the bottom question, which I think many people know, but in some ways we were invited as artists to address what's an appropriate monument for the city of Philadelphia today. There are two things that are maybe impactful to that. One is where I came from, which I described some of. And the other is where I was, which was a new resident of the city of Philadelphia. I actually grew up in Baltimore and I spent most of my adult life in New York. And so, before moving here a little over a year ago, I was, like, " Okay, Philly, no problem. New York. I got it." But, of course, it's a very, very perplexing city. And so, on one hand, I think I used the invitation as a vehicle to try to understand where I was, to try to understand this city better. I started, in some ways, with places that I know. Very often when I'm trying to learn a city, I go toward its queer history.

And so I did start in the William Way archives trying to find my way around some of those threads and legacies. And so this is an image from the 1972 Philadelphia Gay Pride Parade, which was the first gay pride in Philadelphia. And the rally began at Rittenhouse Square and then moved to Independence Mall. And, as I was working through these histories, there're some complex moments that those of you who have lived in the city and are attached proximate to these queer histories know far better than I do. But immediately I noticed that Philly has this history of being quite early in terms of a certain kind of public protest that is making a space for queer lives, which are called the Reminder Day Protests, which happened between 1965 [and] 1969. They stopped happening because of Stonewall, because everything shifted to New York. 1972 is a return to that. But inside that history there're also very complicated things around, How do we protest as queer people? How do we publicize ourselves? How do we make

our lives public as queer people? And the Reminder Day Protests hold a lot of tension around that because there was a perception around being kind of easy on the eyes to a certain extent. And that closed off a really important aspect of queer history that I want to mark because I think it became impactful to what I was thinking of, which, as I was [going] through Philly, it resonated with things I'd known in other cities. One of the contributions to our current moment that I think is one of the most powerful [is] people whom I like to call gender warriors, people who, you know, for centuries, but in particular with a kind of ferocity and a collectivity after World War II, who started pushing the boundaries and the containers that we could inhabit in terms of gender. So people who just went about their lives, living and wearing and being the gender that they were, which we have understood in a public sense as sometimes gender non-normative, gender nonconforming, it now is also sometimes referred to.

And so, for me, that work postwar, which, in some ways had eruptions in this city with sit-ins and Dewey's cafe in 1965 and other eruptions, was really impactful. So it's this labor and this effort and this risk and this courage that I think becomes hard to materialize. In these early stages of the project, I was thinking a lot about absence and I was thinking a lot about how you celebrate what we probably think of as non-monumental activities, as just going about one's day, but going about one's day in a way that makes space for more complex inhabitation. Perusing around, then, the monuments that exist in Philly, I also was circulating around another absence, which we're all, I think, quite aware of, which [is] the absence of monuments to women in the city. Philadelphia is very like other American cities in that there is an enormous disparity between the monuments that are dedicated to them and the very, very few that are dedicated to a real, historic woman who lived.

Very often in monuments, of course, female figures are used to represent some kind of allegory for an allegorical scene or setting. But in terms of real historical women who lived in Philadelphia, there are two: Joan of Arc and Mary Dyer. Mary Dyer is at the Cherry Street Friends Meeting House courtyard. And neither Joan of Arc nor Mary Dyer was a Philadelphian. Both were killed, of course. And so I found myself lingering around some of the monuments that exist in our landscape in the city and I think in some ways maybe it was my performance-based work or my video work that compelled the invitation. But, in fact, when I thought about addressing absence, I didn't want to work in mediums that capitulate to absence, the mediums that I adore, that I love, but that are also ephemeral, [and] I felt like I needed to speak with weight and with girth and with heaviness and with presence. So that meant that I was working in a territory that I don't work, which is, How does an object speak on its own? How does an object speak

without a performer on that object or without the video that is being projected onto that object?

As I lingered around monuments in Philadelphia, I started to move toward a kind of composite object. I guess the one thing I should say also about the gay pride image that I showed is an early idea that I was interested in, which was recreating the same gay pride event. And that meant that Rittenhouse became a kind of focus, which I think in conversation in particular with Paul made a lot of sense. But the Friends of Rittenhouse Square were not so interested in this. So I think I made a long kind of walk to come back to some way that I could still speak to my initial desire to have a platform. As I was considering the way in which women have contributed to our civic life in Philadelphia, I was interested in something that could claim both the space of public speech and the space of public presence. So the object ended up becoming a kind of composite of pedestals. In the end, there are nine pedestals that are recreated from pedestals that exist in the city that are holding monuments to men and they're recreated at half-scale. In part, half-scale was just a way to conform to the amount of footprint that Rittenhouse would allow. A very interesting thing happens when you make a pedestal at least this scale that I was in the range of. When you make this scale pedestal half-size, you've made it human-size.

And so, in essence, what I ended up with was a composite object that I colloquially call "a monument to the absence of monuments to women." Importantly, around its base is text that's inlaid in plastic acrylic that says: "On this site there could be a statue to . . ." And then a list of just under eighty names of women who contributed to the civic, cultural, economic, political, [and] religious life of Philadelphia. There're two other important things that some of you know if you've read some literature about the project. But it is important for me to say. I think when we consider, anecdotally, the absence of monuments to women, we tend to think, "Okay, well, women didn't have political power at the heyday of monuments." But, in fact, for those of us who have dug around in monuments, white women had enormous power and were incredibly instrumental in the populating of our American cities with monuments. And for me, there's a whole complex perversity in that set of conditions that allowed for this sort of empowerment of a range of different white women in the choice that they made essentially for the kind of white patriarchy as the subject of our lives. So, for me, there were two things that were really deeply important in terms of the name: one was to excavate against the collapse that often happens, that has been sort of at the beginnings of our articulations of collectivity around the term *woman*, which is the collapse of women into whiteness, white women, and the collapse of women into women.

So inside of that list of names is an important resistance to the kind of racialization of the term and also this kind of biological determination. In terms of the city of Philadelphia, one of the other things that's interesting to me about these histories is that on this list of just under eighty, which could have been far larger, but for real estate, you realize something when you work with objects that there's this spatial real estate, meaning, there can only be so many names. But there's something very intriguing for me because Philadelphia is a city that loves a particular time period and that we attach very strongly to the late eighteenth century. And if you dig into that history, even at the slightest, there is a massive sort of population of white and black women who were agitating at and working toward the things that I think matter then and matter now. So that there is on this list a range of people from the mid-eighteenth century forward to the present moment. I think everything else will uncover itself as we go. Thank you for your time.

Paul Farber: Thank you, Sharon. Next up: you'll hear opening remarks from Karyn Olivier.

Karyn Olivier: I'm so excited to be here, but now my students are here and they were not supposed to be because Leslie Hewitt was scheduled to be a guest speaker at Tyler. Well, hello students. I feel really honored. That word kept going through my mind. I feel really honored to be sharing this time with you two and with you all and it feels very special.

I never realized that the things I've made in the past were monuments. Now, I recognize, yes, those are monuments. I'm only going to show work from this project. The work I do in the public realm begins with research. I have to spend time in a place. I need to hang out with people, chill there and then begin digging in the library. That's how I do it. When I was offered the opportunity in Germantown, my neighborhood—I live five blocks from this park—first, I thought, "This is my park." I can just hang out and gain a more acute sense. But then I quickly realized I still needed to adopt the same process of research. I was intrigued by two monuments in the park.

This one is *The Battle of Germantown Memorial* and it commemorates a failed battle that George Washington led in the Revolutionary War. I was thinking how interesting it was that this commemorates a failed battle. I'm going to read the plaque that's adhered to the monument. It reads: "Upon the whole it may be said that the day was unfortunate rather than injurious. We sustained no material losses. The enemy are

nothing but bettered by the event and our troops, who are not in the least bit discouraged by it, have gained what all young troops gain by being in action." I was pondering who gets to have a monument. How does that decision happen? Well, it's George Washington, but on the other hand it represents a battle that was lost. There was no victory on that day.

While conducting all of this research about the monuments, I realized that it's difficult to discern what is myth or what the truth is because every account said the same thing—the reason why we lost the battle was because the fog came upon us and the British troops had the upper hand [*laughs*]. And maybe it's true, maybe it's not, but this is the story we choose to tell ourselves about this event. And every year this battle is reenacted. October 7. I've got a bit of hate mail about it—"You covered up our monument and our moment is approaching." I'm getting ready to explain to them that now that it's covered, people are paying attention to the monument and I'm actually protecting it for three months from the elements.

I was initially interested in this monument in the far corner of the park that commemorates Francis Daniel Pastorius, a German settler who brought the first Germans to Philadelphia—the reason why the neighborhood is called Germantown. But what I loved about this was finding that he led the first Quaker protest against slavery. He convinced the Quakers to affirm, "Come on, we can't be Quakers and own slaves," which lead to this 1688 fight for liberation. But I also found out that at the beginning of World Wars I and II, the monument was covered and boxed over because civic leaders felt the language and aesthetic were too Germanic. I thought it was so interesting—this immigrant fighting for a section of the American population—fighting for the freedom of slaves. Then you have this monument to George Washington, who is fighting for America's liberty from Britain, attempting to win our freedom as a collective while still owning slaves. I wanted to do something that meshes these disparate but complex histories.

I thought about the paradox and the complexity of that. I wanted to take what happened to the Pastorius monument and apply it today. So I decided to shroud *The Battle of Germantown Memorial* with a mirrored surface. In effect, I boxed it up in the way the Pastorius monument was in years past. I was hoping that the concealment—the covering, the cloaking—would allow it to feel really expansive. I was hoping

that all of a sudden this monument would feel accessible and less intimidating; its colossal nature and material weightiness would dissipate, or you would feel access to it in different ways because you're no longer burdened by the scale of it. I was also interested in invisibility. I approach the park from the Rittenhouse entrance and it's so funny because every time I enter, I panic because I don't see it and it's the dumbest thing because I knew that would happen—it would disappear at different vantage points.

It's quite arresting that it actually appears to disappear. So I was thinking about invisibility. I'm literally rendering the monument invisible but, in this invisibility, I'm making people notice it again. This park is not like Rittenhouse Park, which is a neighborhood park that also functions as a touristic park. Mine is solely a neighborhood park. People from Germantown go there and the reenactors [go] once a year. I was questioning this monolithic, imposing presence that monuments and statues in public tend to take on. Perhaps there may be a physical or metaphoric distance you experience with the piece because of its imposing presence. Or maybe if you walk past something every day, you don't register it or see it anymore. Or perhaps you feel that "the history portrayed is not mine."

While spending time in the park, people would come up to me sometimes and say, "You've covered up our monument." And I'd ask, "What's under there?" And they replied, "I don't know. It's a monument to something." And I would say, "I bet you when the covering comes down you're going to go see what it is." OK, I'm off-topic. So I was hoping that, because it's a neighborhood park, you see this monument all the time. At some point, you don't see it anymore or just marginally. You know it's there on the periphery but you're not paying attention. But I was hoping that this thing that's familiar or supposedly known, if I cover it up and change the surface, all of a sudden it would become strange and the park would become new in a way.

I figured a kind of uncanny moment would happen, like this guy pictured here on his bike kept moving, would go back and forth—"Wait, what? What?" Now you can see the world above, behind, around you. That's just not a perspective we usually have with monuments. I thought the mirror would be a way to expose how traditional monuments exist. That guy became a friend of mine, the one in the yellow shirt. He didn't speak to me for days and then finally the day the installation was complete, he called me over. I wasn't sure

If he was one of the folks who were skeptical of this project, because there were a couple who felt as though, "Two blocks from here people are starving. How much did it cost to build this? $25,000?" He took a while to speak and finally said, "This is what we need." Another person in the park said, and I'm paraphrasing, "If the city is willing to spend this money on this park and this neighborhood, maybe they realize we're still here. Maybe they see us. Yes, we took a downturn, but maybe the hope and dream for a better Germantown are coming. We finally have coffee shops with espressos, you know, maybe, they know we are here." I get teary thinking of it. Someone else asked me to pray with them.

Some of my seniors at Tyler last week were complaining, "Who cares about all this theory we read, we just want to see it in practice." And I feel as though this piece material-ized at a moment when it can actually have an impact. Even if nothing happens and the city doesn't re-invest in Germantown, there's a hope right now that something *is* going to happen for this to exist here, for us to be able to see ourselves. There's this assumption that monuments are built because we've collectively decided something's important to celebrate, honor, to cherish. But we know that we don't have equal voices in that mandate. So I was thinking, maybe this could be some sort of gesture, a tempo-rary corrective. Or maybe it can be both a realized new kind of monument or a humble proposition. I wanted to engage different axes. We're just so used to that verticality of looking up, reverence equals looking up at this imposing structure, but maybe now one is asked to look around and this object becomes a living, breathing entity.

Can a monument reveal my joys, my disappointments? Can it be both humble and grand? The scale of this sculpture allows it to be grand, but I wanted it to express humility too, reflecting our humanity. I heard someone say that a monument reads like the end of the sentence. But no, no, a monument should be the beginning, where you start to ask the questions. The problem is that you always have this single perspective, a singular interpretation. You can't have a single perspective and think it is the whole truth. We are often given a single perspective that's supposed to stand in for the universal, but the universal is impossible. So having this object reflect a constantly shifting and activated surrounding forces the viewer to consider these multiplicities, the simultaneity of disparate beings and the landscape in the park.

And I loved seeing this; these kids were at first cautiously jumping on it, and I said, "Nothing's going to happen to it; keep jumping." If this was a traditional sculpture, they might look at it and maybe take a stick to it, but these kids were actually dancing in front of it, on it; there're so many great videos of kids playing with it. We know this park is a publicly shared space. We can claim it. We can claim the benches and the walkway. But I hope this project will make one realize that we can also claim the monuments, that monuments are ours, or now I become the monument. I'm the keeper of it.

Maybe monuments can be instruments that offer us a mirror to give witness to ourselves, our community, our city, or to the world. Or maybe they implore us to be aware of the present moment and allow us to reflect on our shared complicated histories. It can be a space that interrogates our histories and poses questions about our past that can speak about its impact today.

This image is my favorite. She's another woman I encountered daily. She always looked serious, angry, or maybe it was sadness. One day she came up to me and said, "You are beautiful." And she didn't mean me but this work became her mirror—*she* was beautiful. I am teary by how emotional it's been for me. Yes, it's my park; I know it. That corner of the park—you don't hang out at that spot because the drug addicts/dealers are over there. It's amazing the range of people that are my posse now, because of this piece. I can't explain how it's beyond what I could've imagined. I knew it was going to be beautiful. I knew it would be timely. I knew the monument would disappear. It could be read politically in relation to Charlottesville, but I didn't expect how much it would become a light, this beacon in a way. The piece is not mine. And that's the great thing about successful public work. Viewers are not thinking about you, the author. If they are thinking about me, I've failed. The audience has to claim it as theirs. They have to say this is mine. This is me.

PF: For the last year, our curatorial team has had the pleasure to work with both of you and see the amount of immense effort that both of you have put into this. Clearly, you both have a research process. You have a rigor to your work reflected in your prototype monuments in public spaces, which required a push and iterative approach. I'm curious to hear how, for each of you, these projects fit into your usual art making and what you had to do here that was different from what you normally do to make your work.

SH: Well, because you also cited research, I do also want to acknowledge two people who are here—Monika Uchiyama and Carolyn Lazard, who've helped me immensely in terms of that sprawling research process and continue to help me with that sprawling research project because there's a web component to it where we are trying to fill in content and make it easy for people to find all the names on the object and the names that didn't exist on the object. And that's ongoing. So, I mean, I guess I've anecdotally said that my work is labor intensive. I make multichannel video work that involves a lot of people very often. And it's labor intensive.

I have never worked as hard on a project as I have on this project. I was constantly, "Oh, my God, this is taking so much time" [*laughs*]. And I think it's a number of things, like, I think it's the stakes of being in public space in that way, as somebody who has spent a lot of time making work on the street. This is a really different piece and there's a really different sense of publicness. So I think, for me, actually, this is unlike almost anything I've ever done. So everything was different, and the learning curve was super steep and I was, like, really wavering up the mountain to try to learn things really fast to try to learn something. I guess I can say that these are cast concrete. I have a great fabrication team, a mold maker who does historic restoration in West Philly who has these great profiles to make some of the kind of lines of the pedestals or to recreate those, and a really awesome concrete-casting team. But all of these things were also new too, to have an object that I had to conceive of in my mind. I mean, all I can know, like, that moment of, like, presenting a proposal of what you're going to do. I was like, "Okay, next week I'm going to get you that proposal. Next week." That was totally the antithesis of how I usually work. Usually I work in the space of working. I construct scripts as I make the project. I don't sort of plan something out and then hand it over to someone to then see it realized. So, in some ways, I had to do that. And then, in other ways, I just actually kept going until even now, just to keep working.

KO: I have done some public work in the past. I did a series of works using public playgrounds. My background is not art— I started studying ceramics here at University of the Arts when I turned thirty. So I think when I started creating public sculpture, I always started from what I knew. For example, I understand this table. And now that I think I know this table, how can I change it? I did these playground pieces in different parks, which was exciting. But then I think the other projects I've done that have been in the public realm do start with research. I did a project in Central Park with Creative Time. But Central Park isn't my park. Prospect Park in Brooklyn was my park. So I approached it in an objective way

using research, research, research. It's funny how I made assumptions about Vernon Park, thinking research wasn't necessary; the experiential would suffice. And there was a degree of responsibility. This is my park. These are my neighbors. These are my peeps. So it was tough in that way. I knew it had to matter in a way that maybe my piece in Central Park didn't have to, even though in that work I was also dealing with the invisible black community that was destroyed to build Central Park. The evidence was on the surface and layered in the foundation of the park—everywhere, if you knew why and where to look. People are very much aware of Germantown being in this, not-gentrified situation, but there's tension, so I felt as though I did have a responsibility to make it matter more than ever.

PF: Monuments are statements of power and presence and each of your works conjures that. But they also kind of summon absence and make that absence visible in these parks. How did you balance this idea of making an object that would take up space but also deal with clear absences that your work was trying to summon in those spaces, and to this project?

KO: Once I found out about Pastorius's monument being boxed over, my search for an idea was done. I knew I wanted to box over that same monument, but you saw the ratchet straps. It's a mess, that monument. It's barely being held up. Is this legal [*laughs*]? If this was a white neighborhood, they wouldn't have this monument being held this way.

SH: Some of them have neck braces and stuff.

KO: I immediately thought that it would be great to use this history because it's a history that you wouldn't necessarily know about. And I thought the mirrored surface would speak about the present. But I was quickly told I couldn't use the monument because of its compromised state. So I decided to look at the other monuments in the park and focused in on the *Battle of Germantown Memorial*. And then I thought, oh, my God, they're both trying to do the same thing in opposite ways. So, for me, it was easy. I knew I wouldn't want to make another monument. It just made sense to use what was already there. You don't have to invent. Just use what's right there. And I think it's probably not having an art background—I don't have many ideas. I wasn't a kid who grew up drawing imagined worlds, you know? So my mantra is, "Use what's right in front of you." The monument's there. There's this other monument that was boxed up. Just put it

there. And that was It. It just completely made sense. The thing that's amazing is, when you're far away, it's gone. And then, when you get up close, you are confronted with its towering presence. And then all of a sudden you look closer and you see your face. So it's this layering/progression of complete invisibility to being overwhelmed, to "No, it's just, you. And your hair's messed up."

SH: I think that for me—because, in a way, the idea that I ended up coalescing around was exactly absence—like, there was a real struggle to say [that]. I didn't necessarily want to be facing that. I feel like we all know that there are not very many monuments to women and it's this gap that is impossible. It's like an impossible path because how do you address that gap? Like, what do you do about that gap? Would it solve the problem to have sections of all of these women that I propose? No, it wouldn't, because they'd all be constructed now and the gap that still sort of persists with us. So, in some ways, I guess I was struggling with the question of I didn't want to make an object that you suggested we could deal with this, you know, like, okay, here we go, we're done. So it felt important in some ways to find some materialization that could hold absence. And I think so very often in the conversation, and the conversation with the public and other people in the course of Monument Lab, I've heard you asked and I've heard Ken [Lum] be asked the question: "Wow, you know, you're getting this Monument Lab exhibition and now all this stuff about monuments." And you have said, and I've heard others say that, of course, this has been going on for a long time. It's not that all of this has just arisen. First, I think I said this to Caroline or we were saying it to each other, but I'm not sure I ever thought I would live through a moment in our country where monuments were being toppled. And it's great to be alive at this moment. I deeply appreciate this fight. The pedestals and the plan for the pedestals happened before the sharpness of the eruption that has transpired over the past few months and it is amazing to have our objects out in the midst of this conversation. So while the conversation, in some ways, was already going on, it has erupted on a scale and it has proliferated in such a way that now I don't have to myself construct what an empty kind of pedestal might mean. That is great and helpful.

KO: Because after Charlottesville, I remember someone coming up to me and saying: "Yeah, he owned slaves. Right? I'm glad you covered it over." That wouldn't have happened two weeks prior, I don't think. To me, it was more about all you see is blackness or all that is being reflected is blackness and how beautiful that is. But then it became this other politicization when Charlottesville happened, which is great.

SH: I mean, the other thing that, as a newcomer to Philly, I do also want to shout out as really important to my process is the President's House. And the national park that exists, Independence Hall that, you know, as I understand it, was really fought for and the way in which absence and presence and embodiment happened, to go to your point about Washington, and to find a way to articulate the mind, the way in which the founding of our country is held with slavery. That's an astounding site and it has been really impactful to me and to thinking through material absence and presence and marking lines around these rigid histories.

KO: Also with that absence, some people at the park have been saying, "We're not going to want to take this down." But I think it's interesting that the "absence" of the monument is going to do this weird flip [*laughs*]. There will be an absence in the returned monument's presence, which I think is going to be interesting.

PF: In the context of Germantown—which is thought of as a historic district outside of the center of the city, out in neighbor-hoods—Germantown Avenue still has its cobblestones on it, and there're a number of historical institutions that are there. You did reference that the reenactors of the Battle of Germantown reached out to you. So I'm curious, as you artfully come up with your response and try to invite them into dialogue, what do you make of that moment? And, in particular, that idea that these re-enactors have access to history in a very particular way, and do so routinely, and do as part of the backdrop of a neighborhood and you're trying to do something else. How do you make sense of that sort of inquiry regarding your work?

KO: It's tricky because, I've done a lot of research about that Battle of Germantown reenactment. And it was amazing to see they have all these black reenactors and there's a lot of pride in that in relation to black soldiers. I'm torn with it and I don't know how I'm going to really address it because of the importance of the Revolutionary War, but I have to find a way to explain that it's okay to honor within the paradox. It's okay for me to interrogate or investigate or ask a question while still acknowledging what that battle eventually led to: America's freedom. So I have to find a way of saying, "This was one moment out of many that was happening in that single moment in time." So why is it not okay for me to lay other histories, other realities, alongside it? Why can't that happen and be okay? It'd be silly for us to act as though Washington didn't have slaves because that conversation can't be a part of this because we're talking about America's

freedom. No, let's get it all in here. You know? I'm hoping I can meet the reenactors that day with some people protecting me [*laughs*]. No, I think I can say, "We become the monument (through our mirrored reflection), we become the protectors of your monument. It works both ways. We're protecting your monument. We have taken your monument and are actually allowing people to see it in a new way." People who aren't paying attention to this monument right now are going to revisit it. So I feel as though this could only be a good thing that there's a new lens to see this, to see our history. How can we go wrong with that?

SH: We'll show you.

PF: When we entered this project and the goal was to have public prototype monuments in five squares and five neighborhood parks, we thought that Rittenhouse Square would be the most challenging. In one sense because it is its own prototypical public space, but it is one where you don't see new forms of artwork. There's a kind of mandate and a kind of set choreography for what kind of artwork goes in. There are standards of what you can and cannot do. I'm just curious in terms of what we were going back and forth with [during our planning process], what did you feel like you had to give Rittenhouse? And what did you feel like you had to give your own process?

SH: You told me what I had to give Rittenhouse. You said, "You have to give them something that not anybody can make." Which is unlike what I usually make. Usually, I make things that anybody can make. So there. You said that I can't make something that's kind of DIY, which is what I usually make. And that it looks ramshackle, I think you said also. So when I was thinking about the gay pride stage that was just made out of like plywood, I was, like, "Oh, should I cast that in concrete? How do I make that something that not everybody can make?" I think in some ways, of course, it was because I was shepherded, shepherded sort of by you and Ken and then by Mural Arts and then also by the amazing and brilliant Corin Wilson, who made way in that constituency, I should say. I think one of the things that was to my advantage in Rittenhouse, that made it easier, is that Rittenhouse, as you said, is also a tourist park. But also, as being new to Philly, it strikes me as the square that has the most, sort of, dispersed ownership in that it does sit inside of that neighborhood. And that neighborhood for sure has a demographic. But there are a lot of people, because of its history, because of their claim to that space, who have held onto it. And so it's a more dispersed public. And so something like my work doesn't even have to speak to the locality but can speak to the city, and so I took advantage of that and I think in

some ways, yeah, part of the steep learning curve was Rittenhouse and the Friends of Rittenhouse were just a part of that, like, "How do I stay true to what is important to me?" And it was in some ways that it be a speaking platform. That was one of the things that was super important to me and one that I feel really happy to have held onto because it's potentially the one that I rubbed up against the most. Now that's then another interesting thing because I resisted any impulse to program the platform such that it became a kind of object that people performed from, although I thought about that. And now it's interesting to go, because I think a lot of people, and kids in particular, like, when you were talking about kids, immediately go on it with no inhibition whatsoever.

KO: It's that human scale.

SH: Yeah. But I have noticed sometimes going there and at a really active time that there are people lined up on the fountain edge and people sitting on the balustrade behind it but not sitting on the object. And so I've been also taking note that it's in part because it's a stage, because, if you sit on it, you're watched and there's this expectation that you maybe should say something or do something. I have a couple of pictures that people have sent me and I walked by one morning and there was a woman standing up on the center pedestal, which is circular, with a notebook. She was just standing up on the pedestal, kind of just working. I asked her if I could take a picture and she said, "Sure." And I thought, "Oh, that's awesome. That's an awesome way to use it. To be on stage and not on stage."

PF: I want to ask about the names. In one sense, you gestured to this a bit, but it would be helpful to hear about how you worked in a way collectively to gather the names. You also mentioned that it's a process that's not finished and it's a process that's ongoing. I'm curious to hear more about the names that are on the object and the names for you that are important to gather as part of the project.

KO: And how'd you end up with who got excluded from the object?

SH: In terms of process, Monika and I started sort of in my studio being like, "Okay, let's do research on all the women in Philadelphia." And she so bravely was like, "Okay." And I was talking to a librarian and the librarian was like, "What? You have to narrow it down." I appreciate this because I'm good at research, but also I always have this impossible—like, of course I'm not supposed to research all the women in Philadelphia. But I kind of wanted to know the lay of the land. Like, I want it to kind of understand something and I think in

a way that breadth was useful because I always knew it was impossible and that very often when I step into a research position, when I go into an archive, when I pull a document out of the archive, it's really important to me to be present in the object as an artist, not a historian. An artist, not an archivist. An artist, not a sociologist. That the piece has to evidence that. So I think there were things that were important to me about the breadth, but also then to be somewhat subjective. So we started sort of in our small team and then Corin organized a really great dinner with the maybe twenty-four, twenty-five activists, community organizers, religious leaders in Philadelphia, where we kind of posed some questions and asked also for contributions of names, and they threw in a bunch of awesome things that I didn't know about. And then my struggle was just to keep somehow with the object the idea of its being nonexhaustive. So, there are some spaces in the lists, like, a moment where you think, "Why is there a space there?" I hope this also generates this idea that there's more to fill, that people can add. When I was there assembling it, that was actually constant. People would come up and at first they asked me, "Well, what is this?" And then they're just like, "Oh, well, what about this person? And what about this person? And what about this person?" I guess the one thing I can say about the names and the process of the names, I think every one of them is absolutely important. And, you know, if we had six hours, I could go through every one of them. And with every one of them, evidence is something that is important to our understanding of both history and history's incapacities and misrecognitions and failures. But also that's tied up with monuments. My sense of the field of monuments in the United States is that what they do most dominantly is mis-identify or mis-tell history. And when I was finding names, like, you'd often find the name of somebody, or there was a whole period of time where Monika and I were really centered in and spent a lot of time researching the Philadelphia Female Antislavery Society, which is an amazing collective of women. And so, on one hand, at every turn in the research, you run into an obstacle, an obstacle that prevents these histories from being recognized, that prevents them from being celebrated, on one hand with, if you look at the historical marker to the Female Antislavery Society, it's basically Lucretia Mott and her friends.

KO: Totally.

SH: So it's, like, on one hand, its collective labor is hard to recognize. On the other hand, the monuments have this idea of significance or celebration. Of course, that's totally invested. And because also one of the false understandings we have of monuments is that somehow we all decided these were the important people, when in fact, a small group of people who had an enormous amount of money and influence worked over different periods of time to get somebody to give

them permission to put that object there. So, for me, this idea of significance was also evident throughout this kind of pass. Like, women whose contribution was not deemed volume-wise enough or, or women who were—God, there're so many of these instances of people who are covering territory wherein the state and city government are not taking care of a population and they stepped in to do that. So labors of care and labor around care and collective labor. Also, I think that for me, there's a lot about this object that I have no idea. I have no idea really yet if it works. What it does. How it operates. What its use might be for people out in the world. I do think there was also a struggle I had with the recognition of women who were Lenni Lenape and I don't think that's settled. I'm not sure how I arrived. There's maybe four women on there who are Lenni Lenape from various periods of time and one of the things that you very quickly discover there is, of course, is that the white settler colonialism came in and misrecognized gender and misrecognized labor, you know, and the relationship between gender and labor, and, therefore, constantly misrecognized, violently so, labor that a lot of people were doing. Therefore, the name, like the ability of someone's name to move forward in the historical record, has these intersecting obstacles to that. That's certainly been something that happened really strongly with trans women, for me to struggle over, well, how do I recognize the historical contributions of trans women to our city? And I think that there is also not only this kind of violence regulation of who fits into that category of woman [and] transphobia violently excludes but also then language, the language has changed such that, I guess that's what I was also referring to when I talked about gender nonconforming warriors, you know, for whom maybe we didn't have precise names, who fall out of this kind of category of woman altogether.

> PF: I have many more questions for you both, but I want to open it up to the audience to see if there are questions. Yes. And make sure to speak up so everyone can hear you.

Audience Member 1: I've been following the debate and the removal of the Confederate monuments in major cities, Baltimore, and New Orleans, and what not. And it's about our history and I know that Princeton is having debates about [the legacy of] Woodrow Wilson. For me, it's a great opportunity to ask you guys a question, either one of the three of you. Rizzo on the south side there—if you had to make a decision to stay or go, no gray areas, stay or go, what would your answer be? Where would it go if the answer is go?

> PF: I want to say that I want to know what the artists have to say first. First of all, it's important to note that the legacies of racism, of police brutality are not just things from the past. They're present. It's important to note that the conversation about Rizzo is not just something that was created in the past few weeks.

That it's something that has lasted now for multiple generations. It's also important to note that artists and activists and students have sought multiple ways to address the statue itself as well as the policies around it. All that to say, I don't think it's a gray area of yes or no. Any solution that should come up in all the options should be on the table, including removing it from the front door, front steps of our municipal services building. The placement matters. But any discussion about it has to address both the symbolism and the enduring practices of injustice. Because if we are just having a conversation only about whether we keep it or whether we remove it, we miss out on that broader context. For me, I want to know what artists, what students, what Philadelphians have to say first to make sure that any move that goes forward is one that addresses what really is at hand. There are wounds in the city, especially around racism, around sexism, homophobia that ring out around that particular statue.

Audience Member 2: I have a question for Karyn. You talked about the piece being beautiful and you talked about invisibility and humility. I wanted to follow up on whether these are qualities that you believe are moving through your work.

KO: I think so. I mean, it's tough when people haven't seen the work or they haven't read the didactics or know the history. Everyone says, "It's so beautiful" and I'm thinking, "It is, but that's not the thing." So I think it's tricky with the work where, if you just see an image, of course it's beautiful. It's a mirrored surface reflecting a very green park. But hopefully there's a space or there's room for someone to want to investigate why I would want to do this here. I've done several projects. When I moved to Houston, I was overwhelmed by the billboard culture there. I just couldn't get over it. In New York there are billboards, but you're sitting in traffic so you feel their weight. In Houston they were whizzing by. I moved down there for residency five days before September 11. It was a horrible time to be there. So there I was, driving down endless freeways inundated with countless billboards and I just felt as though no one seemed bothered by their ubiquity and what they perhaps say about American culture. I received a Creative Capital grant where I proposed to take photographs of what existed behind the billboards and insert that photograph onto the billboard structure. So, in a way, the billboards would disappear for a month. I was interested in the everyday motorist/passerby who is not really experiencing the present moment fully—I am guilty of this too. But suddenly, while driving you had a moment of thinking the billboard disappeared or you thought, "Did the billboard get taken down?"

There was something between veracity and artifice going on. My premise was [that] invisibility would make one more aware of the present moment. So you weren't just a commuter driving kind of aimlessly; instead, you were given an opportunity to engage or challenge your experience—"Did I see that?" All of a sudden you're awakened to the moment. So for me, when I do use this idea of invisibility, it usually allows you to see. There's always something different to see. There's another way of seeing it. And I hope the work allows kids to just enjoy it because they can stomp on it *and* see themselves. I aim for the work to be layered. There is always some sort of political moment with my work. For the Central Park piece I created a lenticular billboard where I had an image of a pottery shard from this black community—Seneca Village—that was destroyed. It was the first case of eminent domain where park proponents were given authority to dismantle this community. But no, they had these dishes. They were middle-class blacks, free blacks. It was the only area in New York City that had a concentration of freed slaves who were doing really well. So I had an image of the pottery alongside an image of a glacier. The Wisconsin Glacier traversed through Central Park and created all of the hills and valleys we see (a result of the ice sheet melting). And the third image was a photograph of the park itself. So I was layering those different histories, equating the massiveness of the glacier with this pottery. I was in a sense compressing and conflating these disparate histories to show what the impact is now. Elements are disappearing or rendered invisible or layered that forced you to see in a new way. But beauty, I think, was the hook to reel you in a little. But I hate if it just stays with beauty. It fails when it's just about being beautiful. It's just a hook.

Audience Member 3: I just want to follow up on the Rizzo thing and [the] importance of its context. Where could the Rizzo statue go? Could we put it in a difference context that would actually satisfy both sides?

KO: Put it in a museum. Why do I have to see that thing? Put it in a museum. That seems to be the space to have it. Museums aren't supposed to be spaces of just beauty.

Audience Member 3: The Rocky statue had the same issue. The context is very important.

PF: Yes, another mythic Philadelphian, right? Yeah, I mean, I think back to Sharon's point about what happens when you take a pedestal and you make it half-scale. You make it human-size.

And so to think about a statue that is meant to be larger-than-life but is also meant to look real, is meant to be figural, I think, is part of that particular conversation, right? What are the places for that statue? Well, it's right now at the center of an essential debate about our values, and again, my hope is that the voices that are being heard are the ones who point to the ways that the statue symbolizes broader systems of injustice. Right? Something that we've seen throughout Monument Lab, and I think our artists reflect this, is that, with all of the tools that we have today, digital tools, other kinds, you still would build a monument if you have the time, the power, and the resources.

KO: Absolutely.

PF: But if you don't have the time, power, [and] resources, you stand next to monuments that exist to amplify your presence and make your voice heard.

KO: Ours are problematic in the same way. All of them.

Audience Member 4: I have a question about the titles of your works. I pay a lot of attention to titles in any artistic medium. And I feel like you both have particularly lovely and evocative titles for your pieces. If you just talk a little bit about how you came to those titles. I'm very curious.

SH: It does feel really important to me. But I have found myself sort of anecdotalizing this, like, "It's a monument to the absence of monuments for women," which becomes a second title first or a first title or something. The title is *If They Should Ask.* I was struggling a little bit with the title and it felt like, yeah, the story doesn't have to be that long. *If They Should Ask* in some ways represents for me both a past and a future of how we might reconcile or wrestle with this gap, you know, two and hundreds. I was interested in working with this kind of conditional, both, I think, on this site, there could be a statue that suggests that in, you know, 1803, in 1890, in 1910 there could have been a statue and there could be one now and there could be one in 2024. It's a wrestle. And so, that they should ask—I think it has all these multiple positions. If they should ask, "Why are there no statues to women?" If they should ask, "What do we do about it?" If they should ask, "What do these women do?" If they should ask, "Why you want to represent women?" If they should ask.

KO: I couldn't come up with a title. My wife is a writer and she understands my work. So I just told her, "You have to give me a title." She gave me some and then said, "I think *The Battle Is Joined* is best." And that's exactly what the piece should be titled. It happened a couple of days, maybe three days, before

Charlottesville. I really wanted to make sure I referenced the *Battle of Germantown Memorial* so we don't get stuck in just the presentness of that object. So for me, I wanted to reference the original memorial's title. I like the idea that we collectively are joined in this battle. I was thinking about racism and all those issues in a generalized way. But three days later was Charlottesville, so it intensified its meaning. I was thinking it could be read as a resignation but also empowering. We know there's always a resignation in a battle. It's never a good thing in the end. War is never a good thing. So I wanted it to be the resignation, but also an empowerment. But then when Charlottesville happened, I was thinking of a call to arms and it really became, "Okay, now what are we doing? Let's get up." So I think it's extending further than I anticipated.

Audience 5: Do you all believe that projects of this size would require large amounts of money to enact? And, if not, how did you work that belief into the projects you put up?

KO: I think I was saying to Sharon, the first day we were installing, there was a man who was pissed. He was really pissed that the city of Philadelphia was spending this money. He said, "We need this money for food." And I had to break it down to him. You know, "I understand survival. I know we need shelter. I know we need food. But are you saying that things that are beautiful or things that allow us a space for a pause or reflection or a moment where I could imagine another possibility don't belong here? Are you saying that should only be downtown where people can afford it? I'm asking. Is that what you're saying? We don't deserve this?" He then said, "Okay sister, you're right, you're right." We ended up having a great conversation, chatting for hours. Every day he would come visit me. We'd meet there. But it was a thing: "Why don't we deserve that? Why can't we, in a struggle? Why wouldn't we want a moment when we can see ourselves and see that we are beautiful? Why can't we have a moment when I could just not think about my hardships and see this thing that I can't believe I'm seeing, see this park in a way that I've never seen it before? Like the lights at night flickering. It's just, magical. Why not?" I'm not saying it's taking away the struggles. But I'm hoping it's allowing for a moment of some consequence. A what-if. So that's my justifying the money. But the money thing's messed up. I try to use it as responsibly as I can. I felt pressured with this piece because of that, you know?

SH: That's a super thoughtful answer. I'm not sure I can contribute that much more, but I think, for me, I spoke at a discussion about public art maybe a year ago and I found myself thinking that so many of our public institutions are in crisis but public art is thriving. And I think that's a contrast that I care a lot about and that I think is ours. We all have to share it because public art doesn't thrive only on its own. It's a specious kind of comparison for the same reasons that Karyn just elaborated because I don't think that public education and public art should be pitted against each other. They should be in concert with each other. I guess to your point, I think that meaningful public encounters happen all the time and meaningful objects, events, statements, actions, resistances do proliferate our moment and our past moments and I imagine our future moments and they happen on the whole scale of a sort of an economy. So I feel incredibly privileged, incredibly lucky to have been able to realize this object with those materials, which did have a pretty high cost. I feel super lucky and I'm trying to be responsible to that. But I don't privilege that. I'm so attracted typically in my work to a thing that gets posted up on something that says, like, "Bush Sucks" or something.

Monumental Exchange 3
Public Conversation: Michael Eric Dyson, Michael Kimmelman,
and Salamishah Tillet, moderated by Paul M. Farber

Pennsylvania Academy of the Arts, November 15, 2017

Paul M. Farber: Tonight, we are here to talk about the future of memory. But, in many ways, the current moment that we're in is a moment of reckoning with monuments and it's a moment that's not newly arrived, per se. It's been ushered in by the long-arc work of activists, artists, scholars, students who have, for years, if not decades, pushed against the status quo. And, of course, the recent goings-on in Charlottesville, New Orleans, Dallas, and other cities reckoning with their own legacies of Confederate monuments have also brought this moment to us. Where are we in this moment, or this history of monuments, as a society?

Michael Kimmelman: Let's see. Let's take it as a given that the issue of the Confederate monuments has unearthed all sorts of unfortunate truths about parts of our society and I think if you begin there, you can say that these monuments, on some level, work. And what I mean is that monuments are created or memorials are created to commemorate or to mark something, to mourn something, but they have had, historically, the downside that they also tend to close down discussions in history. They tend to be the dead spots in cities, the kind of things that people stop looking at. The real function of them, I think, is to continue to provoke conversation and to force us, in some way, to confront our own changing ideas. So, we now have this political upheaval and the fact that these monuments have now caused these conversations to take place, on some level, I think is a useful thing. They're making us face a truth about ourselves. So I think we can begin by saying the monuments work if they remain living options. They don't if they are things we no longer feel we need to deal with.

Salamishah Tillet: I'm thinking a lot about the Confederate monuments in the context of my own research around how you remember slavery today and what's at stake in these representations. And so I've been also thinking a lot about Kirk Savage's book, *Standing Soldiers, Kneeling Slaves.* And I think that our current moment is similar to that late nineteenth- and early twentieth-century period when there was all this anxiety about what the nation was going to be in this post-slavery, post–Civil War period. That's when all these monuments that are now being taken down or being contested were created. So, as you said, monuments are about the way in which the image of the nation wants to put forth and those

280

in power are able to create them in their own image, right? You know, sort of like "God created man in his image and man created God in his image."

Well, we can think about how the monuments are doing a similar kind of thing. So who gets erased and who gets represented has everything to do with who's included in the nation state and how the nation projects its image to the world and to itself. I think this is a similar moment. It makes sense that what's being contested was that old narrative of America that really, I think, has persisted and permeated, reproduced itself, throughout the twentieth century, despite ongoing social movements. The fact that these have existed for so long and are now being taken down despite the fact we had the civil rights movement and the Black Power Movement and so many different interventions. I think this is a really radical awakening and a reckoning. But it's also similar to that period in its critique and contestation. So for me, it's about what monuments are being taken down, what's being erected in their place or alongside, what can co-exist. And then, also, what we don't need to see anymore. And I guess we'll talk about this in terms of memory of the future. But the kind of narrative that to take away certain monuments is—a lot of people are kind of comparing it to the Stalin era. For me, I think that's so fascinating because I don't think we need stark reminders of like, you know, the Civil War or the Confederate soldiers or [the] secession of South Carolina. We don't need reminders that white supremacy and slavery was substituted with Jim Crow. I think we're still living through the legacy of racism today. What [we] do need reminders of [are] those [that] weren't allowed to be represented back then—the people who contributed to the United States, who contributed their labor and their lives, who never had monuments for them[selves] in the first place. And so I think that's just something that we can talk about in terms of questions about censorship and amnesia, forgetting, and then removal of monuments. But I'm one who thinks that we don't need these monuments to remind us of our painful past because I don't think we've really dealt with that painful past in any really super productive way until, really, now.

> Michael Eric Dyson: I'm just happy to be on this stage with these smart people and my brother, Michael Kimmelman. You know, it is interesting to know that we live in the United States of Amnesia and think about the addiction to amnesia as the predicate for the expansion of American democracy, right? When [Louis] Althusser talks about stuff

you cannot not know, the stuff you're forced to know. And what's interesting if we say, well, they were monuments for people who prevailed in the culture because the South lost the war but won the memory. That's big, though. That's not inconsequential. And, indeed, memory is a greater battlefield for the extension of a quest to that new victory because it's a great production of war as a metaphor for reproduction of the nation. So the constant battle over memory is the relitigation of a case that was lost. In the court, but in the court of public opinion, which is partly where monuments are, there's a constant fascination with the totemic power that's generated by witnessing a monument. It's not that black people didn't have monuments, but they were pint-sized monuments. Mammies, Aunt Jemimas, Uncle Ben on a box, right? They were mobile and they were owned, as black people themselves were owned, enslaved to a white imagination that uses them for their purposes so they can move those monuments.

Monuments, by their very definition, are rooted in the ground of our common civic land, right? The reason there was such an argument over whether Martin Luther King Jr. would occupy the most sacred ground of civil religion in America, in Washington D.C., and for his monument to rise nineteen feet above the others, is all about not just compensation for the historical neglect of public memory around, in this case, blackness, but it's also a reckoning with America about the shape and size of its future. So monuments scar the public landscape. They intervene on a kind of dis-memory.

Interestingly enough, at the same time, and you know, I've argued with people about whether or not it's great, it's educational. Well, what education has been had? Now, first of all, that's a lie. Ain't nobody going to the Robert E. Lee memorial every year. Right? Monuments are like spare tires. You never need them until the stuff that you regularly depend on breaks down. So civic society goes on all right as long as white supremacy is dominant and unquestioned. But the moment there's a crack in the edifice, the monument peeks up. You ain't paid attention to them and the folk for whom they mean something don't really care? It's like the monuments of bodies in a cemetery where the weeds grow over them and overtake the mark of their existence. Monuments exist above ground, but they'd been covered over, papered over, by the weeds of this memory and the lack of necessity defines them, urgent only when

the lifestyle is challenged, as the monuments have a kind of electrifying, radiating power.

So I think it's an extremely healthy debate about who gets included in and who gets included out, so to speak, and as Professor Tillet said, when we think about, you know, who's at the table to make the decisions about who gets memorialized. I mean, I was on my way over here when we stopped at the Afro pick [Hank Willis Thomas's *All Power to All People*]. You know, the Afro pick? Afro prison industrial complex, too, right? The Afro pick stuck in the ground and then the bus passes on one side and the bus passes on the other side: Free Meek Mill, right? That's marking public space in Philadelphia with an exigent extrajudicial pressure being brought to bear on the monument of justice that is embodied in, some would say entombed, some would say interned, in a courtroom, which becomes a different monument, an unintentional monument, that preserves a radical hierarchy that disavows the very black presence on which it rests and on which it depends to really exist. The prison industrial system itself is resting on the labor of those people.

So in that sense to me monuments are fascinating. They're always about where we are now. They're always about our anxieties. They're always about how we think we're being lost and left behind. I'll end by saying this: I don't think it's coincidental that in a very election where both the left and [the] right converged to say that the problem is identity politics, right? Donald Trump and all were saying that: "politically correct." And Bernie Sanders was, too, "The thing is, we have to get over, you know, these groups make a difference." But it's always that conjunction. And then, "But you know, we've got to do something that includes everybody." The white working class is not everybody. The white working class is a contradiction to the very argument about an ostensible neutrality, that the politics of identity point to. Knowing that the politics of identity came out of the black feminist movement, right? To argue for the fact that identity has always been at the heart of America, always been at the heart of the democratic experiment— and so I think monuments become especially useful at moments of national crisis and anxiety about identities, and there's no coincidence that the rise of a certain kind of resentment among white working-class people meets again over the investment in statues of people long since forgotten but who—you talk about revisionist historiography

and at the end it trips me out in a culture of white masculinity that says we don't give out participation trophies. That's what you're doing, 'cause they lost. And we want to celebrate the losers. Hey, the Cleveland Cavaliers lost to the Golden State Warriors. Let's have a monument to Cleveland. Cleveland don't exist! It's Golden State's championship and their trophy. In this culture, the contradiction of those norms, I think, is mediated in a discussion about what those monuments mean.

MK: I like a lot of what you said, especially in the way you put this in terms of what is contested in public space. Because I think this is really an interesting aspect of this, right? That public space always becomes the space of contesting our identity, our identity as a community, our identity as a society, as a nation, and monuments occupy public space. So the question really is, Who gets to have a say in that public space? Paul and I have talked about this before, but I was struck with the Occupy Movement, the way in which Occupy took over public spaces and in those spaces created, by virtue of needing to occupy them for a period of time, the kind of idealized polis. There was a little town that they were creating: there were places to sleep and a media center, medical center, a place where people could get food. It was like a little town, because they saw, I think, the notion of protest itself as needing to demonstrate in public space what their ideal of a society would be. I think that's part of what monuments have always been about. Who are we and who are we as a collective society going to therefore give over this space to? But the one thing that occurs to me as you were saying this, we're talking now about the defeated South belatedly, during the 1920s, putting up monuments because they feared these changes they saw taking place. So it was a kind of a rear-guard action by reactionary racists in the South to try to rewrite that history. As you say, who owns the history is, in a way, who owns the nation. Of course, I lived in Germany for years and there are other kinds of monuments, which are the monuments of defeat. We do actually have such things. We, in America, do not tend to reckon with them very well. So, in Germany, of course, there is an incredibly interesting history of creating monuments to their own failures: monuments for the Holocaust, monuments of their own guilt. I think one of the most interesting strains of monuments, moving away a little bit from a legacy of the Confederate monuments, are these monuments that we created since the Vietnam War. And if you think about it, they have had to deal with this question, How do you memorialize something about which we have not as a nation really decided collectively what they need? And so I find it interesting, for instance,

that the Vietnam Memorial in Washington enshrines this very abstract language, you know? There is that monument with the typical soldiers, but, really, the monument that everyone knows is this very abstract blank wall, Minimalism essentially, turned into a kind of monumentalism with just plain names. What does that suggest? We really don't know what we think about this. So I'm mentioning this because I think the two principal issues here are we use monuments in public spaces, because public spaces are where we debate the nature of who we are. And those monuments can take many forms. They can take the forms of heroic idealization for people that a certain part of society loves, who wants to idealize, but they can also take the opposite form. They can acknowledge our failures. The last thing I'll say about this is, therefore, in response to this really alarming but interesting thing that is happening now around Confederate monuments, we have raised this issue: Well, what might replace them? What should we put there? And I think that can be a constructive step forward in deciding how we build things that will deal in a much more honest and democratic way about our history and our present.

> ST: The question becomes, what we fill in its place. There are a couple of things I was thinking about in terms of monuments that deal with the messiness of American history. So in terms of creating, the Martin Luther King Jr. monument is one example, but all these other kinds of civil rights monuments in Birmingham that are dealing with [it]. It's almost like they're freezing the conflict in time. And so it's an unresolved history and yet there are these testaments to the fact that these are unresolved, right? The heroes would be, you know, civil rights activists. But I'm thinking of the one in Birmingham in particular with the police officer and the dog going after an African American activist. So I think there are times and places that are really trying to grapple with the unfinished legacy of American democracy. But I do think, and again, this is in terms of your German example, part of my research was thinking about, you know, before we had the Whitney plantation and Louisiana and when you do these plantation tours, there's just such an erasure of how horrible slavery is.
>
> So for most Americans, you have to go to West Africa to get physical space in which you remember the legacy of slavery. And so there are just certain traumas that were highly resistant of and there are other ones that we're willing to grapple with as a nation, and I think that has to do with, like you said, the identity that most Americans, even if you're excluded

from how the nation has historically mythologized itself, that idea that most of us galvanize around is an idea of, you know, the American Dream: that we can all achieve something or that we can all move forward in society if you work hard enough. Even if you are so marginalized from it, you still kind of buy into it. And most of the ways in which we memorialize ourselves is to maintain that triumphalist narrative despite all evidence to the contrary. That's one thing.

The other thing I think is interesting about the moment we're in is a question of temporality. So those 1920s monuments—and I think that's what's interesting about one of the monuments here in terms of, you know, the actual form that they take, the materials that you're using. Are they supposed to be enshrined forever? Or are they supposed to be able to decompose within a shorter time period? So what's the function of a monument? Is it to represent the kind of dynamic plurality of the nation? Therefore, the monument may have a shorter lifespan than these earlier. Or is it to do something? I think that it's a question of like we're living in a time where, on one hand, everything is ephemeral, and at the same time you're, maybe it's in the cloud forever, right? Like it's a conflict of how we live in time.

PF: There's a half-life to the history.

ST: Yeah. And so what is the monument if not that temporality? It's just a fascinating question that we have to grapple with as artists around the world, but in particular, here.

MED: Well, the prospect of the disappearing monument, right? There is that Elizabeth Alexander essay on Rodney King, "Can you be BLACK and Look at This?" I mean, what are these films of Philando Castile, Alton Sterling, or another black person who gets killed by the police unarmed? I'm pushed by what you're saying. What's the difference between a monument and an icon, and what's the difference between a visual archive and curation, curatorial, curiosity, curium? That what becomes consumed by onlookers of black death, literal snuff films of black existence going away, bodies losing their essence and being and having to see that. That's one displaced trauma. That's a trauma we can see, except the language of trigger points and it's too tough, we're in class. When we were in class a couple of days ago and a white woman, older woman, who visits my class and sits in when we were showing the Philando Castile and she came to me and says, "I think

the students are getting very upset," and so on. I looked around at the black students, white students, and so on, and I asked a question. They're like, "No, it's just that we're shocked to see this." But this is the stuff that we choose not to see. We choose not to look at it. We choose not to engage it. And so for me, the difference between what's going on in Germany, there are mournful cadences and the rhythms integrated into the structure of those monuments. It's an acknowledgment of failure. They don't acknowledge failure in Robert E. Lee.

MK: That's absolutely right.

MED: So it's a repudiation of the redemption that these monuments in civic space are to lead to, to overcome. I mean, are we going to put on a par Thomas Jefferson and Robert E. Lee? I would argue there's a difference, because what Thomas Jefferson opens up is the possibility of sub-verting what Thomas Jefferson did according to which Thomas Jefferson actually said and thought. And so, you know, the Declaration of Independence becomes a kind of literary monument to a set of ideals that open up space for a charge to be brought against the blindness or the inaudibility of blackness, you know, within the culture. So to me, that's a huge difference in the sense between people collectively mourning of failure as opposed to a kind of defiance. And do we really expect in a nation that has practiced apartheid for so long that civic space wouldn't be segregated, that monumental space wouldn't be segregated, that what finds resonance in one commu-nity will not find residence in another, and that one is at the expense of the other, so that if you don't even have the means to erect those monuments and have the nation be forced to reckon with them? I think that those consider-ations, the financial, the economic, and the political have to be brought into play when we talk about who gets a chance to make those decisions and who literally gets a chance to make them and what they make of them.

MK: I don't disagree at all. In fact, I brought the example of Germany up because humiliating defeat helps clarify a national identity. In a way, it's very liberating for Germans to be able to say, "Everything you think about us, everything you said about us, everything you were accusing of, it's all true and we're going to put up monuments and, in fact, we'll put up plaques on every building. We will keep doing this." However it's very simple on some level to do that. We are still engaged in a civil war, and in

a civil war there is no clarity, no consensus. It's the very notion of that division that needs to be recognized, memorialized, constantly on our minds. That is much more difficult to do. It's exactly what we don't build monuments to, though.

> MED: Given the point you just made. It's not that we ain't got clarity about what the thing was about. We have to stop lying about it. It's about states' rights. States' rights to do what? Own people! Can we stop lying? Can we just say, "What you thought it was about is wrong." A kind of cultural time-out and say: "Check it out. What you thought was the deal was not the deal. You think it's the deal because you want it to be the deal because you lie about history to begin with and you erect monuments to not only your amnesia but . . . a kind of productive dis-memory that eradicates, distorts, lies, gets rid of anything else that could contradict it." So there's an active agency in memorialization that allows those monuments to become chess pieces on a board to try to pawn somebody else. And I think, in that sense, it makes a difference.

PF: Each of you has brought up intentional monuments, the ones that were installed through the will of a memory process, or a mis-remembering. You also mentioned the "unintentional" monuments. I think about the closed school, closed factory, or a shuttered casino once named Taj Mahal. So thinking about those two terms, intentional and unintentional monuments, is it useful to think of them as different? Does the unintentional conjure some of the same wavelengths that you've been bringing up? Or is that a different conversation about what we value, what we remember, what we bring forward?

> ST: This is an obvious example and this is not exactly answering your question, but I do think with Kara Walker's installation in the Domino Sugar Factory [*A Subtlety*] and the way in which the very use of that bookmarks an end of a particular kind of factory labor market in New York City, on one hand. And yet you have this engagement with the long history of sugar, of slavery. I mean, I think there are ways in which you can kind of appropriate those spaces to point to the longer forms of discrimination that Walker's piece does brilliantly, I think, as well as kind of point to the ways in which in the present shows a kind of displacement of a particular culture, practice, and socioeconomic conditions of certain people, right? So I think there are ways in which that's a good example of the intentional and unintentional monument being conflated. But I guess, you know, just bringing up the work that you have done here with Monument Lab and Terry

Adkins's empty classroom [*Prototype Monument for Center Square, City Hall, Philadelphia*] that was the first Monument Lab piece. I thought that was such a striking way of thinking about or having a kind of resonance or reverberation of ways in which all these students are being literally displaced from their schools in Philadelphia, which also harkens to ways the students are being displaced in Chicago, displaced in New Orleans, displaced nationally.

And then, at the same time, you have these kinds of markers that are aesthetic, that are communal, that are quite deliberate ways in which the everyday citizen can kind of experience that for a moment and then engage it, but at that same time, that's not their full existence. I guess what I'm saying is that I think what you all are doing here, trying to push citizens, push audiences, and push artists to really think about the relationship between the unintentional and intentional is really provocative. And the empty classroom being a really compelling one. Since then the model has changed a little bit in the sense that not all of the monuments that you all had were speaking directly to those issues.

But I think, obviously, they resonate in some ways. The Kara Walker one, I thought, was actually a good example of trying to appropriate unintentional monuments and make them into a monumental space, even if it's temporary. And I guess I just wanted think about that idea of temporary monuments a little bit more because [Jean-François] Lyotard talks about the grand narratives and the petit narratives and I think the closer we get to complex truth, little narratives, multiple narratives, that's what the problem is. There are these big narratives. Robert E. Lee would represent the big narrative. And for those of us who are really thinking about the question of democracy and plurality and a multiplicity of identities, we want the little narratives to thrive and to have monuments and voices and testimonies of the diversity of America. But then can you have, you know, monuments to posterity or do you have to have a different relationship to the very concept of what a monument is? I'm interested in things that disappear. We were talking about the videos. On one hand, you can see them over and over and over again, but at the same time you don't want to watch something repeatedly. They're so traumatic and yet they're there. And so this relationship between the desire to not remember, the desire for things to disappear quickly, the things we forget, and things we want to remember, all of this has to do with these questions of monuments. How we think about time determines, then, how

we think about the past, the future, and what we want to keep around us. It's a more philosophical question.

MED: Well, given what you said, I'm thinking about the top one of men in this sexual harassment era. Unintentional monuments? Harvey Weinstein and his company are a monument to a monumental masculinity, misogynistic, and patriarchal, to be sure, sexism, shot through, but its unintentionality is revealed after its defeat or at least only after it is unsettled as an unquestioned example of success or convenience or status quo. Only when it's challenged. Only when people begin to think, "Ah, that really wasn't cool. That really wasn't good. That really wasn't right." And now it becomes something contradictory to what it was alleged to have been in the first place.

And its monumental status depends on its defeat because before it's part of a status quo and is kind of a monument to this aggressive masculinity that pervades the American cinema. On one hand, you've got Clint Eastwood and the grumbling, scruffy charisma of a minimalist, and, on the other hand, you've got the liberal, fluid, fluent, linguistically sophisticated, culturally informed, and enlightened presence. And yet it is the warehouse for so much trauma that women have literally had to bear, right? Unwanted hugs, unwanted stares, unwanted touches. And so you're talking about disappearing or temporary monuments. I don't know. It seems to me that the gendered character of all of that occupation of space shifts the power dynamics. And to throw in another, I love the grand narrative and the petit narrative, and I'm thinking about [Michel] Foucault with the insurrection of subjugated knowledge because partly what's going on here is that the subaltern are speaking, but it's the people who were not supposed to have the knowledge speaking up. Women, who are, of course, not the center of any intelligence. You're there for beauty. You're there for enhancement. [Did] you see the story today of the woman, you know—the show runner says that all the women are chosen because they look good, not because they can write, not because they can think, not because they bring any value. So [erecting] unintentional monuments to the viciousness of the everyday is only revealed in defeat. And that I'll say, finally ending, what do we get every morning at 5:30? We got a guy excreting the feces of moral depravity into a nation he's turned into his psychic commode. So, I mean, that's a monument. So what kind of disruptive digital presence is that, that at once erases as it

reinforces dominance? I don't—I just think that it's complicated.

MK: I'm just picturing him on his commode at 5:30 in the morning.

MED: It's us. We're the commode.

MK: I love this notion of temporary monuments. I think all monuments are temporary, actually. It just depends on what kind of temporality we're speaking of. But if we think about the way in which revolution has often been expressed, it's expressed with the toppling of monuments, which should be weird, right? These are sculptures. These are inanimate objects and yet they do take on this incredibly resonant and meaningful value. There's a book that David Freedberg wrote some years ago called *The Power of Images* and it's really interesting because he's talking about these talismanic and physical powers that art takes on. Very often they are public monuments. But they could be billboards. What people attack when they overthrow. When there were protests in the Philippines, they were destroying billboards of rulers. I mean, this is very often the thing, that these objects become surrogates. So, I think that that relationship that we have to them as almost quasi-living objects, it's where I was starting. On some level, that's good. Obviously, when I said we were in a civil war, when you come back to this question, why don't people just admit what's true? Which is, of course, the great mystery of where we are as a nation at the moment. But I, for some reason, want to have some optimism about this and believe that the very conversation that this is forcing, essentially outing people who are doing this, is in some way going to be useful, that the repressed conversation was dangerous. And although it seems like a deeply dangerous moment now, that this somehow needs to be gone through.

MED: No, I absolutely agree with that. The question is, What are the adjudicating forces? Who decides between the rival claims about a culture? A lot of times it comes out in the money. I wish we'd talked earlier. Now it's Sean Hannity who has had the revelation of God: "Roy Moore has 24 hours." Like, who the hell are you? "He has 24 hours to prove to me." That means your advertisers are pulling out! And that's the same with American culture. The people who bankroll dis-memory or bankroll amnesia. I mean, the Ten Commandments are the tablets that got destroyed pretty early in the game. Like, boom, come down the mountain, boom. But they live on in memory, like for

three, four, five thousand years. So the talismanic, totemic process, think about Freud there with Moses. When you think about how those physical realities take on a life of their own, so to speak. So when people are toppling, they're trying to get to ideas, but they can't get the ideas so they get to what represents those ideas. So isn't this what it meant when they looked at the story in the Bible of Joseph: you can kill the dreamer but not the dream? Monuments are on that level.

So I agree with you that the dis-memory and their suppression of memory is a horrible thing and, therefore, let's deal with it. I wasn't saying we shouldn't deal with it. But, you know, for a culture that seems to call women and people of color and queer folks snowflakes, there's no bigger pampered people in the world than white folk. Like, everything is according to what you want. No! Get up and leave a lecture because you're pissed. Leave the room because you're in a rage. People of color, we just got in the room, we ain't going nowhere. Say shit, do crazy stuff, we're not going. Queer people who fought so long to get into the room, like *Hamilton* said, the room where it happens. We try to get in that room. A lot of people have such leisure that they leave the very room it takes our lives to get into, to break into. So the pampering, which is called white fragility and white innocence, but to take it out of the realm of, I think, that kind of rarefied nomenclature, the pampering and being conducive to and capitulating to the needs and psychic desires of white brothers and sisters, not to hear the truth that every day other people got to hear while they're brushing their teeth, right? How many people of color and women and other people watching Fox News is lying, fake news is lying, before we even put our kids in their clothes to go to school. This is the culture we've had to negotiate from the beginning. So what Donald Trump has done is make all of America black in a certain way. Now white people are ill-equipped, like Jiminy Cricket. What are we going to do? It's not the people whose backs are against the wall who are cynical. They're not the ones who are cynical. Well, a couple of writers in exception, but that's a different story. They're not the ones who are cynical. They're the ones who are living embodiments, monuments to hope, the very ideal that the people who were defeated in that war now claim to represent.

I mean, why is it that Colin Kaepernick kneeling pisses this group off so much? That's the nerve center of the culture

right there. So I think you're right in terms of suppression, I just happen to believe that women, people of color, and other minorities have always had no choice but to hope. Howard Thurman said, "When it comes down to it, you either going to be a prisoner of the event or you're going to be a prisoner of hope." And I think that black people, and I don't want to just generalize, but I think en masse and at our best, and others as well, have certainly been prisoners of hope.

ST: I'm optimistic about the toppling or the overnight taking away of Confederate statues. There's all this stuff that's going on in a clandestine manner because people don't want white supremacists to come into their town with torches and kill people. So there're all these ways in which the monuments are disappearing and I'm really optimistic about that because I think, for all the reasons that have been already said, they've been enduring and been here for so long, and I didn't know the moment was possible. It's exciting that it's here and it's also created by the civil war. I think civil war is a really good way of describing what we're in now and it's a civil war precisely because it is a civil war among white people. That's how I think of it. It's people, as you said, it's marginalized people, and, as an African American, I'm not simply an onlooker. I'm dispossessed. I'm a woman experiencing it. But I do think this is like a battle between white liberals and white conservatives about what kind of country we really are.

For those of us who've been trying to say America can be its ideal, we're watching it and it's crazy. We're championing it and hoping that the right side wins. But I do think it's an existential crisis around whiteness and the monuments in the 1920s were about that too. It's just that one group won. And so who's going to win now? And then what kind of monuments are we going to create as this battle is going on? I think, again, it's a testament to the curatorial vision that you all had. What does it mean to be American? Who's going to participate in the public space of Philadelphia? Not simply as people, because when we did the conversation with Hank [Willis Thomas] and Black Thought [Tariq Trotter], it was so fascinating to hear [Black Thought] talk about seeing that Frank Rizzo statue because it's right here and this is the center of the city and having to confront that statue every day as he was taking the train, growing up as an African American man in Philadelphia, a boy becoming a man, and what that meant to him. And now to have the Afro pick means that I belong, right? I belong. I belong in the city in

fundamentally radical ways. You know, there's something that looks kind of like me. It's like, you know, Hank created this very revolutionary throwback to the Black Panther Party. But also he talked about it being inspired by his grandmother. So it's a kind of black feminist project as well. And for that to be next to Rizzo as people are contemplating whether Rizzo should be there in the first place, I'm really optimistic about that. That's exciting. That means that we're going somewhere different and I think that's hope. That gives me hope because when the battles are being waged, someone can win and that doesn't mean that the problematic people are always going to win. It could mean that those that are dissenters could win.

PF: For those seeking to bring change to the monumental landscape, they seemingly have two options. One is to leave history as it is. The other one is to dismantle. Clearly with the work of artists, activists, students, they often find other options and recognize there are no zero-sum outcomes. I'm curious, for each of you, what are the options? What are the tactics? What are the new ways that we can evolve the way we make monuments?

ST: One of the things I've been thinking in this particular conversation in terms of saving protest in public spaces, reclaiming public spaces, are the ways in which the 1980s and 1990s, the rise of graffiti as both permanent and transitory art and the way in which artists were under surveillance, were being arrested, were, obviously, seen as a threat to the state and yet at the same time really creating a different urban landscape. How you look at the city changes as a result. How you take a train or how you look at a building. And our understanding of art changes. That to me was already a third option, right? You have insurgence, subaltern artists really redefining art, I guess I'm always going to talk about hip hop because I'm just that generation, being part of a larger cultural movement. Redefining one's relationship to the city as theirs, creating a permanence, even if it's not your name that your parents gave you. I mean, there's just so much there. And I think that's a kind of third option that we have with Monument Lab that you're trying to think through. And not just Monument Lab, but artists and activists in Houston, for example, or in Chicago, are really trying to think through: What does it mean to be engaged in public spaces that create community as opposed to police communities? And the third option is being able to do all of that and, for me, because I'm a cultural critic, also to change how we think about art itself, right? To me, there always has to be this aesthetic value, even if it's redefining what we think about that value that's going

on at the same time. So it's almost like it has to be beautiful to someone, but it also has to do a lot of other work. And I think we already have models that had been doing it for quite a long time and we can just think about that as a part of a genealogy of those artists.

MK: There was, in fact, a monument in Germany to the Holocaust, I guess. It was in a shopping mall, I think, outside Hamburg. A couple made it. I think their names were Esther Shalev-Gerz and Jochen Gerz. It was basically called an anti-monument [*Monument against Fascism*] because it was a kind of a pillar that people were invited to write on and it was tall, like twelve meters high, and people could write anything they wanted. So they would say, you know, "I love Suzie," or, you know, "Burn the Jews," or whatever it is. And they would have chalk and stuff and they would write these things on this pillar. And as the pillar filled, it would be lowered into the ground. So it was a progressively disappearing monument. And essentially it was a memorial to your public memories or your public statements. It was a kind of enshrining of people's prejudices, hopes, whatever it was. And the whole notion of the monument was that this is not the kind of thing that will dominate you. In fact, it will disappear. Then [it] ends up as this tiny little thing, a square buried in the ground that goes twelve meters down.

But I think this issue of money is the other question here when you raised it, and that is, these things often take power and money. And so the question always has to be. How does one subvert that? One of the most powerful things about graffiti art was, of course, that it was done not just by people who were doing what they wanted but it was done on the cheap. It didn't require resources, and yet it could have enormous scale and enormous effect. And so I think we're addressing that balance— partly projects like this do it, you know—we're addressing the balance, both this notion of needing to put something up that's forever and then needing something that is costly and big and declares itself a monument. I think we need to get out of that. I don't even think people believe in most of those monuments anymore. I don't know what it is that we would build a monument around any longer that all of us would think that we need to do. I mean, I don't even like the 9/11 memorial at the World Trade Center. I think that's just a giant, weird corporate project. And I think its failures even express our inability to have reckoned with that event.

PF: In the design of that memorial, visitors can encounter voids and the waterfalls that [go] down. The sight lines to the bottom are

cut off. You can't see it, as if to express that the grief is unsuitable beyond our reach. And, of course, we carry profound grief in all kinds of ways in public space, but people find ways to cope and they must, they carry on.

MK: Look at the 9/11 monument for a second. What's actually going on? First of all, it's the two places where the towers were. So it reiterates the exact same shape and form, which basically is a rip-off of a sculpture that Michael Heizer made in the 1960s but with water and on a really big scale. I don't even understand what the meaning of that water is. It's there just like giant toilets? I don't know what we're supposed to get out of this. Why is this uplifting? In what way [is] this recognizing or honoring the lives that were lost? And why are those monuments there occupying that space? Because George Pataki wanted to become president and because he wanted to get development on that site under way and get a memorial finished in time for his ridiculous campaign. So the city spends crazy amounts of money on this so that they can build this tower, One World Trade Center, which is a giant office tower. Listen, I mean, this was a traumatic event, but as we're sitting here talking about Civil War monuments, when I think about the money and effort and political will that was spent on creating this really poorly thought-out object because of the deaths of three thousand people and then I think about the centuries and untold lives of African Americans who are barely recognized at all. I mean, this is really kind of an extraordinary symbol, I think, of the very way in which monuments express profound inequity. So there you go. That's a perfect example to me of money, not bad will necessarily, but money in politics trumping all else expressed through these monuments.

ST: This goes back to the conversation we had at the beginning, because I was actually there this morning for breakfast and I hadn't been to the World Trade Center in about six months. So it's almost a throwback to how it used to function with the mall. But then I thought, oh, so fundamentally American in the way that I think, not the way we're saying plurality or democracy, but also this idea that the triumphalist narrative ultimately has to reign supreme. And that to have the Freedom Tower look the way it does, to be this huge phallic symbol of American freedom, to have exhaustible grief, on one hand, but also not really be a place of consistent mourning, on the other. I mean, that to me is the problem with the Confederate monuments that we're talking about. That this is the United States trying to reproduce the narrative of victory. And this is what a monument to that would look like and it's corporate, and it's the tallest building, and it's not

really dealing with all of what 9/11 really, really, really means. And so we were talking about complex truths. That's the dominant—that's a way in which a dominant narrative wins. And yet, in some ways, you still get moments that we're yearning for, moments of dealing with trauma, moments of dealing with loss. But it's not a consistent place that generates that. I don't think it can be, following what you said. So I think that's just a good example of one way you deal with these questions of what America means and who is American and what America wants to be. And then you can have all these other ways of dealing with it and they could kind of co-exist. But ultimately you would want—and again, I lean toward the kind of multiplicity of things as opposed to one dominant symbol that reinforces a patriarchal vision of itself.

MED: I'm just trying to build on that question. I think history is always at stake. The past is always unstable. There's that Faulkner quote: It's ain't even past. We know it's not past because we keep fighting these battles. Look at the battle reenactment crowds, right? If you have to announce it, you ain't really sure.

And when I think about your discussion about the quite insightful and enlightened conversation about what these monuments are, it says something about us when we choose to memorialize what we do and how we choose to memorialize what we do. So I was on *Meet the Press* arguing with Rudy Giuliani and we were talking about Michael Brown. It was right before we were going to find out whether the grand jury was going to indict the officer who killed Michael Brown or not. And Rudy Giuliani goes, "You know what? You know it ain't but a small percentage of black people who died at the hands of police in this country." He said, "What you need to be concerned about is the masses of black people who died from black-on-black violence." You know the story: forget the police violence thing, there's basically only five, ten people dying from that. Every year black people are being slaughtered. Now, of course, it's true that 93 percent of black people who die, die at the hands of other black people. But we know that 84 percent of white people who died, died at the hands of white people. And there's no narrative, no memorialization, no narrative to capture white violence directed against other white people because it can't even exist.

We can't even think about [it]. The language can't even approach it. So the memorials can't even reflect it, right?

So, by that same logic of Rudy Giuliani, why do we have a 9/11 memorial anyway? Because, let's go by his logic: How many white folk have died from terror since 9/11? A hundred and something? I don't know. Not many. How many more white people die every year from white people killing white people? Like thousands. And white violence is far more lethal in terms of its victims. They victimize more vulnerable people, women and children, and, until recently, it was an unintegrated prospect of mass murderers, right? Brothers have been trying to get in that game now recently. Integration ain't good all across the board. Then you think, man, look at what happened last week, two weeks ago, three weeks ago? Churches and stuff. One brother, again, yesterday in California. And, as you've brilliantly written about [gestures to Tillet], the domestic is the predictor for the civic terror that is unleashed. First of all, we don't want to see that, because what would those monuments look like? And then second, it ain't Muhammad, it's Billy Bob who's fucking it up, who's destroying the culture, who's eviscerating the very vital, nourishing ideals that are the tap source of American civic and democratic creativity.

How do we memorialize that? How do you signify in public space that that is the case? Well, that's why the graffiti was not simply about the cheapness of it. That it was radically accessible in a way. It also created an afterlife. They got bid on. [The artist Jean-Michel] Basquiat is selling for millions and millions and so on and so forth. It becomes a fetish because if journalism is said to be the first draft of history, then that's kind of public witness, because public art is public witness to a certain degree. It's a witness of the ideas that have been avoided or suppressed. And it's a countermemory, a counternarrative to the public memory that exists.

So I think the beautiful thing about what creators do on local levels, and on national levels, and sometimes on global levels, they're forcing us to deal with stuff we don't want to talk about, but they're forcing us to see what we've invested in, literally. And they're forcing us to be honest about the degree to which the hypocrisy at the heart of so much that we want to celebrate renders us a bit more ambivalent about the meaning of that, on the one side, and rabidly reinforcing the Robert E. Lee school, on the other end. And in between what's left are those of us trying to negotiate the status of our existence in relationship to the monuments that are said to represent us. And we contest

those monuments. What Tariq meant when he came every day and saw that Frank Rizzo [statue] and why that would be offensive, why that would be hurtful, why that would be problematic, why that would, in some sense for others, [be] a monumental eclipse of past prejudice. Rizzo represented, for a group of people of ethnics in this city, the rise of the "un-meltable ethnics," as they used to say, and the way in which Jews, Poles, Italians, Lithuanians were in the process of being remade in the pulverizing cauldron of American society and race into whiteness. So Frank Rizzo's memorial is a memorial to the triumph of whiteness over countervailing narratives of ethnicity and the productive memory of ethnicity being made into whiteness. It's right that that memorial would somehow be contested, on one hand, and a source of pride for others, on the other.

But as we've seen with so many other things in our culture, what used to once give pride, now gives pause, now is recognized as offensive, but that's only because the very people whose lives are at stake finally get a chance to speak, finally get a chance to talk, finally get a chance to say something, like in *The Color Purple,* at least in the movie part, when Whoopi goes out, "I may be black, I may be ugly, but I'm here." I mean, that's the announcement. That's the articulation of the logic of democracy for those who have been denied and the fact that I'm here and that I'm recognized in a certain way has been memorialized. So I think it's going to always be a tremendous dispute.

And I'll end by saying that people made the distinction between hope and optimism and hope was hope against hope, as the Bible talked about, that even when there's no evidence for what you believe in to exist. I think people of color and others have taught America how to hope, and I think to pick up on what Professor Tillet said there, it's like that *Saturday Night Live* skit [about election night 2016] with Chris Rock and Dave Chappelle and white people go, "Oh, my God, that's the worst thing ever." Yeah, okay, that's what you think that is because of what you've been through, right? So the memorial is a mark also of a trajectory, a trace, and a prospect that people who themselves have been cut off from their history don't even know what's possible. The real meaning of the monument lies often with the people that it's directed against, that were meant to be excluded. They are the bearers of the rich, fecund resourceful fertile tradition of the very thing that they've been closed off from. So I think, that in that sense,

the public arguments of those memorials will continue to be incredibly meaningful and produce hope.

PF: This has been a provoking, deep, expansive conversation and unfortunately our night's coming to an end soon. I want to end with a question and also just an expression of gratitude that will keep continuing as we close tonight. This exhibition, this project does not try to offer one answer but instead asks a question to as many people as we can in this city, which is: "What is an appropriate monument for the current city of Philadelphia?" And, in the course of this project, that question of what is appropriate, appropriating municipal logic or illogic to be able to open up what's possible, we've seen others, collaborators and other cities, New Orleans, Chicago, and in several other cities, and asked very similar questions about what monuments they've inherited and what monuments are possible. So I close by posing that question to you and, of course, opening it up, not just for the current city of Philadelphia, but perhaps your cities, the country, or beyond. What are appropriate monuments from your purview for where we are now?

MK: I think the practice of intervening in public space, of occupying public space, of provoking in public space, that's what this is about. I think it should happen everywhere. That's what public space is for to a large extent. It's for litigating who we are, what we believe in, coming to collective ideas about what public good is, what the meaning of democracy is, and that is where art comes in. But the one thing that I would disagree with is sometimes it's about beauty and sometimes it's about ugliness. Whatever it is, it needs to wrestle with the issues that face us now. It doesn't have to last forever but it has to do something. And that's why I began by saying, if nothing else, the federal monuments are doing something again. They're forcing us to have a conversation we need to have. They're revealing this incredibly ugly fact about us that we have to wrestle with. So I think every city—you mentioned several where Confederate monuments either have been removed or haven't been removed, but it could be said in any city. Every city is a complex social organism with hopefully very diverse and hopefully very different attitudes. And this is what art should do, I think, is provide the ways in which people are forced to confront who we are, what we believe in.

ST: To answer that question, it's a project that we intend to work on together with A Long Walk Home. One of our major programs is working with African American girls from the West Side of Chicago. So last summer at the School of the Art Institute we invited a hundred black girls to just take

over the school. Visual artists, dancers, musicians all reimagined that space as a place in which African American girls could feel and be safe. That's a particular investment I have because public spaces and private spaces are really oftentimes harmful for black girls and black women. And so how can we reimagine a public art project that really renders those who are invisible visible? How could they take up space through their art, through their imagination, through their creativity, and also be part of a longer way in which we imagine Chicago or America and in the ways in which this group has been not just discriminated against but kind of written out of historical narratives and out of how the nation sees itself. So I think that project can happen anywhere. But I do think my particular investment is in Chicago. What I do like about the question about what does a monument mean or what is an ideal monument or what a monument should be in that particular city—and I wrote about the President's House, which is right next to the Liberty Bell—but the ways in which you have those conversations, the ways in which people have dialogue about how they see themselves, that first step of people posing that question to themselves and coming up with a variety of answers, that's like civic engagement. That's democracy. That's creating dialogue, dialogue among citizens and artists to reimagine themselves, but also reimagine the public space. I think that just begins, I mean, you can think about the focus groups or you can think about them as critical dialogues. All that is the messy work with democracy, right? And that's the kind of conversation that gets shut down on Fox News or most cable news networks at large, right? Those are combative conversations as opposed to people really trying to understand what their neighborhood thinks about what Philadelphia should be like, or what their friend thinks should be valued over something else, what are our politics or ideology or aesthetic values. All of that stuff, I think, is the beautiful thing that you're trying to create [with] public art projects that really value the community and value the citizen. That's the potential. Again, obviously I'm very optimistic and hopeful. That's why I think it's so exciting. And with the beauty thing, I don't think it has to be pretty. I think, for me, I'm interested in the dissolving monument. That, to me, [is the] aesthetically complicated thing. That's exciting. That's exciting to me as a critic. It's exciting to think about a monument that's going to disappear into the ground, which means that it's both permanent and impermanent. So that's what I meant by taste or something.

PF: And Dr. Dyson, take us home.

MED: I'm going to answer very simply [about] three cities, Philadelphia, D.C., and Detroit, where I'm from. So for Philly, for what exists, I like the Afro pick and the Rocky statue. That's working-class white sensibility with ethnic particularity with the radical freedom aesthetic of the pick, picking at, picking away, right? I love that. But for new ones, I'd have a monument to the cheesesteak because it's working-class food that draws political lines. Then I'd have one for Philly International Records. Now, I'm from Detroit, we have the 1960s on lock, don't get it twisted, but I have to grudgingly concede that in the 1970s, Philadelphia International Records stole the show. I mean, the smooth, mellow, R&B music, the beautiful humanity of a Muslim writer that people don't even know was a Muslim writer: "Wake up, everybody, no more sleepin' in bed." Teddy Pendergrass, who writes for him, "My burden's gone and turned into a song." I mean the, "Let's clean up the ghetto." The universalism of that music is still underexplored and astonishing in its reach. For Washington, D.C., I'd have Marion Barry, he cracks the nature of American democracy. And he shows the cracks in the edifice of American democracy. And people laughed at him. He went to jail and people reelected him. Why? Because he took the lessons from the 1960s and he put them in action that very few of the mayors have done for black people in an unapologetic way. The same way Italian mayors did in Boston or Irish in Chicago, Philadelphia, right? So he explicitly articulated that as the basis of his own argument in Chocolate City, which is now Frappuccino City. And the ways in which Marion Berry becomes important because now gentrification has robbed it of its identity. So, on one hand, I'd have Marion Barry and then I'd still have, you know, Thomas Jefferson, because he represents everything people hope for, you know, and everything they were afraid of at the same time. And the contradictions that were there. White people say, "Oh, he could never have a black wife." You know, I don't know if you know, that's what they did all the time. That's routine and it brings in very perilous things. Roy Moore. Thomas Jefferson. Fourteen-year-old girls. Both of them. And what that means about the rape culture at the heart of American democracy. At its heart.

ST: Why would you have it for Thomas Jefferson and not for Sally [Hemings]?

MED: Well, because Sally is going to be brought along in a way that has to be, right? I mean, if we put Sally Hemings

at the heart, we certainly have to refer to Thomas Jefferson. But since Thomas Jefferson is the ostensible father of American independence and democracy, everybody will initially be drawn to that as an uncomplicated representation of what they need and Sally Hemings stands up to criticize that. So we've got to get him in first and then we've got to punch him when he gets there. I get your point, but I'm saying that the greatest appeal, right, in terms of Thomas Jefferson and what the shadow is. I'm not saying Sally's the shadow. I'm saying the shadow of slavery that falls across it. But we can have a Sally. I'm with the Sally Hemings statue as well, right? And then in Detroit, I'd have to put Aretha Franklin. The greatest sound a voice has made, to me. The greatest sound with voices ever made, right? Sam Cooke, maybe second. [Frank] Sinatra, maybe third, in terms of great singing. I'm just saying. So I put her up there and then I put her daddy up there, Reverend C. L. Franklin. If Aretha Franklin has precocity, she derived from the legendary and fertile black rhetorical genius of her father. And the hoot sermon, the sung sermon, which is a staple of American rhetoric that is underexplored, didn't begin with him, but it reached its zenith in him in a very serious way.

PF: Thank you, Michael Kimmelman, Michael Eric Dyson, and Salamishah Tillet. And thank you, PAFA. Thanks to all of you. Thank you, Mural Arts. And thank you, Monument Lab. Good night.

Acknowledgments The Monument Lab editors thank our families, friends, artists, collaborators, contributors, and colleagues who helped make this exhibition and book project possible. We offer profound gratitude to the Mural Arts Philadelphia leadership and staff—especially Jane Golden, Joan Reilly, and Caitlin Butler—and to all of the exhibition's participating artists, speakers, essay contributors, and lab research teams. We are grateful for the care and guidance of Temple University Press, especially editor Aaron Javsicas; we also thank the larger press team, including Ann-Marie Anderson, Gary Kramer, Nikki Miller, Mary Rose Muccie, Kate Nichols, Deborah Smith, Joan Vidal, Dave Wilson, and others who worked together with us to imagine and produce this volume. We thank the Elizabeth Firestone Graham Foundation for its generous support of this publication. We also acknowledge supporters of current and previous Monument Lab projects, including the John S. and James L. Knight Foundation, National Endowment of the Arts, Pew Center for Arts and Heritage, Sachs Program for Arts Innovation at the University of Pennsylvania, Surdna Foundation, Tuttleman Family Foundation, University of Pennsylvania Stuart Weitzman School of Design, and William Penn Foundation. We are indebted to Kristen Giannantonio, Monument Lab associate curator, who also served as the book's editorial director; Luke Bulman, the book's designer; and others who contributed their creative and critical energies to the book's production, including Alliyah Allen, Anita Allen, Laurie Allen, Matthew Callinan, Gretchen Dykstra, Michael Eric Dyson, Stephanie Garcia, Justin Geller, William Hodgson, James Huckenpahler, Michael Kimmelman, Heather Lance, Nilay Lawson, Heidi Lee, Donna Mastrangelo, Matt Neff, Neysa Page-Lieberman, Gabrielle Patterson, Sebastianna Skalisky, Tiffany Tavarez, Yannick Trapman-O'Brien, and Tariq Trotter. We are continuously inspired and encouraged by our families, including Aaron Skrypski, Ruth Farber, Barry Farber, Ivan Farber, Wendy Farber, Sam Farber, Paloma Lum, Linus Lum, and Linnea Lum. Finally, we are grateful to all those Philadelphians and visitors who engaged the exhibition, for sharing their ideas for and commitment to our city's living history.

2017 Exhibition Credits

Monument Lab Curatorial Team
Paul M. Farber, artistic director
Ken Lum, chief curatorial advisor
Laurie Allen, director of research
A. Will Brown, deputy curator
Matthew Callinan, director of exhibitions
Kristen Giannantonio, director of curatorial operations
Justin Geller, music director
Maya Thomas, lab research coordinator
Corin Wilson, project coordinator
William Roy Hodgson, exhibition strategist
Sebastianna Skalisky, web designer
Conrad Benner, social media coordinator
Justin Spivey/WJE, structural engineer
Student researchers: Alliyah Allen, Molly Collett,
 Sarah Green, Will Herzog, Jabari Jordan-Walker,
 and Esme Trontz

Mural Arts Philadelphia Team Members
Jane Golden, executive director
Joan Reilly, chief operating officer
Karl Malkin, chief financial officer
Caitlin Butler, chief strategy officer
Nicole Steinberg, director of communications and brand
 management
Netanel Portier, director of project management
Zambia Greene, director of mural operations
Ellen Soloff, director of tours and merchandise
Todd Bressi, interim director, muraLAB
Chris Newman, events coordinator
Operations + Project managers: Phil Asbury, Nick Gibbon,
 Maude Haak-Frendscho, Cathy Harris, Judy Hellman,
 Jess Lewis-Turner, Nicole McDonald, and Gaby Raczka
Communications and marketing: Laura Kochman,
 Laiza Santos, and Steve Weinik
Branding and design: J2 Design
Public relations consultants: Cari Feiler Bender and
 Jan Rothschild
Development: Emily Cooper-Moore, Christina DePaul,
 Naima Murphy, Mel Regn, and Meg Wolensky
Tours and merchandise: Nancy Davis and Rachel Penny
Finance: Lissette Goya, Shiffonne Lindsey, and Don Serjani
Crew members: Gregory Christie, Donovan Freeman,
 Ryan Spilman, Carlos Vasquez, and Michael Whittington

Advisory Committee
Tiffany Tavarez (chair), vice president, community relations
 and senior consultant, Wells Fargo
Alliyah Allen, Haverford College student
Jesse Amoroso, Amoroso's Baking Company
Sandra Andino, cultural anthropologist
Conrad Benner, StreetsDept.com
Robert Cheetham, Azavea
Jess Garz, Surdna Foundation
Bill Golderer, Arch Street Presbyterian Church
Amari Johnson, assistant professor, Africana studies,
 Temple University
Malcolm Kenyatta, Greater Philadelphia Chamber
 of Commerce
Claire Laver, Make the World Better Foundation/
 Urban Roots
Randy Mason, PennPraxis
Loraine Ballard Morrill, iHeartMedia
Ed Rendell, former governor
Jenea Robinson, Visit Philadelphia
Amy Sadao, Institute for Contemporary Art
Jawad Salah, Klehr I larrison
Sara Schwartz, social worker
Elaine Simon, associate professor, urban studies,
 University of Pennsylvania
Linda Swain, Swain Entertainment
Max Tuttleman, Tuttleman Family Foundation
Amanda Wagner, City of Philadelphia
Kellan White, political consultant
Pamela Yau, City of Philadelphia Office of Arts,
 Culture, and the Creative Economy

Prototype Monuments
MONUMENT TO NEW IMMIGRANTS
Collaborators and Fabricators: John Greig, Gary Pergolini,
 Alessandra Saviotti (Estudio Bruguera), and Britta Valles
Partner: Pennsylvania Academy of the Fine Arts
Project manager: Maria Möller

TWO ME
Collaborators and Fabricators: Barron Brown; Mason Darling;
 Severn Eaton; Zhuoer (Audrey) Liu; Helen K. Nagge;
 MichaelAngelo Rodriguez; Greg Skelton of American
 Access, Inc.; Angelo Tartaglini of Angelo's Marble and
 Granite, Inc.; and Amanda Wiles
Partners: City of Philadelphia; City of Philadelphia
 Department of Public Property; and City of Philadelphia
 Office of Arts, Culture, and the Creative Economy
Project manager: Kristen Giannantonio

SAMPLE PHILLY
Collaborators: Ric Allison (console support consultant),
 Tim Bieniosek (LED specialist), Delta Gate Solutions
 (metal fabricators), Justin Geller (music director),
 Frank Musarra (engineering specialist), Leon Phillpotts
 and Anders Uhl (kiosk fabricators and codesigners),
 and Schummers of Kensington
Partner: Historic Philadelphia
Project manager: Corin Wilson

THE TIMES
Partners and Collaborators: City of Philadelphia, City of
Philadelphia Department of Behavioral Health and
Intellectual disAbility Services, Heidelberg Project,
Impact Services and veterans in the transitional housing
facility managed by Impact Services, Mark Johnston
(Detroit), McPherson Square Library Maker Jawn program,
New Kensington Community Development Corporation,
Prevention Point, and everyone who joined us for public
paint days in Kensington
Project manager: Gaby Raczka

DIGGING (ARCHAEOLOGY OF THE VACANT LOT)
Collaborators: AECOM, Alvin and Sheila Bunch,
Doug Mooney, and James Wright
Site partners: City of Philadelphia, Councilwoman Jannie
Blackwell's Office, and People's Emergency Center
Project manager: Maya Thomas

FOR EVERYONE A GARDEN VIII
Partners: City of Philadelphia, Norris Square Neighborhood
Project, and Philadelphia Parks and Recreation
Project manager: Cathy Harris

IF THEY SHOULD ASK
Advisory Group: Nina Ahmad, Alliyah Allen, Kennedy Allen,
Erica Atwood, Rev. Bonnie Camarda, Lorene Cary,
Hazel Edwards, Lauren Footman, Tianna Gaines-Turner,
Jane Golden, Giana Graves, Councilwoman Helen Gym,
Gayle Isa, Ariell Johnson, Celena Morrison, Dawn Munro,
Jessica Roney, Raquel Evita Saraswati, Janet Sturdivant,
Maya Thomas, and Hilary Wang
Collaborators: Emily Belshaw (production assistant),
Molly Collett (Monument Lab summer intern),
Gwen Comings (production assistant), Pavel Efremoff
(production manager), Toren Falck (lasercutter),
Carolyn Lieba Francois-Lazard (research assistant),
Matt Gilbert (metal fabricator), Kathryn Hedley (produc-
tion assistant), Human Kind Design (concrete casting
specialist), James Sprang (production assistant),
Louis Tannen (mold fabricator), Kristen Neville Taylor
(production assistant), and Monika Uchiyama (research
assistant)
Partners: Amalgam Comics and Coffeehouse, City of
Philadelphia, Friends of Rittenhouse Square, Philadelphia
Art Alliance, and Philadelphia Parks and Recreation
Project manager: Corin Wilson

DREAMS, DIASPORA, AND DESTINY
Collaborators: King Britt (electronics specialist), Rich Hill
(upright bass player), Lyrispect (poet), Joshua Mays (visual
artist), John Morrison (electronics specialist),
Heru Shabaka-Ra (trumpet player), and Chuck Treece
(guitartronics musician)
Partners: City of Philadelphia, Friends of Malcolm X Park,
Mural Arts Philadelphia's Art Education program, and
Philadelphia Parks and Recreation
Project manager: Phil Asbury

PASSAGE :: MIGRATION
Collaborators: Michelle Barbieri (executive producer),
Julian Grefe (music), RethinkTANK LLC (designer), and
Ricardo Rivera (artist)
Partners: City of Philadelphia, Friends of Marconi Plaza,
and Philadelphia Parks and Recreation
Project manager: Nicole McDonald

IN PERPETUITY
Collaborators: Sassa Linklater (for her hand and thought
while rewriting the words of Chief Tamanend), and
Davidson Neon with Len Davidson, Hugo Hsu, and the
Cohen Metals Group
Partners: Friends of Penn Treaty Park and Philadelphia
Parks and Recreation
Project manager: Corin Wilson

LOGAN SQUARED: ODE TO PHILLY
Collaborators: Ric Allison and Anders Uhl (listening station
designers and fabricators), Sharon Curley (project
technician), Justin Geller (music director and producer),
John Greig (speaker stand designer and fabricator),
Nathan Lofton (choral arranger and conductor),
Morningstar Studios (recording venue), Drew Schlegel
(recording engineer), and Dave Schonauer (assistant
recording engineer
Speakers provided by Eminence
Chorus: Kendra Balmer, Sonja Bontrager, Cory Davis,
Michael Hogue, Michael Johnson, Elissa Kranzler,
Hank Miller, Victoria Nance, Jordan Rock,
Daniel Schwartz, Caroline Winschel, and
Michele Zuckman
Special acknowledgment: Joe Benford, Gary Galván,
Corinne Militello, and Janine Pollock
Logan Squared: Ode to Philly © 2017 Emeka Ogboh.
All rights reserved.
All poetry © 2017 Ursula Rucker. All rights reserved.
Logan Square at Dusk from Four Squares of Philadelphia
by Louis Gesensway © 1972 by Theodore Presser
Company. All rights administered by Carl Fischer, LLC.
All rights reserved. Used with permission.
Choral arrangement of Four Squares of Philadelphia: "Logan
Square at Dusk" prepared with original score of Four
Squares of Philadelphia provided courtesy of the
Edwin A. Fleisher Collection of Orchestral Music at the
Free Library of Philadelphia
Partners: City of Philadelphia, Free Library of Philadelphia,
Friends of Aviator Park, and Philadelphia Parks and
Recreation
Project managers: Kristen Goldschmidt and Judy Hellman

THE BATTLE IS JOINED
Collaborators: Adam Franklin, Tim Rusterholz of RustFab,
Ian Schmidt, and Matt Speedy
Partners: City of Philadelphia; City of Philadelphia Office
of Arts, Culture, and the Creative Economy; and Friends of
Vernon Park
Project manager: Maude Haak-Frendscho

SEGUIMOS CAMINANDO (WE KEEP WALKING)
Collaborators: Jeff Bethea, Gralin Hughes, Klip Collective, Jose Mazariegos, Mothers at Berks, Jasmine Rivera, and Shut Down Berks Coalition
Partners: Barnes Foundation; City of Philadelphia; City of Philadelphia Department of Public Property; and City of Philadelphia Office of Arts, Culture, and the Creative Economy
Project manager: Gaby Raczka

ON THE THRESHOLD (SALVAGED STOOPS, PHILADELPHIA)
Collaborators: Debbie Anday, Bob Beaty, Kevin Brooks/Kevin Brooks Salvage, Billy Dufala, Scott Ferris, Starr Herr-Cardillo, Roy Ingraffia, Walter Mangual/Mangual Excavations, Rocco Matteo, National Park Service, Dennis Pagliotti, Pedro Palmer, and Robert Powers
Partners: Bricklayers and Allied Craftsworkers Local 1 PA-DE, Independence National Historical Park, International Masonry Institute, and Williamson College of the Trades
Project manager: Corin Wilson

PLAINSIGHT IS 20/20
Collaborators: American Treescapes, Best Line, Delaware River Corporation, Doosan, Image360, Revolution Recovery, and Rockland
Partners: City of Philadelphia, Friends of Penn Treaty Park, and Philadelphia Parks and Recreation
Project manager: Corin Wilson

THE BUILT/UNBUILT SQUARE
Collaborators: Night Kitchen and Hilary Wang
Site partners: City of Philadelphia, Friends of Rittenhouse Square, Philadelphia Art Alliance, Philadelphia Parks and Recreation
Project manager: Corin Wilson

LOVE IS THE MESSAGE
Collaborators: Brands Imaging, Rocio Cabello and Renny Molenaar and iMPeRFeCT Gallery, Malachi Floyd, Dr. Althea Hankins and Aces Museum, Marcus Hines, and Supreme Dow and Black Writers Museum
Site partners: City of Philadelphia, Councilwoman Cindy Bass's Office, Friends of Vernon Park, Germantown United CDC, Historic Germantown, and Philadelphia Parks and Recreation
Project manager: Maude Haak-Frendscho

ALL POWER TO ALL PEOPLE
Partners: City of Philadelphia and City of Philadelphia Department of Public Property
Project manager: Kristen Giannantonio

FREE SPEECH
Collaborators: Melissa Fogg (cofounder and programming specialist)
Youth: Khin Aye, Bwe Ku, Pau San Lian, Than Than Nain, Ermyas Sereke, Mnar Shay, Liliana Velasquez, and students at Northeast High School
Teachers: Diego Bedoya, Gena Bernal, Amanda Feigel, and Tiffany Lorch

Artists/writers: Thagi Bastola, Tika Bhandari, Fernando Chang-Muy, Naw Doh, Randy Duque, Lisa Butler Grainge, Brae Howard, Phila Italiana, Fariha Khan, Kohai, Mark Lyons, Boone Nguyen, Indah Nuritasari, James Onorfrio, Sinta Penyami, Leona Pongparnsana, Sanctuary Poets, Senpai, Rorng Sorn, Jessica Whitelaw, and Hitomi Yoshida
Partners: City of Philadelphia, City of Philadelphia Department of Behavioral Health and Intellectual disAbility Services, Friends of Marconi Plaza, Furness High School, Migrant Education, Northeast High School, and Philadelphia Parks and Recreation
Project manager: Jessica Lewis-Turner

SWEET CHARIOT: THE LONG JOURNEY TO FREEDOM THROUGH TIME
Collaborators: Kyla J. Ayers (performer), Dena Bleu (performer), Blue Visual Effects, Inc. (application developers), Ibn Days (performer), Sallie Days (performer), Erica Armstrong Dunbar (performer), William Hodgson (graphic designer), Gabrielle Patterson (artist), Raymond Reese (performer), Archie Shepp (musician), Jay Simple (artist), James Allister Sprang (cameraman), Lamont B. Steptoe (poet), Rev. Mark Kelly Tyler (performer), Noelle Lorraine Williams (artist), Michael Williamson (artist), and Yolanda Wisher (poet)
Partners: Independence National Historical Park, Library Company of Philadelphia, and Mother Bethel A.M.E. Church
Project manager: Cathy Harris

Exhibition Partners, Supporters, and Sponsors

Lead Monument Lab Partners
City of Philadelphia; Philadelphia Parks and Recreation; University of Pennsylvania; Price Lab for Digital Humanities; City of Philadelphia Office of Arts, Culture, and the Creative Economy; Pennsylvania Academy of the Fine Arts; and Barnes Foundation

Monument Lab Supporters
Major support for Monument Lab projects staged in Philadelphia's five squares was provided by the Pew Center for Arts and Heritage. An expanded artist roster and projects at additional neighborhood sites were made possible by the William Penn Foundation. Lead corporate support was provided by Bank of America. Generous additional support was provided by the National Endowment for the Arts.

Support for the research and development of Monument Lab was provided by the Pew Center for Arts and Heritage and the Hummingbird Foundation.

Support for Monument Lab's final publication was provided by the Elizabeth Firestone Graham Foundation.

Luminaries
Tuttleman Foundation, CLAWS Foundation, and J2 Design

Innovator: PECO

Inventor: Nick and Dee Adams Charitable Fund
Creators: Dean Adler and Susanna Lachs

Patrons: William and Debbie Becker, Davis Charitable Foundation, Parkway Corporation, and Joe and Renee Zuritsky

Supporters: Ira Brind and Stacey Spector, Relief Communications LLC, and Tiffany Tavarez

Media partner: WHYY

Hospitality sponsor: Sonesta

Technology sponsor: Comcast/NBC Universal

Kickstarters: We are grateful to the 432 individuals who supported us on Kickstarter.

Illustration Credits

Steve Weinik/Mural Arts Philadelphia
Pages ii 207, 210–213, and 214 (*bottom*): Hank Willis Thomas, *All Power to All People,* Thomas Paine Plaza, Monument Lab, 2017.
Pages v, 47, 50, 52 (*top*), 53, and 54 (*top*): Mel Chin, *Two Me,* City Hall, Monument Lab, 2017.
Pages vi and 164: Michelle Angela Ortiz, *Flores de Libertad (Flowers of Freedom/Liberty),* in conjunction with *Seguimos Caminando (We Keep Walking),* City Hall, Monument Lab, 2017.
Page xi: Monument Lab exhibition hub, Pennsylvania Academy of the Fine Arts, Monument Lab, 2017.
Pages 7, 137, and 143–144: Emeka Ogboh featuring Ursula Rucker, *Logan Squared: Ode to Philly,* Logan Square, Monument Lab, 2017.
Page 8: Documentation of Monument Lab proposal, LLA27, Franklin Square, Monument Lab, 2017.
Page 10: Monument Lab exhibition hub, Pennsylvania Academy of the Fine Arts, Monument Lab, 2017.
Page 17: Artist Marisa Williamson speaking at public event for *Sweet Chariot: The Long Journey to Freedom through Time,* Washington Square, Monument Lab, 2017.
Page 19: Lab research team, Karyn Olivier, *The Battle Is Joined,* Vernon Park, Monument Lab, 2017.
Pages 21, 67, and 71–74: Tyree Guyton, *THE TIMES,* A Street and East Indiana Avenue, Monument Lab, 2017.
Page 23: City Councilwoman Helen Gym speaking at public event for Sharon Hayes, *If They Should Ask,* Rittenhouse Square, Monument Lab, 2017.
Pages 27, 217, and 219–224: Shira Walinsky and Southeast by Southeast, *Free Speech,* Marconi Plaza, Monument Lab, 2017.
Page 29: Monumental Exchange featuring Hank Willis Thomas and Tariq Trotter, moderated by Salamishah Tillet, City Hall, September 16, 2017, Monument Lab, 2017.
Page 30: Kai Davis, Monument to the Philly Poet event, Free Library/Shakespeare Park, September 27, 2017, Monument Lab, 2017.
Page 33: Public event for Kaitlin Pomerantz, *On the Threshold (Salvaged Stoops, Philadelphia),* Washington Square, Monument Lab, 2017.
Pages 36 and 39–43: Tania Bruguera, *Monument to New Immigrants,* Pennsylvania Academy of the Fine Arts, Monument Lab, 2017.
Page 51: Site visit for Mel Chin, *Two Me,* City Hall, Monument Lab, 2017.
Pages 57, 60, 61, and 64 (*top*): Kara Crombie, *Sample Philly,* Franklin Square, Monument Lab, 2017.
Page 64 (*bottom*): Studio visit preview for Kara Crombie, *Sample Philly,* Monument Lab, 2017.
Pages 89–93: David Hartt, *for everyone a garden VIII,* Norris Square, Monument Lab, 2017.
Pages 97 and 102–104: Sharon Hayes, *If They Should Ask,* Rittenhouse Square, Monument Lab, 2017.
Pages 107 and 111–114: King Britt and Joshua Mays, *Dreams, Diaspora, and Destiny,* Malcolm X Park, Monument Lab, 2017.

Page 110 (*top*): Studio visit for King Britt and Joshua Mays, *Dreams, Diaspora, and Destiny,* Malcolm X Park, Monument Lab, 2017.
Page 110 (*bottom*): Mural Arts Philadelphia, art education class for King Britt and Joshua Mays, *Dreams, Diaspora, and Destiny,* Monument Lab, 2017.
Pages 117 and 120–124: Klip Collective, *Passage :: Migration,* Marconi Plaza, Monument Lab, 2017.
Pages 127, 130–134, and 320: Duane Linklater, *In Perpetuity,* Penn Treaty Park, Monument Lab, 2017.
Pages 147 and 152–153: Karyn Olivier, *The Battle Is Joined,* Vernon Park, Monument Lab, 2017.
Page 154 (*top*): Studio visit for Karyn Olivier, *The Battle Is Joined,* Vernon Park, Monument Lab, 2017.
Pages 157 and 161–163: Michelle Angela Ortiz, *Seguimos Caminando (We Keep Walking),* City Hall, Monument Lab, 2017.
Pages 167 and 170–173: Kaitlin Pomerantz, *On the Threshold (Salvaged Stoops, Philadelphia),* Washington Square, Monument Lab, 2017.
Page 174: Installation, Kaitlin Pomerantz, *On the Threshold (Salvaged Stoops, Philadelphia),* Washington Square, Monument Lab, 2017.
Pages 177 and 180–183: RAIR (Recycled Artist in Residency), *Plainsight Is 20/20,* Penn Treaty Park, Monument Lab, 2017.
Page 184: Installation, RAIR (Recycled Artist in Residency), *Plainsight Is 20/20,* Penn Treaty Park, Monument Lab, 2017.
Pages 189 and 190 (*top*): Alexander Rosenberg, *The Built/Unbuilt Square,* Rittenhouse Square, Monument Lab, 2017.
Pages 197, 200–201, 202 (*bottom*), and 203–204: Jamel Shabazz, *Love Is the Message,* Vernon Park, Monument Lab, 2017.
Page 202 (*top*): Site visit for Jamel Shabazz, *Love Is the Message,* Vernon Park, 2016.
Pages 227 and 233–234: Marisa Williamson, *Sweet Chariot: The Long Journey to Freedom through Time,* Washington Square/Pennsylvania Academy of the Fine Arts, Monument Lab, 2017.
Page 239: Lab research team, David Hartt, *for everyone a garden VIII,* Norris Square, Monument Lab, 2017.

Lisa Boughter/Monument Lab
Page 3: Terry Adkins, *Prototype Monument for Center Square,* City Hall, Monument Lab, 2015—Discovery Phase.

Courtesy of Kara Crombie
Pages 62–63: Kara Crombie, *Sample Philly,* Franklin Square, Monument Lab, 2017.

William Curry/Mural Arts Philadelphia
Pages 77, 83, and 84: Hans Haacke, *Digging (Archeology of the Vacant Lot),* 42nd Street and Lancaster Avenue, Monument Lab, 2017.

Courtesy of David Hartt
Pages 87 and 94: Film stills from David Hartt, *for everyone a garden VIII,* Norris Square, Monument Lab, 2017.

William Roy Hodgson and Stephanie Garcia/Monument Lab

Page 243: Proposals by Type, Data Visualization, *Report to the City*, 2018.

Page 244: Map of Proposal Locations, Data Visualization, *Report to the City,* 2018.

J2 Design (Adapted by Luke Bulman)

Page xiii: Exhibition map.

Courtesy of Sassa Linklater

Page 129: Concept sketch, *In Perpetuity,* Penn Treaty Park, Monument Lab, 2017.

Maria Möller/Mural Arts Philadelphia

Page 44: Tania Bruguera, *Monument to New Immigrants,* Pennsylvania Academy of the Fine Arts, Monument Lab, 2017.

Monument Lab

Page 52 (*bottom*): Mel Chin, *Two Me,* City Hall, Monument Lab, 2017.

Pages 100–101: Studio visit for Sharon Hayes, *If They Should Ask,* Rittenhouse Square, Monument Lab, 2017.

Pages 230–231: Site visit for Marisa Williamson, *Sweet Chariot: The Long Journey to Freedom through Time,* Washington Square /Pennsylvania Academy of the Fine Arts, Monument Lab, 2017.

Page 232 (*top*): Map from Marisa Williamson, *Sweet Chariot: The Long Journey to Freedom through Time,* Washington Square/Pennsylvania Academy of the Fine Arts, Monument Lab, 2017.

Monument Lab—proposals

Page 24: Selection of Monument Lab proposals related to MOVE, Monument Lab, 2015–2017.

Page 45: *Top:* Monument Lab proposal, CH310, City Hall, Monument Lab, 2017. *Bottom:* Monument Lab proposal, MP212, Marconi Plaza, Monument Lab, 2017.

Page 46: *Top:* Monument Lab proposal, PT131, Penn Treaty Park, Monument Lab, 2017. *Bottom:* Monument Lab proposal, PT31, Penn Treaty Park, Monument Lab, 2017.

Page 55: *Top:* Monument Lab proposal, CH471, City Hall, Monument Lab, 2017. *Bottom:* Monument Lab proposal, CH751, City Hall, Monument Lab, 2017.

Page 56: *Top:* Monument Lab proposal, CH1000, City Hall, Monument Lab, 2017. *Bottom:* Monument Lab proposal, CH237, City Hall, Monument Lab, 2017.

Page 65: *Top:* Monument Lab proposal, PT40, Penn Treaty Park, Monument Lab, 2017. *Bottom:* Monument Lab proposal, CH929, City Hall, Monument Lab, 2017.

Page 66: *Top:* Monument Lab proposal, MX131, Malcolm X Park, Monument Lab, 2017. *Bottom:* Monument Lab proposal, CH1047, City Hall, Monument Lab, 2017.

Page 75: *Top:* Monument Lab proposal, PT339, Penn Treaty Park, Monument Lab, 2017. *Bottom:* Monument Lab proposal, FS173, Franklin Square, Monument Lab, 2017.

Page 76: *Top:* Monument Lab proposal, FS382, Franklin Square, Monument Lab, 2017. *Bottom:* Monument Lab proposal, FS202, Franklin Square, Monument Lab, 2017.

Page 85: *Top:* Monument Lab proposal, FS383, Franklin Square, Monument Lab, 2017. *Bottom:* Monument Lab proposal, CH406, City Hall, Monument Lab, 2017.

Page 86: *Top:* Monument Lab proposal, MP117, Marconi Plaza, Monument Lab, 2017. *Bottom:* Monument Lab proposal, MP123, Marconi Plaza, Monument Lab, 2017.

Page 95: *Top:* Monument Lab proposal, LLB28, Barnes Research Field Office, Monument Lab, 2017. *Bottom:* Monument Lab proposal, CH763, City Hall, Monument Lab, 2017.

Page 96: *Top:* Monument Lab proposal, MP197, Marconi Plaza, Monument Lab, 2017. *Bottom:* Monument Lab proposal, MP125, Marconi Plaza, Monument Lab, 2017.

Page 105: *Top:* Monument Lab proposal, MP188, Marconi Plaza, Monument Lab, 2017. *Bottom:* Monument Lab proposal, MP67, Marconi Plaza, Monument Lab, 2017.

Page 106: *Top:* Monument Lab proposal, PT350, Penn Treaty Park, Monument Lab, 2017. *Bottom:* Monument Lab proposal, CH259, City Hall, Monument Lab, 2017.

Page 115: *Top:* Monument Lab proposal, MP209, Marconi Plaza, Monument Lab, 2017. *Bottom:* Monument Lab proposal, MP199, Marconi Plaza, Monument Lab, 2017.

Page 116: *Top:* Monument Lab proposal, FS118, Franklin Square, Monument Lab, 2017. *Bottom:* Monument Lab proposal, PT348, Penn Treaty Park, Monument Lab, 2017.

Page 125: *Top:* Monument Lab proposal, MP200, Marconi Plaza, Monument Lab, 2017. *Bottom:* Monument Lab proposal, MX180, Malcolm X Park, Monument Lab, 2017.

Page 126: *Top:* Monument Lab proposal, PT391, Penn Treaty Park, Monument Lab, 2017. *Bottom:* Monument Lab proposal, PT33, Penn Treaty Park, Monument Lab, 2017.

Page 135: *Top:* Monument Lab proposal, MX211, Malcolm X Park, Monument Lab, 2017. *Bottom:* Monument Lab proposal, PT345, Penn Treaty Park, Monument Lab, 2017.

Page 136: *Top:* Monument Lab proposal, PT402, Penn Treaty Park, Monument Lab, 2017. *Bottom:* Monument Lab proposal, PT415, Penn Treaty Park, Monument Lab, 2017.

Page 145: *Top:* Monument Lab proposal, PT189, Penn Treaty Park, Monument Lab, 2017. *Bottom:* Monument Lab proposal, PT26, Penn Treaty Park, Monument Lab, 2017.

Page 146: *Top:* Monument Lab proposal, PT402, Penn Treaty Park, Monument Lab, 2017. *Bottom:* Monument Lab proposal, PT403, Penn Treaty Park, Monument Lab, 2017.

Page 155: *Top:* Monument Lab proposal, PT428, Penn Treaty Park, Monument Lab, 2017. *Bottom:* Monument Lab proposal, PT336, Penn Treaty Park, Monument Lab, 2017.

Page 156: *Top:* Monument Lab proposal, PT44A, Penn Treaty Park, Monument Lab, 2017. *Bottom:* Monument Lab proposal, PT317, Penn Treaty Park, Monument Lab, 2017.

Page 165: *Top:* Monument Lab proposal, PT412, Penn Treaty Park, Monument Lab, 2017. *Bottom:* Monument Lab proposal, PT429, Penn Treaty Park, Monument Lab, 2017.

Page 166: *Top:* Monument Lab proposal, PT349, Penn Treaty Park, Monument Lab, 2017. *Bottom:* Monument Lab proposal, PT61, Penn Treaty Park, Monument Lab, 2017.

Page 175: *Top:* Monument Lab proposal, PT557, Penn Treaty Park, Monument Lab, 2017. *Bottom:* Monument Lab proposal, LLE38, Promument at PAFA, Monument Lab, 2017.

Page 176: *Top:* Monument Lab proposal, PT301, Penn Treaty Park, Monument Lab, 2017. *Bottom:* Monument Lab proposal, PT303, Penn Treaty Park, Monument Lab, 2017.

Page 185: *Top:* Monument Lab proposal, PT305, Penn Treaty Park, Monument Lab, 2017. *Bottom:* Monument Lab proposal, PT324, Penn Treaty Park, Monument Lab, 2017.

Page 186: *Top:* Monument Lab proposal, PT392, Penn Treaty Park, Monument Lab, 2017. *Bottom:* Monument Lab proposal, LLP288, exhibition hub at PAFA, Monument Lab, 2017.

Page 195: *Top:* Monument Lab proposal, PT331, Penn Treaty Park, Monument Lab, 2017. *Bottom:* Monument Lab proposal, PT35, Penn Treaty Park, Monument Lab, 2017.

Page 196: *Top:* Monument Lab proposal, PT369, Penn Treaty Park, Monument Lab, 2017. *Bottom:* Monument Lab proposal, PT557, Penn Treaty Park, Monument Lab, 2017.

Page 205: *Top:* Monument Lab proposal, PT404, Penn Treaty Park, Monument Lab, 2017. *Bottom:* Monument Lab proposal, PT414, Penn Treaty Park, Monument Lab, 2017.

Page 206: *Top:* Monument Lab proposal, CH446, City Hall, Monument Lab, 2017. *Bottom:* Monument Lab proposal, PT416, Penn Treaty Park, Monument Lab, 2017.

Page 215: *Top:* Monument Lab proposal, PT92, Penn Treaty Park, Monument Lab, 2017. *Bottom:* Monument Lab proposal, PT48, Penn Treaty Park, Monument Lab, 2017.

Page 216: *Top:* Monument Lab proposal, RS276, Rittenhouse Square, Monument Lab, 2017. *Bottom:* Monument Lab proposal, PT420, Penn Treaty Park, Monument Lab, 2017.

Page 225: *Top:* Monument Lab proposal, RS59, Rittenhouse Square, Monument Lab, 2017. *Bottom:* Monument Lab proposal, WS167, Washington Square, Monument Lab, 2017.

Page 226: *Top:* Monument Lab proposal, CH324, City Hall, Monument Lab, 2017. *Bottom:* Monument Lab proposal, VP58, Vernon Park, Monument Lab, 2017.

Page 235: *Top:* Monument Lab proposal, RS28, Rittenhouse Square, Monument Lab, 2017. *Bottom:* Monument Lab proposal, WS166, Washington Square, Monument Lab, 2017.

Page 240: Monument Lab proposal, RS64, Rittenhouse Square, Monument Lab, 2017.

Page 241: Monument Lab proposal, MP46, Marconi Plaza, Monument Lab, 2017.

Page 242: Monument Lab proposal, MX6, Malcolm X Park, Monument Lab, 2017.

Mike Reali/Mural Arts Philadelphia

Page 4: Karyn Olivier, *The Battle Is Joined,* Vernon Park, Monument Lab, 2017.

Pages 150–151 and 154 (*bottom*): Karyn Olivier, *The Battle Is Joined,* Vernon Park, Monument Lab, 2017.

Courtesy of Alexander Rosenberg

Pages 187 and 191–194: Page view from Rittenhouse Square Evening Timeline from Alexander Rosenberg, *The Built/ Unbuilt Square,* Rittenhouse Square, Monument Lab, 2017.

Page 190 (*bottom*): Augmented reality still from Alexander Rosenberg, *The Built/Unbuilt Square,* Rittenhouse Square, Monument Lab, 2017.

@WeFilmPhilly

Page 54 (*bottom*): Aerial shot, Mel Chin, *Two Me,* City Hall, Monument Lab, 2017.

Courtesy of Signe Wilkinson

Page 214 (*top*): Signe Wilkinson, editorial cartoon, *Philadelphia Inquirer/Philadelphia Daily News,* September 15, 2017.

Courtesy of Marisa Williamson

Page 232 (*middle and bottom*): Film stills from *Sweet Chariot: The Long Journey to Freedom through Time,* Washington Square Park/Pennsylvania Academy of the Fine Arts, Monument Lab, 2017.

About the Artists

For more than twenty-five years, **Tania Bruguera** has created socially engaged performances and installations that examine political power structures and their effect on the lives of their constituencies. Her research focuses on ways in which art can be applied to everyday political life, on the transformation of social affect into political effectiveness. She participated in the Documenta 11 exhibition in Kassel, Germany, and established the Arte de Conducta (Behavior Art) program at Instituto Superior de Arte in Havana, Cuba. Her work has been exhibited in such venues as the 2015 Venice Biennale, the Tate Modern in London, the Guggenheim Museum in New York, and the Museum of Modern Art in New York. Bruguera recently opened the Hannah Arendt International Institute for Artivism, in Havana—a school, exhibition space, and think tank for activist artists and Cubans.

Mel Chin was born in Houston, Texas. He is known for the broad range of approaches in his art, which includes works that require multidisciplinary, collaborative teamwork and works that conjoin cross-cultural aesthetics with complex ideas. He developed *Revival Field* (1989–ongoing), a project that pioneered the field of "green remediation," the use of plants to remove toxic heavy metals from the soil. His nationwide *Fundred Dollar Bill Project* continues to engage and present the public will for an end to childhood lead poisoning. Chin is an artist resistant to any branding that may fence in his capacity to execute iconic sculptures in any known medium; engage in any territory, toxic or social; or encourage the expansion and generational transfer of ideas in any alternative field. His work, which is exhibited extensively in the United States and abroad, was documented in the popular PBS program *Art 21: Art of the 21st Century*. Chin is the recipient of numerous national and international awards, including four honorary doctorates. A traveling retrospective exhibition of his work, titled ReMatch, opened at the New Orleans Museum of Art in February 2014. As a follow-up to ReMatch, which explored his mutative strategies, a comprehensive solo survey, *All over the Place,* organized by No Longer Empty and the Queens Museum, took place in spring 2018.

Kara Crombie is a moving images and sound artist who lives and works in Philadelphia and is the creator of the animated series *Aloof Hills*. She is a recipient of the Pew Fellowship in the Arts, MacDowell Colony Fellowship, Headlands Center for the Arts Fellowship, Millay Colony Fellowship, and Sacatar Institute Fellowship. Her work has been exhibited and screened at the Institute of Contemporary Art in Philadelphia, the Philadelphia Art Alliance, Fleisher/Ollman, the Vox Populi Gallery, the Pageant : Soloveev Gallery, and Art Space in New Haven, Connecticut. She was a member of the art collective Vox Populi from 2006 to 2011. From 2015, she worked with Monument Lab to create a temporary monument for Philadelphia's Franklin Square in 2017. Crombie is currently an associate professor of photographic imaging and digital video production at the Community College of Philadelphia.

Tyree Guyton was born and raised in Detroit, Michigan, on the street that gives its name to his most famous work: the Heidelberg Project. Guyton, whose grandfather Sam Mackey introduced him to art as a child and who later spent two years training at the Center for Creative Studies in Detroit, is best known for charting his own path with the creation of the Heidelberg Project. Guyton's work, which is commissioned from around the world and is collected nationally and internationally, is featured in the collections of the Detroit Institute of Arts, the University of Michigan Museum of Art, the Perez Museum, and the Studio Museum of Harlem. Guyton has earned more than eighteen awards and fellowships, including a prestigious one-year residency at the Lorenz Haus in Basel, Switzerland. In 2009 Guyton received an honorary doctorate of fine art from the College of Creative Studies. He is the focus of many journal articles and books in both the United States and Europe, including a book dedicated to his work alone, *Connecting the Dots: Tyree Guyton's Heidelberg Project* (Wayne State University Press, 2007). Guyton is currently working on a book entitled *2 + 2 = 8: A Philosophy by Tyree Guyton.*

Born in 1936 in Cologne, Germany, **Hans Haacke** has lived in New York since 1965. From 1967 to 2002 he taught at The Cooper Union. His personal exhibitions have been held at Museum Haus Lange in Krefeld, Germany; the Museum of Modern Art in Oxford, United Kingdom; Stedelijk Van Abbemuseum in Eindhoven, Netherlands; the Renaissance Society in Chicago; the Tate Gallery in London; the New Museum of Contemporary Art in New York; Centre Pompidou in Paris; the Venice Biennale; Fundació Antoni Tàpies in Barcelona; Museum Boijmans Van Beuningen in Rotterdam; Portikus in Frankfurt; Serpentine Gallery in London; Generali Foundation in Vienna; Deichtorhallen Hamburg and Akademie der Künste in Berlin (2006); Museo Nacional Centro de Arte Reina Sofía in Madrid; and 4th Plinth, Trafalgar Square, in London (2015). His works have been included in five Documentas; the Biennales of Venice, São Paulo, Sydney, Tokyo, Johannesburg, Gwangju, Sharjah, and Mercosul; and the Whitney Biennial in New York. He and Nam June Paik shared the Golden Lion for German Pavilion at the Venice Biennale 1993.

David Hartt creates work that unpacks the social, cultural, and economic complexities of his various subjects. He explores how historic ideas and ideals persist or transform over time. Born in Montreal, Canada, in 1967, he lives and works in Philadelphia, where he is an assistant professor in the Department of Fine Arts at the University of Pennsylvania. He has a master's degree from the School of the Art Institute of Chicago and a bachelor's degree from the Department of Visual Arts at the University of Ottawa. His work is included in the public collections of the Museum of Modern Art in New York; the Whitney Museum of American Art in New York; the Studio Museum in Harlem, New York; the Art Institute of Chicago; the Museum of Contemporary Art in Chicago; the Museum of Contemporary Photography in Chicago; the Henry Art Gallery in Seattle; the National Gallery of Canada in Ottawa; and the Stedelijk Museum in Amsterdam. In 2018 Hartt was a recipient of both a Pew Fellowship and a Graham Foundation Fellowship. In 2015 he received a Foundation for Contemporary Arts grant, in 2012

he was named a United States Artists Cruz Fellow, and in 2011 he received a Louis Comfort Tiffany Foundation Award.

Sharon Hayes is an artist who engages multiple media—video, performance, and installation—in her ongoing investigation into intersections between history, politics, and speech. Hayes's work centers on the development of new representational strategies that examine and interrogate the present political moment as one that reaches simultaneously backward and forward, a present moment that is never wholly its own but rather full of multiple past moments and the speculations of multiple futures. On this ground, Hayes often addresses political events or movements from the 1960s through the 1990s. Her focus on the particular sphere of the near-past is influenced by the potent imbrication of private and public urgencies that she experienced in her own foundational encounters with feminism and AIDS activism. Hayes's work has been staged on the street; in museums, galleries, and exhibition spaces; in theater and dance venues; and in forty-five lesbian living rooms across the United States. Hayes has had solo exhibitions at Andrea Rosen Gallery in New York, Tanya Leighton Gallery in Berlin, the Whitney Museum of American Art in New York, and the Museo Nacional Centro de Arte Reina Sofía in Madrid. Her work has been exhibited at the Venice Biennale (2013), the Museum of Modern Art in New York, the Guggenheim Museum in New York, the Institute of Contemporary Art in Philadelphia, and numerous museums and venues across Europe and the Americas. Hayes is also the recipient of, among other awards, a Pew Fellowship (2016), a Guggenheim Fellowship (2014), the Alpert Award in Visual Arts (2013), the Anonymous Was a Woman Award (2013), and a Louis Comfort Tiffany Foundation Fellowship (2007). She teaches in the Department of Fine Arts at the University of Pennsylvania.

King Britt is a renowned Philadelphia DJ, record producer, composer, and performer. He has released more than twenty albums with a variety of collaborators. King Britt has toured and worked with Digable Planets, Sade, Alison Moyet, De La Soul, and Josh Wink. He is also a Pew Fellow (2007) and has been a guest curator at MoMA PS1 and Fringe Arts. **Joshua Mays** is a muralist, illustrator, painter, and mixed-media artist who lives and works in Oakland, California. He has created public murals, and his work has been exhibited in cities around the world, including Philadelphia; Denver; Washington, D.C.; Portland; and Mexico City.

Klip Collective is an experiential art shop that integrates projection lighting and storytelling to create compelling experiences. **Ricardo Rivera,** creative director and cofounder of Klip Collective, is a visual artist, a filmmaker, and a true pioneer of video-projection mapping, having earned a U.S. patent for his technological breakthroughs in the medium. His work has been featured at the Sundance Film Festival on multiple occasions, including on the commissioned festival bumper in 2014. Rivera directed *Nightscape: A Light and Sound Experience* at Longwood Gardens, which attracted more than 175,000 visitors in 2015 and again in 2016. In the advertising world, brands including Nike, Target, NBC Sports, and Adult Swim have sought his unique ability to use video projection art as a bridge between architecture, technology, and storytelling. The common element in Ricardo's work is groundbreaking creativity and technological innovation.

Duane Linklater, who is Omaskêko Ininiwak/Moose Cree First Nation in Northern Ontario, Canada, is currently based in North Bay, Ontario. Linklater attended the Milton Avery Graduate School of Arts at Bard College in upstate New York, earning a master's degree in film and video. His work has been exhibited nationally and internationally at the Vancouver Art Gallery; the Family Business Gallery in New York; Te Tuhi Centre for the Arts Auckland in New Zealand; City Arts Centre in Edinburgh, Scotland; the Institute of Contemporary Arts in Philadelphia; the Utah Museum of Fine Arts in Salt Lake City; and, more recently, the SeMa Biennale in Seoul and 80WSE Gallery in New York. His collaborative film project with Brian Jungen, *Modest Livelihood,* was originally presented at the Walter Phillips Gallery at the Banff Centre as part of Documenta 13, with subsequent exhibitions of this work appearing at the Logan Center Gallery at the University of Chicago and the Art Gallery of Ontario. Linklater was also the recipient of the 2013 Sobey Art Award, an annual prize earmarked for a deserving Canadian artist under age forty. He is currently represented by Catriona Jeffries in Vancouver.

Emeka Ogboh connects to places with his senses of hearing and taste. Through his audio installations and gastronomic works, Ogboh explores how private, public, and collective memories and histories are translated, transformed, and encoded into sound and food. These works contemplate how sound and food capture existential relationships, frame our understanding of the world, and provide a context in which to ask critical questions about immigration, globalization, and postcolonialism. Ogboh has participated in international exhibitions, including Documenta 14 (2017), Athens and Kassel, Skulptur Projekte Münster (2017), the fifty-sixth edition of Venice Biennale (2015), and Dakar Biennale (2014). Ogboh was awarded the Prize of the Bottcherstraße in Bremen in 2016, and he and Otobong Nkanga were awarded the Sharjah Biennial 14 prize for their collaborative project (2019). Ogboh is currently one of the inaugural fellows at Columbia University's Institute for Ideas and Imagination in Paris. **Ursula Rucker** is a Philadelphia-born poet, mother, activist, and recording artist. She has been performing, recording, and releasing works for more than twenty years. Rucker has traveled and toured extensively—throughout North America, Europe, Asia, Australia, New Zealand, and Africa—sharing her poetry, her heart, and her soul. She is dedicated to art as/for social change and committed to freedom fighting, truth telling, and peace- (and a little trouble-) making through her chosen art form. Rucker believes in taking her art as far as it can go, whether through teaching, activism, lecturing, conducting workshops, merging it with music and recording, or rocking mics and stages. To date, Rucker has released five solo albums and has collaborated on more than a hundred songs, in a wide array of musical genres, with producers/artists from around the world. Among her most recent rewarding endeavors are her Monument Lab collaboration with Emeka Ogboh and Voices of Kensington, a poetry series she curates through Mural Arts Philadelphia. The recipient of the Leeway

Foundation's Art for Change Grant and its Transformation Award, Rucker was named a 2018 Pew Fellow.

Born in Trinidad and Tobago, **Karyn Olivier** has exhibited at the Gwangju and Busan Biennales, the Studio Museum in Harlem, the Whitney Museum of Art, MoMA PS1, the Museum of Fine Arts in Houston, CAM Houston, the Mattress Factory, and SculptureCenter. In 2015 Olivier created public works for Creative Time in Central Park and New York City's Percent for Art program. She is the recipient of the John Simon Guggenheim Memorial Foundation Fellowship, the Joan Mitchell Foundation Award, the New York Foundation for the Arts Award, a Pollock-Krasner Foundation grant, the William H. Johnson Prize, the Louis Comfort Tiffany Foundation Biennial Award, a Creative Capital Foundation grant, and a Harpo Foundation grant. Her work has been reviewed in the *New York Times, Time Out New York,* the *Village Voice, Art in America, Flash Art, Mousse,* the *Washington Post, Nka: Journal of Contemporary African Art,* and *Frieze,* among other publications. Olivier is currently an associate professor of sculpture at Tyler School of Art.

Michelle Angela Ortiz is a visual artist/skilled muralist/community arts educator who uses her art as a vehicle to represent people and communities whose histories are often lost or co-opted. Through painting, printmaking, and community arts practices, she creates a safe space for dialogue around some of the most profound issues communities and individuals may face. Her work tells stories using richly crafted and emotive imagery to claim and transform spaces into a visual affirmation that reveals the strength and spirit of the community. For twenty years, Ortiz has continued to be an active educator in using the arts as a tool for communication to bridge communities. As a highly skilled muralist, Ortiz has designed and created more than fifty large-scale public works nationally (in Pennsylvania, New Jersey, Mississippi, and New York) and internationally. Since 2008, Ortiz has led community-building and art for social change public art projects independently in Costa Rica and Ecuador and through the U.S. Embassy as a cultural envoy in Fiji, Mexico, Argentina, Spain, Venezuela, and Honduras. In Cuba, she completed the first U.S.-funded public art project since the reopening of the U.S. Embassy in Havana in 2015. Ortiz is a 2018 Pew Fellow, a Rauschenberg Foundation Artist as Activist Fellow, a Kennedy Center Citizen Artist National Fellow, and a Santa Fe Art Institute Equal Justice Resident Artist. In 2016, she received the Americans for the Arts' Public Art Year in Review Award, which honors outstanding public art projects in the nation.

Kaitlin Pomerantz is a visual artist and educator based in Philadelphia. Her sculpture, intermedia installation, 2D works, and writing explore the relationship among humans and nature; landscape and land use; and themes of history, vacancy, loss, and renewal. In fall 2018, Pomerantz participated in the academic arts residency program, Land Arts of the American West, based at Texas Tech University. She is cofacilitator of the recurring botanical arts project WE THE WEEDS, whose participants attended the Cabin Time residency out of Los Angeles in spring 2019. Pomerantz has most recently exhibited her work at Little Berlin in Philadelphia, Texas Tech Museum in Lubbock, and Fjord

Gallery in Philadelphia. She holds a bachelor's degree in art history from the University of Chicago and a master's degree in interdisciplinary visual art from the University of Pennsylvania. Pomerantz is a visiting assistant professor of fine arts at Haverford College.

Co-directed by artists Lucia Thomé and Billy Dufala, **RAIR (Recycled Artist in Residency)** is a nonprofit organization whose mission is to challenge the perception of waste culture by providing a platform for artists at the intersection of art and industry. Situated inside a construction and demolition waste recycling company in Northeast Philadelphia, RAIR offers artists both studio space and access to more than 450 tons of materials a day. Since 2010, RAIR's flagship Residency Program has established itself as a unique opportunity for emerging, mid-career, and established artists. By facilitating artists' direct engagement with the waste stream, RAIR encourages residents to consider their studio practice through the lens of sustainability and to thoughtfully reassess their processes of material sourcing and waste disposal. Collaborating with community groups, art institutions, and waste industry partners, RAIR has also extended its reach far beyond its resident artists through projects including recycling facility tours, class presentations, public events, and exhibitions that illuminate the connections between art, industry, and sustainability. RAIR offers assistance with the material sourcing, planning, design, and fabrication involved in a range of cross-disciplinary projects and works with collaborators to maximize the creative potential of waste materials. Though RAIR has worked with mostly local (Philadelphia) artists and arts organizations, its artists' projects have been featured in international projects as well. Notable exhibitions include Mohamed Bourouissa: Horse Day in Le Bal, Paris; Abigail DeVille: Intersection at Hauser Wirth in Los Angeles, California; Bryan Zanisnik: Aquarium Painting at 1646 in The Hague, Netherlands; and Filthy Rich: projects made possible by the waste stream, at the Galleries at Moore in Philadelphia. Notable support for RAIR has come from the Barra Foundation; the City of Philadelphia's Office of Arts, Culture, and the Creative Economy; the Pennsylvania Council for the Arts; the Pew Center for Arts and Heritage; the Philadelphia Cultural Fund; PhillyStake; the Samuel S. Fels Fund; and the Warhol Foundation.

Alexander Rosenberg is a Philadelphia-based artist, educator, and writer. He received a bachelor's degree in glass from Rhode Island School of Design and a master's degree in visual studies from Massachusetts Institute of Technology (MIT). His artistic practice is rooted in the study of glass as a material, in conjunction with a broad interdisciplinary investigation that crosses into numerous other media and research areas. Rosenberg pursues his practice with artist residencies, teaching, performances, and exhibitions locally and internationally. He is the recipient of the 2012 International Glass Prize, an Awesome Foundation Grant (2019), the Sheldon Levin Memorial Residency at the Tacoma Museum of Glass, a Windgate Fellowship at the Vermont Studio Center, the Esther and Harvey Graitzer Memorial Prize, the UArts FADF Grant, and the deFlores Humor Fund Grant (MIT). He has attended artist residencies at the MacDowell Colony, Wheaton Arts, Urban Glass, Vermont

Studio Center, StarWorks, Pilchuck Glass School, GlazenHuis in Belgium, Rochester Institute of Technology, Radical Heart in Detroit, and Worcester Craft Center. His writing has been published in *Glass Quarterly Magazine*, *Glass Art Society Journal*, and the *Art Blog*. A founding member of Hyperopia Projects (2010–2018), he headed the glass program at University of the Arts (2010–2017) and was an artist member of Vox Populi gallery (2012–2015). He currently teaches at Salem Community College.

Jamel Shabazz is best known for his iconic photographs of New York City during the 1980s. A documentary, fashion, and street photographer, he has authored nine monographs and contributed to more than three dozen other photography-related books. His photographs have been exhibited worldwide, and his work is housed within the permanent collections of the Whitney Museum in New York; the Studio Museum in Harlem, New York; the Smithsonian's National Museum of African American History and Culture in Washington, D.C.; the Fashion Institute of Technology in New York; and the Bronx Museum of the Arts. Over the years, Shabazz has instructed young students at the Studio Museum in Harlem's Expanding the Walls Project, the Schomburg Center for Research in Black Culture Teen Curators program, and the Rush Philanthropic Arts Foundation. Shabazz is the 2018 recipient of the Gordon Parks Foundation Fellowship. Shabazz is also a member of the African American photography collective Kamoinge, Inc. His goal as an artist is to contribute to the preservation of world history and culture.

Hank Willis Thomas is a conceptual artist working primarily with themes related to perspective, identity, commodity, media, and popular culture. His work has been exhibited throughout the United States and abroad, including at the International Center of Photography in New York; the Guggenheim Museum in Bilba, Spain; the Musée du quai Branly in Paris; the Hong Kong Arts Centre in Hong Kong; and the Witte de With Center for Contemporary Art in Rotterdam, Netherlands. Thomas's work is included in numerous public collections, including the Museum of Modern Art in New York; the Solomon R. Guggenheim Museum in New York; the Whitney Museum of American Art in New York; the Brooklyn Museum in New York; the High Museum of Art in Atlanta, Georgia; and the National Gallery of Art in Washington, D.C. His collaborative projects include *Question Bridge: Black Males*, *In Search of the Truth (The Truth Booth)*, and *For Freedoms*, which was awarded the 2017 ICP Infinity Award for New Media and Online Platform. Thomas is a recipient of the Gordon Parks Foundation Fellowship (2019), the Guggenheim Foundation Fellowship (2018), the AIMIA | AGO Photography Prize (2017), and the Soros Equality Fellowship (2017), and he is a member of the New York City Public Design Commission. Thomas holds a bachelor of fine arts degree from New York University (1998) and a master of arts/master of fine arts degree from the California College of the Arts (2004). He received honorary doctorates from the Maryland Institute of Art and the Institute for Doctoral Studies in the Visual Arts in 2017. Thomas is represented by Jack Shainman Gallery in New York, Ben Brown Fine Arts in London, Goodman Gallery in South Africa, Maruani Mercier in Belgium, and Kayne Griffin Corcoran in Los Angeles.

Shira Walinsky is a multidisciplinary artist and teacher who has worked with communities throughout Philadelphia. Her endeavors include grassroots community projects that work with underutilized spaces in the city. She is compelled by the personal story and modes of representation from the painted portrait to the documentary. Her murals can be seen throughout Philadelphia. In 2012, Walinsky cofounded **Southeast by Southeast** through Mural Arts Philadelphia. A community center for new refugees from Burma and Bhutan in South Philadelphia, Southeast by Southeast was presented at the North American Refugee Health conference in Rochester, New York. Walinsky's work has been shown at the Pennsylvania Academy of the Fine Arts, the Asian Arts Initiative, and the Institute of Contemporary Art in Philadelphia. She is currently working with teens in South Philadelphia to create a series of short films about the Burmese and Bhutanese refugee experience in Philadelphia.

Marisa Williamson is a Newark, New Jersey–based artist working in performance, video, and installation. She received her bachelor's degree from Harvard University and her master's degree from CalArts. She attended the Skowhegan School of Painting and Sculpture in 2012 and participated in the Whitney Museum's Independent Study Program in 2014–2015. She has staged site-specific performances at and in collaboration with the University of Virginia, Mural Arts Philadelphia, Thomas Jefferson's Monticello, Storm King Art Center, and the Metropolitan Museum of Art in New York. Her videos, performances, and objects are exhibited internationally. She has taught at the Pratt Institute, the Brooklyn Museum, and Rutgers University's Mason Gross School of the Arts. She is currently on the faculty at the Hartford Art School at the University of Hartford.

About the Editors and Contributors

EDITORS

Paul M. Farber is the artistic director and cofounder of Monument Lab and senior research scholar at the Center for Public Art and Space at the University of Pennsylvania Stuart Weitzman School of Design. Farber earned his doctorate in American culture from the University of Michigan. He previously served as a postdoctoral fellow at Haverford College and a doctoral fellow at the German Historical Institute in Washington, D.C. Farber's research explores transnational urban history, cultural memory, and creative approaches to civic engagement. He is the author of *A Wall of Our Own: An American History of the Berlin Wall* (University of North Carolina Press, 2020), which examines representations of the Berlin Wall in American art, literature, and popular culture from 1961 to the present. He is also the editor of a new critical edition of *Made in Germany* (Steidl Verlag, 2013) and coeditor of a special issue of the journal *Criticism* on HBO's series *The Wire* (2011). Farber has contributed essays to several edited collections and advised the production of photography books, including Leonard Freed's *This Is the Day: The March on Washington* (Getty Publications, 2013), Nathan Benn's *Kodachrome Memory: American Pictures 1972–1990* (powerHouse, 2013), and Jamel Shabazz's *Pieces of a Man* (ArtVoices, 2016). His work on culture has also previously appeared in *The Guardian, Museums and Social Issues, Diplomatic History, Art and the Public Sphere,* and *Vibe* and on NPR. As a curator, Farber maintains the practice of working directly with artists to engage, revisit, and reimagine their archives. In addition to his work on Monument Lab, he previously curated the traveling exhibition The Wall in Our Heads: American Artists and the Berlin Wall and the exhibition Stephanie Syjuco: American Rubble. He has been invited to lecture and lead workshops at the Library of Congress, New York Public Library, the Philadelphia Museum of Art, and the Barnes Foundation. He also served as the inaugural scholar in residence for Mural Arts Philadelphia and conducted research residencies with the High Line and Pulitzer Arts Foundation. He currently serves as the curator in residence for New Arts Justice at Express Newark.

Vancouver-born artist **Ken Lum** is known for his conceptual and representational art in several media, including painting, sculpture, and photography. He is chief curatorial adviser and cofounder of Monument Lab. A longtime professor, he is currently the chair of Fine Arts at the University of Pennsylvania Stuart Weitzman School of Design. He was formerly a professor of art at the University of British Columbia in Vancouver, where he was also head of the Graduate Program in Studio Arts at Bard College in Annandale-on-Hudson, New York, and at the l'Ecole des Beaux Arts in Paris. In addition to English, Lum speaks French and Cantonese Chinese. A cofounder and founding editor of *Yishu: Journal of Contemporary Chinese Art,* he is a prolific writer with numerous published articles, catalogue essays, and juried papers. In 2000, he worked as coeditor of the Shanghai Biennale. As an artist, he has a long and active art exhibition record of more than thirty years, including, among others, major exhibitions such as Documenta 11, the Venice Biennale, São Paulo Bienal, Shanghai Biennale, Carnegie Triennial, Sydney Biennale, Busan Biennale,

Liverpool Biennial, Gwangju Biennale, Moscow Biennial, and Whitney Biennial. Since the mid-1990s, Lum has worked on many permanent public art commissions, including commissions for the cities of Vienna, the Engadines (Switzerland), Rotterdam, St. Louis, Leiden, Utrecht, Toronto, and Vancouver. He has also completed temporary public art commissions in Stockholm, Istanbul, Torun (Poland), Innsbruck, and Kansas City. In 2016, he completed a memorial to the Canadian war effort in Italy during World War II. He is currently working on a memorial to the 1986 Lake Nyos disaster for the government of Cameroon. Lum has also been involved in co-conceiving and co-curating several large-scale exhibitions, including Shanghai Modern: 1919–1945, an exhibition about the art, culture, and politics of Shanghai during the first republican period of China after the demise of the Qing Dynasty, to which he contributed an essay on the policy of aesthetic education in China's first modern art school; Sharjah Biennial 2007: Belonging, in Sharjah, United Arab Emirates, a groundbreaking exhibition to which he contributed an essay on the subject of identity formation without foundations; and the NorthWest Annual in Seattle. He is a Guggenheim Fellow and a Penn Institute of Urban Research Fellow. In late 2017, Lum was appointed an officer of the Order of Canada. In 2018, he was granted a Pew Fellowship from the Pew Center for Arts and Heritage.

CONTRIBUTORS

Alexander Alberro, Virginia Bloedel Wright Professor of Modern and Contemporary Art History at Barnard College/Columbia University, is the author of *Abstraction in Reverse: The Reconfigured Spectator in Mid-Twentieth-Century Latin American Art* (University of Chicago Press, 2017) and *Conceptual Art and the Politics of Publicity* (MIT Press, 2003) and has edited books on contemporary art, including *Working Conditions: The Writings of Hans Haacke* (MIT Press, 2016), *Institutional Critique: An Anthology of Artists Writings; Art after Conceptual Art* (MIT Press, 2009), *Museum Highlights: The Writings of Andrea Fraser* (MIT Press, 2005), *Recording Conceptual Art* (University of California Press, 2001), *Two-Way Mirror Power: Selected Writings by Dan Graham on His Art* (MIT Press, 1999), and *Conceptual Art: A Critical Anthology* (MIT Press, 1999).

Alliyah Allen is the program coordinator for New Arts Justice at Express Newark and an assistant curator of Monument Lab. As a photographer and writer, Allen focuses on the experiences, narratives, healing practices, and transformational image practices surrounding blackness, spirituality, and womanhood. Employing photography and writing as tools, Allen aims to use them in her mission to empower and give space to those who are unseen and unheard. Based in Newark, New Jersey, Allen is a graduate of Haverford College. She has previously worked at the Village of Arts and Humanities, at the Cantor Fitzgerald Gallery, and on each of the Monument Lab research teams. For more on Allen's work, see www.alliyaha.com.

Laurie Allen is a senior research specialist at the Library of Congress. A native Philadelphian, she also serves as research director for Monument Lab. Previously, as director for digital scholarship at the University of Pennsylvania Libraries, she and her colleagues collaborated on new forms

of scholarship to support campuswide open-access publishing, data curation and management, digital humanities, and mapping and geospatial data efforts. Allen was also one of the co-investigators of the Mellon Foundation–funded Collections as Data: Part to Whole initiative. Before joining the Penn Libraries, Allen was the coordinator for digital scholarship and research at Haverford College. She holds a bachelor's degree in philosophy from Bard College and a master's degree in library and information science from Simmons College.

Andrew Friedman is an associate professor of history at Haverford College. He is the author of *Covert Capital: Landscapes of Denial and the Making of U.S. Empire in the Suburbs of Northern Virginia* (University of California Press, 2013), winner of the Stuart L. Bernath Book Prize from the Society for Historians of American Foreign Relations, and recipient of an honorable mention for the Spiro Kostof Book Award from the Society of Architectural Historians. His work has appeared in numerous publications, including the *New York Times*, the *Village Voice*, the *Journal of Urban History*, *Progress in Human Geography*, *Diplomatic History*, and *Race and Class*. Friedman lives in Philadelphia.

Justin Geller is a Philadelphia-based sound designer and producer and creative consultant. Since the early 1990s, he has been involved in a diverse group of music projects and collaborations, producing music and sound-based art for film, video, outdoor installations, and commercial release. You can learn more about his work at justingeller.com. Geller is the music director and sound director for Monument Lab.

Kristen Giannantonio is an arts administrator, educator, and curator from Philadelphia. She is currently the assistant director of the Undergraduate Fine Arts Program at the University of Pennsylvania and associate curator of Monument Lab. Giannantonio has ten years' expertise working in the nonprofit arts sector and in higher education, specializing in strategic planning, program development, project management, and operations. She has acute experience working on large-scale interdisciplinary projects and exhibitions, with an emphasis on public art, social practice, community-based art, and emerging contemporary art and design practices. Giannantonio holds a master's degree with a concentration in art, education, and urban studies from the University of Pennsylvania (2015) and a bachelor's degree in journalism and art history from Pennsylvania State University (2008).

Jane Golden is executive director of Mural Arts Philadelphia, overseeing its growth from a small city agency to the nation's largest mural program and a model for community development around the globe. Under Golden's direction, Mural Arts has created more than four thousand landmark works of public art through innovative collaborations with community-based organizations, city agencies, nonprofits, schools, the private sector, and philanthropies. Sought after as an expert on urban transformation through art, Golden has received numerous awards for her work, including the 2018 Anne d'Harnoncourt Award for Artistic Excellence from the Arts + Business Council of Greater Philadelphia, the 2018 Dare to Understand Award from the Interfaith Center of Greater Philadelphia, the 2017 ACE (Mentor Program) Person of the Year Award, the 2016 Women of Distinction Award from the Philadelphia Business Journal, the 2016 Paul Philippe Cret Award from the American Institute of Architects, the 2016 Woman of Influence Award from Pearl S. Buck International, the Philadelphia Award, the Hepburn Medal from the Katharine Houghton Hepburn Center at Bryn Mawr College, the Visionary Woman Award from Moore College of Art and Design, the 2012 Governor's Award for Innovation in the Arts, a Distinguished Daughter of Pennsylvania Award from former governor Edward G. Rendell, the Adela Dwyer/St. Thomas Peace Award from Villanova University, LaSalle University's Alumni Association's Signum Fidei Medal, and an Eisenhower Exchange Fellowship Award. Golden has coauthored three books about Philadelphia's murals. She is an adjunct instructor at the University of Pennsylvania and Moore College of Art and Design. She holds a master's degree in fine arts from Rutgers University, degrees in fine arts and political science from Stanford University, and honorary degrees from Drexel University, St. Joseph's University, Swarthmore College, Philadelphia's University of the Arts, Widener University, Haverford College, Villanova University, Albright College, and Maryland Institute College of Art. Golden serves on the Mayor's Cultural Advisory Council, the Penn Museum Advisory Committee, and the board of directors of the Heliotrope Foundation.

Aviva Kapust is a designer, educator, and advocate for equitable revitalization in underserved urban communities. Her work increases community access to design to create and nurture spaces of racial, social, and cultural equity. As executive director at the Village of Arts and Humanities, Kapust founded seven arts-based community-development initiatives that address socioeconomic challenges confronting more than fifteen hundred youth and families in north-central Philadelphia, most notably the Village's SPACES Artist-in-Residence Program. She is a frequent panelist and speaker at local and national engagements focused on equitable creative placemaking, social arts practice, and the integration of art into community economic development. Under Kapust's leadership, the Village was placed on the Yerba Buena Center for the Arts 2018 YBCA 100 list, which honors thought leaders, provocateurs, and innovators who use their platform to create cultural movement. She has steered the organization to excellence at the intersection of arts, culture, and social justice, as recognized by the 2017 Councilman David Cohen Award, Philadelphia Associations of Community Development Corporations' Blue Ribbon Award, two ArtPlace America grants, and the 2018 Citizens Bank's Champions in Action Award. At the Village, Kapust has found synergy between work and life purpose, a journey she first began by honing her creative problem-solving skills as an awarded art director and creative director at top agencies in New York, San Francisco, and Los Angeles and as an adjunct professor at Temple University in Philadelphia.

Fariha Khan is the associate director of the Asian American Studies program at the University of Pennsylvania, where she also teaches courses on South Asians in the United States, Asian American communities, and Muslim identity in

America. She received her master's degree in Arabic and Islamic studies from Yale University and her doctorate in folklore and folklife from the University of Pennsylvania. Her current research focuses on South Asian American Muslims and the Asian American community. Actively involved in the Philadelphia community, Khan is chair of the Board of Directors for the Pan Asian American Community House at Penn and cochair of the Board of Directors for the Philadelphia Folklore Project and serves on the Board of Directors of the Samuel S. Fels Fund. In 2015 she was appointed to the Governor's Advisory Commission on Asian Pacific American Affairs.

Homay King is a professor of the history of art and cofounder of the Program in Film Studies at Bryn Mawr College. She is the author of *Virtual Memory: Time-Based Art and the Dream of Digitality* (Duke University Press, 2015), which won the SCMS Anne Friedberg Award of Distinction, and *Lost in Translation: Orientalism, Cinema, and the Enigmatic Signifier* (Duke University Press, 2010), an inspiration for the Metropolitan Museum of Art's China: Through the Looking Glass. Her essays on film, contemporary art, and theory have appeared in *Afterall, Criticism, Discourse, Film Criticism, Film Quarterly, October, Qui Parle,* and elsewhere. She is a member of the Camera Obscura editorial collective.

Stephanie Mach is a Diné (Navajo) doctoral student in anthropology at the University of Pennsylvania. Her research focuses on the history of anthropological museums and their changing practices in the wake of postcolonial and settler colonial critiques. As academic coordinator at the Penn Museum, Mach provides support for University of Pennsylvania classes through access to museum collections and guest lectures on the intersection of museums, colonial ideology, policy, and representation. She received her bachelor's degree in archaeology from Boston University and her master's degree in museum studies from New York University. Since 2013, Mach has been part of the Wampum Trail Restorative Research project as a research assistant, studying wampum materials in museum collections and exploring both the historic and contemporary significance of wampum for Native communities and museums. Her current research focuses on museum transformations, specifically through contemporary collaborations with Native American communities.

Trapeta B. Mayson, a native of Liberia, works extensively to conduct poetry and creative writing workshops and reads her poetry widely. Her work amplifies the stories of everyday people, shedding light on and honoring the immigrant experience. Mayson is an author and a recipient of a Pew Fellowship in Literature, the Leeway Transformation Award, a Leeway Art and Change Grant, and Pennsylvania Council on the Arts grants; her work was also nominated for a 2016 Pushcart Prize. In addition, her writing has appeared in such publications as the *American Poetry Review, Epiphany Literary Journal, Aesthetica Magazine,* and *Margie: The American Journal of Poetry.*

Nathaniel Popkin is the author of six books, including the novel *The Year of the Return* (Open Books, 2019), and coeditor of *Who Will Speak for America?,* a literary anthology produced in response to the American political crisis (Temple University Press, 2018). The fiction review editor of *Cleaver Magazine,* he is also a prolific book critic—and National Book Critics Circle member—who focuses on literary fiction and works in translation. His writing has appeared in such publications as the *New York Times,* the *Wall Street Journal, Public Books, The Rumpus, Tablet Magazine, LitHub, The Millions,* and the *Kenyon Review.* As a keen observer of cities and lived places, Popkin has often turned his eye to the layers of history and life in his own city. He is founding coeditor of the *Hidden City Daily,* a web magazine that covers architecture, design, planning, and preservation in Philadelphia, and coauthor of the 2017 work of nonfiction *Philadelphia: Finding the Hidden City* (Temple University Press). He is also the senior writer and story editor for the multipart documentary film series *Philadelphia: The Great Experiment,* for which his work has received several Emmy awards.

Jodi Throckmorton is the curator of contemporary art at the Pennsylvania Academy of the Fine Arts (PAFA) in Philadelphia. Before joining PAFA in fall 2014, she was curator of modern and contemporary art at the Ulrich Museum of Art at Wichita State University in Kansas and had previously been associate curator at the San Jose Museum of Art in California. She organized the exhibitions and publications for Rina Banerjee: Make Me a Summary of the World (2018) and Postdate: Photography and Inherited History in India (2015). Her other projects include Nick Cave: Rescue (2018), Paul Chan: Pillowsophia (2017), Melt/Carve/Forge: Embodied Sculptures by Cassils (2016). Alyson Shotz: Plane Weave (2016), Bruce Conner: Somebody Else's Prints (2014), Questions from the Sky: New Work by Hung Liu (2013), Dive Deep: Eric Fischl and the Process of Painting (2013), Ranu Mukherjee: Telling Fortunes (2012), and This Kind of Bird Flies Backward: Paintings by Joan Brown (2011).

Salamishah Tillet is the Henry Rutgers Professor of African American Studies and Creative Writing and the associate director of the Price Institute of Ethnicity, Culture, and the Modern Experience at Rutgers University in Newark and the founding faculty director of the Public Arts and Social Justice Initiative at Express Newark. A contributing culture critic for the *New York Times,* Tillet is the author of *Sites of Slavery* (Duke University Press, 2012), *In Search of "The Color Purple"* (Abrams series Writers on Writing, forthcoming), and *All the Rage: Mississippi Goddam and the World Nina Simone Made* (Ecco, forthcoming). In 2003, she and her sister, Scheherazade Tillet, cofounded A Long Walk Home, a nonprofit that uses art to empower young people and end violence against girls and women. She is the featured subject and writer of "Story of a Rape Survivor," the groundbreaking multimedia performance on surviving sexual assault.

Jennifer Harford Vargas, who received her doctorate from Stanford University, is an associate professor of English at Bryn Mawr College. She researches and teaches Latina/o/x cultural production, hemispheric American studies, race and ethnicity, theories of the novel, decolonial imaginaries, narratives of undocumented migration, and testimonio forms in the Americas. She is the author of *Forms of Dictatorship: Power, Narrative, and Authoritarianism in the Latina/o Novel* (Oxford University Press, 2017) and coeditor of *Junot Díaz and*

the *Decolonial Imagination* (Duke University Press, 2016). Her work has also appeared in journals and edited books, such as *MELUS, Callaloo,* and *Latina/o Literature in the Classroom.* She recently joined the Board of Directors of Juntos, a community-led Latinx organization in South Philadelphia that fights for immigrant rights.

Naomi Waltham-Smith is an associate professor in the Centre for Interdisciplinary Methodologies at the University of Warwick. Sitting at the intersection of continental philosophy, music, and sound studies, her work appears in journals including *boundary 2, parrhesia, CR: The New Centennial Review, diacritics, Music Theory Spectrum,* the *Journal of Music Theory,* and *Sound Studies.* She is also the author of *Music and Belonging between Revolution and Restoration* (Oxford University Press, 2017); her second book, *The Sound of Biopolitics,* is forthcoming in Fordham University Press's Commonalities series. In 2019–2020 she will be a fellow at the Akademie Schloss Solitude, undertaking a project entitled "Cart-otographies of Cities: Soundmapping Urban Political Economies."

Bethany Wiggin is an associate professor of German and affiliate faculty in English and comparative literature at the University of Pennsylvania. In 2014, she established the Penn Program in Environmental Humanities, a collective of students, faculty, staff, artists, and writers at Penn and in the Philadelphia region who collaborate through interdisciplinary research, teaching, and imaginative public engagement. She has published on such topics as early modern European globalism, religious radicals and their tolerance in the Atlantic world, the Atlantic slave trade and the antislavery movement, the rise of fashion and commodity culture (including the modern novel), world literature, and translation. At present, she is completing her second monograph, *Germanopolis: Utopia Found and Lost in Penn's Woods,* which is based on deep dives into colonial archives on both sides of the Atlantic.

Mariam I. Williams is a writer, dancer, arts educator, and public historian whose work aims to present the true stories of underserved communities whose narratives have historically faced erasure. As project director of Chronicling Resistance, she guides the Philadelphia Association of Special Collections Libraries in amplifying stories of resistance in Philadelphia's archives and preserving records of today's acts of resistance. An alumna of Voices of Our Nations Arts Foundation, Williams holds a master's degree in creative writing and a certificate in public history from Rutgers University–Camden. In the spring of 2019, she launched *Black Womanhood Revival,* an online course series that engages womanism and black feminism to help black women pursue spiritually, emotionally, and physically healthier lives. Williams is currently writing a memoir about growing up in Kentucky with black radical parents, a churchgoing extended family, and a Christian sisterhood. Her work can be found in Women's Review of Books; on Salon.com; on Longreads.com; on resistance.pacscl.org; and on her website, mariamwilliams.com.

For more than thirty years, **Leslie Willis-Lowry**, associate archivist at the Charles L. Blockson Afro-American

Collection, Temple University Libraries, has worked in collections management and as an archivist, a researcher, and a consultant in several capacities for special collections, exhibitions, films, television, and publications, including the African American Museum in Philadelphia, the Schomburg Center for Research in Black Culture, the Museum of Afro-American History in Boston, the Studio Museum in Harlem, the Bronx Museum of Art, the Reginald F. Lewis Museum of Maryland African American History and Culture, Scholastic Books, and the International African American Museum. Willis-Lowry's career has been divided into two distinct areas—archival and educational—within the broad areas of photographic history, visual culture, African American history, and popular and material culture. Within these fields she has consistently emphasized the importance of the use of archives to build programming, educational, and community connections.

Duane Linklater, *In Perpetuity*, Penn Treaty Park, Monument Lab, 2017. (Steve Weinik/Mural Arts Philadelphia.)